FLEMISH AND DUTCH BAROQUE PAINTING

LA PEINTURE FLAMANDE ET HOLLANDAISE BAROQUE

FLÄMISCHE UND HOLLÄNDISCHE MALEREI DES BAROCK

PINTURA FLAMENCA Y HOLANDESA DEL BARROCO

LA PITTURA FIAMMINGA E OLANDESE DEL BAROCCO

VLAAMSE EN HOLLANDSE SCHILDERKUNST VAN DE BAROK

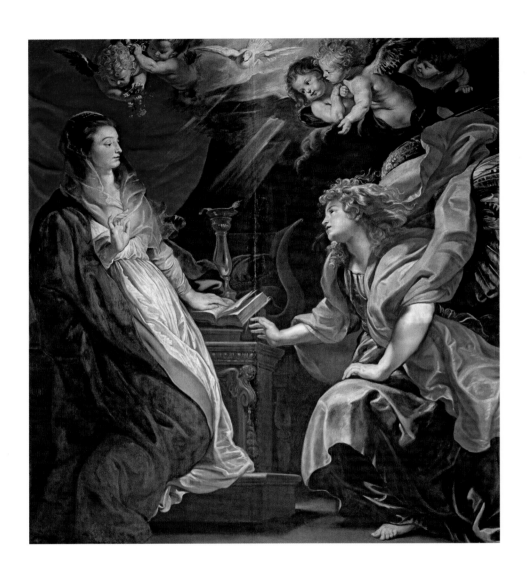

UTA HASEKAMP

FLEMISH AND DUTCH BAROQUE PAINTING

LA PEINTURE FLAMANDE ET HOLLANDAISE BAROQUE

FLÄMISCHE UND HOLLÄNDISCHE MALEREI DES BAROCK

PINTURA FLAMENCA Y HOLANDESA DEL BARROCO

LA PITTURA FIAMMINGA E OLANDESE DEL BAROCCO

VLAAMSE EN HOLLANDSE SCHILDERKUNST VAN DE BAROK

ÉDITIONS
PLACE DES
VICTOIRES

KÖNEMANN

p. 2

Peter Paul Rubens (1577–1640)

The Annunciation

L'Annonciation

Verkündigung Mariae

La Anunciación

Annunciazione

De Aankondiging

c. 1609, Oil on canvas/Huile sur toile, 225 × 202 cm, Kunsthistorisches Museum, Wien

KÖNEMANN
© 2017 koenemann.com GmbH
www.koenemann.com

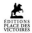

ÉDITIONS
PLACE DES
VICTOIRES

© Éditions Place des Victoires
6, rue du Mail – 75002 Paris
www.victoires.com
ISBN : 978-2-8099-1690-4
Dépôt légal : 2ᵉ trimestre 2019

Concept, Project Management: koenemann.com GmbH
Text and selection of the works: Uta Hasekamp
Editing: Kristina Menzel

Translation into French: Denis-Armand Canal
Translations into English, Spanish, Italian, Dutch:

✗ TEXTCASE
Translation Agency

info@textcase.nl
textcase.de textcase.eu

Layout: Christoph Eiden
Picture credits: akg-images gmbh

ISBN: 978-3-7419-2415-6

Printed in China by Shenzen Hua Xin Colour-printing & Platemaking Co., Ltd

Contents Sommaire Inhalt Índice Indice Inhoud

Dutch/Hollandaise

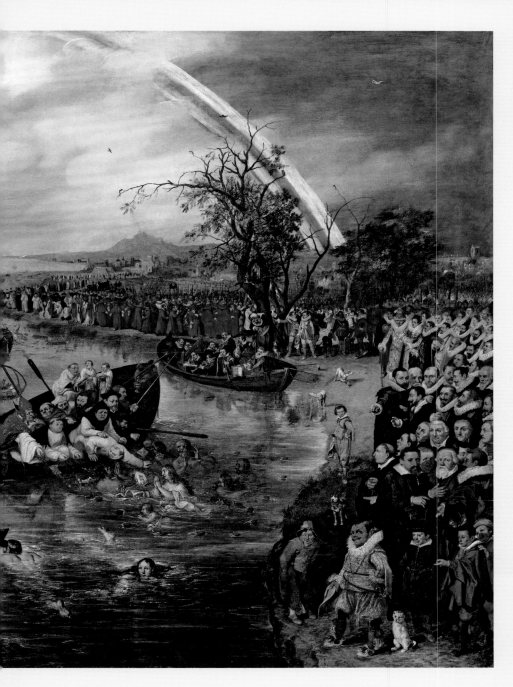

INTRODUCTION
INTRODUCTION
EINFÜHRUNG
INTRODUCCIÓN
INTRODUZIONE
INLEIDING

Adriaen Pietersz. van de Venne (1589–1662)

Fishing for Souls

La Pêche aux âmes

Die Seelenfischerei

La pesca de almas

Pesca delle anime

De zielenvisserij

1614, Oil on wood/Huile sur bois, 98,5 × 187,8 cm,
Rijksmuseum, Amsterdam

Flemish and Dutch Baroque Painting

Flanders in modern-day Belgium and Holland in the modern-day Netherlands (or the Southern and Northern Netherlands as they were known then) produced many of the great masterpieces of Baroque art. Since the late Middle Ages, the painting of the Low Countries had been distinguished by a pronounced naturalism. Collectors wanted precise, life-like, and technically masterful representation of people, their social lives, as well as the cities, houses, and landscapes in which they lived. In the Baroque period, which extended from about 1575 to 1750, with its heyday between 1600 to 1680, this naturalistic tradition experienced a renaissance.

La peinture flamande et hollandaise baroque

La peinture des Flandres et de la Hollande – foyers artistiques des Pays-Bas méridionaux et septentrionaux – est saluée comme un sommet de l'art baroque. Dès la fin du Moyen Âge, les tableaux néerlandais se distinguaient déjà par un naturalisme prononcé. Les amateurs d'art attachaient de la valeur à la représentation fidèle, réaliste et techniquement impeccable des hommes et de leur vie sociale, mais aussi des villes, des maisons et des paysages dans lesquels ils vivaient. À l'époque baroque (de 1575 à 1750 environ, la période s'étalant de 1600 à 1680 étant plus particulièrement traitée dans ce livre), la tradition naturaliste des Pays-Bas connut un nouvel apogée.

Flämische und holländische Malerei des Barock

Die Malerei Flanderns und Hollands (Kunstzentren der Südlichen und Nördlichen Niederlande) gilt als ein Höhepunkt der Kunst des Barock. Schon seit dem Spätmittelalter zeichneten sich niederländische Bilder durch einen ausgesprochenen Naturalismus aus. Die Kunstliebhaber legten Wert auf eine genaue, lebensechte und technisch meisterhafte Darstellung – der Menschen und ihres sozialen Lebens sowie der Städte, Häuser und Landschaften, in denen sie lebten. In der Zeit des Barock (von etwa 1575 bis 1750, wobei in diesem Buch die Jahre von 1600 bis 1680 im Vordergrund stehen) gelangte die naturalistische Tradition der niederländischen Malerei zu einer neuen Blüte.

Archduke Leopold Wilhelm Hunting Herons
Chasse au héron avec l'archiduc Léopold-Guillaume
Erzherzog Leopold Wilhelm auf der Reiherjagd
Caza de la garza con el archiduque Leopoldo Guillermo
Caccia all'airone con l'Arciduca Leopoldo Guglielmo
Aartshertog Leopold Wilhelm van Habsburg op reigerjacht

c. 1652–56, Oil on canvas/Huile sur toile,
82 × 120 cm, Musée du Louvre, Paris

Carel Fabritius (1622–54)
The Goldfinch
Le Chardonneret
Der Distelfink
El jilguero
Il cardellino
De distelvink

1654, Oil on wood/Huile
sur bois, 33,5 × 22,8 cm,
Mauritshuis, Den Haag

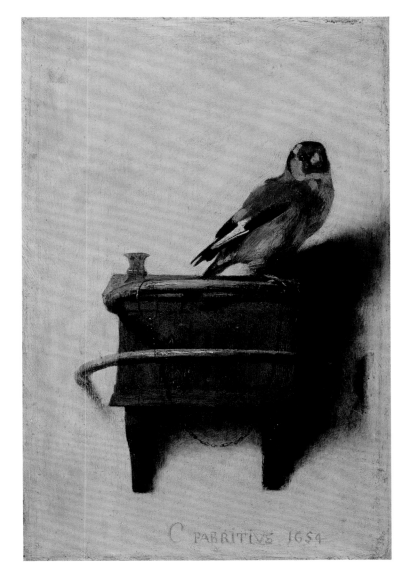

Pintura flamenca y holandesa del Barroco

La pintura de Flandes y Holanda (centros de arte del sur y del norte de Holanda) tiene como punto culminante el arte del barroco. Desde finales de la Edad Media, los cuadros holandeses se distinguían por un pronunciando naturalismo. Los amantes del arte atribuyen esta importancia a una presentación precisa, realista y técnicamente magistral – de las personas y su vida social, así como de las ciudades, casas y paisajes en los que vivían. En la época barroca (desde 1575 a 1750, dentro de la cual en este libro ponemos de relieve los años desde 1600 a 1680) se llevó la tradición naturalista de la pintura holandesa a nuevas alturas.

La pittura flamminga e olandese del Barocco

La pittura delle Fiandre e dell'Olanda (centri artistici dei Paesi Bassi meridionali e settentrionali) è considerata un punto culminante dell'arte barocca. Fin dal tardo Medioevo, i quadri prodotti in queste regioni sono stati caratterizzati da uno spiccato naturalismo. Gli amanti dell'arte attribuivano grande importanza alla rappresentazione precisa, realistica e tecnicamente magistrale sia delle persone e della loro vita sociale, sia delle città, delle case e dei paesaggi da esse abitati. Al tempo del Barocco (dal 1575 circa al 1750, periodo del quale questo volume approfondisce gli anni compresi tra il 1600 e il 1680), la tradizione naturalistica della pittura dei Paesi Bassi conobbe una nuova fioritura.

Vlaamse en Hollandse schilderkunst van de barok

De schilderkunst van Vlaanderen en Holland (de kunstcentra van de Zuidelijke en Noordelijke Nederlanden) wordt gezien als een van de hoogtepunten van de barokkunst. Al in de late middeleeuwen kenmerkte de Nederlandse schilderkunst zich door een uitgesproken naturalisme. Kunstliefhebbers waardeerden de nauwkeurige, levensechte en technisch meesterlijk uitgevoerde uitbeeldingen van gewone mensen en de stadsgezichten, interieurs en landschappen die ze bevolkten. In de tijd van de barok (vanaf ongeveer 1575 tot 1750, waarbij in dit boek de tijd van 1600 tot 1680 op de voorgrond staat) maakte de Nederlandse naturalistische traditie een nieuwe bloeiperiode door.

Pauwels van Hillegaert (1596–1640)

The Defeated Spanish Garrison Leaving 's-Hertogenbosch, 17 September 1629

La Retraite des troupes espagnoles après le siège de Bois-le-Duc en 1629

Der Abzug der spanischen Truppen von Herzogenbusch

La retirada de las tropas españolas de Bolduque

Il ritiro delle truppe spagnole da Boscoducale

Aftocht van het Spaanse garnizoen na de overgave van 's-Hertogenbosch

c. 1630–35, Oil on canvas/Huile sur toile, 109 × 173 cm, Rijksmuseum, Amsterdam

The profound political and social changes in the Low Countries during this century led Flemish and Dutch painting to develop in different directions. The years 1568 to 1648 were characterized by a series of religiously and politically motivated uprisings and wars, which today are called the Eighty Years' War or the Dutch War of Independence. Until 1580, the seventeen provinces of the Netherlands, both north and south, were under Spanish rule. King Philip II had tightened the reins of power as part of the Counter-Reformation and curtailed political and economic freedoms previously granted. In 1581, some of the largely Protestant northern provinces declared independence from Spain and formed the Republic of the Seven United Netherlands.

De profonds bouleversements politiques et sociaux amenèrent toutefois la peinture des Pays-Bas à évoluer dans des directions différentes. Les années 1568 à 1648 furent marquées par une suite de révoltes et d'hostilités d'origine religieuse et politique, appelée aujourd'hui « guerre de Quatre-Vingts Ans ». Jusqu'en 1580, les dix-sept provinces néerlandaises restèrent territoires de la couronne d'Espagne sous le nom de « Pays-Bas espagnols » : le roi Philippe II y intensifia la Contre-Réforme, limitant ou supprimant des libertés économiques et politiques précédemment octroyées. En 1581, sept provinces septentrionales – majoritairement protestantes – proclamèrent leur indépendance, en prenant le nom de Provinces-Unies.

Doch durch tiefgreifende politische und gesellschaftliche Veränderungen entwickelte sich die Malerei in Flandern und Holland in unterschiedliche Richtungen. Die Jahre 1568 bis 1648 waren durch eine Folge von religiös und politisch motivierten Aufständen und Kriegshandlungen gekennzeichnet, die man heute den Achtzigjährigen Krieg nennt. Bis 1580 unterstanden die 17 niederländischen Provinzen als Spanische Niederlande der spanischen Krone, die unter König Philipp II. die Gegenreformation verschärfte und zuvor gewährte politische und wirtschaftliche Freiheiten beschnitt. 1581 erklärten einige der großenteils protestantischen nördlichen Provinzen als Republik der Sieben Vereinigten Provinzen ihre Unabhängigkeit von Spanien.

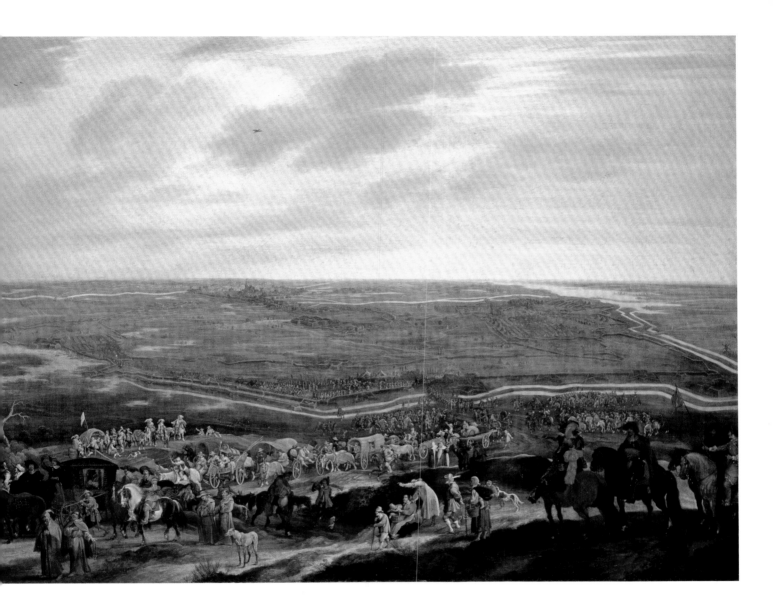

Pero por profundos cambios políticos y sociales, la pintura se desarrolló en Flandes y en Holanda en diferentes direcciones. Los años desde 1568 a 1648 estuvieron marcados por una serie de disturbios y actos bélicos debidos a motivos religiosos y políticos, los cuales son conocidos hoy con el nombre de la Guerra de los Ochenta Años. Hasta 1580, las 17 provincias holandesas estaban bajo los Países Bajos españoles de la Corona española, y bajo el mandato del rey Felipe II se intensificó la Contrarreforma así como los recortes de las previamente concedidas libertades políticas y económicas. En 1581 declararon su independencia de España algunas de las provincias del norte, en gran parte protestante, como la República de las Siete Provincias Unidas.

Tuttavia, in virtù di profondi cambiamenti politici e sociali, essa intraprese strade diverse nelle Fiandre e in Olanda. Gli anni tra il 1568 e il 1648 furono caratterizzati da una serie di disordini e atti bellici di carattere politico e religioso, attualmente denominati nel loro complesso Guerra degli ottant'anni. Nel periodo precedente al 1580 nacquero le 17 province della regione che andarono a costituire i Paesi Bassi spagnoli governati dalla corona di Spagna, la quale sotto Filippo II intensificò la Controriforma e ridusse le libertà politiche ed economiche concesse precedentemente. Nel 1581 alcune province settentrionali, in gran parte protestanti, dichiararono la loro indipendenza dalla Spagna sotto il nome Repubblica delle Sette Province Unite.

Door grote politieke en sociale veranderingen ontwikkelde de schilderkunst in Vlaanderen en Holland zich in verschillende richtingen. De jaren tussen 1568 en 1648 werden door een reeks religieuze en politieke opstanden en conflicten gekenmerkt, die tegenwoordig als de Tachtigjarige Oorlog worden samengevat. Tot 1580 vielen de zeventien Nederlandse provinciën als de Spaanse Nederlanden onder de Spaanse kroon, die onder koning Philips II de Contrareformatie verscherpte en eerder toegekende politieke en economische vrijheden inperkte. In 1581 riepen enkele van de overwegend protestantse noordelijke provincies zich uit tot de Republiek der Zeven Verenigde Nederlanden en verklaarden zich daarmee onafhankelijk.

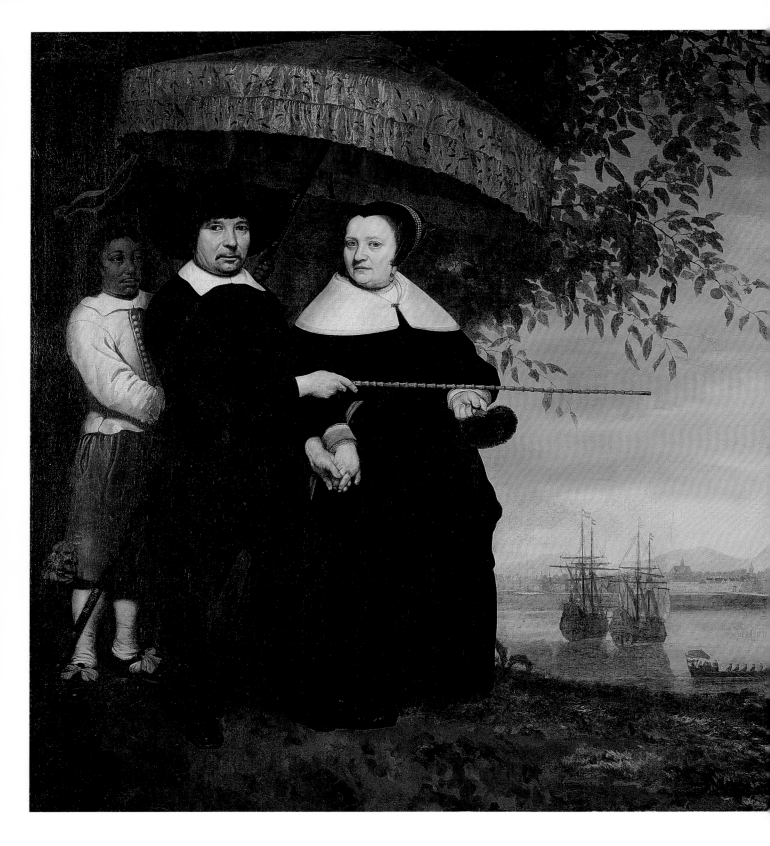

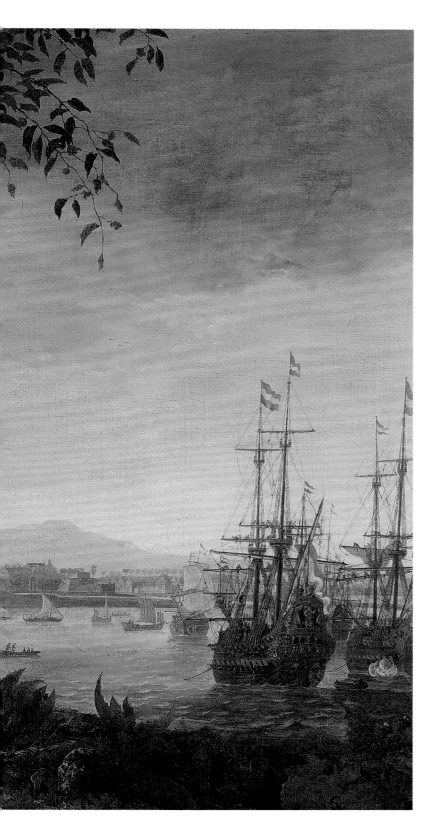

Aelbert Cuyp (1620–91)

VOC Senior Merchant and Wife in Batavia

Un marchand de la Compagnie néerlandaise des
Indes orientales et son épouse à Batavia

Ein Kaufmann der VOC und seine Frau in Batavia

Un comerciante de la VOC y su mujer en Batavia

Un commerciante della Compagnia delle Indie orientali e sua moglie in Batavia

Opperkoopman van de VOC en zijn vrouw in Batavia

c. 1640–60, Oil on canvas/Huile sur toile, 138 × 208 cm, Rijksmuseum, Amsterdam

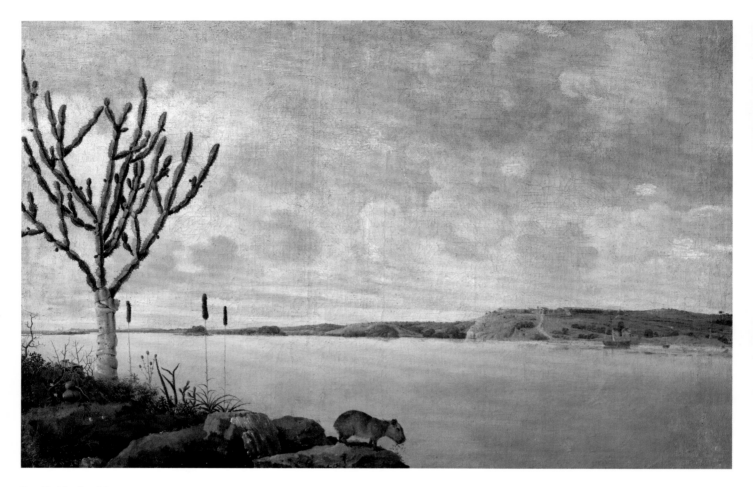

Frans Post (c. 1612–80)

Rio São Francisco and Fort Maurits in Brazil
Le Rio São Francisco et le fort Maurice
Rio São Francisco und Fort Maurits in Brasilien
Rio São Francisco y Fort Maurits en Brasil
Il fiume São Francisco e Fort Maurits in Brasile
Rio São Francisco en Fort Maurits in Brazilië

1639, Oil on canvas/Huile sur toile, 62 × 95 cm, Musée du Louvre, Paris

Despite its small territory, the Dutch Republic (today's Netherlands) became the most important sea and trading power of the 17th century. In 1602, trading companies joined forces to create the Dutch East India Company (VOC) and the Dutch West Indies Company (WIC) was founded in 1621. The state gave these organizations political powers and trade monopolies which covered the globe from the Americas to East Asia. They were responsible for bringing to the Netherlands and Europe such goods as porcelain and tea from Japan and China, carpets from the Middle East, and furs from North America, among others.

Malgré l'exiguïté du territoire, les Pays-Bas septentrionaux devinrent une grande puissance maritime et commerciale au XVIIe siècle. En 1602, les compagnies de marchands s'unirent pour former la Compagnie néerlandaise des Indes orientales (Verenigde Oost-Indische Compagnie ou VOC), puis en 1621 la Compagnie néerlandaise des Indes occidentales (Geoctroyeerde Westindische Compagnie ou GWC). Ces organisations, dotées par l'État de pouvoirs politiques et militaires et de monopoles commerciaux, avaient des comptoirs dans le monde entier, de l'Amérique à l'Extrême-Orient. Ainsi arrivaient en Hollande et en Europe la porcelaine et le thé du Japon

Diese Nördlichen Niederlande (die heutigen Niederlande) wurden trotz ihres kleinen Territoriums zur bedeutendsten See- und Handelsmacht des 17. Jahrhunderts: 1602 schlossen sich Kaufmannskompanien zur Niederländischen Ostindien-Kompanie (VOC) zusammen, 1621 wurde die Niederländische Westindien-Kompanie (WIC) begründet. Diese Organisationen wurden vom Staat mit politischen Befugnissen und Handelsmonopolen ausgestattet und unterhielten Niederlassungen von Amerika bis Ostasien. So gelangten Porzellan und Tee aus Japan und China, Teppiche aus dem Orient, Pelze aus Nordamerika und viele andere Güter nach Holland und Europa.

Dirk Valkenburg (1675–1721)

Plantation in Suriname

Plantation à Surinam

Plantage in Surinam

Plantación en Surinam

Piantagione nel Suriname

Plantage in Suriname

1707, Oil on canvas/Huile sur toile,
52,5 × 45,5 cm, Rijksmuseum, Amsterdam

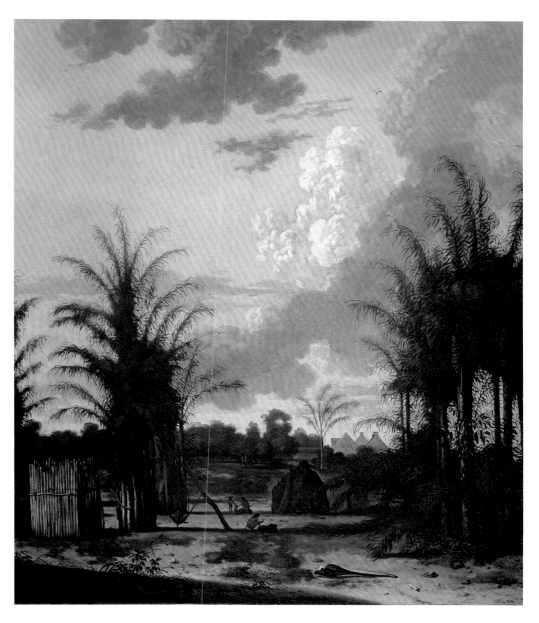

Esta Holanda del Norte (Holanda actualmente) fue, a pesar de su pequeño territorio, la potencia naval y comercial más importante del siglo XVII: en 1602 las empresas Kaufmann se fusionaron para formar la Compañía Neerlandesa de las Indias Orientales (VOC), así como se fundó también en 1621 la Compañía Neerlandesa de las Indias Occidentales (WIC). A estas organizaciones el estado les concedió autorizaciones políticas y monopolios comerciales y mantenían sedes desde América a Asia Oriental. Así llegó la porcelana y el té de Japón y China, las alfombras de Oriente, las pieles de América del Norte y muchos otros bienes a Holanda y Europa.

Nonostante le dimensioni ridotte del loro territorio, i Paesi Bassi settentrionali così creatisi (l'odierna Olanda) divennero la maggiore potenza navale e commerciale del XVII secolo: nel 1602, alcune compagnie di commercianti si unirono a formare la Compagnia olandese delle Indie orientali (VOC), e nel 1621 fu fondata la Compagnia olandese delle Indie occidentali (WIC). Lo Stato concesse a queste organizzazioni diritti politici e monopoli commerciali, ed esse fondarono diverse colonie e avamposti commerciali in vari territori, dall'America all'Asia orientale. Giunsero così in Olanda e in Europa

Deze noordelijke Nederlanden (het tegenwoordige Nederland) groeiden ondanks hun kleine territorium uit tot een van de voornaamste zee- en handelsmachten van de zeventiende eeuw. In 1602 sloten enkele koopmansverenigingen zich aaneen tot de Verenigde Oost-Indische Compagnie (VOC), en in 1621 werd de West-Indische Compagnie (WIC) opgericht. Deze organisaties werden door de staat van politieke bevoegdheden en handelsmonopolies voorzien en bezaten nederzettingen van Amerika tot Oost-Azië. Porselein en thee uit Japan en China, tapijten uit de

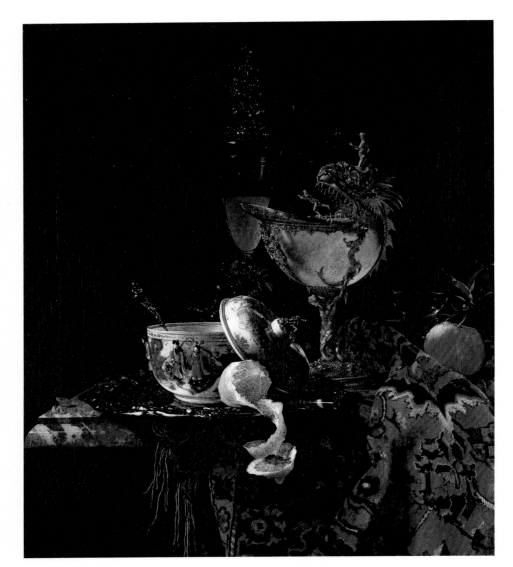

The economic success and the religious and social tolerance that took hold in the Dutch Republic attracted many qualified immigrants and many Flemish artists. The Dutch enjoyed the highest per-capita income in Europe in the 17th and 18th centuries. Unlike in other parts of Europe, the prosperity was not largely limited to the aristocracy, even if the head of state (Stadhouder) was the Prince of Orange. (Most of the aristocrats had moved to the Southern Netherlands still under Spanish control.) Instead, it was the bourgeoisie, which consisted not only of wealthy merchants, entrepreneurs, and military officers, but also a wide middle class of craftsmen, traders, sailors, and other professionals who benefited. This economic prosperity soon gave birth to a flourishing cultural life which has been called the Golden Age of the Netherlands.

et de la Chine, les tapis d'Orient, les peaux et fourrures d'Amérique du Nord, et bien d'autres marchandises.

Le succès économique ainsi que la tolérance religieuse et sociétale attirèrent les immigrants qualifiés et de nombreux artistes flamands et firent de la Hollande, aux XVIIᵉ et XVIIIᵉ siècles, la nation européenne au plus haut revenu par habitant. Ce bien-être profitait moins à la noblesse – il y avait bien une élite dirigeante autour du Stadhouder, mais la plupart des aristocrates étaient partis s'installer dans les Pays-Bas méridionaux – qu'à la bourgeoisie, qui se composait non seulement de riches marchands, d'entrepreneurs et de hauts officiers, mais aussi d'une vaste classe moyenne de commerçants, de bateliers, d'artisans, d'ouvriers et d'autres professions. Cette prospérité économique – qui s'accompagna très vite

Der wirtschaftliche Erfolg – und auch die religiöse und gesellschaftliche Toleranz, die qualifizierte Einwanderer wie auch viele flämische Künstler anzog – machten Holland im 17. und 18. Jahrhundert zur Nation mit dem höchsten Pro-Kopf-Einkommen in Europa. Der Wohlstand kam weniger einer Adelsschicht zugute (zwar gab es mit dem Statthalter ein adeliges Staatsoberhaupt, doch waren die meisten Aristokraten in die Südlichen Niederlande übersiedelt) als dem Bürgertum, das nicht nur aus reichen Kaufleuten, Unternehmern und hohen Militärs bestand, sondern auch aus einer breiten Mittelschicht aus Handwerkern, Händlern, Schiffern und anderen Berufssparten. Diese wirtschaftliche Blütezeit, mit der schon bald auch eine kulturelle Blüte einherging, wird als das Goldene Zeitalter der Niederlande bezeichnet.

Samuel van Hoogstraten (1627–78)

Slippers

Vue d'intérieur *ou* Les Pantoufles

Die Pantoffeln

Las zapatillas

Le pantofole

Gezicht vanuit een gang in een kamer

c. 1658, Oil on canvas/Huile sur toile, 103 × 70 cm, Musée du Louvre, Paris

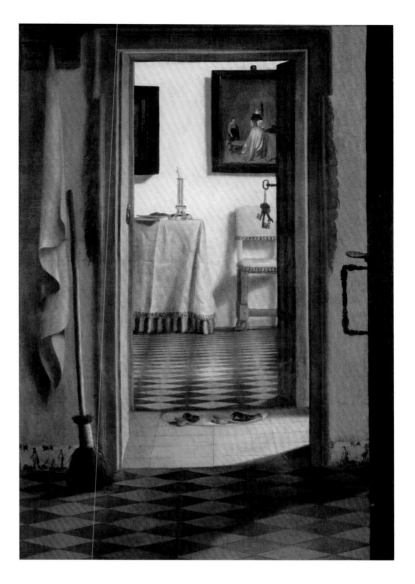

El éxito económico – y también la tolerancia religiosa y social que atraía a inmigrantes cualificados, como muchos artistas flamencos – hizo de Holanda en los siglos XVII y XVIII la nación con el mayor ingreso per cápita de Europa. La prosperidad no era tanto un beneficio de la nobleza (aunque había un jefe de estado noble con el gobernador, la mayoría de los aristócratas se trasladó a los Países Bajos del Sur) sino de la clase media, que consistía no sólo de ricos comerciantes, empresarios y líderes militares, sino también de una amplia clase media de artesanos, comerciantes, transportistas y otras profesiones. Este auge económico, al que pronto acompañó un florecimiento cultural, se designa como el Siglo de Oro neerlandés.

Surgió una nueva sociedad y los ciudadanos de todas las clases sociales solicitaban cuadros de esa

porcellana e tè dal Giappone e dalla Cina, tappeti dall'Oriente, pellicce dal Nord America e numerosi altri beni.

Nel XVII e XVIII secolo, il successo economico, unitamente alla tolleranza religiosa e sociale, che attraeva gli immigrati qualificati e molti artisti fiamminghi, rese l'Olanda la nazione con il più alto reddito pro capite in Europa. La prosperità non beneficiò tanto la nobiltà (sebbene, con la figura del governatore, la Repubblica avesse un capo di stato nobile, la maggior parte degli aristocratici si trasferì nei Paesi Bassi meridionali) quanto piuttosto la borghesia, costituita non solo da ricchi mercanti, uomini d'affari e militari di alto rango, ma anche da un'ampia classe media di artigiani, commercianti e trasportatori, tra gli altri. Questo boom economico,

Oriënt, pelzen uit Noord-Amerika en vele andere goederen werden naar Holland en Europa vervoerd.

Het economische succes – en ook de religieuze en sociale tolerantie, die gekwalificeerde immigranten en ook veel Vlaamse kunstenaars aantrok – maakten Holland in de zeventiende en achttiende eeuw tot het land in Europa met het hoogste inkomen per capita van Europa. De welvaart kwam niet alleen aan de adellijke geslachten ten goede (hoewel de Republiek met de Stadhouder een adellijk staatshoofd had, waren de meeste aristocraten naar het zuiden gevlucht), maar vooral aan de burgerij, die was opgebouwd uit rijke kooplieden, handelaren en hoge militairen, maar ook uit een brede middenstand van ambachtslieden, kooplui, kleine reders en andere beroepsgroepen. Deze economische – en al snel

Abraham Willaerts (1603/13–69)
Battle at Sea between the Spaniards and the Dutch
Bataille navale entre Espagnols et Néerlandais
Seeschlacht zwischen Spaniern und Holländern
Batalla entre españoles y holandeses
Battaglia navale tra spagnoli e olandesi
Zeeslag tussen de Spanjaarden en Hollanders
1641, Oil on canvas/Huile sur toile, 163,5 × 243 cm, Statens Museum for Kunst, København

A new society was emerging and citizens in every social class wanted to see it depicted on the walls of their homes. The result was the emergence of a massive art market (around 1650, approx. 70,000 paintings were created each year) and a marked specialization in painting. Many artists devoted themselves to a single type of painting, be it portraits, genre scenes, seascapes, still lifes, or animals (with subspecialties in specific animals or types of still life). Paintings were affordable for almost all groups of the population, but this also meant that many of the painters best known today had to earn their real living through other activities.

Philip II had given the southern provinces of the Spanish Netherlands (approximately present-day Belgium and parts of Northern France around Lille) to his daughter Isabella Clara Eugenia (1566–1633) and her husband Archduke Albrecht VII of Austria (1559–1621) to rule. Their tolerant rule contributed substantially to reconciling the inhabitants of the Southern

d'un épanouissement culturel – constitua bientôt l'âge d'or de la peinture néerlandaise.

Une nouvelle société était née et les citoyens de toutes les couches sociales réclamaient des représentations de cette société. Il s'ensuivit la création d'un énorme marché de l'art – vers 1650, quelque 70 000 tableaux étaient réalisés chaque année – accompagné d'une spécialisation dans les différents genres de peinture. De nombreux artistes se consacraient à un seul type d'œuvre : portraits, scènes de genre variées, vues d'architecture, paysages, marines, natures mortes ou représentations animalières – un artiste pouvant, de surcroît, se spécialiser dans un type particulier de nature morte ou d'animal. Les tableaux étaient accessibles à presque toutes les classes de la société, ce qui amena de nombreux peintres (aujourd'hui estimés) à devoir gagner leur vie grâce à d'autres activités.

Philippe II avait donné les provinces méridionales des Pays-Bas espagnols – couvrant à peu près l'actuelle

Eine neue Gesellschaft war entstanden, und Bürger aller sozialen Schichten verlangten nach Bildern von dieser Gesellschaft. So entstanden ein riesiger Kunstmarkt (um 1650 wurden jährlich etwa 70 000 Gemälde geschaffen) und eine ausgesprochene Spezialisierung innerhalb der Malerei: Viele Künstler widmeten sich einer einzigen Bildgattung, wie dem Porträt, dem Genrebild in seinen unterschiedlichen Spielarten, der Architekturmalerei, der Landschaft, dem Seestück, dem Stillleben oder dem Tierbild (wobei ein Künstler sich auf eine bestimmte Art von Stillleben oder Tieren spezialisieren konnte). Gemälde waren für fast alle Bevölkerungsgruppen erschwinglich, was jedoch auch dazu führte, dass viele heute geschätzte Maler ihren eigentlichen Lebensunterhalt durch andere Tätigkeiten verdienen mussten.

Die südlichen Provinzen der Spanischen Niederlande (in etwa das heutige Belgien und Teile Nordfrankreichs) hatte Philipp II. an seine Tochter Isabella Clara Eugenia (1566–1633) und deren Gatten

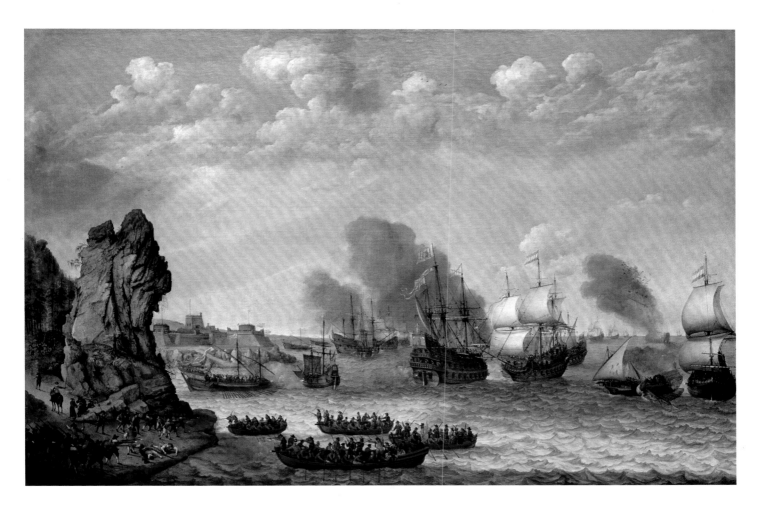

sociedad. Las consecuencias fueron la creación de un gran mercado del arte (en 1650, se crearon alrededor de 70 000 pinturas) y una marcada especialización dentro de la pintura: muchos artistas se dedicaron a un solo género, como el retrato, la pintura de género en sus diferentes variedades, la pintura arquitectónica, el paisaje, las marinas, la naturaleza muerta o la pintura de animales (dentro de las cuales un artista podía especializarse en un tipo particular de naturaleza muerta o de animales). Las pinturas eran asequibles para casi todos los sectores de la población, pero esto también dio lugar a que muchos pintores hoy apreciados tuvieran que ganarse el sustento mediante otras actividades.

Las provincias del sur de los Países Bajos españoles (que corresponden más o menos con la actual Bélgica y partes del norte de Francia) fueron entregadas por Felipe II a su hija Isabel Clara Eugenia (1566–1633) y a su marido el archiduque Alberto de Austria (1559–1621). El régimen tolerante de los gobernadores Alberto e Isabel contribuyó significativamente a conciliar a

ben presto accompagnato anche da una fioritura culturale, prende il nome di Secolo d'oro dei Paesi Bassi.

Era nata una nuova società, e cittadini di tutte le classi sociali desideravano quadri che la raffigurassero. Si svilupparono dunque un enorme mercato di opere arte (intorno al 1650 venivano prodotti ogni anno circa 70 000 dipinti) e una spiccata specializzazione all'interno della pittura: molti artisti si dedicarono infatti ad un solo genere, come ad esempio il ritratto, la pittura di genere nelle sue diverse varietà, la pittura architettonica, il paesaggio, il paesaggio marino, la natura morta o i dipinti di animali (in cui un artista poteva specializzarsi in un particolare tipo di natura morta o di animali). I dipinti erano accessibili a quasi tutti gli strati della popolazione, cosa che portò molti pittori oggi stimati a doversi guadagnare da vivere mediante altre attività.

Le province meridionali dei Paesi Bassi spagnoli (più o meno l'attuale Belgio e parte della Francia

ook culturele – bloeiperiode wordt aangeduid als de Gouden Eeuw.

Er was een nieuwe samenleving ontstaan waarin burgers van alle rangen en standen behoefte hadden aan schilderijen die deze samenleving uitbeeldden. Hierdoor ontstond er een reusachtige kunstmarkt (rond 1650 werden jaarlijks zo'n 70 000 schilderijen vervaardigd) en een opmerkelijke specialisatie binnen de schilderkunst: veel kunstenaars wijdden zich aan slechts één onderwerp, zoals het portret, het genrestuk in zijn verschillende soorten, de architectuurschilderkunst, het landschap, het zeegezicht, het stilleven of het dierenstuk (waarbij de kunstenaar zich op stillevens met specifieke diersoorten richtte). Schilderijen waren voor bijna alle lagen van de bevolking betaalbaar, wat er ook toe leidde dat veel schilders die tegenwoordig hoog worden aangeslagen, zich voor hun levensonderhoud met andere zaken moesten bezighouden.

De zuidelijke provincies van de Spaanse Nederlanden (ongeveer het huidige België en delen van Noord-Frankrijk) had Philips II onder bestuur

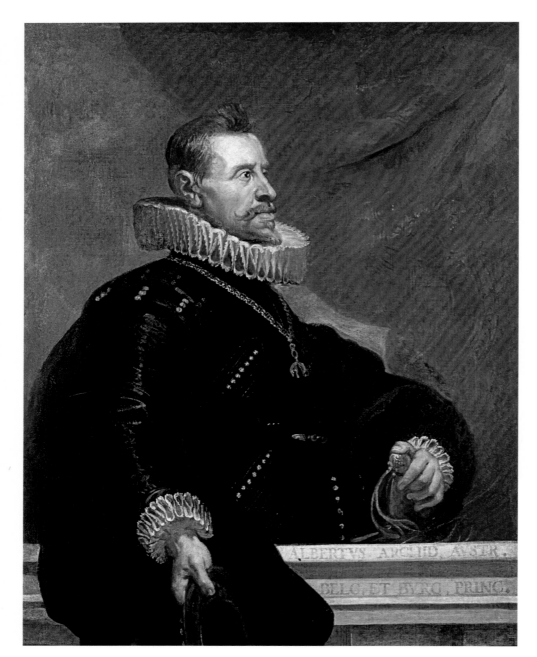

Netherlands to Spanish sovereignty. Even during
this time of war with their fellow Dutch speakers to
the north and economic stagnation due to Antwerp's
loss of its role as a center for trade to the Dutch
capital of Amsterdam, Flemish painting likewise
experienced a boom. The artists worked not just for
an international market of collectors, but also for an
internal market where the Catholic Church of the
Counter-Reformation, the nobles and wealthy citizens
of Flanders, and also Albrecht and Isabella themselves

Belgique et une partie du nord de la France – à sa
fille Isabelle-Claire-Eugénie (1566–1633) et son mari,
l'archiduc Albert VII d'Autriche (1559–1621). Le
gouvernement tolérant des régents Albert et Isabelle
contribua beaucoup à réconcilier les habitants des
Pays-Bas méridionaux avec l'Espagne. Dans une
période d'hostilités ouvertes avec les voisins du Nord
et malgré la stagnation économique (Anvers avait dû
céder à Amsterdam son rôle de centre principal du
commerce international), la peinture flamande connut

Erzherzog Albrecht VII. von Österreich (1559–1621)
übergeben. Die tolerante Herrschaft der Statthalter
Albrecht und Isabella trug wesentlich dazu bei, die
Einwohner der Südlichen Niederlande mit Spanien
zu versöhnen. So erlebte auch in einer Zeit der
Kriegshandlungen mit dem nördlichen Nachbarn und
der wirtschaftlichen Stagnation (Antwerpen hatte
seine Rolle als Haupthandelszentrum an Amsterdam
abtreten müssen) die flämische Malerei einen neuen
Aufschwung. Die Künstler arbeiteten nicht nur – wie

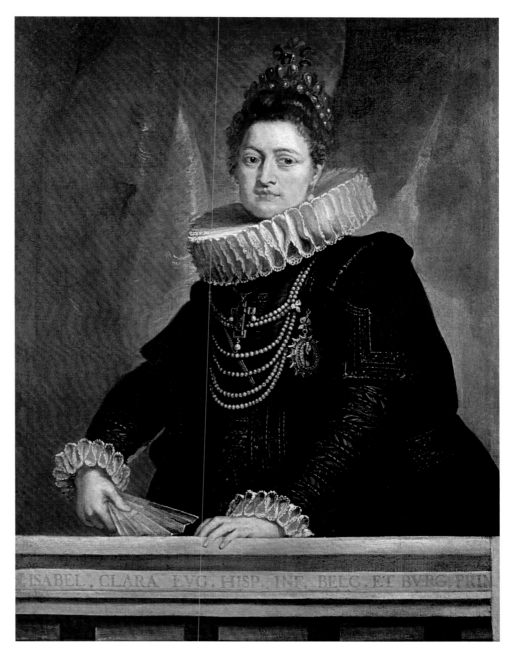

Cornelis De Vos (1584–1651), retouched by/retouché par Peter Paul Rubens (1577–1640)

The Infanta Isabella Clara Eugenia, Wife to Archduke Albrecht VII, Ruler of the Southern Netherlands

Portrait d'Isabelle-Claire-Eugénie, archiduchesse d'Autriche

Infantin Isabella Clara Eugenia, Statthalterin der Südlichen Niederlande

Infanta Isabel Clara Eugenia, gobernadora de los Países Bajos del sur

Ritratto dell'Infanta Isabella Clara Eugenia, governatrice dei Paesi Bassi meridionali

Infante Isabella van Spanje, landvoogdes der Zuidelijke Nederlanden

1634/35, Oil on canvas/Huile sur toile, 138 × 105,5 cm, Musées royaux des Beaux-Arts de Belgique, Bruxelles

los habitantes de los Países Bajos meridionales con España. Así, la pintura flamenca experimentó un nuevo auge incluso en un momento de guerra con el vecino del norte y en medio de un estancamiento económico (Amberes tuvo que ceder su papel como importante centro comercial a Ámsterdam). Los artistas trabajaron no sólo –como siempre– para un mercado internacional de expertos en arte, sino también para un mercado interno en el que la Iglesia católica de la Contrarreforma, ricos nobles, ciudadanos

settentrionale) furono cedute da Filippo II alla figlia Isabella Clara Eugenia (1566–1633) e a suo marito Alberto VII d'Asburgo, arciduca d'Austria (1559–1621). Il regime tollerante dei governatori Alberto e Isabella contribuì in modo significativo a riconciliare gli abitanti dei Paesi Bassi meridionali con la Spagna. Fu così che, nonostante la guerra con i vicini settentrionali e la stagnazione economica (Anversa aveva dovuto cedere ad Amsterdam il suo ruolo di capitale commerciale), la pittura fiamminga conobbe un

van zijn dochter Isabella (1566–1633) en haar gemaal, aartshertog Albrecht VII van Oostenrijk (1559–1621) gesteld. Het tolerante beleid van de landvoogden Albrecht en Isabella droeg er in hoge mate aan bij dat de inwoners van de Zuidelijke Nederlanden hun band met Spanje wilden behouden. Zo maakte ook de Vlaamse schilderkunst, ondanks het conflict met het noorden en de economische stagnatie (Antwerpen had zijn rol als voornaamste handelscentrum moeten afstaan aan Amsterdam) een nieuwe bloeiperiode door.

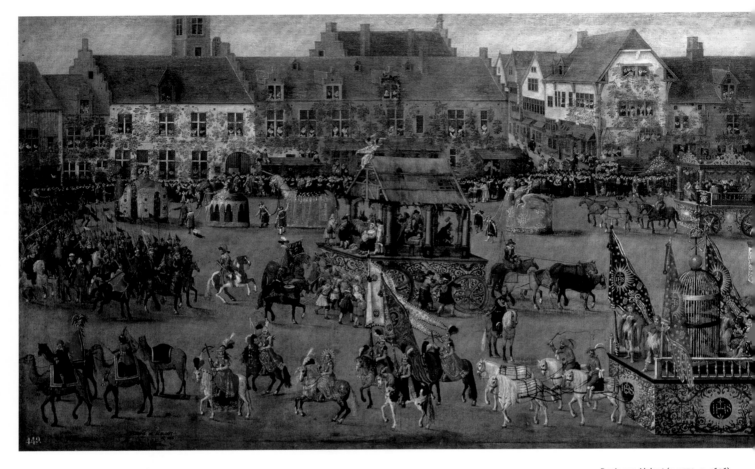

generated demand for new works of art. This patronage resulted in a large number of religious paintings, portraits, and idealized representations of rural life, many of which have become known as masterpieces of Baroque art.

également un nouvel essor. Les artistes travaillaient non seulement – comme toujours – pour un marché international d'amateurs et de connaisseurs, mais aussi pour un marché intérieur où l'Église catholique, les nobles et les riches bourgeois ainsi que les régents d'Espagne commandaient des œuvres d'art. Il faut attribuer à ce mécénat le grand nombre de tableaux religieux, de portraits représentatifs et de scènes de la vie de campagne réalisés à cette époque – dont de nombreuses toiles qui comptent parmi les chefs-d'œuvre de l'art baroque.

von jeher – für einen internationalen Markt von Kunstkennern, sondern auch für einen Binnenmarkt, auf dem die katholische Kirche der Gegenreformation, Adlige, reiche Bürger und auch Albrecht und Isabella nach Kunstwerken verlangten. Auf dieses Mäzenatentum ist die große Anzahl von religiösen Bildern, repräsentativen Porträts und Darstellungen des Landlebens zurückzuführen, die zu dieser Zeit entstanden, darunter viele Gemälde, die zu den Meisterwerken der Kunst des Barock zählen.

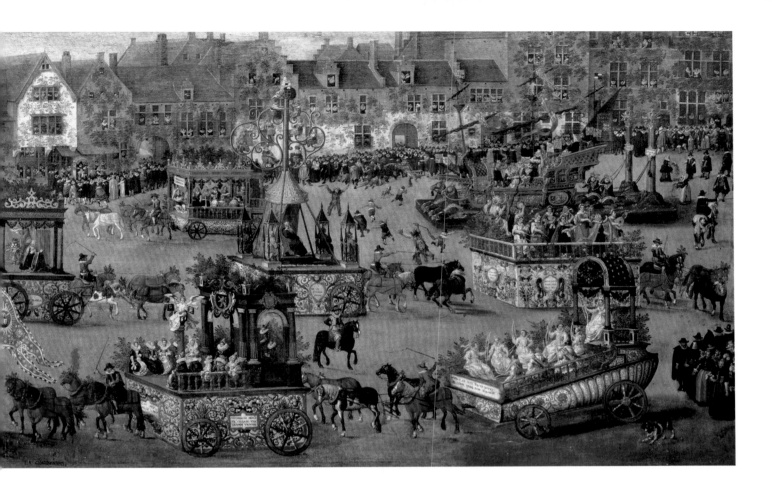

e incluso Alberto e Isabel les solicitaban obras de arte. Debido a este patrocinio surgió en ese momento una gran cantidad de imágenes religiosas, retratos y representaciones de la vida en el campo, incluyendo muchas pinturas que se encuentran entre las obras maestras del arte barroco.

nuovo sviluppo. Gli artisti non lavoravano solo (come sempre) per il mercato internazionale di intenditori d'arte, ma anche per il mercato interno costituito dalla Chiesa cattolica della Controriforma, da nobili, da ricchi cittadini e dagli stessi Alberto e Isabella. A questo mecenatismo si deve la gran quantità di dipinti religiosi, ritratti rappresentativi e raffigurazioni della vita di campagna prodotti in tale periodo, tra cui numerosi dipinti che costituiscono capolavori dell'arte barocca.

De kunstenaars werkten niet alleen (zoals van oudsher) voor een internationale markt van kunstkenners, maar ook voor een binnenlandse markt, waar de katholieke kerk van de Contrareformatie, de adel, de rijke burgerij en ook Albrecht en Isabella kunstwerken aankochten. Dit brede mecenaat leidde tot het enorme aantal religieuze werken, representatieve portretten en uitbeeldingen van het landleven dat in deze tijd ontstond, waaronder veel schilderijen die tot de meesterwerken van de barok worden gerekend.

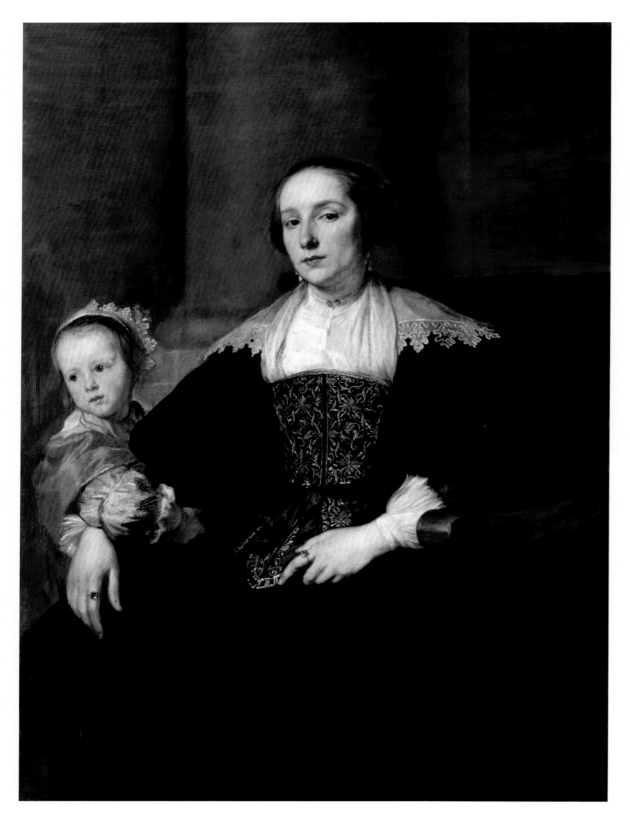

The Painter Rombouts'
Wife Anna van Thielen
and Daughter

Anna van Thielen, épouse
du peintre Theodore
Rombouts, et sa fille

Die Gemahlin des Malers
Rombouts Anna van
Thielen
und ihre Tochter

La esposa del pintor
Rombouts Anna van
Thielen y su hija

La moglie del pittore
Rombouts Anna van
Thielen con la figlia

Anna van Thielen,
echtgenote van de schilder
Theodoor Rombouts,
en hun dochter

c. 1632, Oil on wood/Huile
sur bois, 122,8 × 90,7 cm,
Alte Pinakothek, München

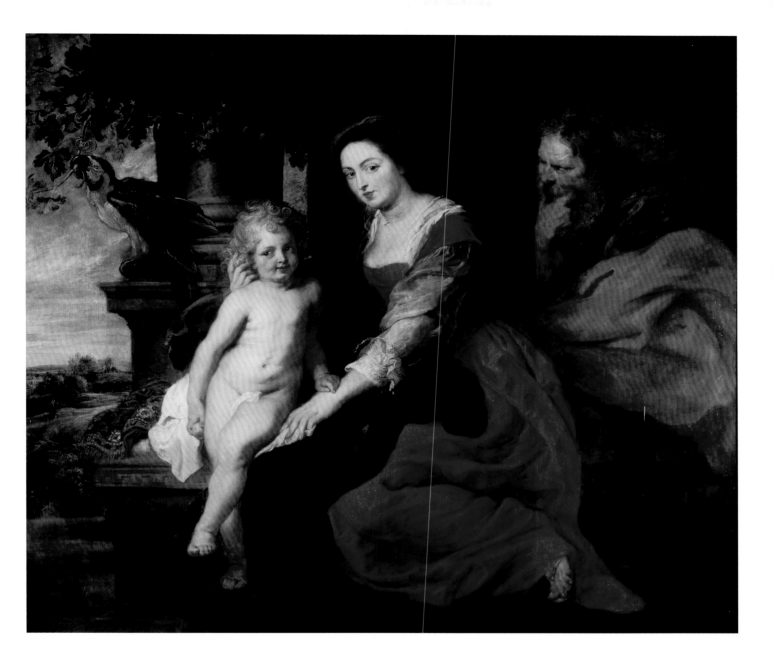

Peter Paul Rubens (1577–1640)

The Holy Family with Parrot

La Sainte Famille *ou* Vierge au perroquet

Die heilige Familie mit dem Papagei

La sagrada familia con papagayo

La Sacra Famiglia con un pappagallo

De Heilige Familie met een papegaai

c. 1614, Oil on wood/Huile sur bois, 163 × 189 cm,
Museum voor Schone Kunsten, Antwerpen

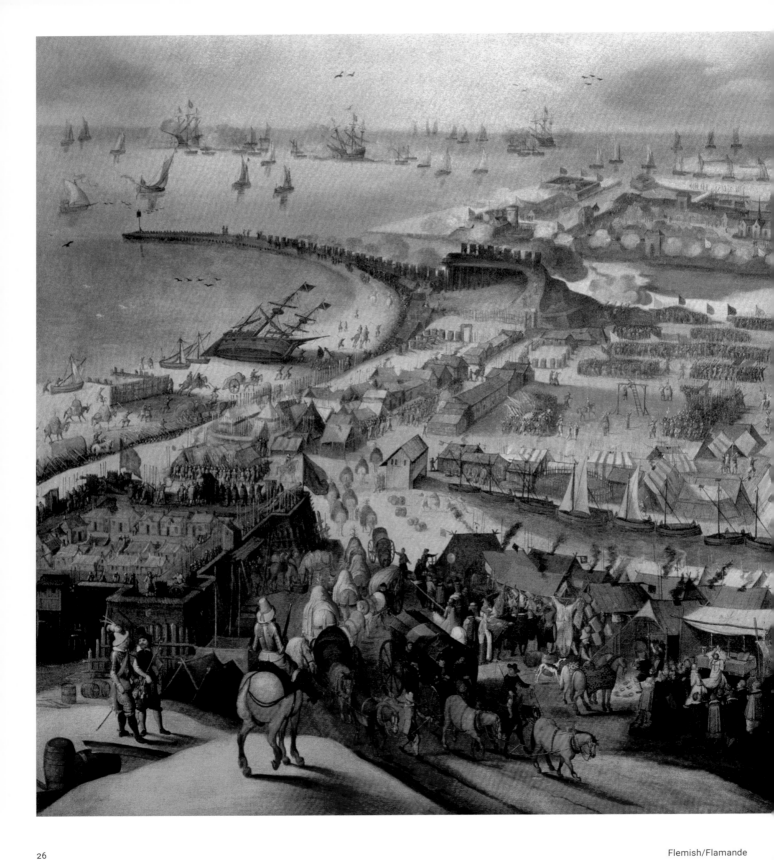

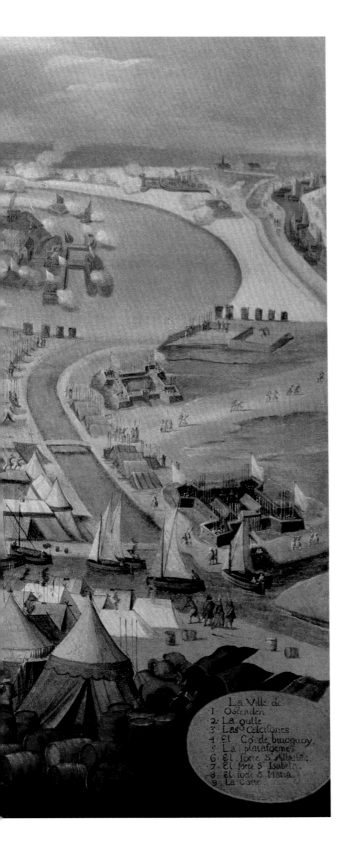

La Ville de
1. Ostenden
2. La gulle
3. Las Calcifones
4. El Cō de buoquoy
5. La plataforme
6. El forte S. Albuto
7. El forte S. Isabela
8. El fort S. Maria
9. La Corte

Flemish school/École flamande

The Spanish Siege of Ostende 1601–04

Le Siège d'Ostende par les Espagnols

Die Belagerung von Ostende durch die Spanier 1601–04

El asedio de Ostende por los españoles 1601–1604

L'assedio di Ostenda da parte degli spagnoli nel 1601–1604

Het beleg van Oostende door de Spanjaarden, 1601–1604

1601–50, Oil on canvas/Huile sur toile, 118 × 158,5 cm, Musées royaux des Beaux-Arts de Belgique, Bruxelles

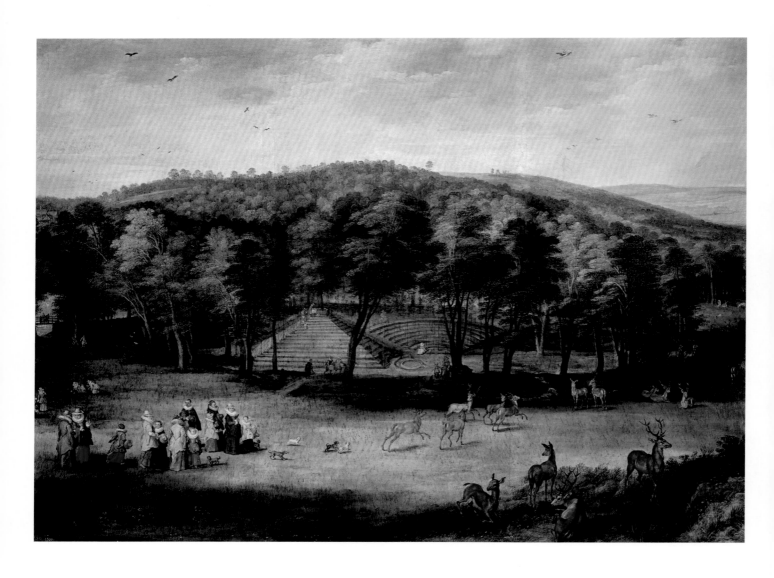

Jan Brueghel de Oude/the Elder/l'Ancien, *dit* de Velours (1568–1625), Joos de Momper de Jonge/the Younger/le Jeune (1564–1635)

The Infanta Isabella Clara Eugenia in Mariemont Park

L'Infante Isabelle-Claire-Eugénie d'Espagne dans le parc de Mariemont

Die Infantin Isabella Clara Eugenia im Park von Mariemont

La Infanta Isabel Clara Eugenia en el parque de Mariemont

L'Infanta Isabella Clara Eugenia nel parco di Mariemont

De infante Isabella van Spanje in het Park van Mariemont

1600–25, Oil on canvas/Huile sur toile, 176 × 236 cm, Museo del Prado, Madrid

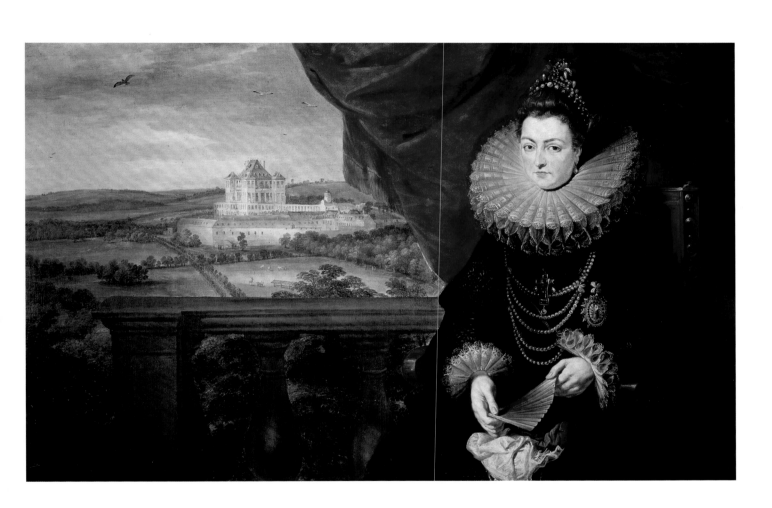

Peter Paul Rubens (1577–1640), Jan Brueghel de Oude/the Elder/l'Ancien, *dit* de Velours (1568–1625)

The Infanta Isabella Clara Eugenia and Mariemont Palace

 L'Infante Isabelle-Claire-Eugénie devant le château de Mariémont

Die Infantin Isabella Clara Eugenia und Schloss Mariemont

La Infanta Isabel Clara Eugenia y el castillo de Mariemont

L'Infanta Isabella Clara Eugenia e il castello di Mariemont

De infante Isabella van Spanje en het Slot Mariemont

c. 1615, Oil on canvas/Huile sur toile, 113 × 175,8 cm, Museo del Prado, Madrid

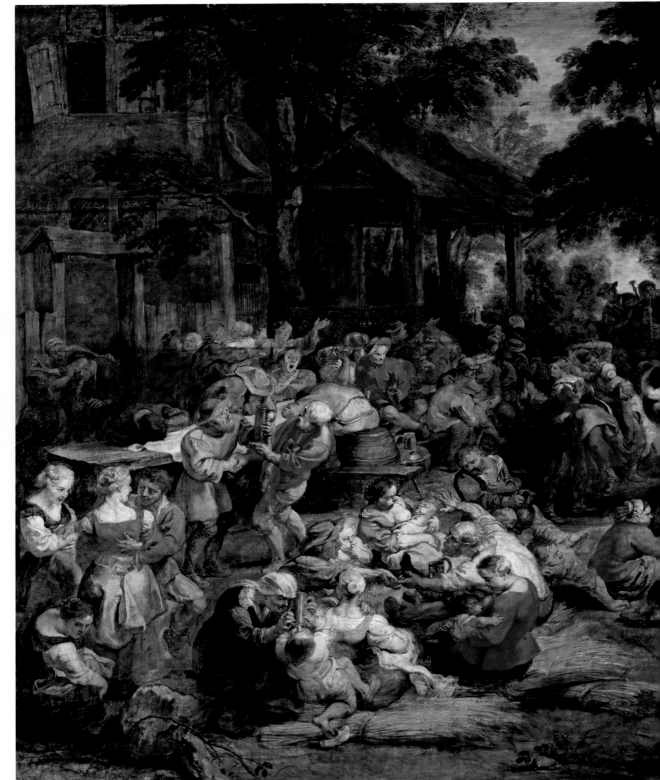

Peter Paul Rubens
(1577–1640)

Flemish Fair

La Kermesse *ou*
Noce de village

Flandrische
Kirmes

La feria de
Flandes

Kermesse
fiamminga

Vlaamse kermis

c. 1635–38, Oil on
wood/Huile sur
bois, 149 × 261 cm,
Musée du
Louvre, Paris

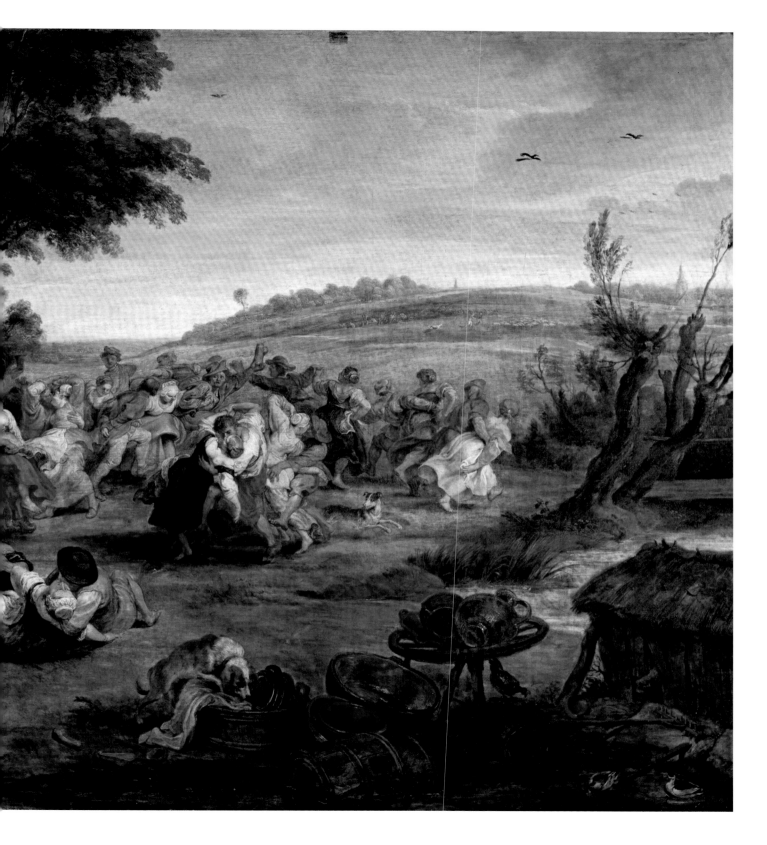

31

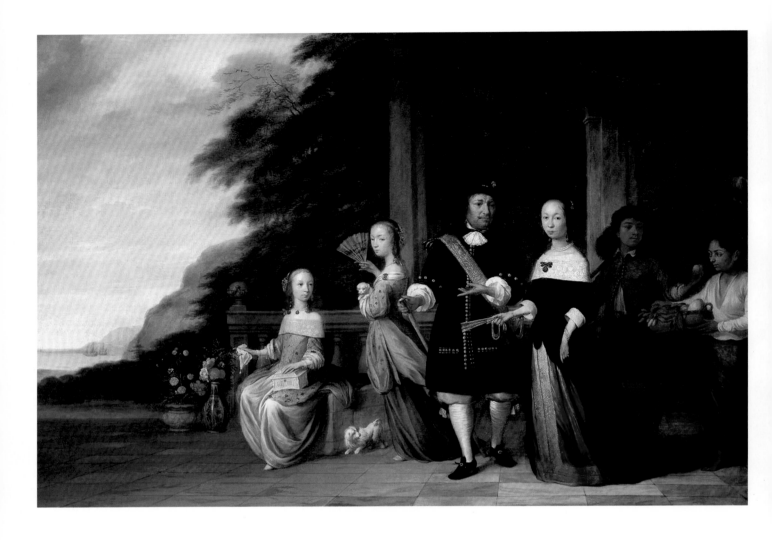

Jacob Coeman (c. 1632–76)

Merchant Pieter Cnoll and Family in Batavia

Le Commerçant Pieter Cnoll et sa famille

Der Kaufmann Pieter Cnoll und seine Familie in Batavia

El comerciante Pieter Cnoll y su familia en Batavia

Il commerciante Pieter Cnoll e la sua famiglia in Batavia

Familieportret in Batavia, Pieter Cnoll, Cornelia van Nijenrode en hun dochters

1665, Oil on canvas/Huile sur toile, 132 × 190,5 cm, Rijksmuseum, Amsterdam

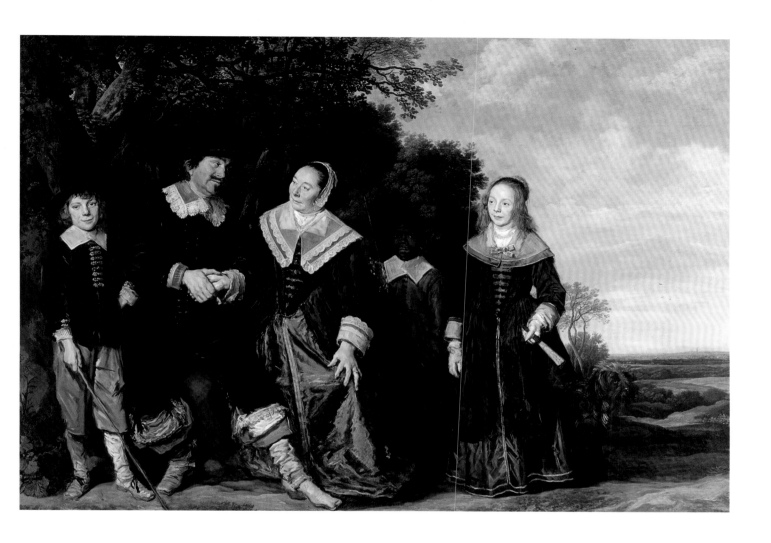

Frans Hals (c. 1580–1666)

Family in Landscape

Portrait de famille dans un paysage

Familie in einer Landschaft

Grupo familiar ante un paisaje

Famiglia in un paesaggio

Familie in een landschap

c. 1645–48, Oil on canvas/Huile sur toile, 202 × 285 cm, Museo Thyssen-Bornemisza, Madrid

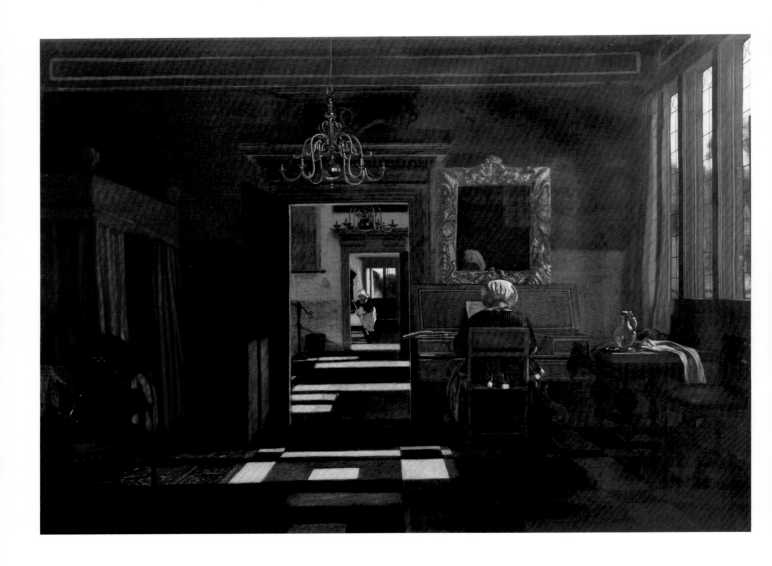

Emanuel de Witte (1617–92)

Interior with Woman at Virginal

Intérieur avec une femme assise au virginal

Interieur mit Frau am Virginal

Interior con mujer al virginal

Interno con donna al verginale

Interieur met vrouw aan een virginaal

1665–70, Oil on canvas/Huile sur toile, 77,5 × 104,5 cm, Museum Boijmans Van Beuningen, Rotterdam

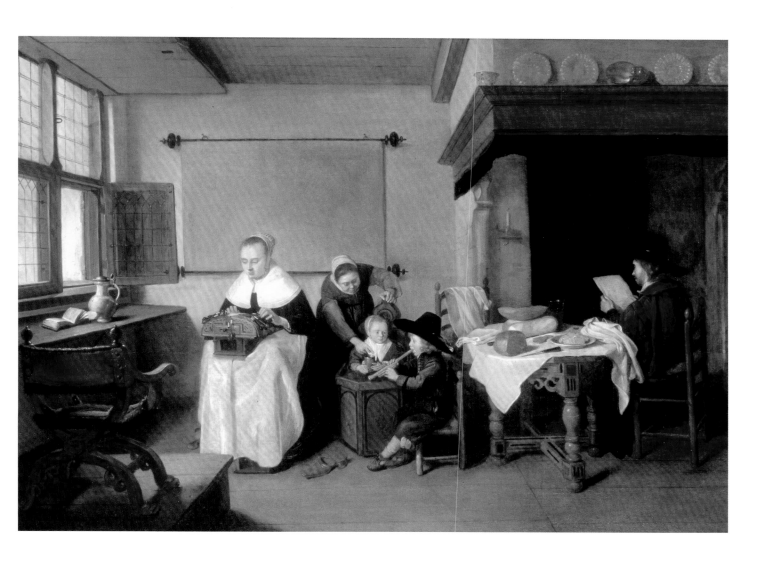

Quiringh Gerritsz. van Brekelenkam (c. 1622–69)

Family Scene

Scène d'intérieur avec une famille

Familienszene

Escena familiar

Scena familiare

Interieur met een familie

c. 1655, Oil on wood/Huile sur bois, 59 × 84 cm, Private collection

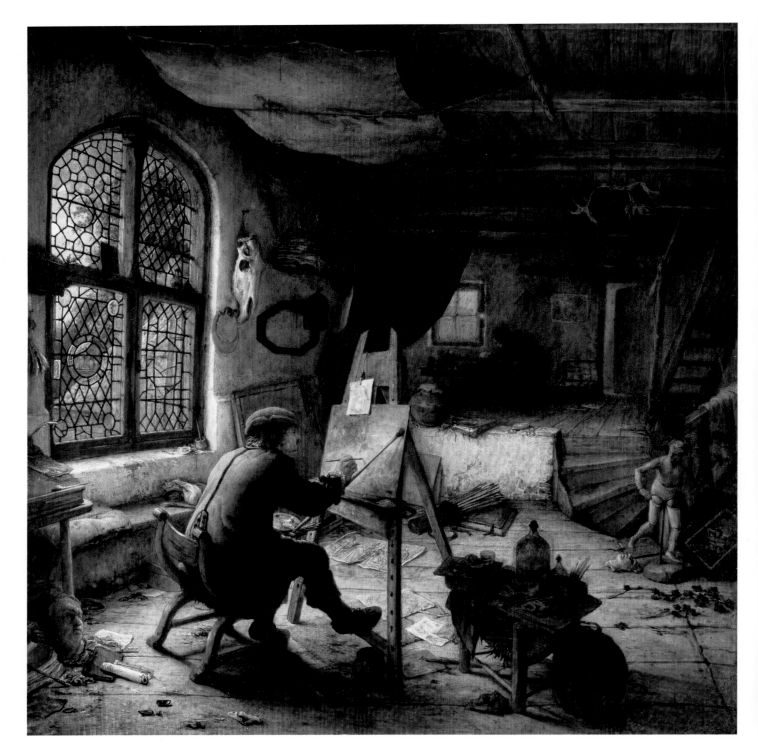

Adriaen van Ostade (1610–85)

The Painter in His Studio	Der Maler in seiner Werkstatt	Il pittore nel suo studio
Le Peintre dans son atelier	El pintor en su taller	De schilder in zijn atelier

1663, Oil on wood/Huile sur bois, 38 × 35,5 cm, Gemäldegalerie Alte Meister, Dresden

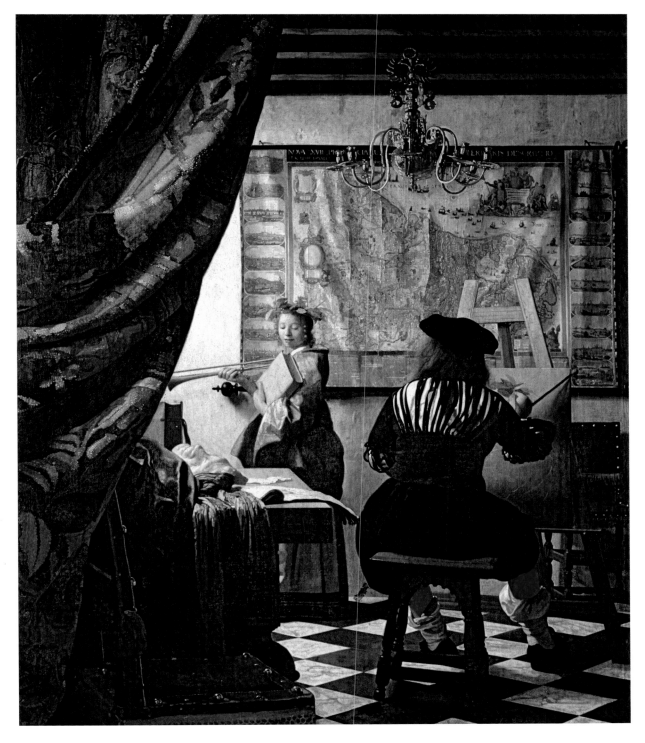

Jan Vermeer van Delft (1632–75)

The Art of Painting Die Malkunst Allegoria della Pittura

L'Art de la peinture El arte de la pintura De schilderkunst

c. 1666–68, Oil on canvas/Huile sur toile, 120 × 100 cm, Kunsthistorisches Museum, Wien

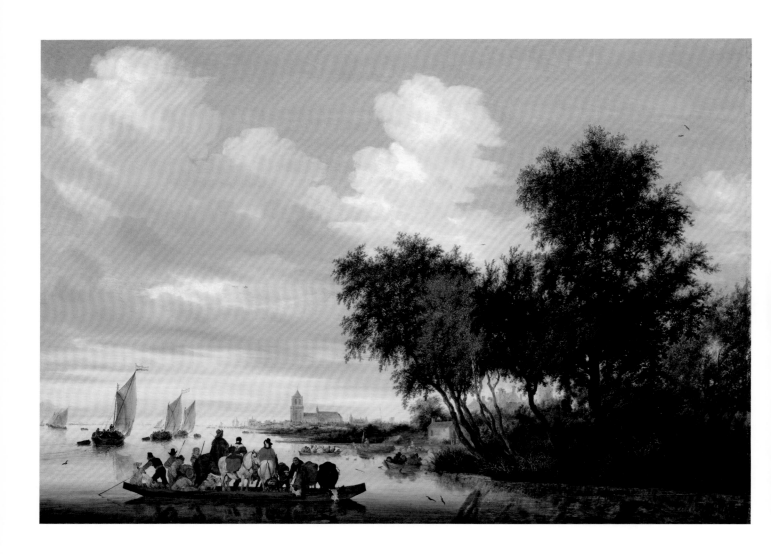

Salomon van Ruysdael (c. 1600–70)

River Scene with Ferry

Paysage fluvial avec ferry

Flusslandschaft mit Fähre

Paisaje con río y transbordador

Paesaggio fluviale con traghetto

Rivierlandschap met veerpont

1649, Oil on wood/Huile sur bois, 91 × 116,5 cm, Rijksmuseum, Amsterdam

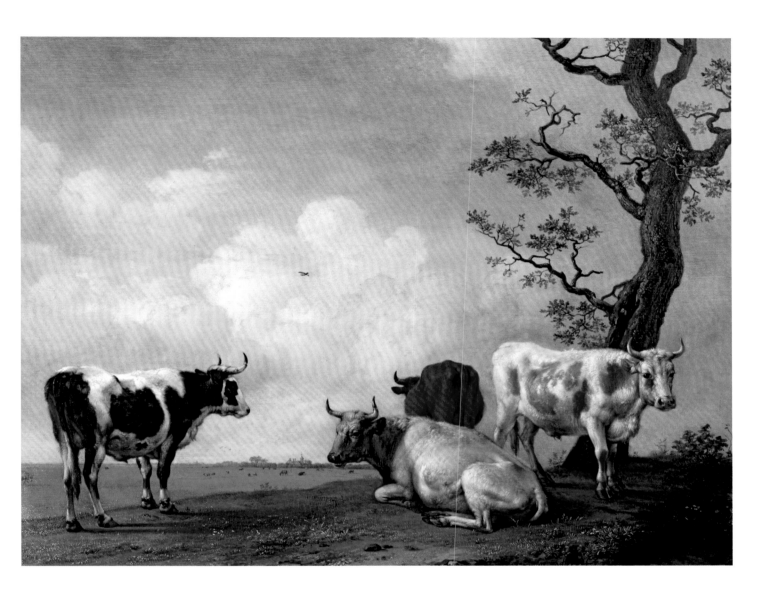

Paulus Potter (1625–54)

Four Bulls

Quatre taureaux

Vier Bullen

Cuatro toros

Quattro tori

Vier stieren

c. 1645–54, Oil on canvas/Huile sur toile, 57 × 67 cm, Galleria Sabauda, Torino

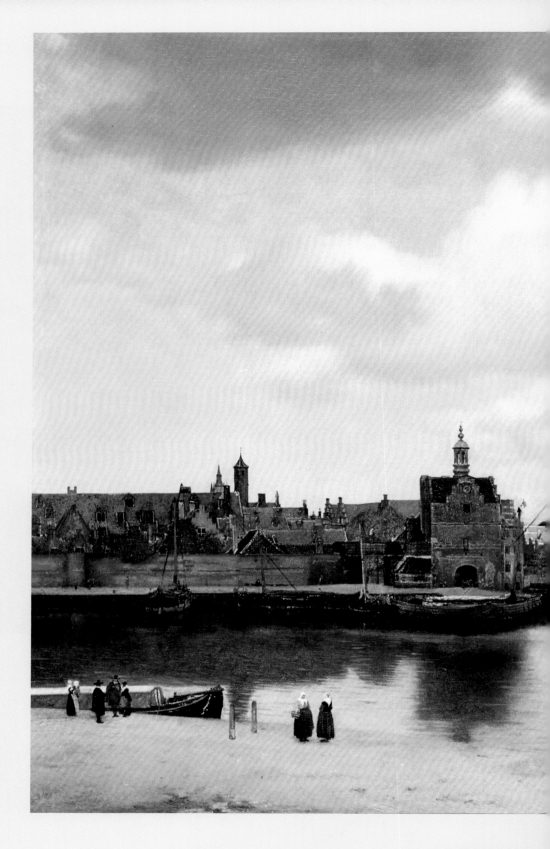

Dutch/Hollandaise

CITY, LANDSCAPE, SEA
VILLE, PAYSAGE, MER
STADT, LANDSCHAFT, MEER
CIUDAD, PAISAJE, MAR
CITTÀ, PAESAGGIO, MARE
STAD, LAND EN ZEE

Jan Vermeer van Delft (1632–75)

View of Delft

Vue de Delft

Ansicht von Delft

Vista de Delft

Veduta di Delft

Gezicht op Delft

c. 1660/61, Oil on canvas/Huile sur toile, 96,5 × 115,7 cm, Mauritshuis, Den Haag

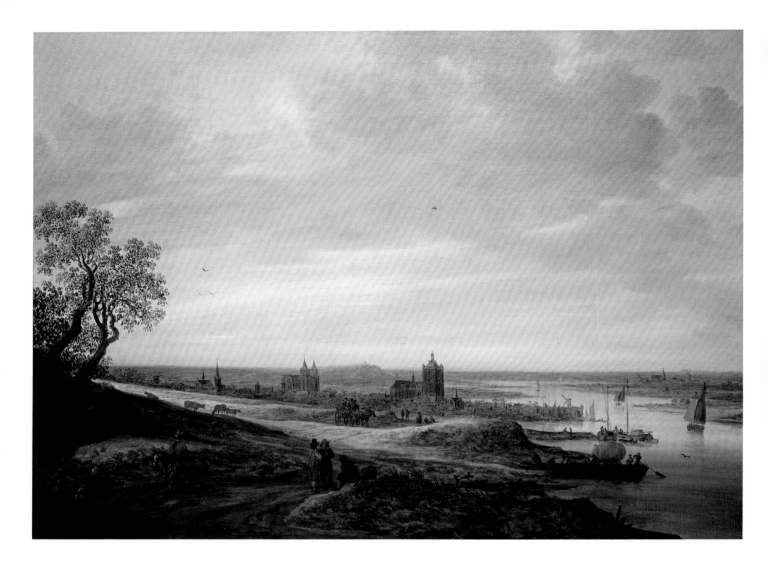

City, Landscape, Sea

Many views of Dutch cities have survived, especially numerous images of Amsterdam as it appeared in the first half of the 17th century when it became a major center for global trade. The wealth was manifested in the growth of the city with the so-called "Grachtengordel" with its stately houses lining the canals and buildings like the new city hall which reflected the city's standing. The less favorable economic situation in Flanders meant that cities like Brussels and Antwerp stagnated during this same period. Paintings of these cities at this time show older buildings from the Middle Ages and Renaissance.

 In landscape painting, Flemish art initially continued with older traditions. Works by Joos de Momper and Paul Bril, for example, recall the idealized "world landscapes" of earlier painting from the Low

Ville, paysage, mer

Plusieurs vues de villes hollandaises sont parvenues jusqu'à nous. Nombre de ces tableaux montrent avant tout l'aspect contemporain d'Amsterdam, qui devint dans la première moitié du XVIIᵉ siècle l'une des plus grandes places commerciales du monde. La richesse était visible dans les extensions urbaines (naquit alors la ceinture de canaux avec ses maisons seigneuriales) et dans des édifices prestigieux comme le nouvel hôtel de ville. En raison d'une situation économique moins favorable en Flandres, la capitale Bruxelles et le port d'Anvers stagnèrent à la même époque. Les tableaux y montrent alors des bâtiments du Moyen Âge et de la Renaissance.

 Dans la peinture de paysage, l'art flamand poursuivit d'abord les traditions anciennes. Les tableaux de Joos de Momper et de Paul Brill rappellent

Stadt, Landschaft, Meer

Von vielen holländischen Städten haben sich Ansichten erhalten. Vor allem künden zahlreiche Bilder vom damaligen Erscheinungsbild Amsterdams, das in der ersten Hälfte des 17. Jahrhunderts zu einem der weltweit größten Handelszentren aufstieg. Der Reichtum zeigte sich in den Stadterweiterungen (so entstand der Grachtengürtel mit seinen herrschaftlichen Häusern) und aufsehenerregenden Bauwerken wie dem Neuen Rathaus. Die weniger günstige wirtschaftliche Lage in Flandern führte dazu, dass die Hauptstadt Brüssel wie auch Antwerpen in dieser Zeit stagnierten. Gemälde dieser Städte zeigen Bauten aus Mittelalter und Renaissance.

 In der Landschaftsmalerei setzte die flämische Kunst zunächst ältere Traditionen fort. Die Bilder von Joos de Momper und Paul Bril erinnern noch

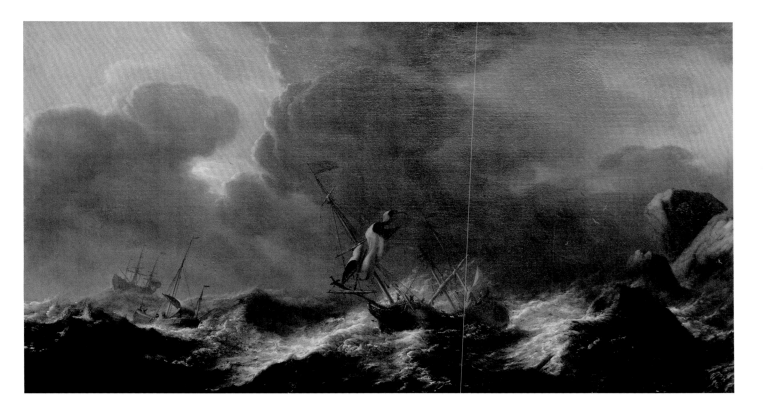

Jan van Goyen (1596–1656)
Panoramic View of Arnheim
Paysage avec vue de Arnhem
Panorama-Landschaft mit Blick auf Arnheim
Paisaje panorámico con vista a Arnhem
Panorama con vista su Arnhem
Panoramalandschap met gezicht op Arnhem
1646, Oil on canvas/Huile sur toile, 98,5 × 135 cm, Museum Kunstpalast, Düsseldorf

Aernout Smit (1641/42–c. 1710)
Ships in Peril off a Rocky Coast
Navires en perdition devant une côte rocheuse
Schiffe in Seenot vor felsiger Küste
Barcos en peligro frente a costa rocosa
Navi in difficoltà di fronte alla costa rocciosa
Schipbreuk voor een rotsachtige kust
n. d., Oil on canvas/Huile sur toile, 89,5 × 147 cm, Staatliche Kunsthalle, Karlsruhe

Ciudad, Paisaje, Mar

Se han conservado muchas vistas de ciudades holandesas. Numerosas imágenes dan especial testimonio de la antigua apariencia de Ámsterdam, que se erigió en la primera mitad del siglo XVII en uno de los centros comerciales más grandes del mundo. La riqueza se refleja en el crecimiento urbano de la ciudad (se construyeron los canales con sus casas señoriales) y en los espectaculares edificios como el nuevo ayuntamiento. La situación económica menos favorable en Flandes llevó al estancamiento de Bruselas y Amberes durante este período. Los cuadros de estas ciudades muestran edificios de la Edad Media y del Renacimiento.

En un primer momento, la pintura paisajística del arte flamenco siguió las tradiciones más antiguas. Las imágenes de Joos de Momper y Paul Bril todavía

Città, paesaggio, mare

Sono pervenute vedute di molte città olandesi, in particolare numerosi quadri che raffigurano l'antica Amsterdam, che nella prima metà del XVII secolo divenne uno dei più grandi centri commerciali del mondo. Grazie a questa ricchezza, la città crebbe progressivamente (venne costruito il quartiere Grachtengordel con i suoi canali e le sue case signorili) e vennero eretti imponenti edifici, come il Nuovo Municipio. A causa della situazione economica meno favorevole delle Fiandre, la capitale Bruxelles e Anversa attraversarono in tale momento un periodo di stagnazione. I quadri raffiguranti queste città mostrano così edifici del Medioevo e del Rinascimento.

Nel campo della pittura paesaggistica, l'arte fiamminga restò inizialmente fedele alle antiche

Stad, land en zee

Van veel Hollandse steden zijn stadsgezichten bewaard gebleven. Zo tonen talloze werken het aanzien van Amsterdam, de stad die in de eerste helft van de zeventiende eeuw tot het voornaamste handelscentrum ter wereld uitgroeide. De rijkdom uitte zich in stadsuitbreidingen (waardoor de Grachtengordel met zijn statige herenhuizen ontstond) en in opmerkelijke bouwwerken, zoals het nieuwe Stadhuis. Door de economisch minder gunstige situatie in Vlaanderen stagneerden de hoofdstad Brussel en Antwerpen in deze tijd. Op stadsgezichten van deze steden zien we vooral gebouwen uit de middeleeuwen en de renaissance.

In de landschapsschilderkunst bouwde de Vlaamse kunst voort op aloude tradities. De werken van Joos de Momper en Paul Bril doen nog sterk

Dutch/Hollandaise

43

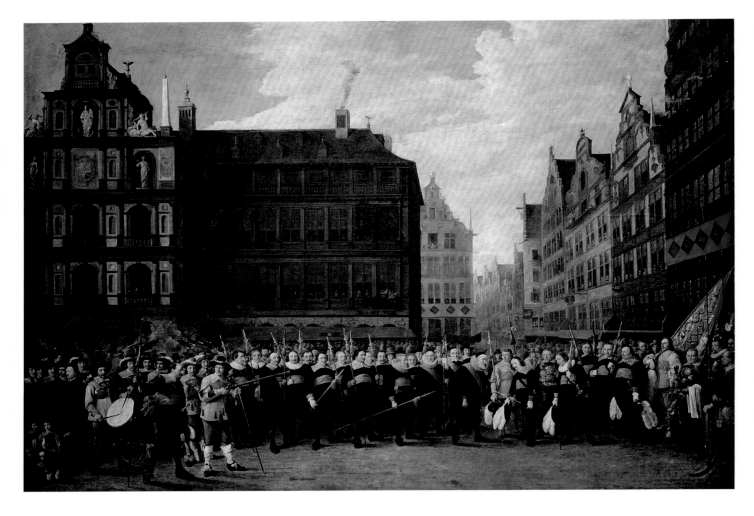

David Teniers de Jonge/the Younger/le Jeune (1610–90)

The Oude Voetboog Guild, Antwerp Die Oude Voetboog-Gilde in Antwerpen La gilda di Oude Voetboog ad Anversa

La Guilde de la Vieille Arbalète à Anvers La guilda de la Oude Voetboog en Amberes De Gilde van de Oude Voetboog

1643, Oil on canvas/Huile sur toile, 135 × 183 cm, State Hermitage Museum, St. Petersburg

Countries. A naturalistic style only appeared with the advent of the Brussels School including artists such as Jacques d'Arthois and Lodewijk de Vadder around 1650. Biblical or mythological scenes, often painted by a second artist, are frequently integrated into these landscape scenes; it took some time for landscape painting to develop into its own separate genre. This seems to have happened faster in the Dutch Republic, where dunes or a simple avenue of trees in the countryside were deemed suitable subjects by the likes of Esaias van de Velde and Jan van Goyen around 1630. These works were often created based on precise study and drawings of nature done on-site. Other landscapes,

encore les vues idéalisées des primitifs hollandais. L'école de Bruxelles (avec Jacques d'Arthois et Lodewijk de Vadder) fut la première, vers 1650, à adopter un style naturaliste. Des scènes bibliques ou mythologiques – généralement peintes par un autre artiste – sont souvent intégrées dans le tableau, avant que le paysage ne s'émancipe en devenant un genre autonome. Ce passage semble être intervenu plus rapidement dans les Pays-Bas septentrionaux. Par exemple, dès 1630, avec Esaias Van de Velde et Jan Van Goyen, des dunes ou une simple allée dans la campagne étaient jugées dignes de représentation. Ces œuvres suivaient souvent une étude précise et un dessin sur le motif. Cependant,

an die idealisierten Weltlandschaften der früheren niederländischen Malerei. Erst die Brüsseler Schule (mit Jacques d'Arthois und Lodewijk de Vadder) pflegte um 1650 einen naturalistischen Stil. Häufig sind biblische oder mythologische Szenen, die oft von einem zweiten Künstler gemalt wurden, in die Landschaften integriert – als eigenständige Gattung musste sich diese Bildform erst emanzipieren. Dies scheint in den Nördlichen Niederlanden schneller gelungen zu sein, wo seit etwa 1630 (Esaias van de Velde, Jan van Goyen) Dünen oder eine einfache Allee auf dem Land der Darstellung würdig waren. Diese Werke entstanden häufig durch ein genaues Naturstudium und Zeichnen

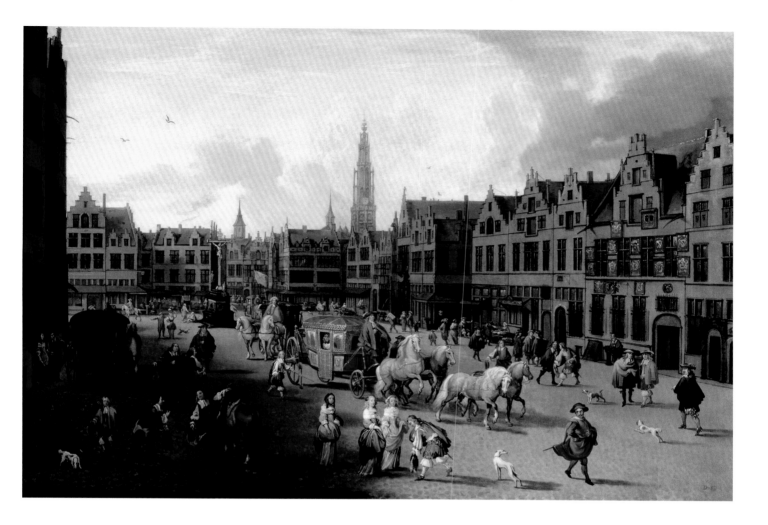

Erasmus de Bie (1629–75)

Antwerp: a procession on the Meir	Prozession auf dem Meir in Antwerpen	Processione lungo la Meir ad Anversa
Procession sur le Meir, à Anvers	Procesión en el Meir de Amberes	Gezicht op de Meir te Antwerpen

c. 1660, Oil on canvas/Huile sur toile, 85 × 117,5 cm, Private collection

nos recuerdan los paisajes del mundo idealizado de la antigua pintura holandesa. Al principio la escuela de Bruselas (con Jacques d'Arthois y Lodewijk de Vadder) utilizaba en 1650 un estilo naturalista. Se tratan a menudo de escenas bíblicas o mitológicas, en las que intervenía un segundo artista para integrar el paisaje–como un género separado, esta forma de imagen tuvo que emanciparse. Esto parece haber tenido éxito con mayor rapidez en los Países Bajos del norte, donde ya desde 1630 (Esaias van de Velde, Jan van Goyen) se consideraban dignos de representación las dunas o un sencillo camino del campo. Estas obras resultaban ser con frecuencia estudios precisos de la naturaleza

tradizioni. I dipinti di Joos de Momper e Paul Bril ricordano ancora i paesaggi idealizzati della pittura dei Paesi Bassi precedente. La scuola di Bruxelles (con Jacques d'Arthois e Lodewijk de Vadder) fu la prima ad adottare, nel 1650, uno stile naturalistico. Spesso venivano integrate nel paesaggio scene bibliche o mitologiche, frequentemente dipinte da un secondo artista, pertanto questo tipo di pittura dovette dapprima emanciparsi come genere indipendente. A quanto pare, tale processo avvenne più rapidamente nei Paesi Bassi settentrionali, dove a partire dal 1630 circa (Esaias van de Velde, Jan van Goyen) iniziarono ad essere considerati degni di essere rappresentati dune

denken aan de geïdealiseerde wereldlandschappen van de vroegnederlandse schilderkunst. Pas met de Brusselse School (met Jacques d'Arthois en Lodewijk de Vadder) deed rond 1650 een naturalistische stijl haar intrede. Vaak zijn in de landschappen Bijbelse en mythologische taferelen opgenomen, die vaak door een tweede kunstenaar werden geschilderd en als zelfstandig genre moest het landschap zijn plaats nog veroveren. Dat schijnt sneller te zijn gebeurd in de Noordelijke Nederlanden, waar vanaf circa 1630 (Esaias van de Velde, Jan van Goyen) motieven als duinen of een eenvoudige landweg afzonderlijk werden uitgebeeld. Deze werken waren nauwgezette studies

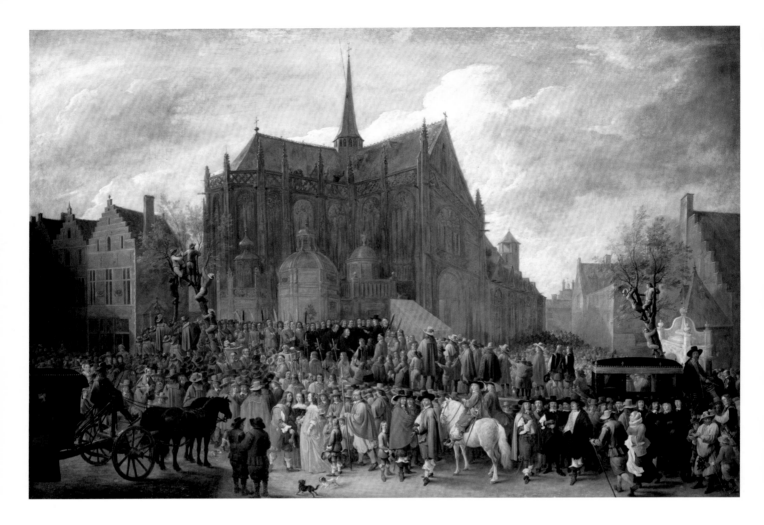

David Teniers de Jonge/the Younger/le Jeune (1610–90)

The Popinjay Shooting in Brussels Das Vogelschießen zu Brüssel Caccia agli uccelli a Bruxelles

Le Jeu du papegai à Bruxelles Ejecución en Bruselas Het vogelschieten in Brussel

1652, Oil on canvas/Huile sur toile, 172 × 247 cm, Kunsthistorisches Museum, Wien

however, such as the waterfalls painted by Jacob van Ruisdael, seem like exact images of nature, but the painters had to resort to other images as sources due to the lack of corresponding natural phenomena at home.

In the Dutch Republic, where about 10 percent of the men were at sea at any given time, seascapes were especially popular. They frequently show ships loaded with cargo or caught in a storm in the midst of seas precisely observed with a wide range of waves and cloud formations.

d'autres tableaux de paysage, comme les cascades de Jacob Van Ruysdael, ont bien l'air de représentations naturalistes, mais faute de lieux correspondants dans leur pays, les peintres devaient se servir d'autres images comme modèles.

Les marines étaient particulièrement populaires dans les Pays-Bas septentrionaux, où quelque 10 % des hommes allaient en mer. Elles représentent souvent le chargement des bateaux ou des navires pris dans une tempête : la mer y est fidèlement observée, avec des formes de vagues les plus diverses et sous les ciels les plus changeants.

vor Ort. Andere Landschaftsbilder aber, wie die Wasserfälle Jacob van Ruisdaels, wirken zwar wie genaue Abbilder der Natur, doch mussten die Maler mangels entsprechender Naturphänomene in ihrer Heimat auf andere Bilder als Quellen zurückgreifen.

Insbesondere in den Nördlichen Niederlanden – in denen etwa 10 Prozent der männlichen Bevölkerung zur See fuhren – waren Seestücke populär. Sie zeigen häufig Schiffe, die beladen werden oder sich in einem Sturm befinden, und stets das genau beobachtete Meer mit unterschiedlichsten Wellenformen unter den vielfältigsten Himmeln.

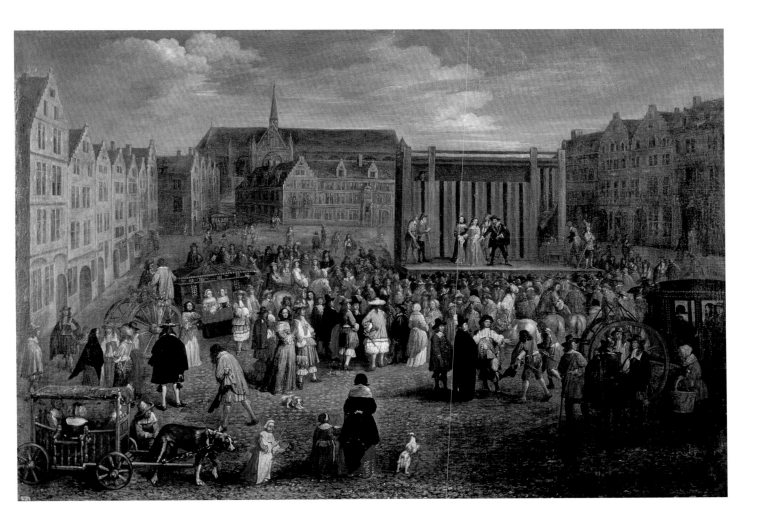

Adam Frans van der Meulen (1632–90)

The Old Horse Market, Brussels Der alte Pferdemarkt in Brüssel L'antico mercato di cavalli a Bruxelles

Le Marché aux chevaux à Bruxelles El antiguo mercado de caballos de Bruselas De oude paardenmarkt te Brussel

c. 1666, Oil on canvas/Huile sur toile, Palais Liechtenstein, Wien

y de dibujos sobre el terreno. Otros paisajes, como las cascadas de Jacob van Ruisdael, actuaban como imágenes exactas de la naturaleza, ya que los pintores carecían de los fenómenos naturales apropiados en su país y usaban otras imágenes como fuente.

En particular, en los Países Bajos del norte – donde alrededor del 10 por ciento de la población masculina navegaba – las pinturas de marinas eran muy populares. A menudo muestran las embarcaciones en el proceso de carga o cuando se encuentran en una tormenta, y siempre el mismo mar con diferentes formas de olas bajo los más variados cielos.

o semplici viali. Queste opere erano spesso un accurato studio della natura e disegni sul posto. Altri quadri di paesaggi, come le cascate di Jacob van Ruisdael, volevano essere raffigurazioni esatte della natura, tuttavia i pittori, a causa della mancanza di taluni fenomeni naturali nella loro patria, dovevano fare affidamento su altri immagini come fonti.

Soprattutto nei Paesi Bassi settentrionali, dove circa il 10 per cento della popolazione maschile si dedicava alla navigazione, erano molto popolari i paesaggi marini, che raffigurano spesso navi in tempesta o in fase di caricamento nel porto, e rappresentano il mare con estrema precisione, con onde di forme diverse e sormontato da un cielo dai molteplici aspetti.

van de natuur en waren gebaseerd op schetsen ter plekke. Andere landschappen, zoals de watervallen van Jacob van Ruisdael, doen weliswaar zeer natuurgetrouw aan maar waren vanwege het ontbreken van dit soort natuurfenomeen in de Nederlanden op andere schilderijen gebaseerd.

Vooral in de Noordelijke Nederlanden – waar circa tien procent van de mannelijke bevolking op zee voer – waren zeegezichten populair. Daarop waren vaak schepen te zien die werden beladen of zich in een storm bevonden, altijd op een zeer nauwgezet uitgebeelde zee met zeer uiteenlopende golfvormen en onder zeer verschillende luchten.

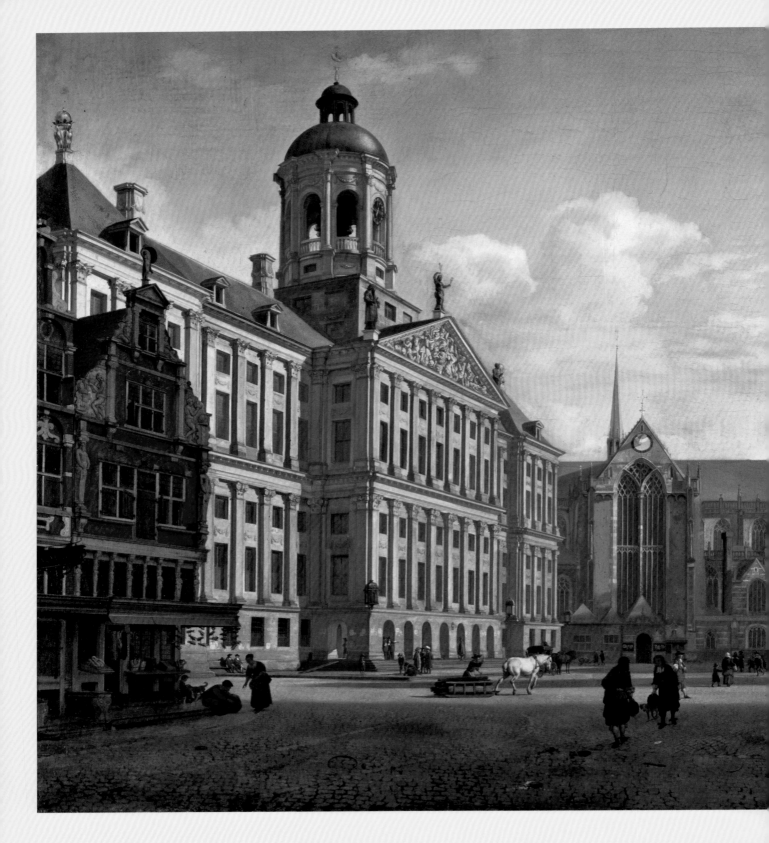

Dutch/Hollandaise

Construction on Amsterdam's New City Hall (now the Royal Palace) began in 1648. The edifice announces Amsterdam's wealth and self-confidence. Architect Jacob van Campen, who had spent a long time in Italy, designed it in what was then the highly fashionable classical style with pavilions reminiscent of French palaces.

Le nouvel hôtel de ville (aujourd'hui Palais royal), édifié à partir de 1648 sur des plans de Jacob van Campen, proclame la richesse et l'assurance des bourgeois d'Amsterdam. L'architecte, qui avait longtemps séjourné en Italie, l'a construit dans le style classique à la mode. La structure à pavillons rappelle des châteaux français.

Das ab 1648 nach Plänen Jacob van Campens erbaute Neue Rathaus (heute Königlicher Palast) kündet vom Reichtum und Selbstbewusstsein der Amsterdamer Bürger. Der Architekt, der sich lange in Italien aufgehalten hatte, errichtete es im hoch aktuellen klassizistischen Stil; seine Bauform mit Pavillons erinnert an französische Schlösser.

La construcción del Nuevo Ayuntamiento (hoy Palacio Real) a partir de 1648 de acuerdo con los planos de Jacob van Campen nos habla de la riqueza y la confianza de los ciudadanos de Ámsterdam. El arquitecto, que había pasado mucho tiempo en Italia, lo construyó en un elaborado y actual estilo clasicista; su diseño con pabellones recuerda a los castillos franceses.

Il Nuovo Municipio (l'odierno Palazzo Reale), costruito a partire dal 1648 secondo il progetto di Jacob van Campen, era un simbolo della ricchezza e dell'autocoscienza dei cittadini di Amsterdam. L'architetto, che aveva trascorso un lungo periodo in Italia, progettò edifici in uno stile classico molto attuale. Le sue forme costruttive con padiglioni ricordano i castelli francesi.

Het nieuwe Stadhuis (het huidige Paleis op de Dam), in 1648 door Jacob van Campen ontworpen, getuigt van de rijkdom en het zelfbewustzijn van de Amsterdammers. De architect had veel door Italië gereisd en bouwde het in een classicistische stijl; met zijn hoekpaviljoens verwijst zijn ontwerp naar de Franse kasteelbouw.

Jan van der Heyden (1637–1712)
The Dam in Amsterdam with the New City Hall
Le Dam avec le nouvel hôtel de ville à Amsterdam
Der Dam in Amsterdam mit dem Neuen Rathaus
La plaza Dam de Ámsterdam con el Nuevo Ayuntamiento
La Piazza Dam di Amsterdam con il Nuovo Municipio
De Dam in Amsterdam met het nieuwe Stadhuis
1668, Oil on canvas/Huile sur toile, 73 × 86 cm, Musée du Louvre, Paris

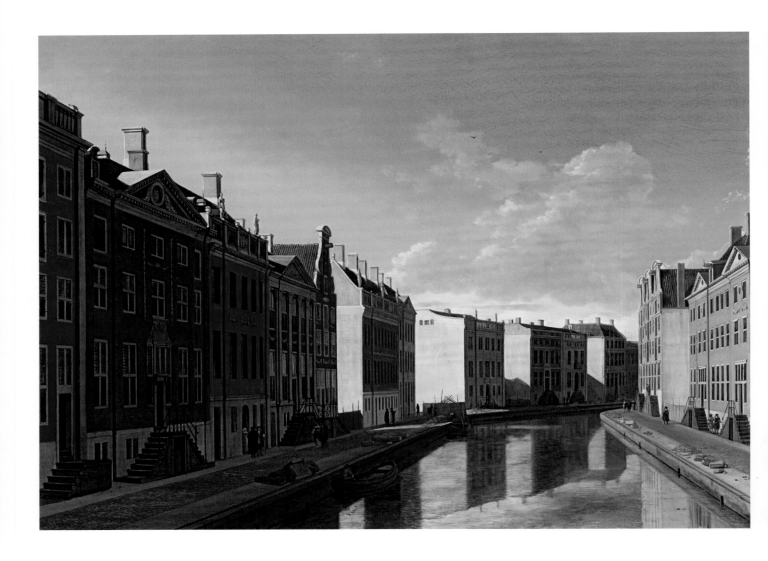

Gerrit Berckheyde (1638–98)

Gouden Bocht in the Herengracht, Amsterdam

La Courbure d'or du Herengracht, à Amsterdam

Gouden Bocht in der Herengracht, Amsterdam

Gouden Bocht en el Herengracht, Ámsterdam

Il Gouden Bocht sull'Herengracht, Amsterdam

Gouden Bocht aan de Herengracht, Amsterdam

1671/72, Oil on wood/Huile sur bois, 42,5 × 57,9 cm, Rijksmuseum, Amsterdam

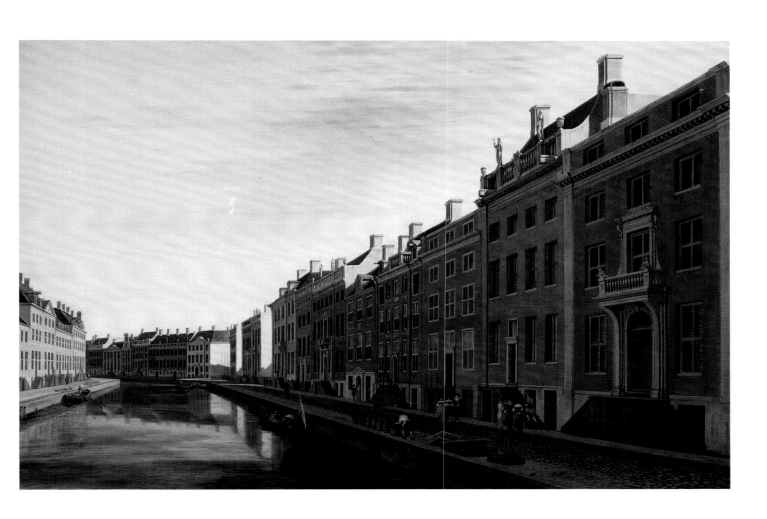

Gerrit Berckheyde (1638–98)

Gouden Bocht in the Herengracht, Seen from the West

La Courbure d'or du Herengracht, à Amsterdam, vue de l'ouest

Gouden Bocht in der Herengracht von Westen

Gouden Bocht en el Herengracht desde el oeste

Il Gouden Bocht sull'Herengracht da ovest

De Gouden Bocht aan de Herengracht gezien vanuit het westen

1672, Oil on wood/Huile sur bois, 40,5 × 63 cm, Rijksmuseum, Amsterdam

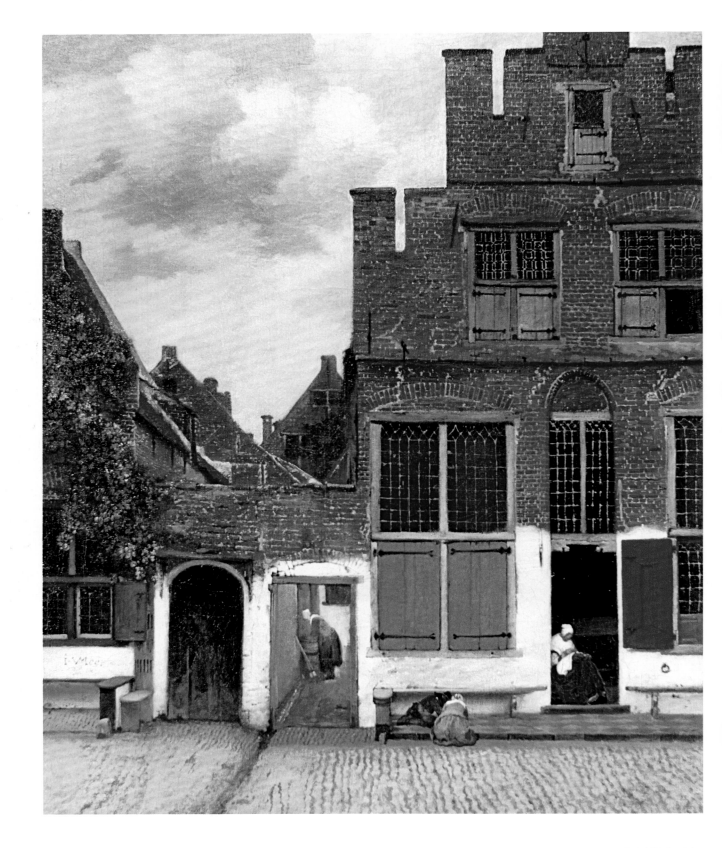

Dutch/Hollandaise

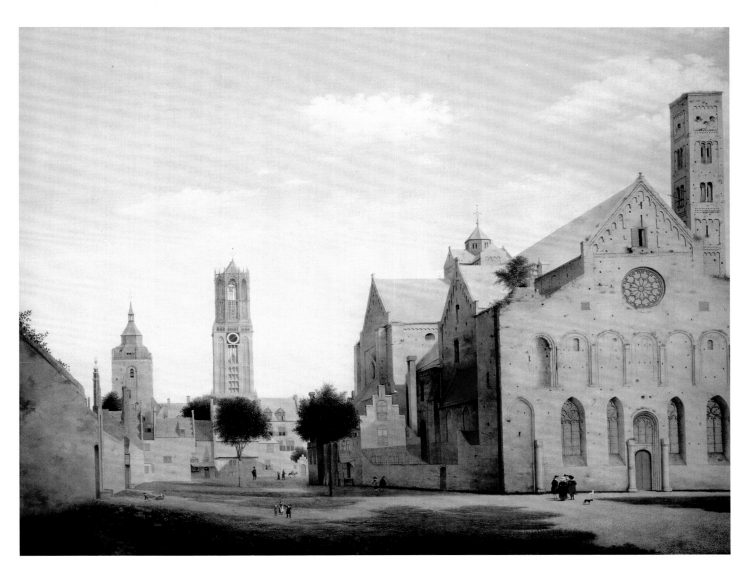

Jan Vermeer van Delft (1632–75)

Street in Delft

La Ruelle

Straße in Delft

La callejuela

Stradina di Delft

Het straatje

c. 1658, Oil on canvas/Huile sur toile, 54,3 × 44 cm, Rijksmuseum, Amsterdam

<div align="right">

Pieter Saenredam (1597–1665)

Mariakerk, Utrecht

La Mariaplaats à Utrecht

Der Marienplatz in Utrecht

La Mariaplaats en Utrecht

La Piazza di Maria di Utrecht

De Mariaplaats met de Mariakerk in Utrecht

1662, Oil on wood/Huile sur bois, 109,5 × 139,5 cm, Museum Boijmans Van Beuningen, Rotterdam

</div>

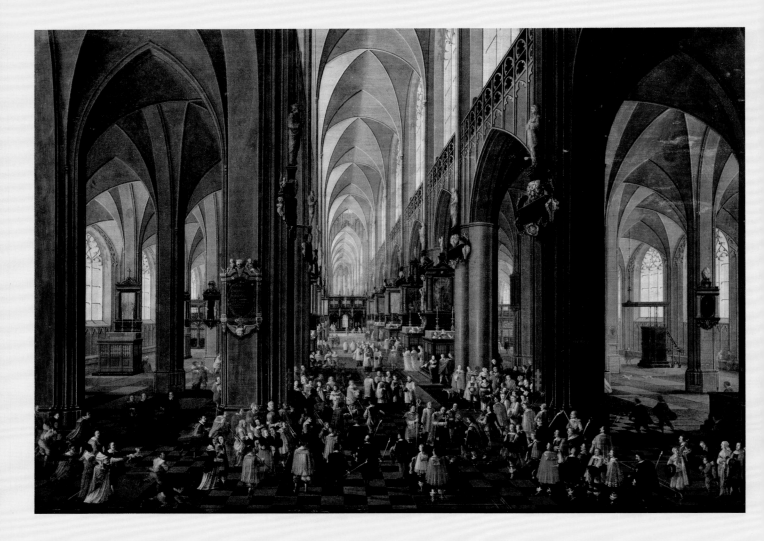

Peter Neeffs de Jonge/the Younger/le Jeune (1620–1675)
Interior of the Cathedral of Our Lady, Antwerp
Intérieur de la cathédrale Notre-Dame à Anvers
Innenansicht der Liebfrauenkathedrale zu Antwerpen
Interior de la catedral de Nuestra Señora en Amberes
Interno della Cattedrale di Nostra Signora ad Anversa
Interieur van de Onze-Lieve-Vrouwekathedraal in Antwerpen

c. 1646–50, Oil on wood/Huile sur bois, 50 × 70 cm, Kunsthistorisches Museum, Wien

During the iconoclasm of 1566, the interiors of most churches in the Low Countries were damaged and stripped of their furnishings. From the early 17th century, the Catholic churches in Flanders began to be richly redecorated with numerous altars and shrines. The Protestant churches in the Dutch Republic, however, refused any such decoration, as seen in Pieter Saenredam's light-filled depictions of church interiors, which are themselves masterpieces of perspective.

Pendant la crise iconoclaste de 1566, la plupart des églises néerlandaises furent saccagées et leurs biens dérobés. À partir du début du XVIIᵉ siècle, dans les Flandres, on dota à nouveau les églises catholiques de multiples autels. Dans les Pays-Bas septentrionaux, les églises protestantes renoncèrent à tout ornement, comme en témoignent les intérieurs inondés de lumière et les perspectives magistrales de Pieter Saenredam.

Während des Bildersturms von 1566 waren die meisten niederländischen Kirchen beschädigt und ihres Inventars beraubt worden. Seit Anfang des 17. Jahrhunderts stattete man in Flandern die katholischen Kirchen wieder mit zahlreichen Altären aus. Die protestantischen Kirchen der Nördlichen Niederlande verzichteten jedoch auf Schmuck, wie die lichterfüllten und perspektivisch meisterhaften Kircheninterieurs von Pieter Saenredam belegen.

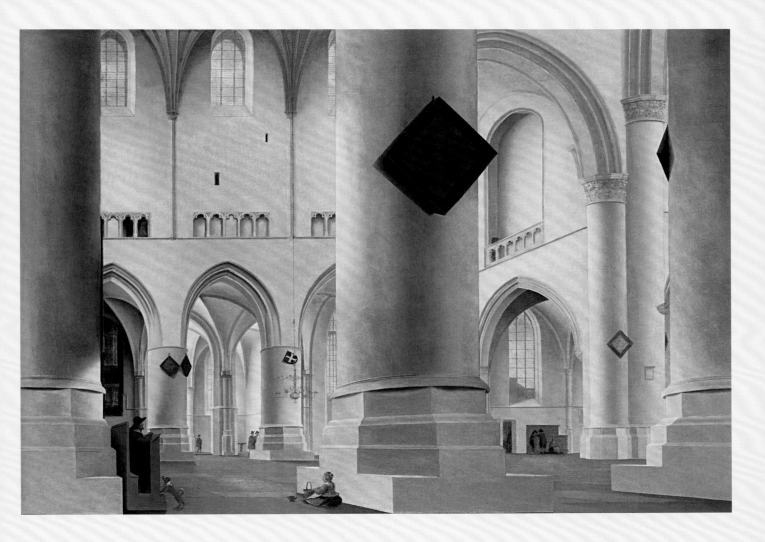

Pieter Saenredam (1597–1665)
Interior of Grote Kerk, Haarlem
Intérieur de l'église Saint-Bavon à Haarlem
Das Innere der Grote Kerk in Haarlem
Interior de la Grote Kerk en Haarlem
Interno della Grote Kerk ad Haarlem
Interieur van de Grote Kerk van Haarlem
1636/37, Oil on wood/Huile sur bois, 59,5 × 81,7 cm, National Gallery, London

Durante la iconoclasia de 1566 la mayoría de las iglesias holandesas sufrieron desperfectos y sus inventarios fueron robados. Desde principios del siglo XVII las iglesias católicas de Flandes fueron equipadas de nuevo con numerosos altares. Sin embargo, las iglesias protestantes de los Países Bajos del norte renunciaron a la decoración, como lo demuestran los interiores de iglesias llenos de luz y las perspectivas magistrales de Pieter Saenredam.

Durante l'iconoclastia del 1566 la maggior parte delle chiese olandesi furono danneggiate e derubate dei loro beni. Dall'inizio del XVII secolo le chiese cattoliche delle Fiandre tornarono ad essere adornate con numerosi altari, mentre le chiese protestanti dei Paesi Bassi settentrionali rinunciarono all'ornato, come dimostrano gli interni pieni di luce e dalla prospettiva magistrale di Pieter Saenredam.

Tijdens de Beeldenstorm van 1566 werden veel Nederlandse kerken beschadigd en van hun schatten ontdaan. Maar vanaf begin zeventiende eeuw werden veel katholieke kerken in Vlaanderen weer voorzien van altaarstukken. In de protestantse kerken in het noorden werd echter helemaal afgezien van versieringen, zoals de in licht badende kerkinterieurs van Pieter Saenredam in meesterlijk perspectief laten zien.

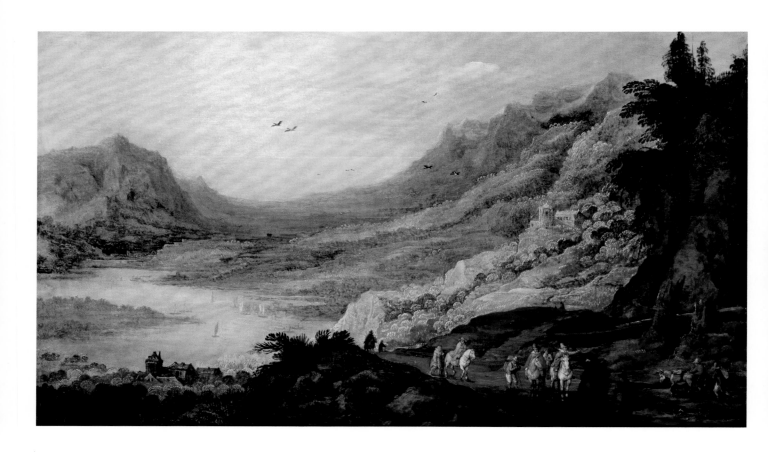

Joos de Momper de Jonge/the Younger/le Jeune (1564–1635),
Jan Brueghel de Oude/the Elder/l'Ancien, *dit* de Velours (1568–1625)

Mountain Landscape with River Valley

Paysage de montagne avec une rivière

Gebirgslandschaft mit Flusstal

Paisaje de montaña con valle

Paesaggio montano con valle del fiume

Berglandschap met rivierdal

c. 1600–10, Oil on wood/Huile sur bois, 45 × 74,8 cm, Kunsthistorisches Museum, Wien

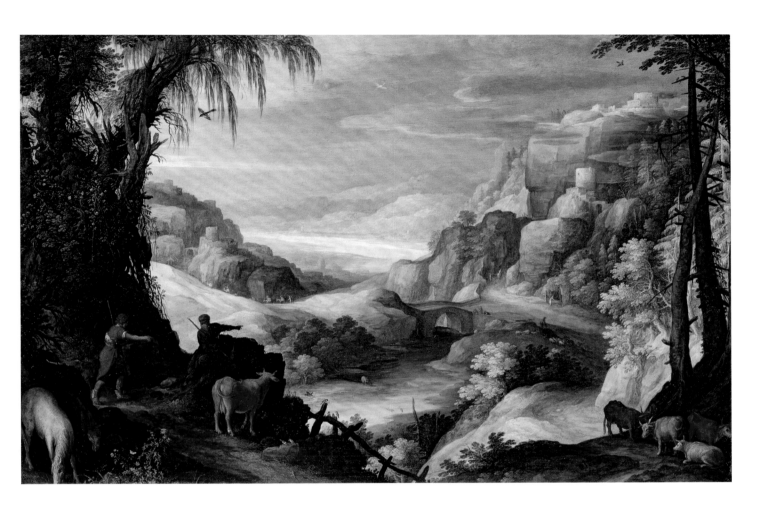

Paul Bril (1554–1626)

Landscape with Mercury and Bacchus

Paysage avec Mercure et Bacchus

Landschaft mit Merkur und Bacchus

Paisaje con Mercurio y Baco

Paesaggio con Mercurio e Bacco

Landschap met Mercurius en Bacchus

1606, Oil on copper/Huile sur plaque de cuivre, 26,5 × 39 cm, Galleria Sabauda, Torino

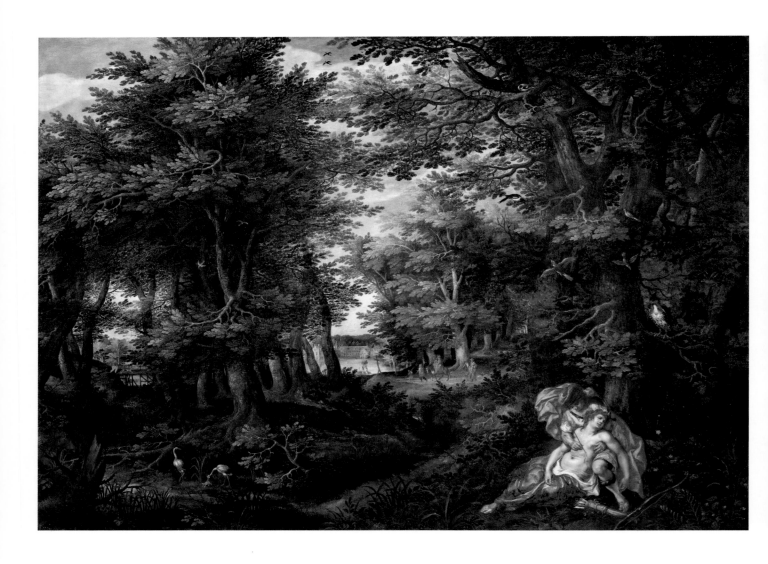

Denis van Alsloot (c. 1570–c. 1626), Hendrick de Clerck (c. 1570–1629)

Forest Landscape with Cephalus and Procris

Paysage boisé avec Céphale et Procris

Waldlandschaft mit Cephalus und Procris

Paisaje forestal con Céfalo y Procris

Paesaggio boscoso con Cefalo e Procri

Boslandschap met Cephalus en Procris

1608, Oil on wood/Huile sur bois, 75 × 105 cm, Kunsthistorisches Museum, Wien

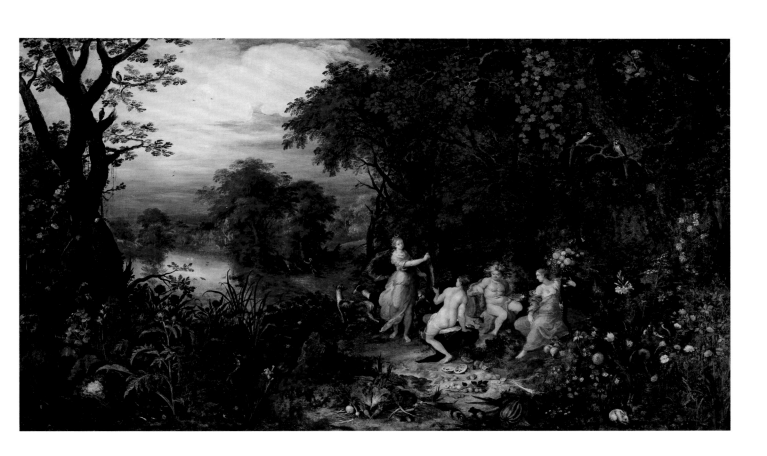

Abraham Govaerts (1589–1626)

Forest Landscape with Diana, a Nymph, Silenus, and Ceres

Paysage boisé avec Diane, une nymphe, Silène et Cérès

Waldlandschaft mit Diana, einer Nymphe, Silen und Ceres

Paisaje forestal con Diana, una ninfa, Silen y Ceres

Paesaggio boscoso con Diana, una ninfa, Sileno e Cerere

Boslandschap met Diana, een nimf, Silenus en Ceres

1610–26, Oil on canvas/Huile sur toile, 62,3 × 109 cm, Private collection

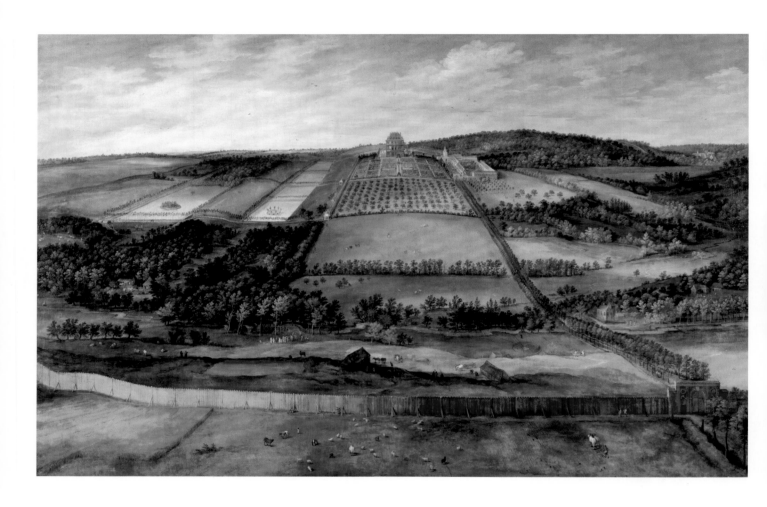

Jan Brueghel de Oude/the Elder/l'Ancien, *dit* de Velours (1568–1625)

Mariemont Palace

Vue du château de Mariemont

Schloss Mariemont

El castillo Mariemont

Castello di Mariemont

Het slot van Mariemont

1612, Oil on canvas/Huile sur toile, 184 × 292 cm, Musée des Beaux-Arts, Dijon

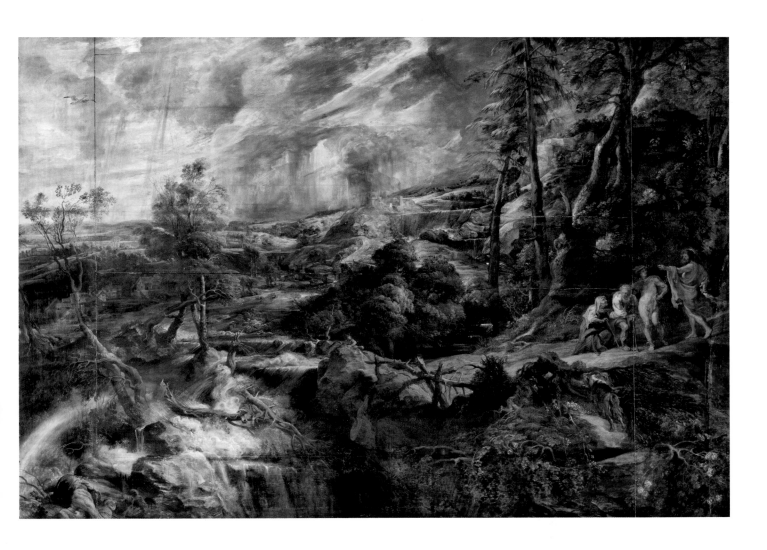

Peter Paul Rubens (1577–1640)

Stormy Landscape with Jupiter, Mercury, Philemon, and Baucis

Paysage orageux avec Jupiter, Mercure, Philémon et Baucis

Gewitterlandschaft mit Jupiter, Merkur, Philemon und Baucis

Paisaje con Júpiter, Mercurio, Filemón y Baucis

Paesaggio in tempesta con Giove, Mercurio, Filemone e Bauci

Onweerslandschap met Jupiter, Mercurius, Philemon en Baucis

c. 1620–25, Oil on wood/Huile sur bois, 146 × 208,5 cm, Kunsthistorisches Museum, Wien

Flemish/Flamande

61

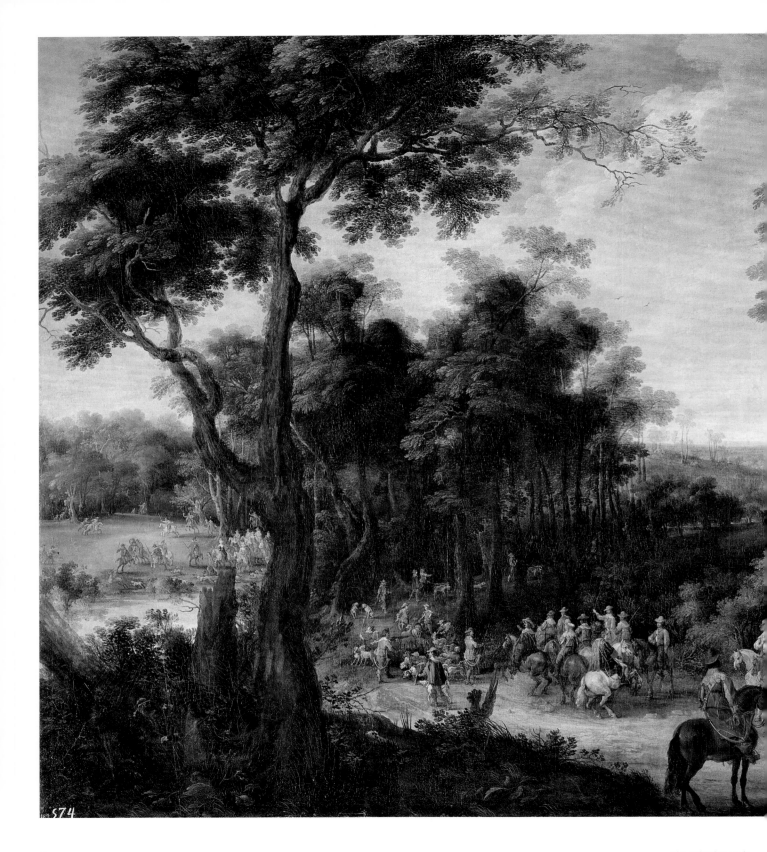

574

Flemish/Flamande

Peeter Snayers (1592–1667)

The Cardinal Infante, Hunting

La Chasse du cardinal-infant

Die Jagd des Kardinalinfanten

Cacería del Cardenal-Infante

L'Infante-cardinale a caccia

De jacht van de kardinaal-infanten

1636–38, Oil on canvas/Huile sur toile,
195 × 302 cm, Museo del Prado, Madrid

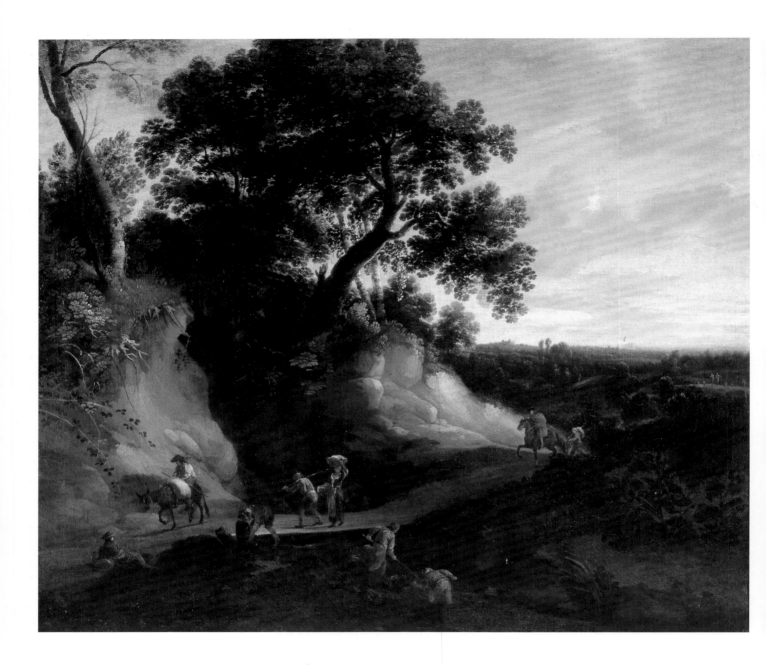

Attr. to/attr. à Lodewijk de Vadder (1605–55)

Landscape with Highway and Travellers

Paysage avec voyageurs sur la route

Landschaft mit Landstraße und Reisenden

Paisaje con camino

Paesaggio con strada di campagna

Landschap met zandweg en reizigers

1650, Oil on wood/Huile sur bois, 68 × 77 cm, Ca' d'Oro, Venezia

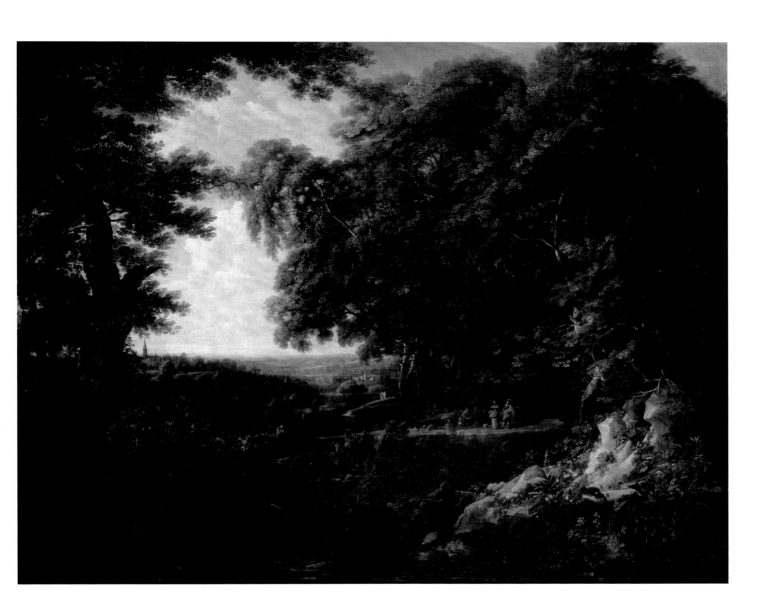

Jacques d'Arthois (1613–c. 86)

Landscape

Paysage

Landschaft

Paisaje

Paesaggio

Landschap

c. 1650, Oil on canvas/Huile sur toile, 115 × 144 cm, Museo del Prado, Madrid

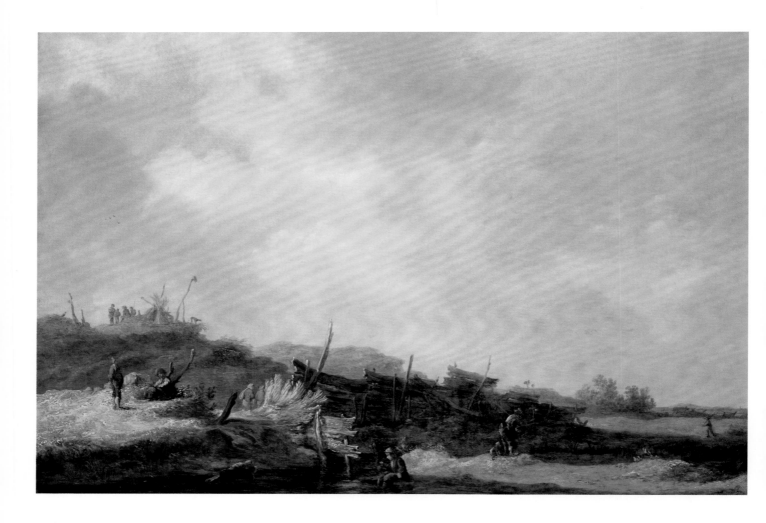

Possibly/Probablement Jan van Goyen (1595–1656)

Dunes

Paysage de dunes

Dünenlandschaft

Paisaje con dunas

Paesaggio con dune

Duinlandschap

c. 1630–35, Oil on wood/Huile sur bois, 36,3 × 54 cm, Kunsthistorisches Museum, Wien

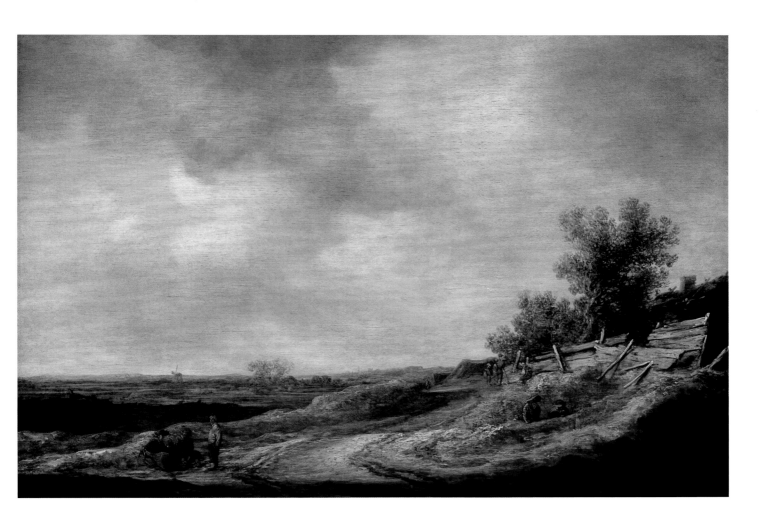

Jan van Goyen (1595–1656) Plains

Paysage

Flachlandschaft

Paisaje llano

Paesaggio piatto

Landschap

c. 1630–40, Oil on wood/Huile sur bois, 39,7 × 55,5 cm, Kunsthistorisches Museum, Wien

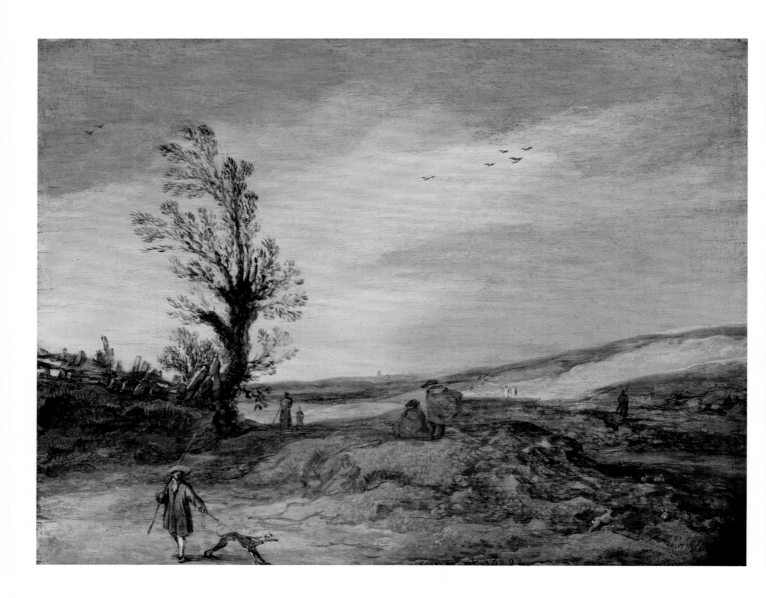

Esaias van de Velde (1587–1630)

Dunes

Paysage de dunes

Dünenlandschaft

Paisaje con dunas

Paesaggio con dune

Duinlandschap

1629, Oil on wood/Huile sur bois, 17,7 × 22,7 cm, Rijksmuseum, Amsterdam

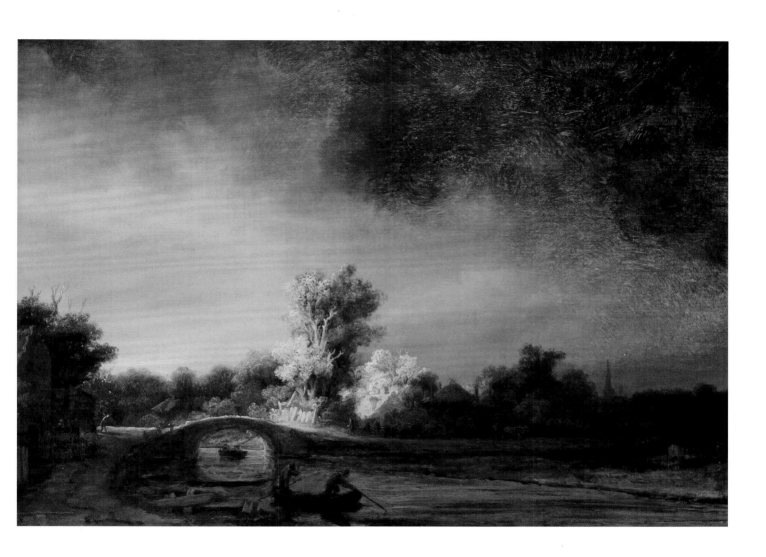

Rembrandt Harmensz. van Rijn (1606–69)

Landscape with Stone Bridge

Paysage avec un pont de pierre

Landschaft mit Steinbrücke

Paisaje con puente de piedra

Paesaggio con ponte di pietra

Landschap met stenen brug

c. 1638, Oil on wood/Huile sur bois, 29,5 × 42,5 cm, Rijksmuseum, Amsterdam

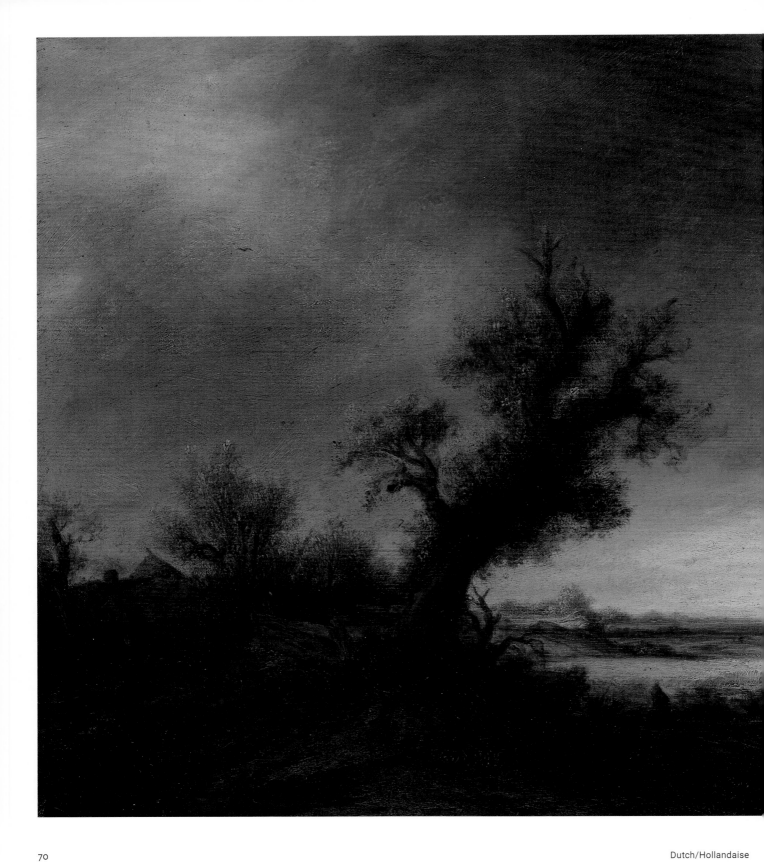

Dutch/Hollandaise

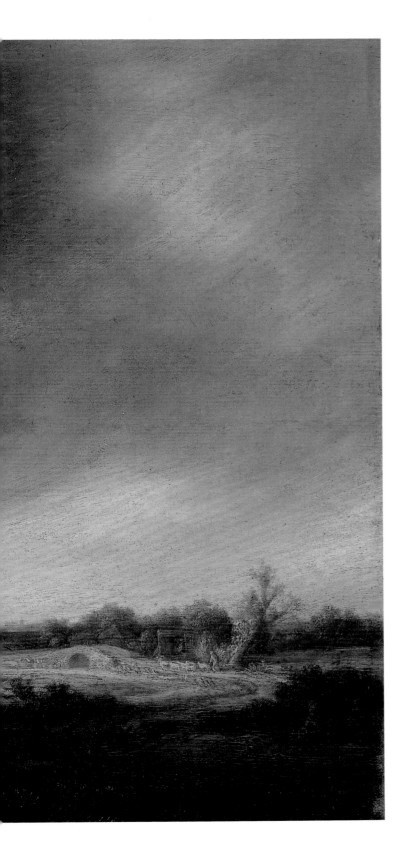

Adriaen van Ostade (1610–85)

Landscape with Old Oak

Paysage avec un vieux chêne

Landschaft mit alter Eiche

Paisaje con roble viejo

Paesaggio con vecchia quercia

Landschap met oude eik

1640–50, Oil on wood/Huile sur bois, 34 × 46,5 cm, Rijksmuseum, Amsterdam

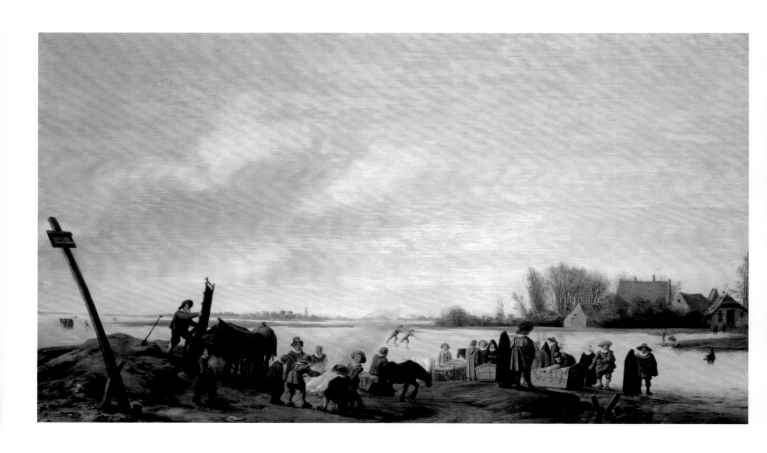

Salomon van Ruysdael (c. 1600–70)

Waterfront in Winter

Paysage d'hiver au bord de l'eau

Winterlandschaft am Wasser

Paisaje de invierno en el agua

Paesaggio invernale sull'acqua

Winterlandschap aan het water

1627, Oil on wood/Huile sur bois, 34 × 58 cm, Kunsthistorisches Museum, Wien

Dutch/Hollandaise

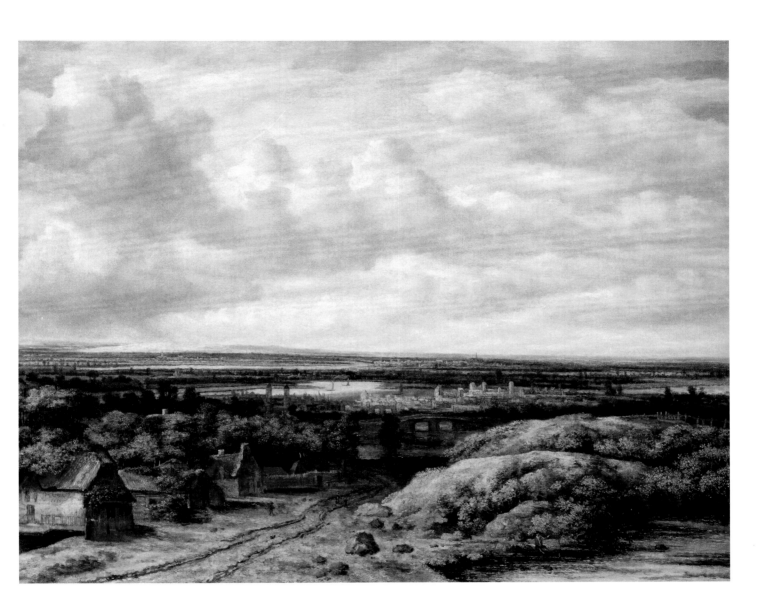

Philips Koninck (1619–88)

Panorama with Cottages on a Path

Paysage avec chaumières au bord d'une route

Panoramalandschaft mit Hütten an einem Weg

Paisaje panorámico con cabañas en un camino

Panorama con capanne su un sentiero

Panoramalandschap met hutten aan een weg

1655, Oil on canvas/Huile sur toile, 134 × 167,5 cm, Rijksmuseum, Amsterdam

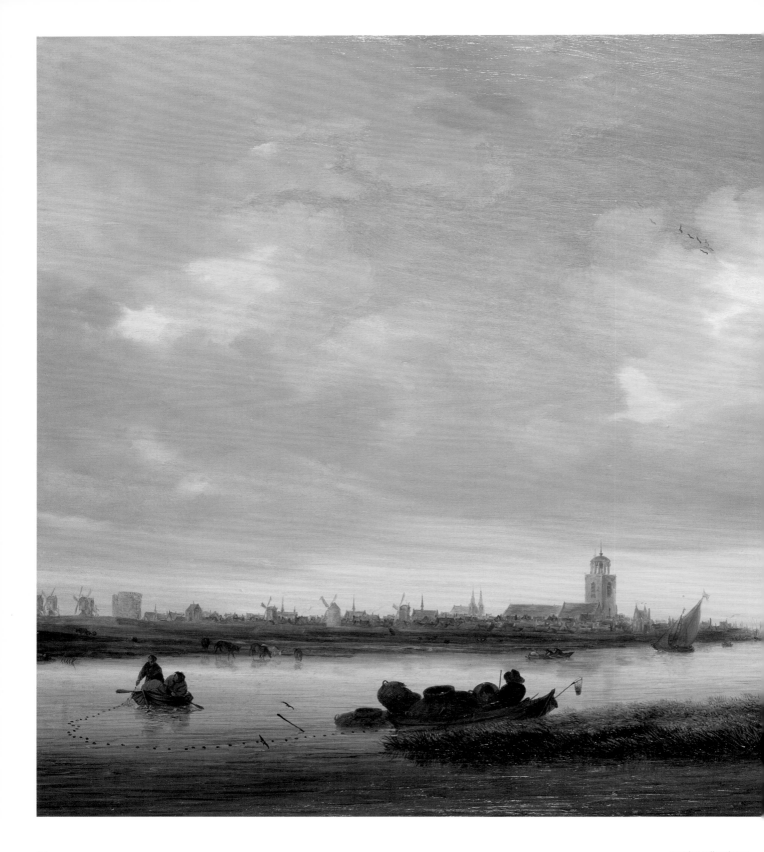

Salomon van Ruysdael (c. 1600–70)

Deventer from the Northwest

Vue de Deventer depuis le nord-ouest

Deventer von Nordwesten

Deventer desde el noroeste

Deventer da nord-ovest

Deventer gezien vanuit het noordwesten

1657, Oil on wood/Huile sur bois, 51,8 × 76,5 cm, National Gallery, London

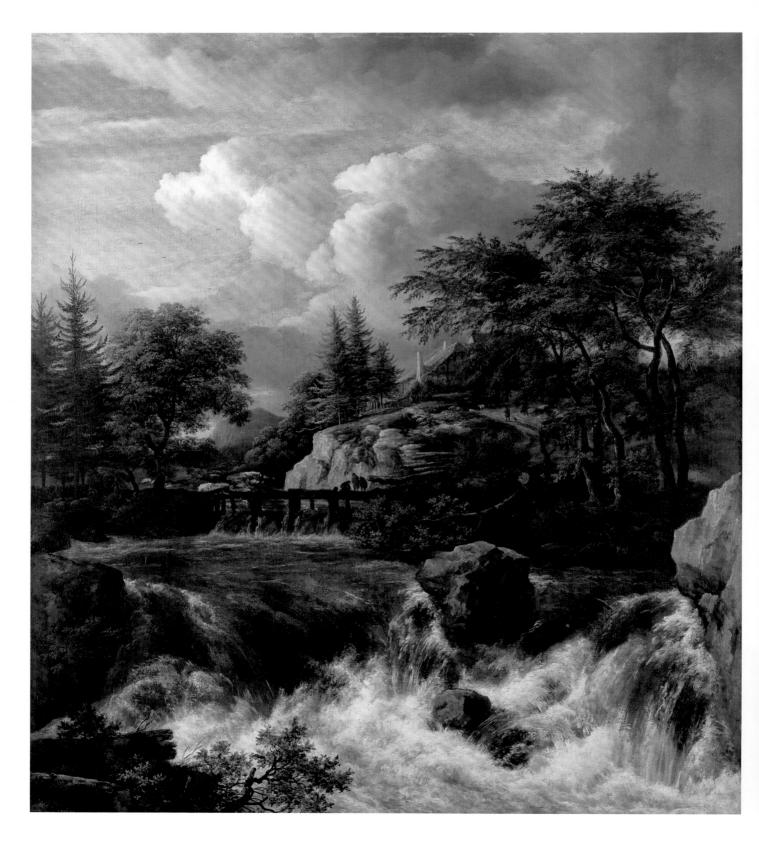

**Jacob van Ruisdael
(c. 1628–82)**

Waterfall in Rocky
Landscape

Paysage de montagne
avec une cascade

Wasserfall in felsiger
Landschaft

Cascada en
paisaje rocoso

Cascata in un
paesaggio roccioso

Waterval in rotsachtig
landschap

c. 1660–70, Oil on
canvas/Huile sur toile,
98,5 × 85 cm, National
Gallery, London

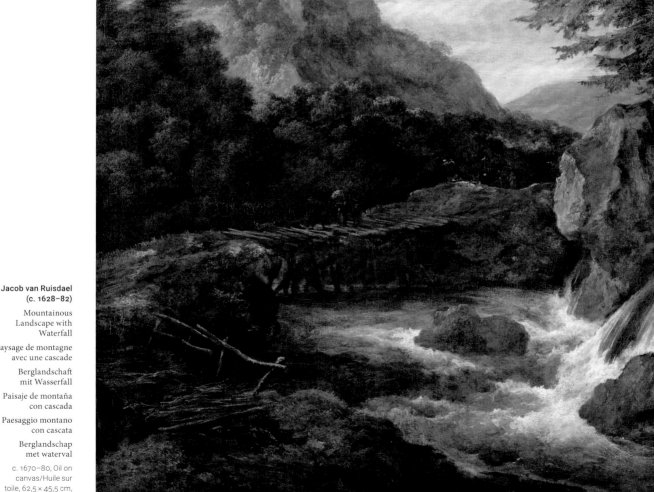

**Jacob van Ruisdael
(c. 1628–82)**

Mountainous
Landscape with
Waterfall

Paysage de montagne
avec une cascade

Berglandschaft
mit Wasserfall

Paisaje de montaña
con cascada

Paesaggio montano
con cascata

Berglandschap
met waterval

c. 1670–80, Oil on
canvas/Huile sur
toile, 62,5 × 45,5 cm,
Kunsthistorisches
Museum, Wien

Meindert Hobbema (1638–1709)

The Avenue at Middelharnis

L'Allée de Middelharnis

Allee von Middelharnis

Avenida de Middelharnis

Il viale di Middelharnis

Het Laantje van Middelharnis

1689, Oil on canvas/Huile sur toile, 103,5 × 141 cm, National Gallery, London

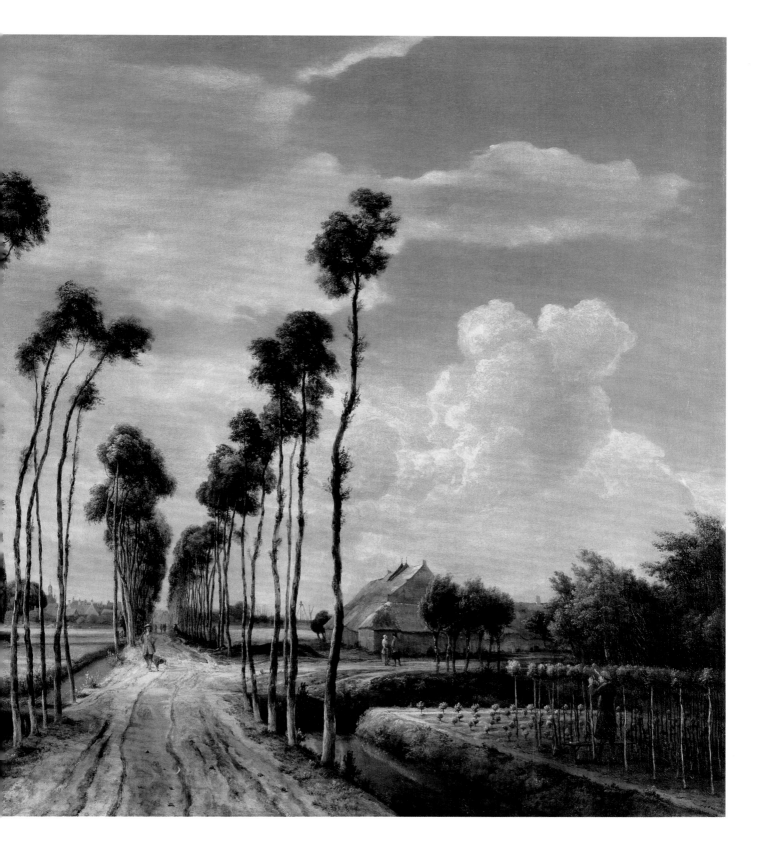

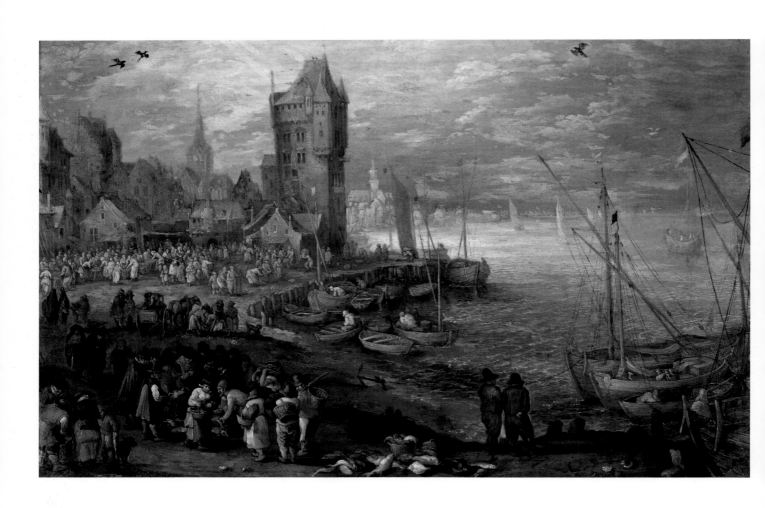

Jan Brueghel de Oude/the Elder/l'Ancien, *dit* de Velours (1568–1625)

Seaside Fish Market

Marché aux poissons sur la côte

Fischmarkt am Meeresstrand

Mercado de pescado en la playa

Mercato del pesce sulla spiaggia

Vismarkt op het strand

c. 1620, Oil on copper/Huile sur plaque de cuivre, 18 × 28 cm, Staatliches Museum, Schwerin

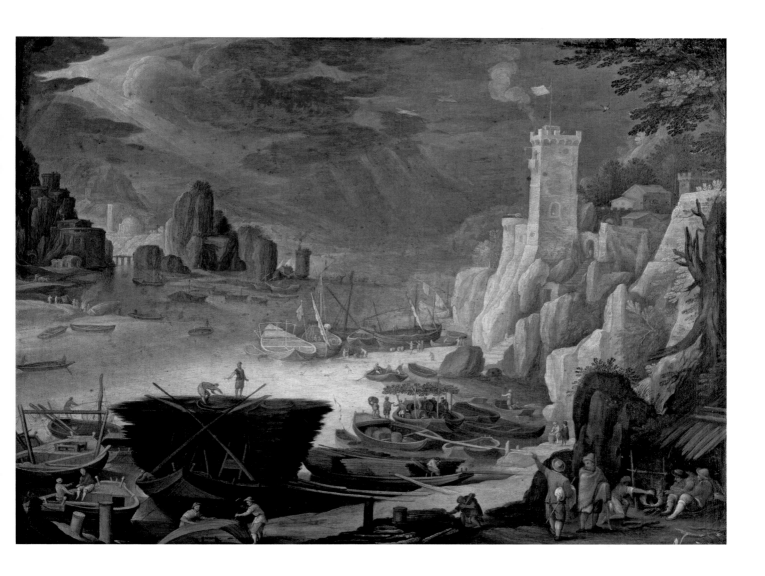

Paul Bril (1554–1626)

Harbour with Lighthouse at Night

Paysage nocturne avec un port et un phare

Nächtliche Hafenlandschaft mit Leuchtturm

Paisaje nocturno del puerto con faro

Paesaggio notturno del porto con il faro

Nachtgezicht op een haven met vuurtoren

1601, Oil on copper/Huile sur plaque de cuivre, 22 × 29,5 cm, Kunsthistorisches Museum, Wien

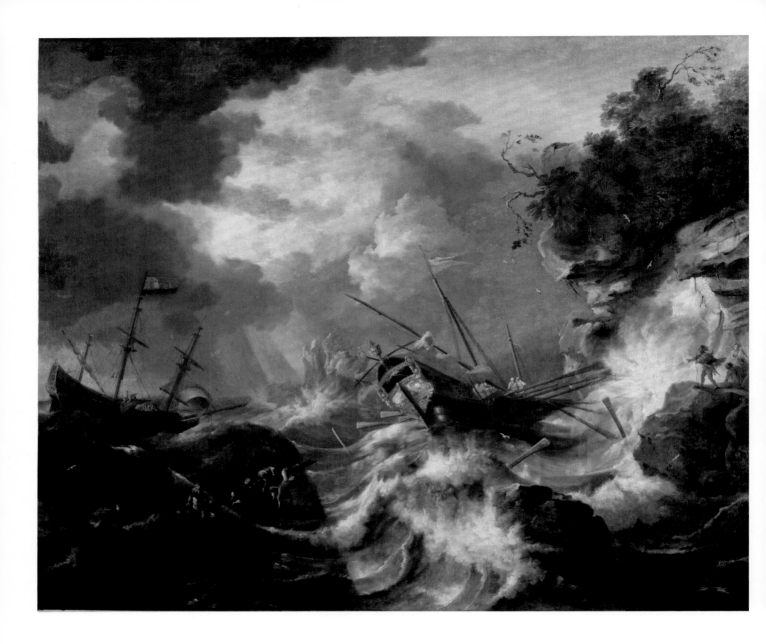

Jan Peeters (1624–77)

Ships in Peril off the Coast

Navire en perdition près de la côte

Schiffe in Seenot an der Küste

Barcos en peligro en la costa

Navi in difficoltà al largo della costa

Schepen in nood voor een rotsachtige kust

c. 1640–70, Oil on canvas/Huile sur toile, 87 × 103 cm, Kunsthistorisches Museum, Wien

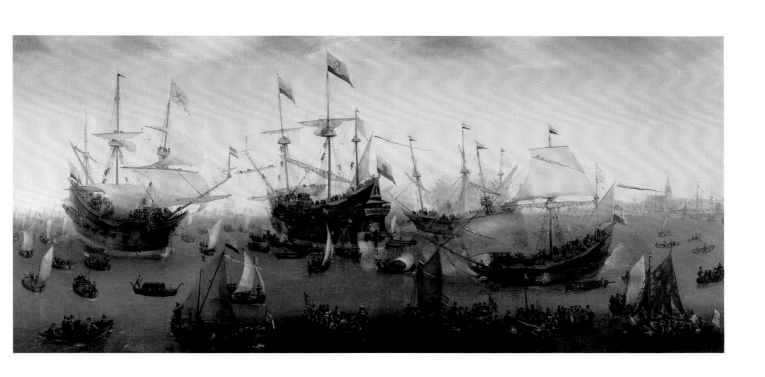

Hendrik Cornelisz. Vroom (c. 1566–1640)

The Return of the Second East India Expedition to Amsterdam

Le Retour à Amsterdam de la seconde expédition des Indes orientales

Die Rückkehr der zweiten Ostindien-Expedition nach Amsterdam

Regreso de la segunda expedición de las Indias Orientales a Ámsterdam

Ritorno ad Amsterdam della seconda spedizione alle Indie orientali

De terugkomst in Amsterdam van de tweede expeditie naar Oost-Indië

1599, Oil on canvas/Huile sur toile, 102,3 × 218,4 cm, Rijksmuseum, Amsterdam

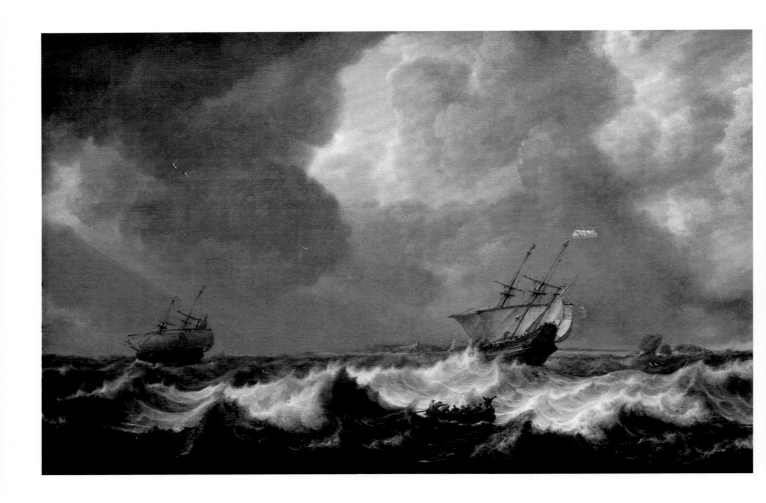

Simon de Vlieger (1600/01–53)

Dutch Merchant Ships on Stormy Seas off Rocky Coastline

Navires marchands hollandais sur une mer tumultueuse, devant une côte rocheuse

Holländische Handelsschiffe auf stürmischer See vor Felsenküste

Barcos mercantes holandeses en mar tormentoso frente a la costa

Navi mercantili olandesi sul mare in tempesta al largo della costa rocciosa

Hollandse handelsschepen op stormachtige zee voor een rotskust

1640–45, Oil on wood/Huile sur bois, 38,5 × 58 cm, Palais Liechtenstein, Wien

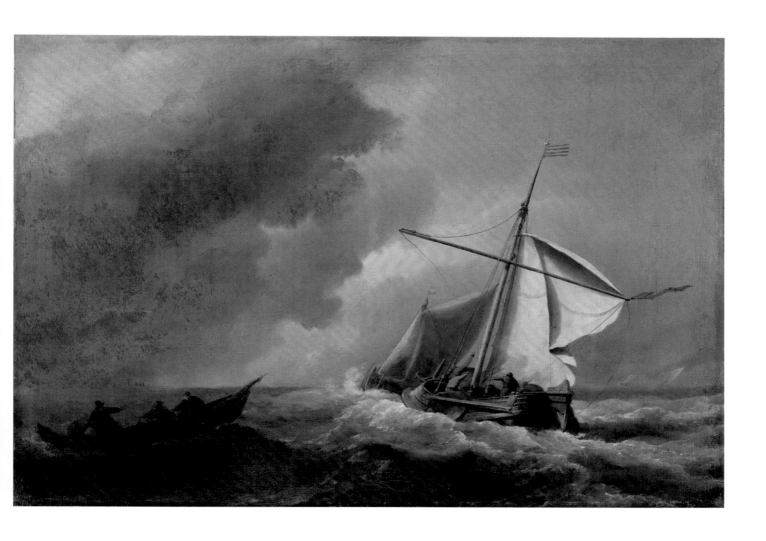

Willem van de Velde de Jonge/the Younger/le Jeune (1633–1707)

Dutch Ship in Strong Wind

Vaisseau hollandais pris dans le vent

Holländisches Schiff in starkem Wind

Navío holandés en el viento

Nave olandese in venti forti

Hollands schip bij stormachtig weer

c. 1670, Oil on canvas/Huile sur toile, 23,2 × 33,2 cm, National Gallery, London

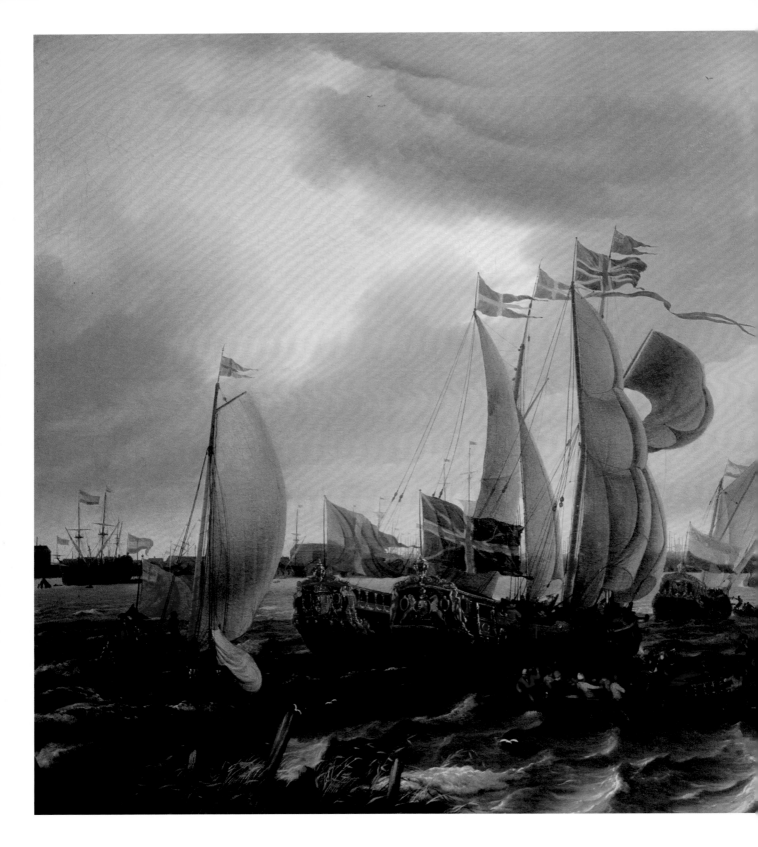

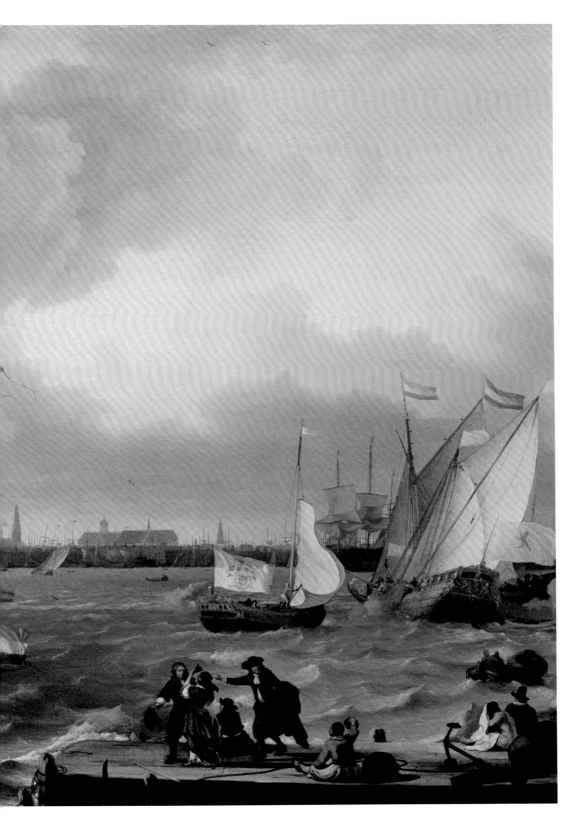

Ludolf Backhuysen (1630–1708)

A Parade of Ships on the IJ

Parade de navires sur la baie de l'IJ

Schiffsparade auf dem IJ

Desfile de barcos en el IJ

Sfilata navale sull'IJ

Schepenparade op het IJ

1660–69, Oil on canvas/Huile sur toile, 78 × 132 cm, Amsterdam Museum, Amsterdam

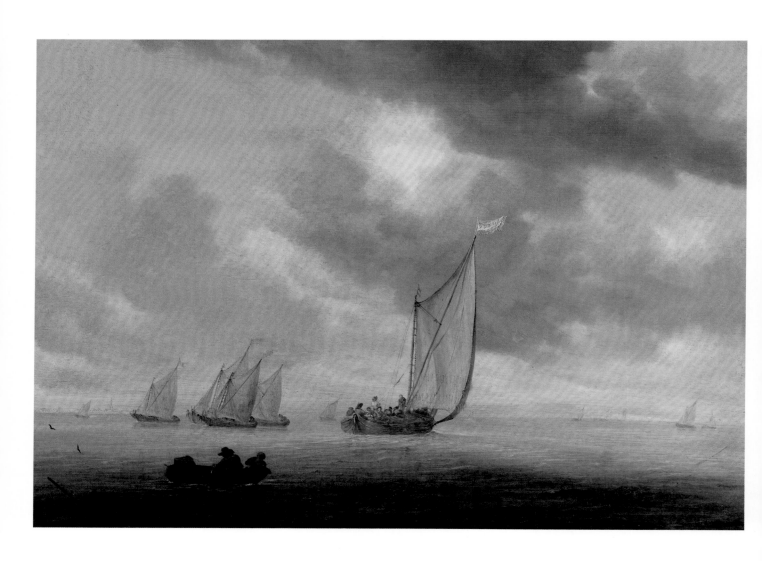

Salomon van Ruysdael (c. 1600–70)

Sailing Ships on an Inland Sea

Bateaux à voiles sur une mer intérieure

Segelschiffe in einem Binnenmeer

Barcos de vela en un mar interior

Barche a vela in un mare interno

Zeilschepen op een binnenmeer

1630–70, Oil on wood/Huile sur bois, 50 × 69 cm, Rijksmuseum, Amsterdam

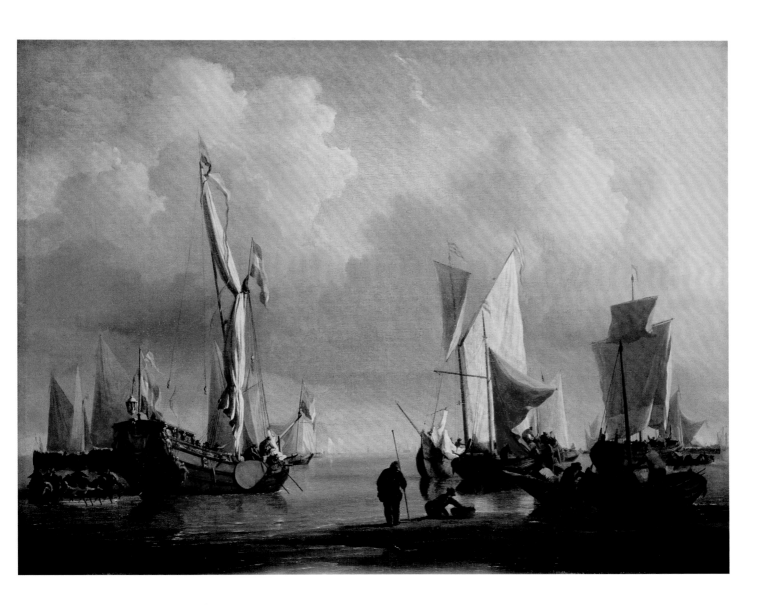

Willem van de Velde de Jonge/the Younger/le Jeune (1633–1707)

Ships off the Coast

Bateaux près de la côte

Schiffe vor der Küste

Barcos desde la costa

Navi al largo della costa

Schepen voor de kust

1672, Oil on canvas/Huile sur toile, 45 × 55 cm, Palais Liechtenstein, Wien

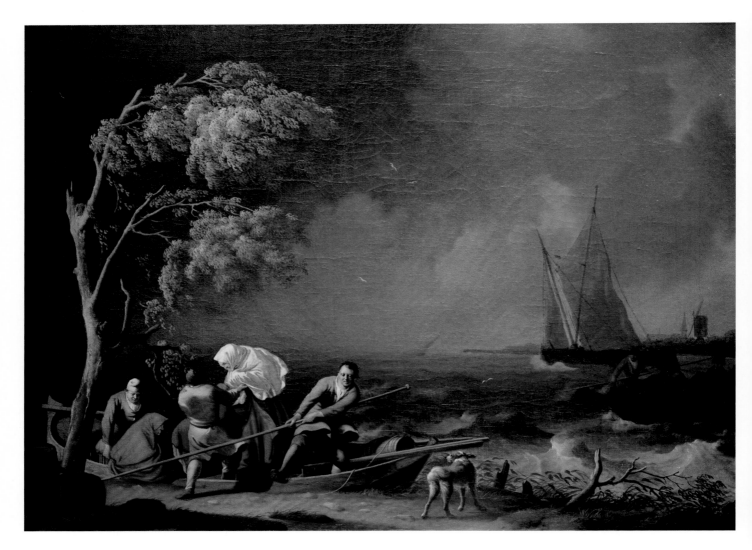

Ludolf Backhuysen (1630–1708)

The Ferry during a Storm

Le Ferry dans la tempête

Die Fähre bei Sturm

Transbordador en la tormenta

Il traghetto durante un temporale

De veerpont bij storm

c. 1682, Oil on canvas/Huile sur toile, 43 × 56 cm, Ostfriesisches Landesmuseum, Emden

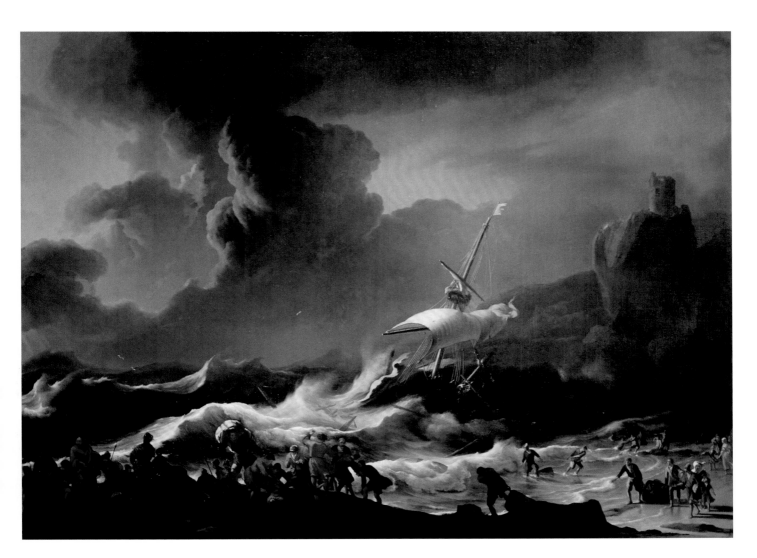

Ludolf Backhuysen (1630–1708)

The Shipwreck of the Apostle Paul off the Coast of Malta

Le Naufrage de l'apôtre Paul devant l'île de Malte

Der Schiffbruch des Apostels Paulus vor Malta

El naufragio del Apóstol Pablo en Malta

Il naufragio dell'Apostolo Paolo a Malta

De schipbreuk van de apostel Paulus voor de kust van Malta

c. 1690–1700, Oil on canvas/Huile sur toile, 151 × 204 cm, Ostfriesisches Landesmuseum, Emden

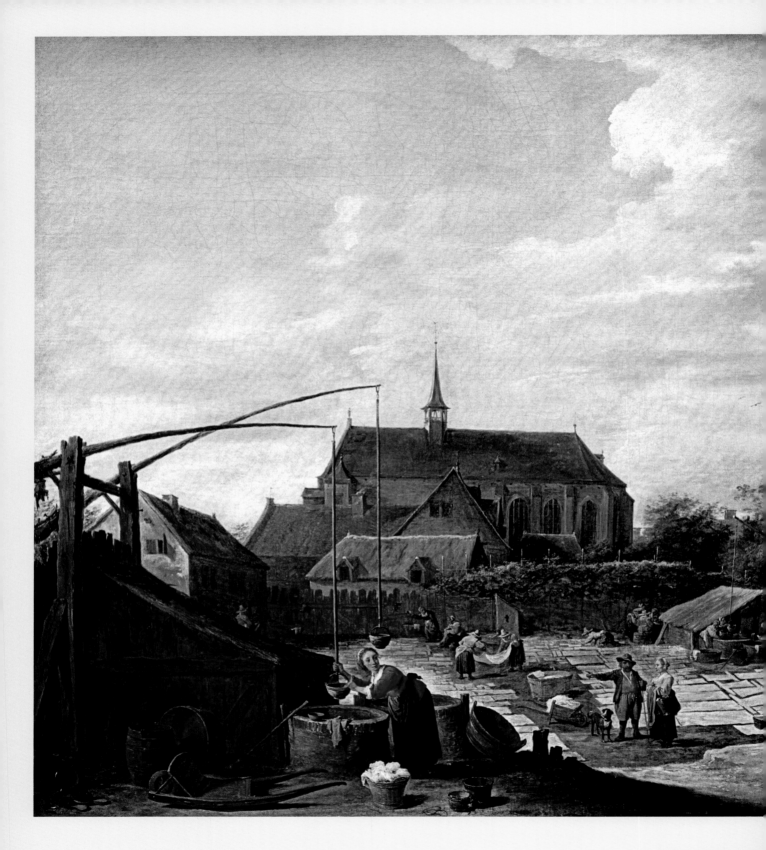

Flemish/Flamande

DAILY LIFE
LA VIE QUOTIDIENNE
DAS TÄGLICHE LEBEN
LA VIDA COTIDIANA
LA VITA QUOTIDIANA
HET DAGELIJKS LEVEN

David Teniers de Jonge/the Younger/le Jeune (1610–90)
Bleaching Linen
La Blanchisserie
Die Bleiche
El blanqueo de la ropa
Il bucato
Gezicht op een blekerij

c. 1645, Oil on canvas/Huile sur toile, 85 × 120,5 cm,
Barber Institute of Fine Arts, Birmingham

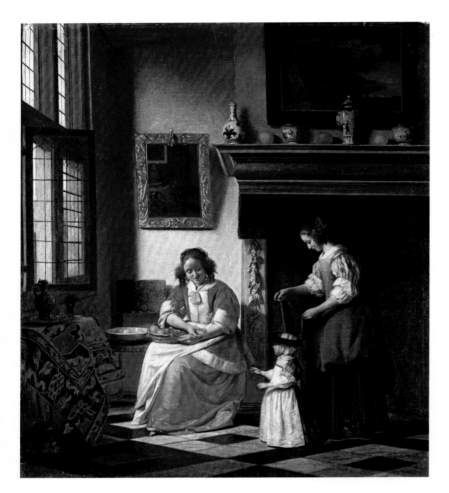

Pieter de Hooch (1629–84)

Teaching Her How to Walk (The Apple Peeler)

L'Apprentissage de la marche *ou* L'Éplucheuse de pommes

Unterricht im Laufen (Die Apfelschälerin)

Aprendiendo a andar (La peladora de manzanas)

Bambina che impara a camminare (Donna che sbuccia delle mele)

Twee vrouwen leren een kind met valhoed lopen

c. 1665–70, Oil on canvas/Huile sur toile, 67,5 × 59 cm,
Museum der bildenden Künste Leipzig

Daily Life

The Dutch penchant for art to represent life as authentically as possible is also clearly seen in the numerous pieces portraying everyday life. These have been called "genre scenes" and reflect the lives of both the wealthy bourgeoisie and the poorest peasants at outdoor celebrations, ice skating, and inside elegant interiors or humble farmsteads.

In the Dutch Republic, especially after 1650, images showing the wealthy at home became very popular. The interiors are often only shown with a few, but usually quite exquisite objects brought to the fore through the mastery of light and perspective as seen in works by Jan Vermeer, Pieter de Hooch, and Gerard ter Borch.

Scenes of peasant life, meanwhile, could be modeled on works done a century early by the likes of Pieter Brueghel the Elder. The painting of peasant scenes was popular throughout the 17th century and includes works by such important Flemish painters as David Teniers the Younger and Adriaen Brouwer. Brouwer came from Flanders, but spent many years living and

La vie quotidienne

Le goût de la Hollande pour une représentation aussi réaliste que possible est attesté par de nombreux tableaux ayant pour sujet la vie quotidienne. Appelés « scènes de genre », ils montrent aussi bien la vie de la riche bourgeoisie que celle des paysans les plus pauvres, lors de fêtes en plein air, de séances de patinage, dans des intérieurs élégants ou des gargotes de campagne.

Dans les Pays-Bas septentrionaux apparaissent, surtout après 1650, des tableaux montrant des personnages dans des intérieurs de maisons bourgeoises cossues. N'y figurent souvent que peu d'objets, mais d'autant mieux choisis et mis en valeur par des peintres comme Jan Vermeer, Pieter de Hooch et Gerard ter Borch à l'aide de perspectives et d'éclairages magistralement conçus.

Pour les représentations de la vie paysanne, les peintres pouvaient se référer à leurs prédécesseurs du XVIᵉ siècle comme Pieter Brueghel l'Ancien. Le « genre paysan » fut cultivé tout au long du XVIIᵉ siècle par des maîtres aussi importants que les Flamands

Das tägliche Leben

Die niederländische Vorliebe für eine möglichst lebensechte Darstellung bezeugen auch zahlreiche Kunstwerke, deren Thema das tägliche Leben ist. Sie werden als Genrebilder bezeichnet und geben sowohl das Leben des wohlhabenden Bürgertums als auch der ärmsten Bauern wieder – beim Feiern von Festen unter freiem Himmel und beim Eislaufen ebenso wie in eleganten Interieurs oder Bauernschenken.

In den Nördlichen Niederlanden entstanden vor allem ab 1650 Bilder, die Menschen in den Innenräumen reicher Bürgerhäuser zeigen. Hier finden sich häufig nur wenige, dafür aber umso erlesenere Objekte, die von Malern wie Jan Vermeer, Pieter de Hooch und Gerard ter Borch durch meisterhafte Lichtführung und perspektivische Gestaltungsmittel zur Geltung gebracht wurden.

Bei den Darstellungen des bäuerlichen Lebens konnten die Maler auf Vorläufer des 16. Jahrhundert wie Pieter Brueghel d. Ä. zurückgreifen. Das sogenannte Bauerngenre wurde während des

Gerard ter Borch (1617–81)

A Glass of Lemonade

Le Verre de limonade

Ein Glas Limonade

Un caso de limonada

Un bicchiere di limonata

Het glas limonade

1663/64, Oil on canvas/Huile sur toile, 67 × 54 cm,
State Hermitage Museum, St. Petersburg

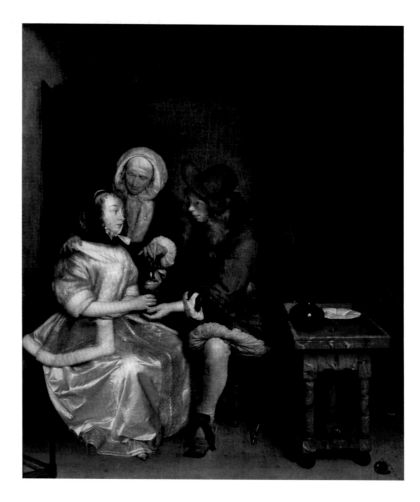

La vida cotidiana

Las numerosas obras de arte cuyo tema es la vida cotidiana atestiguan la preferencia holandesa por una representación realista. Se les llama pinturas de género y reproducen tanto la vida de la clase media acomodada como la de los campesinos más pobres – diversión en el patinaje sobre hielo y al aire libre, así como interiores elegantes o tabernas de los campesinos.

En los Países Bajos del norte surgieron principalmente desde 1650 cuadros que mostraban personas en interiores de las casas burguesas. Aquí encontramos sólo unos pocos, pero escogidos objetos, que eran mostrados por pintores como Jan Vermeer, Pieter de Hooch y Gerard ter Borch a través de la iluminación y los medios de representación magistrales.

En las ilustraciones de la vida campesina el pintor podía recurrir a precursores del siglo XVI como Pieter Brueghel el Viejo. El llamado género campesino se mantuvo durante todo el siglo XVII con artistas tan

La vita quotidiana

Testimoniano la predilezione per una rappresentazione il più realistica possibile da parte del pubblico dei Paesi Bassi anche numerose opere d'arte che hanno come soggetto la vita quotidiana. Questi dipinti sono chiamati quadri di genere e riproducono la vita sia della borghesia che dei contadini più poveri: momenti di divertimento all'aria aperta, pattinaggio sul ghiaccio e, ancora, scene di vita in interni eleganti o nelle umili dimore contadine.

Nei Paesi Bassi settentrionali vennero prodotti, principalmente a partire dal 1650, quadri che raffigurano ricchi borghesi all'interno delle loro case di città. In questi dipinti sono presenti spesso solo pochi, ma proprio per questo tanto più squisiti, oggetti, raffigurati da artisti come Jan Vermeer, Pieter de Hooch e Gerard ter Borch con un uso magistrale della luce e della prospettiva.

Nelle rappresentazioni della vita contadina i pittori potettero ricorrere a precursori del XVI secolo come Pieter Brueghel il Vecchio. Il cosiddetto genere

Het dagelijks leven

De Nederlandse voorliefde voor de natuurgetrouwe weergave toonde zich ook duidelijk in kunstwerken over het dagelijks leven, die `genrestukken` worden genoemd en het leven van zowel de gegoede burgerij als arme boeren uitbeeldden – bij het vieren van feesten in de openlucht of het schaatsen, in elegante interieurs of in boerenschuren.

In de Noordelijke Nederlanden ontstonden vooral vanaf 1650 schilderijen die burgers in het interieur van hun voorname herenhuizen toonden. Deze ruimten zijn vaak met slechts enkele objecten gevuld, die daardoor des te opmerkelijker worden. Deze interieurs, van schilders als Johannes Vermeer, Pieter de Hooch en Gerard ter Borch, kenmerken zich ook door een meesterlijke uitwerking van de lichtval en de enscenering van het ruimtelijk perspectief.

In genrestukken van het boerenleven konden de schilders op voorlopers uit de zestiende eeuw als Pieter Brueghel de Oudere aansluiten. Het boerengenre werd gedurende de hele zeventiende eeuw door belangrijke

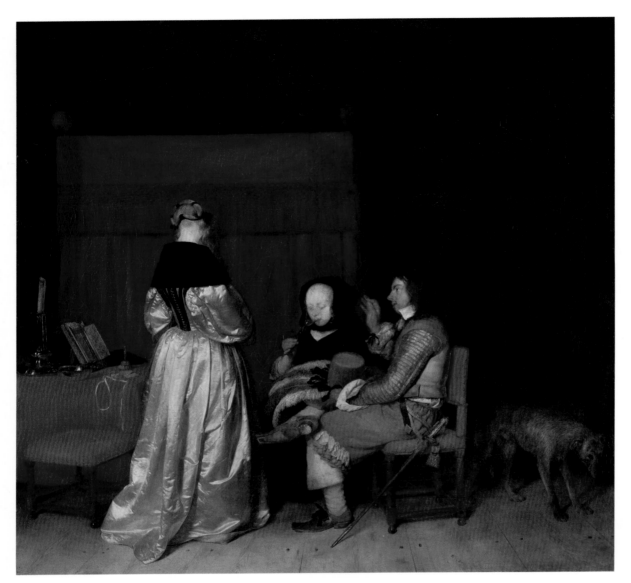

Gerard ter Borch (1617–81)

Galant Conversation (A Father's Admonition)

Admonestation paternelle

Galante Konversation (Die väterliche Ermahnung)

Conversación galante (La amonestación paterna)

La conversazione galante (L'ammonimento paterno)

Galante conversatie (De vaderlijke vermaning)

c. 1654, Oil on canvas/ Huile sur toile, 71 × 73 cm, Rijksmuseum, Amsterdam

working in Haarlem, just outside Amsterdam. He is credited with revitalizing the genre and his scenes come across as unposed and fully natural, helped by a reduction to a few figures, earthy colors, and loose brushwork.

Genre scenes also frequently have a moral message. A tavern scene could thus be hiding the biblical parable of the prodigal son or a family meal might be telling us that despite the reasons for all the cheerfulness, unbridled partying must be kept in check.

David Teniers le Jeune et Adriaen Brouwer. Ce dernier était originaire des Flandres, mais vécut longtemps à Haarlem, en Hollande. Il passe pour le rénovateur du genre avec des scènes très libres qui se caractérisent par une réduction à quelques personnages, une palette argileuse et une touche légère.

Les scènes de genre contiennent aussi souvent un message moral. Une scène d'auberge peut fort bien dissimuler la parabole biblique du Fils prodigue. La représentation d'un repas de famille permettra de suggérer qu'on doit maintenir toute gaieté dans les bornes de la décence.

gesamten 17. Jahrhunderts von so bedeutenden Malern wie dem Flamen David Teniers d. J. und Adriaen Brouwer gepflegt. Letzterer stammte aus Flandern, lebte aber lange im holländischen Haarlem. Er gilt als „Erneuerer" des Genres, und seine völlig ungezwungenen Szenen zeichnen sich durch eine Reduktion auf wenige Figuren sowie eine tonige Farbgebung und lockere Pinselführung aus.

Häufig haben Genrebilder auch eine moralische Botschaft. So kann sich hinter einer Wirtshausszene das biblische Gleichnis des verlorenen Sohns verbergen – oder einem Familienmahl ist sofort anzusehen, dass bei aller Fröhlichkeit der Zügellosigkeit Einhalt geboten werden muss.

Adriaen Brouwer (c. 1605–38)

The Back Operation

L'Opération du dos

Die Operation am Rücken

La operación de espalda

L'operazione alla schiena

Rugoperatie

c. 1636, Oil on wood/Huile sur bois, 34,4 × 27 cm,
Städelmuseum, Frankfurt am Main

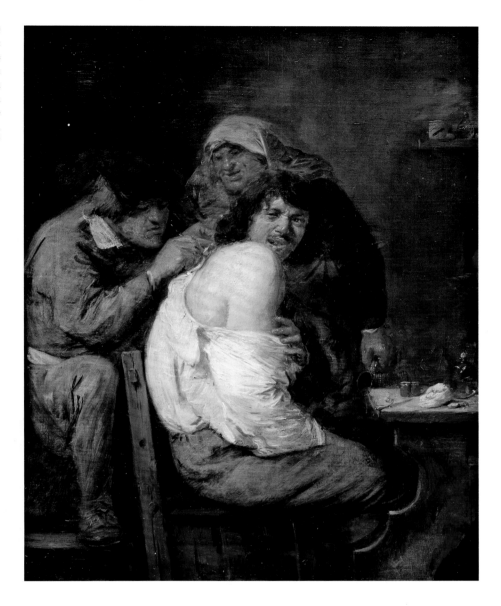

importantes como el flamenco David Teniers el Joven y Adriaen Brouwer. El último procedía de Flandes, pero vivió mucho tiempo en la ciudad holandesa de Haarlem. Se le considera "innovador" del género y sus escenas completamente casuales se caracterizan por la reducción a unas pocas figuras así como a una coloración tonal y una pincelada suelta.

Con frecuencia los cuadros de género también tienen un mensaje moral. Por lo tanto, detrás de una escena que muestra una taberna se puede ocultar la parábola bíblica del hijo pródigo – o una comida familiar puede ser considerada como el control de la alegría de la vida disoluta.

contadino fu praticato per tutto il XVII secolo da artisti importanti, come il fiammingo David Teniers il Giovane e Adriaen Brouwer, originario delle Fiandre, ma vissuto a lungo nella città olandese di Haarlem. Adriaen Brouwer è considerato un "innovatore" del genere, e le sue scene completamente spontanee sono caratterizzate dall'uso di poche figure, di tonalità argillose e di una pennellata sciolta.

Spesso i quadri di genere racchiudevano anche un messaggio morale. Ad esempio, dietro una scena di taverna si nasconde la parabola biblica del figliol prodigo, e un pasto in famiglia vuole trasmettere l'ammonimento che, anche in momenti di allegria, deve essere tenuta a bada la sfrenatezza.

schilders als de Vlamingen David Teniers de Jongere en Adriaen Brouwer beoefend. Brouwer woonde lange tijd in het Hollandse Haarlem en wordt gezien als vernieuwer van dit genre; zijn volstrekt ongedwongen taferelen kenmerken zich door een beperking tot enkele figuren, een coloriet van aardkleuren en een losse penseelvoering.

Vaak hadden deze genrestukken ook een moralistische boodschap. Zo kan achter een herbergscène de Bijbelse gelijkenis van de verloren zoon schuilgaan of achter de vrolijkheid tijdens een maaltijd met het hele gezin de vermaning dat voor bandeloosheid moet worden gewaakt.

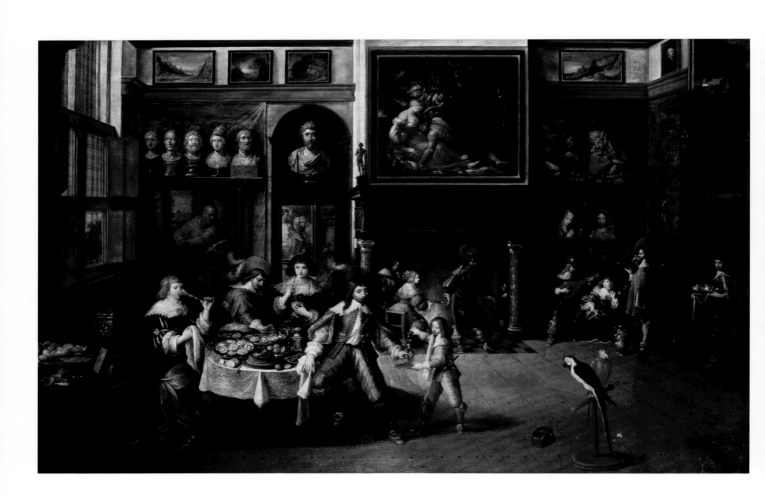

Frans Francken de Jonge/the Younger/le Jeune (1581–1642)

Dinner in the House of Mayor Rockox

Un banquet dans la maison du bourgmestre Rockox

Gastmahl im Hause des Bürgermeisters Rockox

Banquete en la casa del burgomaestre Rockox

Banchetto presso la casa del sindaco Rockox

Gastmaal in het huis van Nicolaas Rockcox

c. 1630–35, Oil on wood/Huile sur bois, 62,3 × 96,5 cm, Alte Pinakothek, München

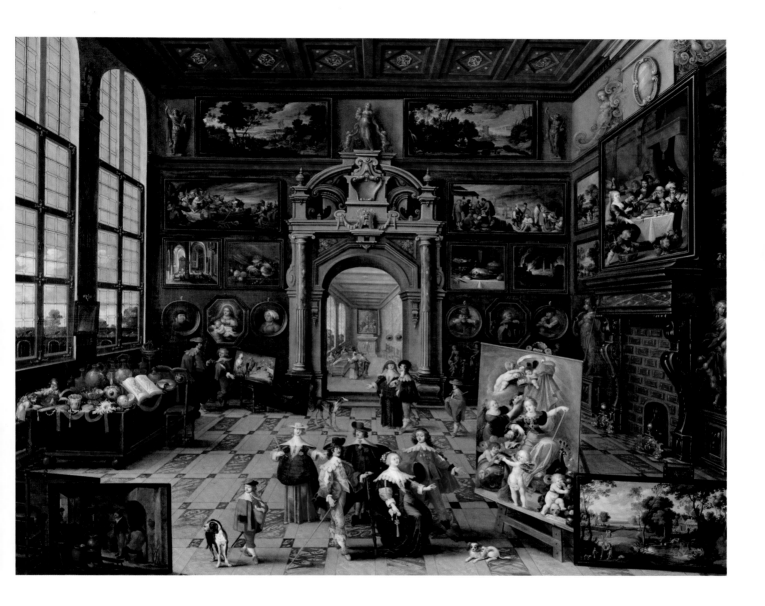

Frans Francken de Jonge/the Younger/le Jeune (1581–1642), Cornelis de Baellieur (1607–71)

The Gallery of an Art Collector

Galerie d'un collectionneur

Die Bildergalerie eines Kunstsammlers

La galería de un coleccionista de arte

La galleria di un collezionista d'arte

De schilderijenverzameling van een kunstkenner

c. 1635, Oil on wood/Huile sur bois, 115,2 × 148 cm, Residenzgalerie, Salzburg

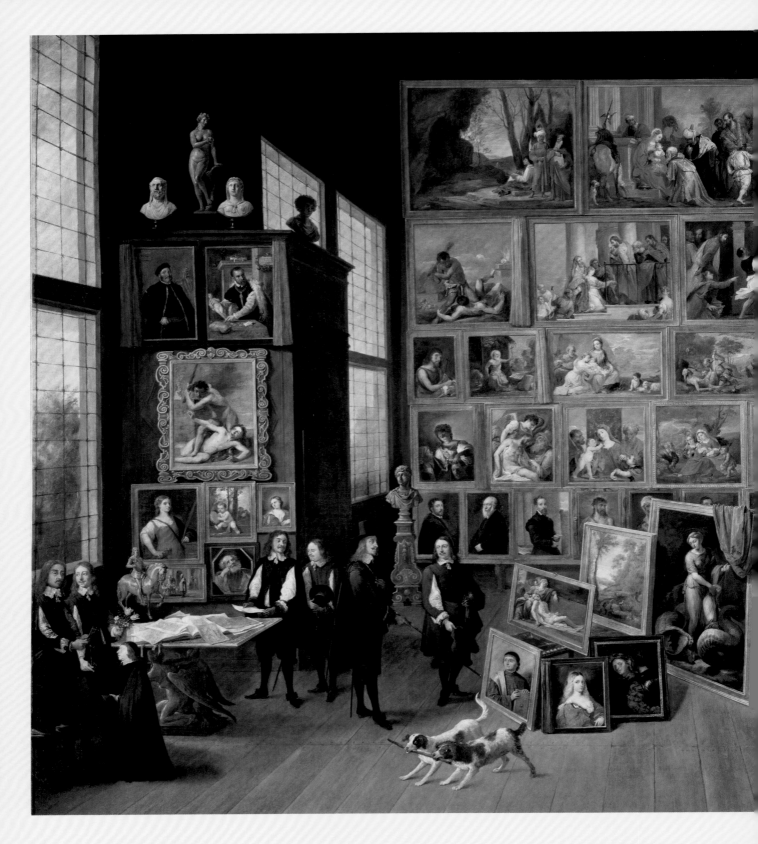

David Teniers de Jonge/the Younger/le Jeune (1610–90)
Archduke Leopold Wilhelm in His Gallery in Brussels
L'Archiduc Léopold-Guillaume dans sa galerie à Bruxelles
Erzherzog Leopold Wilhelm in seiner Galerie in Brüssel
El archiduque Leopoldo Guillermo en su galería de Bruselas
La galleria dell'Arciduca Leopoldo Guglielmo a Bruxelles
Aartshertog Leopold Wilhelm in zijn kunstkabinet te Brussel

c. 1650, Oil on canvas/Huile sur toile, 124 × 165 cm, Kunsthistorisches Museum, Wien

Paintings of picture galleries were a genre that developed in 17th century Antwerp and remained unique to that Flemish city until the turn of the 18th century. They allowed collectors to demonstrate both their social status and their taste in art and allowed painters to present their products, i.e. paintings, as collectable objects in their own right. David Teniers the Younger, who can be seen in the picture, was court painter and administrator of the gallery of Archduke Leopold Wilhelm (ruler of the Spanish Netherlands from 1647 to 1656). He even published engravings of many of the archduke's holdings in the first gallery catalogue ever produced.

Le tableau de galerie – toile représentant une collection de tableaux – est un genre qui se développa au XVIIe siècle à Anvers et y resta confiné jusqu'en 1700, environ. Il permettait au collectionneur de prouver son statut social et ses connaissances artistiques ; au peintre, que son produit – le tableau – était digne d'une collection. David Teniers – visible dans la toile – était peintre de cour et administrateur de la galerie de l'archiduc Léopold-Guillaume (régent des Pays-Bas espagnols de 1647 à 1656). Il publia en gravure de nombreux tableaux de l'archiduc, dans le premier catalogue de galerie connu.

Das Galeriebild – ein Gemälde von einer Gemäldegalerie – entwickelte sich im 17. Jahrhundert in Antwerpen und blieb bis etwa 1700 auf diese Stadt beschränkt. Mit ihm konnten die Sammler sozialen Status und Kunstverständnis demonstrieren und die Maler ihr Produkt, das Gemälde, als sammelwürdig darstellen. David Teniers d. J., der selbst im Bild zu sehen ist, war Hofmaler und Verwalter der Galerie des Erzherzogs Leopold Wilhelm (1647–1656 Statthalter der Spanischen Niederlande). Viele Bilder des Erzherzogs publizierte er als Kupferstiche im ersten Galeriekatalog überhaupt.

La Galería – un cuadro de una galería de cuadros – fue creado en el siglo XVII en Amberes y quedó restringido a esta ciudad hasta alrededor del año 1700. Con él, los coleccionistas fueron capaces de demostrar el estatus social y la comprensión del arte y los artistas presentan su producto, la pintura, como un objeto de colección. David Teniers el Joven, al que se puede ver en la imagen, fue pintor de cámara y director de la galería del archiduque Leopoldo Guillermo (gobernador de los Países Bajos españoles en 1647–1656). Publicitó muchos cuadros del archiduque como grabados en el primer catálogo de galería.

I dipinti di gallerie, ovvero quadri raffiguranti una pinacoteca, nacquero nel XVII secolo ad Anversa e rimasero pressoché limitati a tale città fino a circa il 1700. Mediante questi dipinti i collezionisti erano in grado di dimostrare il loro status sociale e la loro comprensione dell'arte, e gli artisti potevano a loro volta mostrare il loro prodotto, il quadro, come oggetto da collezione. David Teniers il Giovane, che ritrae se stesso nel quadro, fu pittore di corte e direttore della Galleria dell'Arciduca Leopoldo Guglielmo (governatore dei Paesi Bassi spagnoli dal 1647 al 1656), e pubblicò numerosi quadri dell'Arciduca come incisioni su rame nel primo catalogo della galleria.

Het 'galerijstuk' – een schilderij van een schilderijenkabinet–ontstond in de zeventiende eeuw in Antwerpen en bleef tot circa 1700 tot die stad beperkt. Met een galerijstuk konden verzamelaars hun status en kennersschap demonstreren, terwijl schilders hun schilderij als een verzamelobject konden aanprijzen. David Teniers de Jongere, zelf in het werk te zien, was hofschilder en beheerder van het kunstkabinet van Leopold Wilhelm (landvoogd der Spaanse Nederlanden). In de eerste catalogus van zijn soort publiceerde Teniers veel werken van de aartshertog als kopergravures.

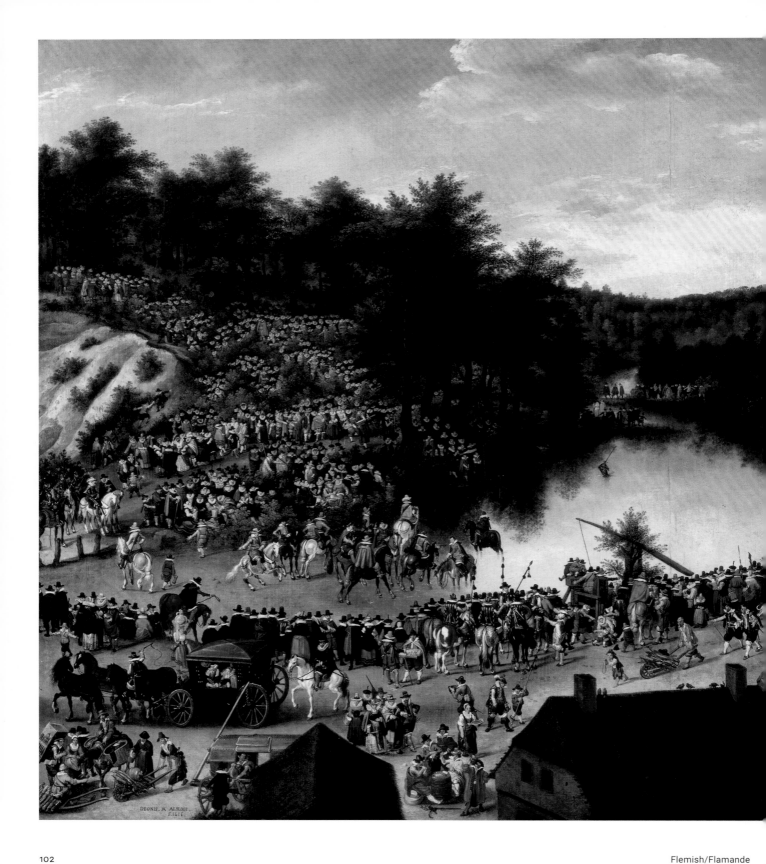

DEONIS. K ALSLOOT.
F.1616

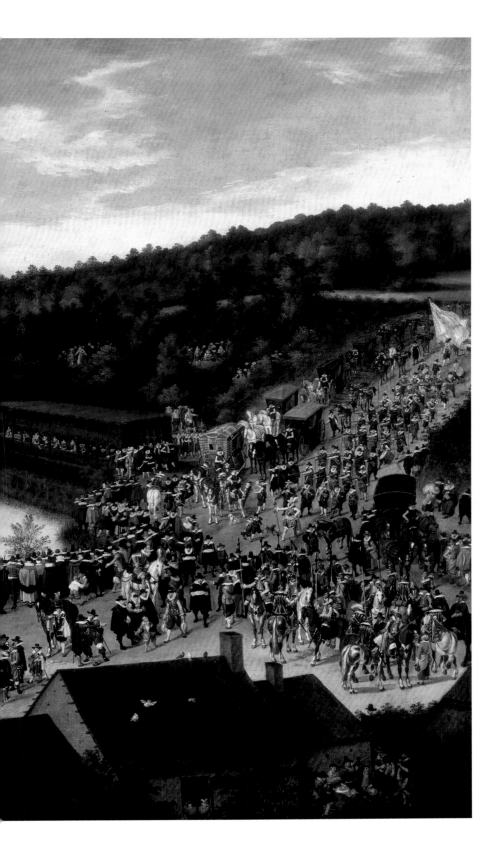

Denis van Alsloot (c. 1570–c. 1626)

Festival of Our Lady of the Woods

Fête de Notre-Dame-des-bois

Das Fest unser lieben Frau im Wald

Fiesta de Nuestra Señora del Bosque

Festa della Madonna dei Boschi

Feest aan de Diesdelle

1616, Oil on canvas/Huile sur toile, 153 × 253,5 cm,
Museo del Prado, Madrid

Jan Brueghel de Oude/the Elder/l'Ancien, *dit* de Velours (1568–1625)

Country Festival in the Presence of the Dukes
Danse champêtre devant l'archiduc Albert

Ländliches Fest vor den Herzögen
Fiesta rural ante los duques

Festa rurale per i duchi
Plattelandsfeest ter ere van Albrecht en Isabella

1623, Oil on canvas/Huile sur toile, 130 × 266 cm, Museo del Prado, Madrid

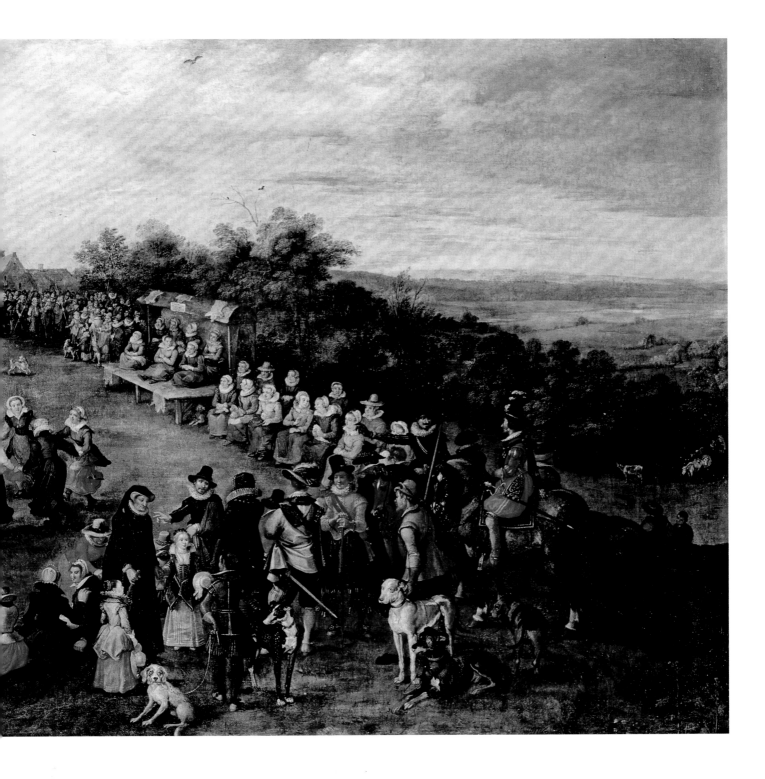

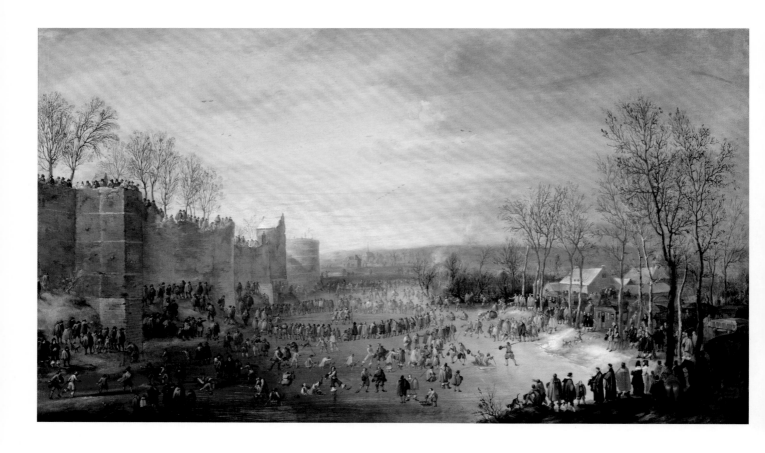

Robert van den Hoecke (1622–68)

Ice Skating on the Moat Surrounding Brussels

Patinage sur les fossés gelés de Bruxelles

Schlittschuhlaufen auf dem Stadtgraben in Brüssel

Patinaje en los fosos de Bruselas

Pattinaggio sul fossato di Bruxelles

IJspret op de stadsgracht van Brussel

1649, Oil on wood/Huile sur bois, 53,7 × 89 cm, Kunsthistorisches Museum, Wien

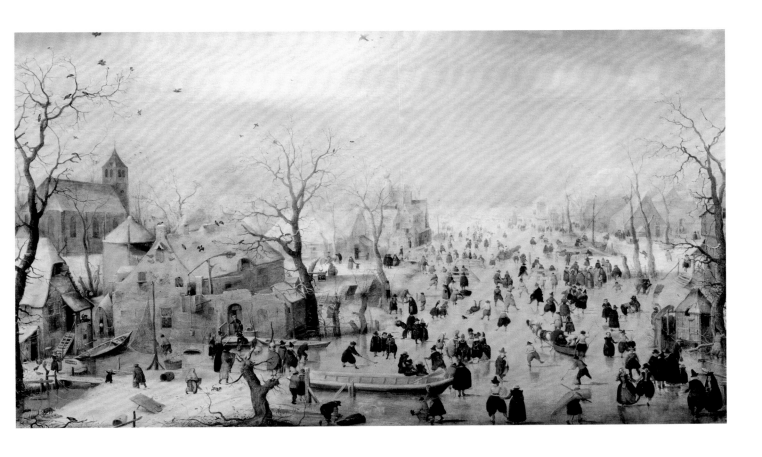

Hendrick Avercamp (1585–1634)

Winter Landscape with Ice Skaters

Paysage d'hiver

Winterlandschaft mit Schlittschuhläufern

Paisaje de invierno con patinadores

Paesaggio invernale con pattinatori

Winterlandschap met ijsvermaak

c. 1608, Oil on wood/Huile sur bois, 77,3 × 131,9 cm, Rijksmuseum, Amsterdam

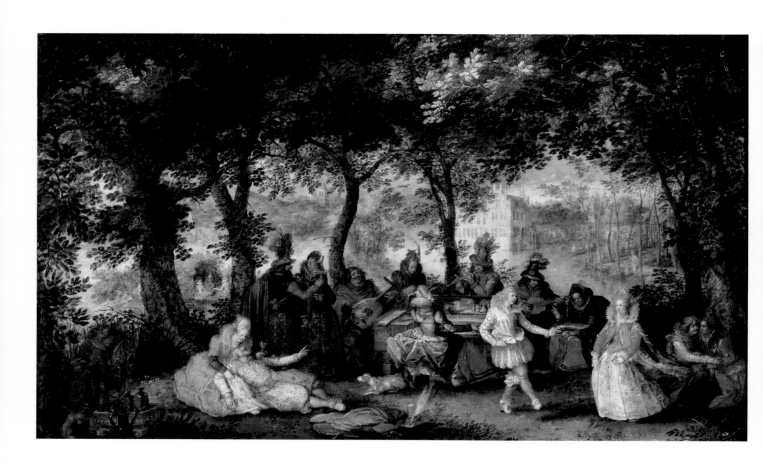

David Vinckboons (1576–c. 1632)

Outdoor Party

Une partie de campagne

Gesellschaft im Freien

Sociedad al aire libre

Festa all'aperto

Musicerend gezelschap in de tuin van een kasteel

1610, Oil tempera on wood/Tempera à l'huile e sur bois, 41 × 68 cm, Akademie der bildenden Künste, Wien

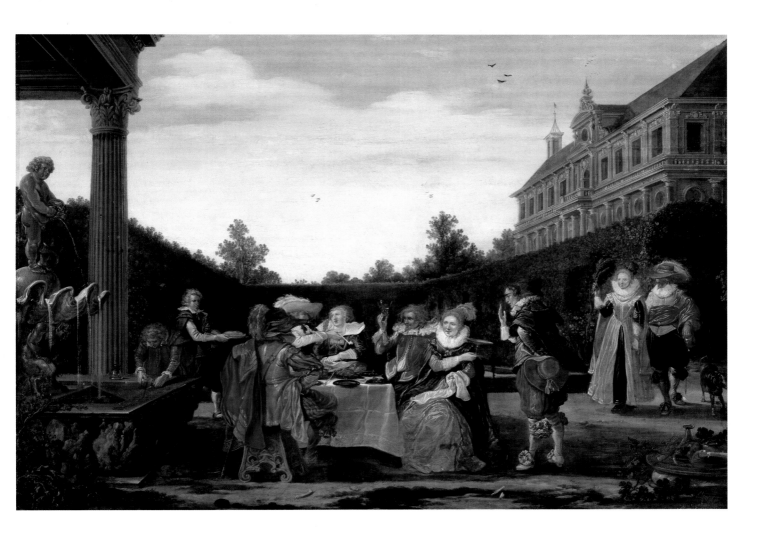

Esaias van de Velde (1587–1630), Bartholomäus van Bassen (c. 1590–1652)

Festive Picnic in the Palace Gardens

Festin dans le parc d'un château

Festmahl im Schlosspark

Fiesta en el parque del castillo

Festa nel parco del castello

Banket in een paleistuin

1624, Oil on wood/Huile sur bois, 47,2 × 67,1 cm, Kunsthistorisches Museum, Wien

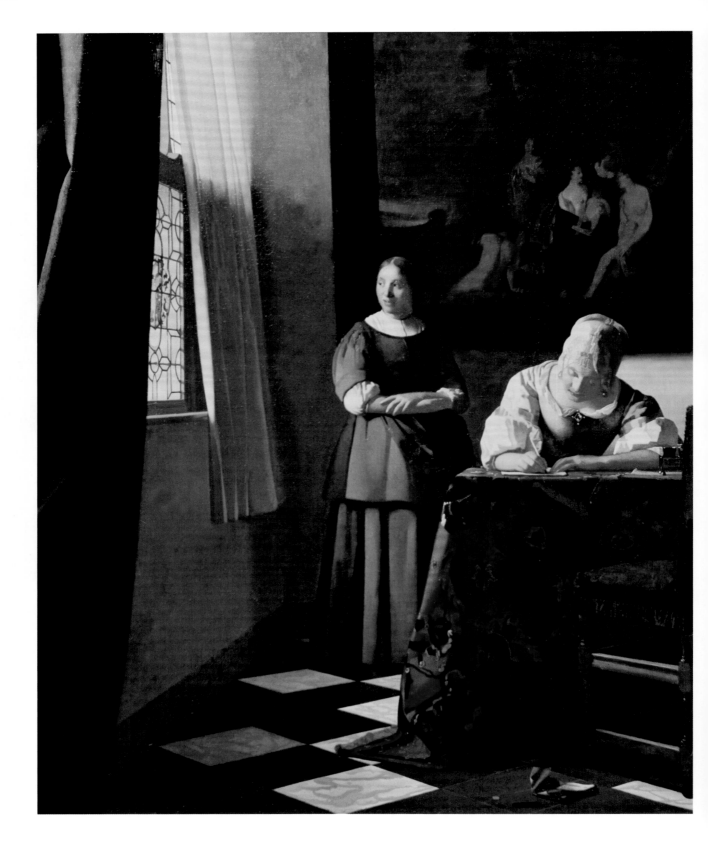

Jan Vermeer van Delft (1632–75)

Woman Writing a Letter and Her Maid

Une dame écrivant une lettre et sa servante

Briefschreiberin und Dienstmagd

Dama escribiendo una carta con su sirvienta

Donna che scrive una lettera alla presenza della domestica

Schrijvende vrouw met dienstbode

c. 1670, Oil on canvas/Huile sur toile, 71,1 × 60,5 cm, National Gallery of Ireland, Dublin

Jan Vermeer van Delft (1632–75)

Woman Reading a Letter

La Femme en bleu lisant une lettre

Einen Brief lesende Frau

Mujer leyendo una carta

Donna in azzurro che legge una lettera

Brieflezende vrouw in het blauw

c. 1663, Oil on canvas/Huile sur toile, 46,5 × 39 cm, Rijksmuseum, Amsterdam

Jan Vermeer van Delft (1632–75)
The Music Lesson
La Leçon de musique
Die Musikstunde
La lección de música
Lezione di musica
De muziekles
c. 1662–63, Oil on canvas/Huile sur toile, 74 × 64,5 cm, Buckingham Palace, London

The vanishing lines of the floor tiles, windows, and the edge of the table all draw viewers into the picture and direct their eye to the young woman standing at a virginal at the back of the room. The mirror shows us the room behind her. The light pouring in from the left illuminates the various textures of the various objects in the room in an almost photo-realistic manner. Jan Vermeer was a master of perspective, light, and natural representation. Viewers cannot help but be drawn in by his sparing, but extremely compelling compositions.

Les lignes de fuite des carreaux, des fenêtres et du bord de table attirent le regard dans le tableau, vers la jeune femme debout dans le fond de la salle, devant un virginal. À travers le miroir, le regard est renvoyé au-delà du personnage. La lumière tombant de la gauche éclaire les diverses textures des objets, rendus dans un réalisme presque photographique. Jan Vermeer était un maître de la perspective, des éclairages et des représentations réalistes. Aucun spectateur ne saurait échapper au charme de ses compositions sobres, mais extrêmement évocatrices.

Die Fluchtlinien von Bodenfliesen, Fenstern und Tischkante ziehen den Blick in das Bild herein und lenken ihn auf die junge Frau, die hinten im Raum an einem Virginal steht. Durch den Spiegel wird der Blick noch über diese Figur hinausgeführt. Das von links einfallende Licht erhellt die verschiedenartigen Texturen der geradezu fotorealistisch wiedergegebenen Gegenstände. Jan Vermeer war ein Meister der Perspektive, Lichtregie und naturgetreuen Darstellung. Dem Reiz seiner sparsamen, aber äußerst beziehungsreichen Bildkompositionen kann sich kaum ein Betrachter entziehen.

Las alineaciones de baldosas, ventanas y borde de la mesa atraen la mirada en la imagen y la dirigen a la mujer joven al virginal al fondo de la sala. A través del espejo, la mirada recae aún más sobre esta figura. La luz incidente por la izquierda ilumina las variadas texturas de los objetos representados casi foto-realísticamente. Jan Vermeer era un maestro de la perspectiva, de la administración de la luz y de la representación realista. El espectador difícilmente puede rehuir del encanto de sus frugales pero extremadamente sugerentes composiciones pictóricas.

Le linee di fuga delle piastrelle del pavimento, delle finestre e del bordo del tavolo attirano lo sguardo nel quadro e lo dirigono verso la giovane donna in piedi al virginale in fondo alla stanza. Attraverso lo specchio lo sguardo viene ulteriormente condotto su questa figura. La luce incidente da sinistra illumina le varie trame degli oggetti, resi con una precisione quasi fotografica. Jan Vermeer era un maestro della prospettiva, della luce e della rappresentazione realistica. Il fascino delle sue composizioni pittoriche, frugali ma estremamente suggestive, può difficilmente sfuggire all'osservatore.

De perspectieflijnen die door tegels, vensters en tafelranden worden gevormd, trekken de blik van de beschouwer het beeldvlak binnen en voeren naar de jonge vrouw achter het virginaal. Door de spiegel boven de vrouw wordt het blikveld nog uitgebreid. Het van links komende licht valt op de uiteenlopende texturen van de bijna fotografisch weergegeven objecten. Vermeer was een meester van het perspectief, de enscenering van de lichtval en de natuurgetrouwe weergave. De ruimtelijke spanning van deze spaarzame maar betekenisvolle compositie zal weinigen kunnen ontgaan.

Pieter de Hooch (1629–84)

The Mother

La Mère

Die Mutter

La madre

La madre

De moeder

c. 1661–63, Oil on canvas/Huile sur toile, 95,2 × 102,5 cm, Gemäldegalerie, Berlin

Dutch/Hollandaise

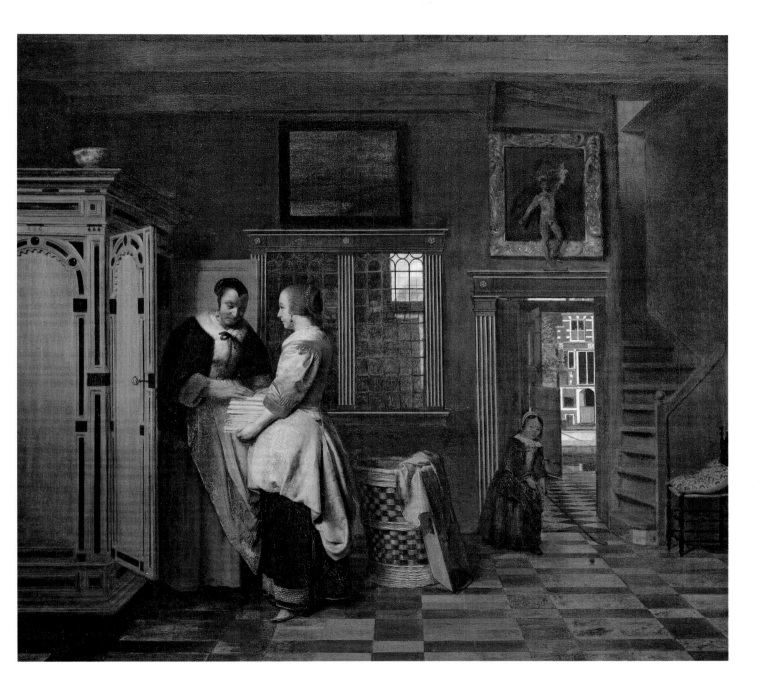

Pieter de Hooch (1629–84)

The Laundry Cupboard

L'Armoire à linge

Am Wäscheschrank

El armario de la ropa blanca

L'armadio delle lenzuola

Interieur met vrouwen bij een linnenkast

1663, Oil on canvas/Huile sur toile, 70 × 75,5 cm, Rijksmuseum, Amsterdam

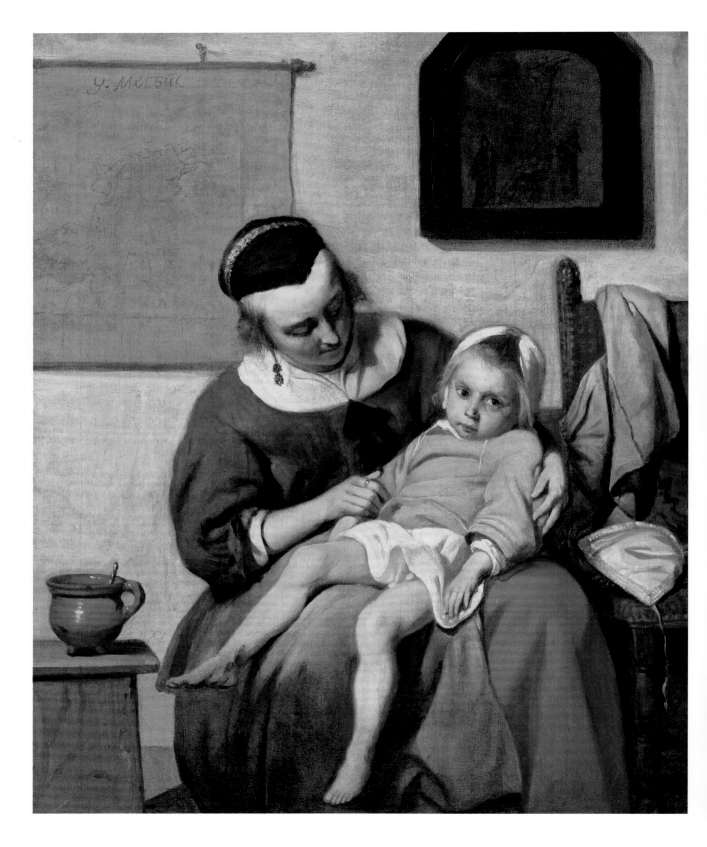

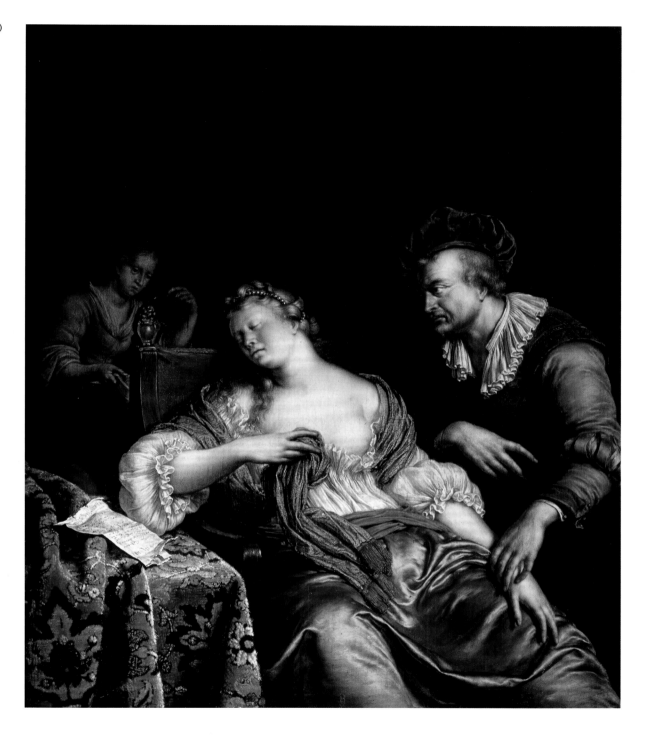

Willem van Mieris (1662–1747)

Fainting Woman	Die Ohnmächtige	La donna incosciente
L'Évanouissement	La impotencia	Een flauwgevallen vrouw

1695, Oil on wood/Huile sur bois, 23,5 × 20 cm, State Hermitage Museum, St. Petersburg

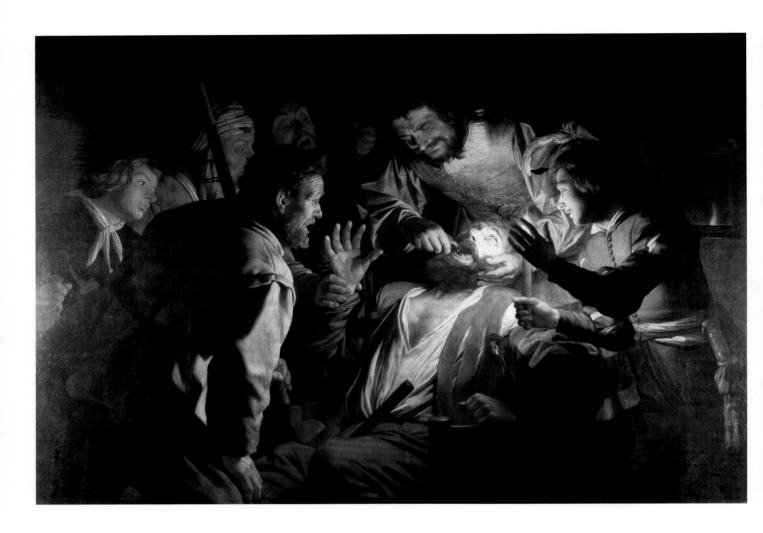

Gerrit van Honthorst (1590–1656)

The Dentist

L'Arracheur de dents

Der Zahnarzt

El dentista

Il dentista

De tandarts

1622, Oil on canvas/Huile sur toile, 147 × 219 cm, Gemäldegalerie Alte Meister, Dresden

Dutch/Hollandaise

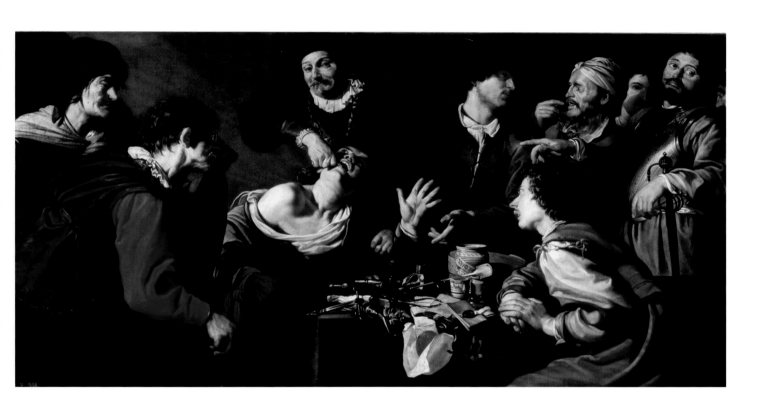

Theodoor Rombouts (1597–1637)

The Tooth Breaker

L'Arracheur de dents

Der Zahnbrecher

El charlatán sacamuelas

Il cavadenti

De tandentrekker

1620–25, Oil on canvas/Huile sur toile, 118 × 223 cm, Museo del Prado, Madrid

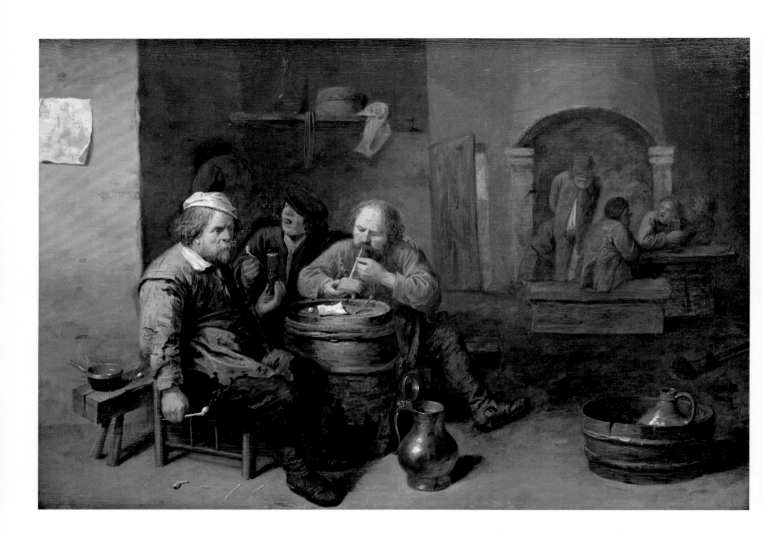

David Ryckaert III (1612–61)

Peasants Smoking and Drinking

Paysans buvant et fumant

Rauchende und trinkende Bauern

Campesinos bebiendo y fumando

Contadini che fumano e bevono

Rokende en drinkende boeren

1638, Oil on wood/Huile sur bois, 40,7 × 57,1 cm, Private collection

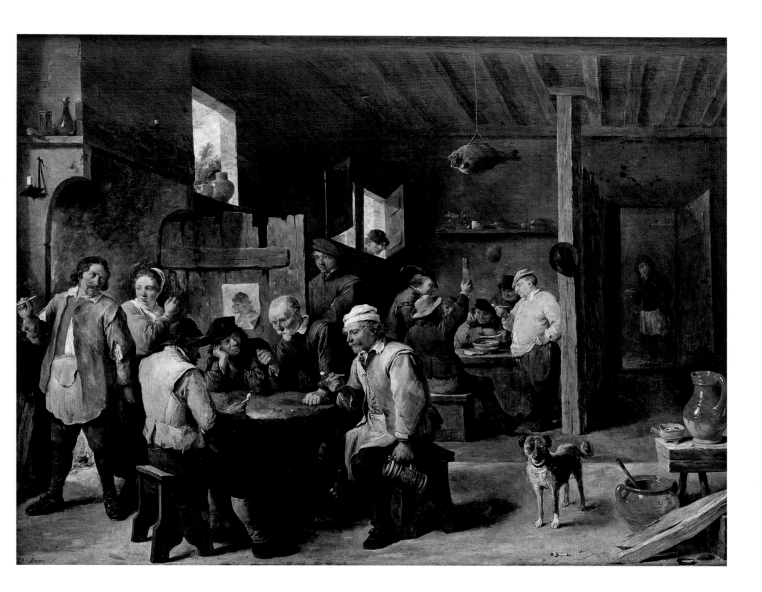

David Teniers de Jonge/the Younger/le Jeune (1610–90)

Tavern

Scène de taverne

Zechstube

Taberna

Taverna

Gelagkamer

1643, Oil on wood/Huile sur bois, 55,9 × 73,6 cm, Alte Pinakothek, München

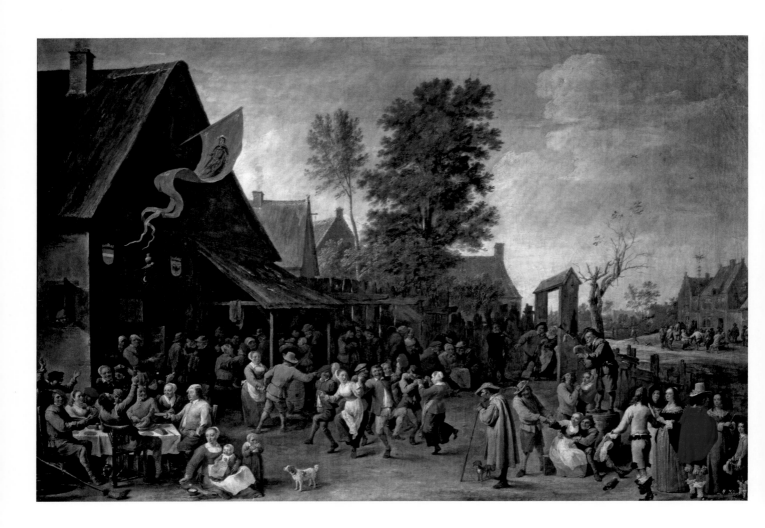

David Teniers de Jonge/the Younger/le Jeune (1610–90)

Peasant Fair

Kermesse paysanne

Bauernkirmes

Fiesta campesina

Kermesse di contadini

Dorpsfeest bij een herberg

c. 1647, Oil on canvas/Huile sur toile, 76 × 112 cm, Kunsthistorisches Museum, Wien

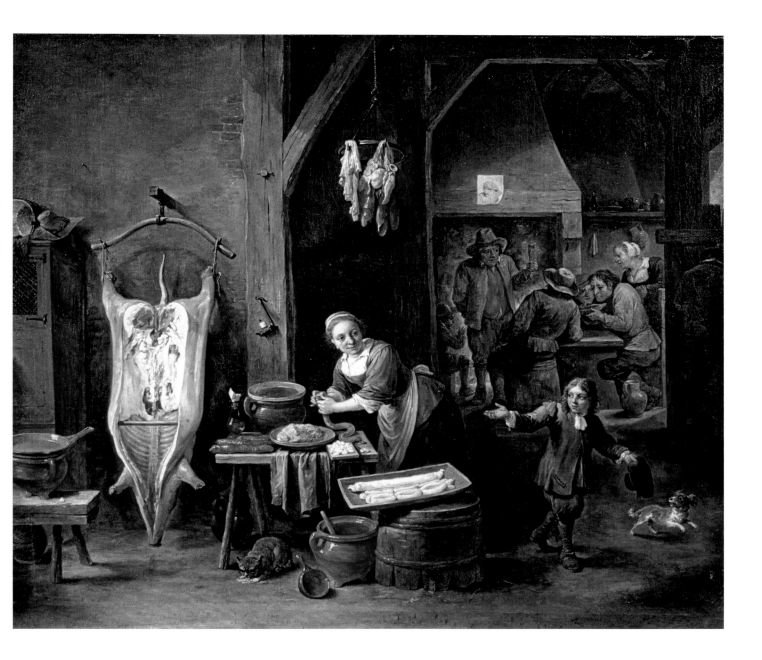

David Teniers de Jonge/the Younger/le Jeune (1610–90)

Making Sausage

Jeune femme préparant des saucisses

Das Wurstmachen

La elaboración de embutido

La preparazione delle salsicce

De worstenmaakster

c. 1651, Oil on canvas/Huile sur toile, 54,5 × 64,5 cm, Kunsthistorisches Museum, Wien

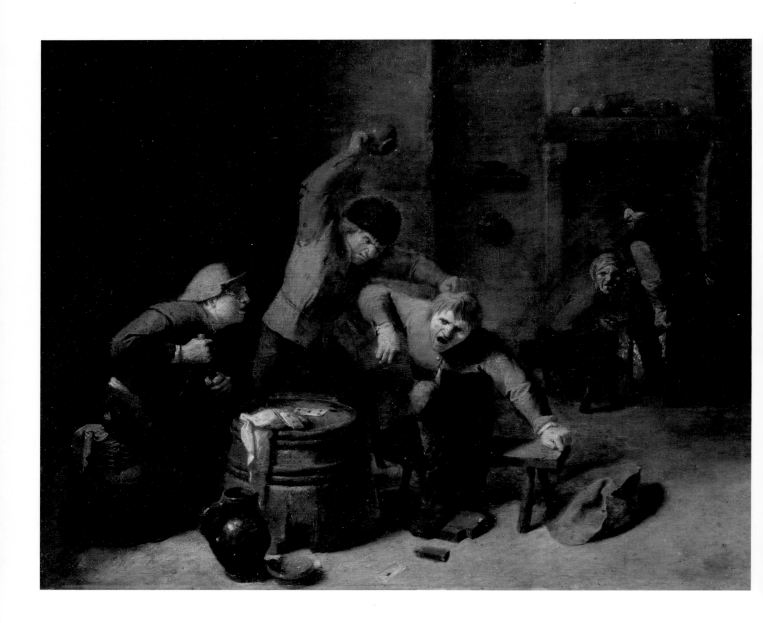

Adriaen Brouwer (c. 1605–38)

Roughnecks

Bagarre entre des paysans

Bauernrauferei

Riña de campesino

Contesa di contadini

Interieur met vechtende boeren

1635, Oil on wood/Huile sur bois, 26,5 × 34,5 cm, Gemäldegalerie Alte Meister, Dresden

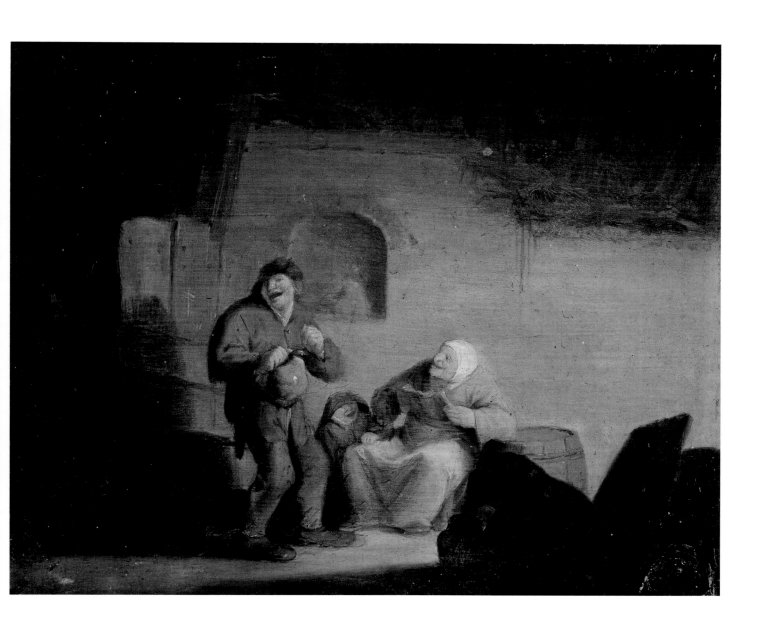

Adriaen van Ostade (1610–85)

Village People Singing

Paysans chantant

Singende Dorfleute

Aldeanos cantando

Abitanti del villaggio che cantano

Zingende boeren

c. 1632, Oil on wood/Huile sur bois, 24 × 29 cm, Museo del Prado, Madrid

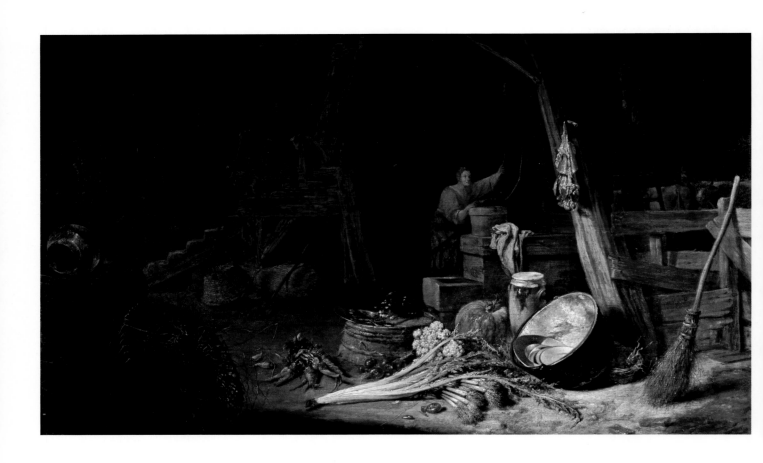

Willem Kalf (1619–93)

Interior of a Peasant Home

Intérieur d'une maison paysanne

Inneres eines Bauernhauses

Interior de una casa campesina

Interno di una casa contadina

Boerendeel met vrouw aan de put

c. 1650, Oil on wood/Huile sur bois, 42 × 71,8 cm, Museum der bildenden Künste Leipzig

Dutch/Hollandaise

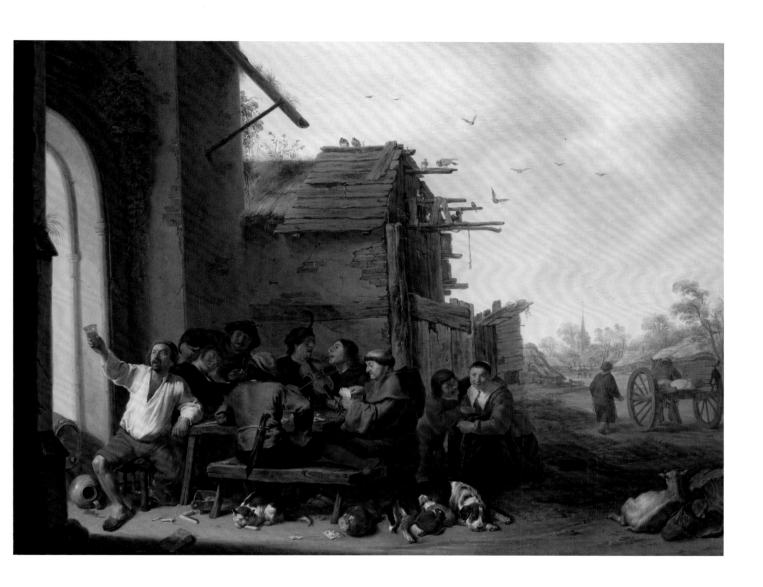

Cornelis Saftleven (c. 1607–81)

Outside the Village Tavern

Personnages devant une taverne de village

Vor einer Dorfschänke

Delante de la taberna

Davanti all'osteria

Gezelschap voor een dorpsherberg

1642, Oil on wood/Huile sur bois, 63 × 83,5 cm, Rijksmuseum, Amsterdam

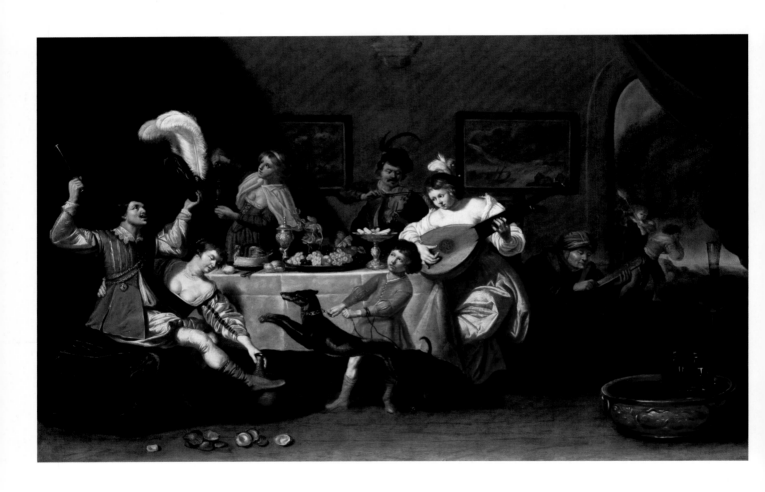

Jan van Bijlert (1597/98–1671)

The Prodigal Son with the Whores

Le Fils prodigue en compagnie de prostituées

Der verlorene Sohn bei den Dirnen

El hijo perdido

Il figliol prodigo dalle prostitute

De verloren zoon bij de hoeren

c. 1650, Oil on wood/Huile sur bois, 44,3 × 71,3 cm, Museum der bildenden Künste Leipzig

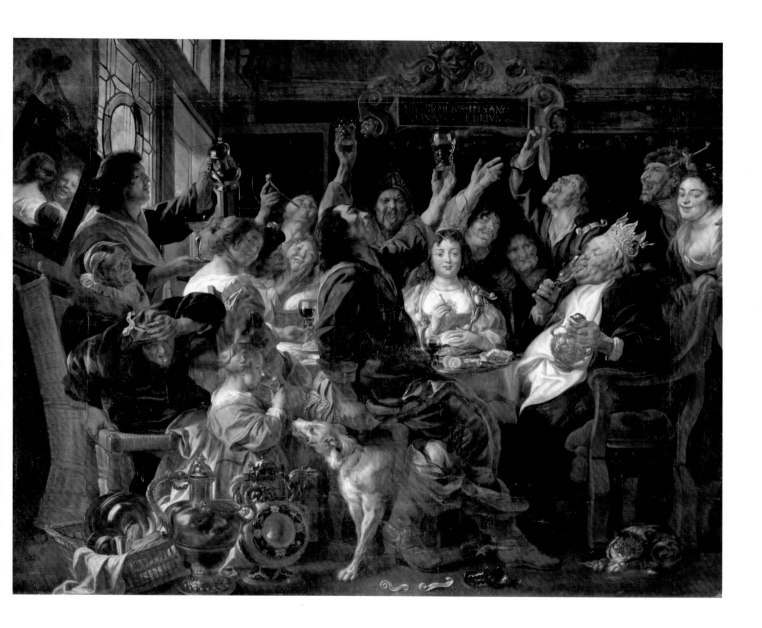

Jacob Jordaens (1593–1678)

The Feast of the Bean King

Le Roi boit *ou* La Fête des rois

Das Fest des Bohnenkönigs

La fiesta del roscón de reyes

La festa del re del fagiolo

De koning drinkt

c. 1640–45, Oil on canvas/Huile sur toile, 242 × 300 cm, Kunsthistorisches Museum, Wien

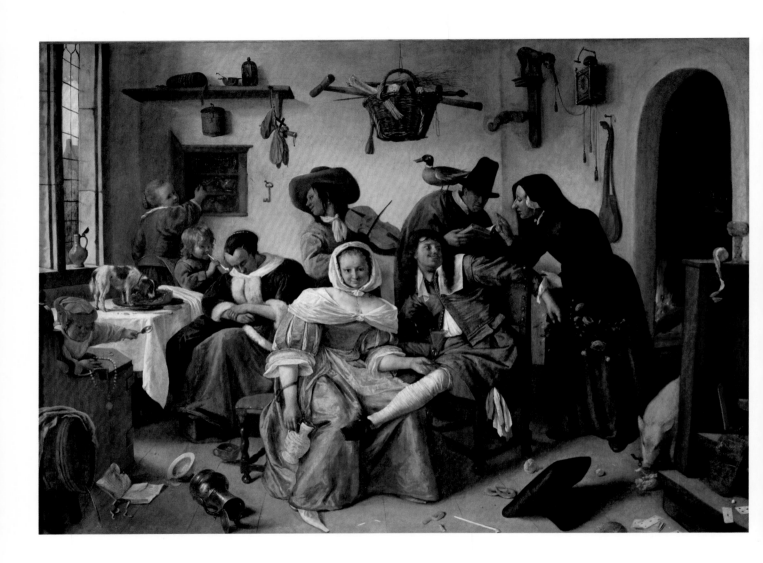

Jan Steen (1626–79)

The World Upside Down

Le Monde à l'envers

Die verkehrte Welt

El mundo al revés

Nella lussuria, fa' attenzione

In weelde siet toe

1663, Oil on canvas/Huile sur toile, 105 × 145,5 cm, Kunsthistorisches Museum, Wien

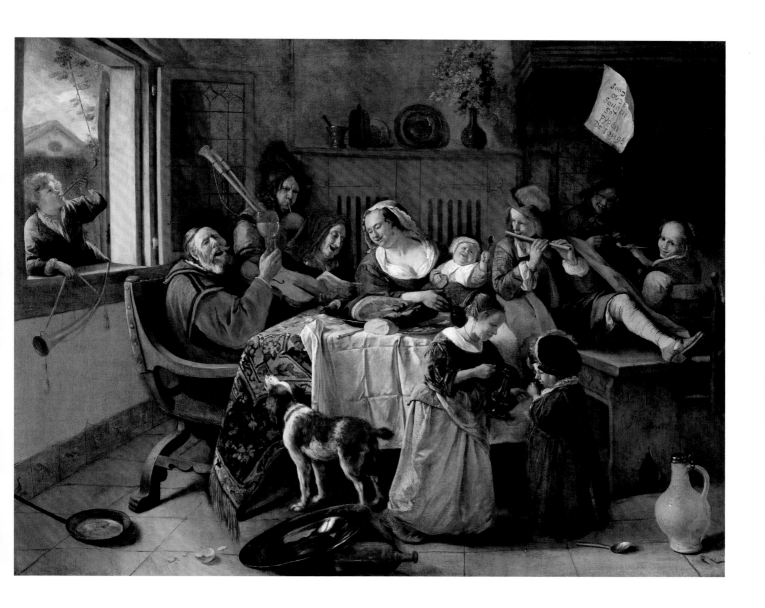

Jan Steen (1626–79)

The Happy Family

La Joyeuse Famille

Die fröhliche Familie

La alegre familia

L'allegra famiglia

Soo d'oude songen, soo pypen de jonge

1668, Oil on canvas/Huile sur toile, 110,5 × 141 cm, Rijksmuseum, Amsterdam

PORTRAITS
PORTRAITS
PORTRÄTS
RETRATOS
RITRATTI
PORTRETTEN

Rembrandt Harmensz. van Rijn (1606–69)

The Staalmeesters (The Syndicate of Cloth Merchants)

Le Syndic de la guilde des drapiers

Die Staalmeesters (Die Syndici der Tuchhändler)

Die Staalmeesters (El sindicato de comerciantes de telas)

I sindaci dei drappieri (De Staalmeesters)

De staalmeesters

1662, Oil on canvas/Huile sur toile, 191,5 × 279 cm, Rijksmuseum, Amsterdam

Portraits

The demand for portraits began to grow exponentially from about 1600 across both halves of the Netherlands. In particular, aristocrats and the bourgeoisie demanded pictures that would testify to their social standing, which is why the portrait genre developed ever greater autonomy.

Among the most important portrait painters in the Dutch Republic were Frans Hals, whose portraits and brushwork are often characterized by their seeming informality, and Rembrandt van Rijn, whose early portraits are characterized by the contrast between light and dark as well as a masterly elaboration of textures and details. As Rembrandt's personal circumstances changed, these portraits that had been popular with his clients began to take on a darker palette and became more psychological. This includes

Portraits

À dater d'environ 1600, les commandes de portraits augmentèrent dans l'ensemble des Pays-Bas. La noblesse et surtout la bourgeoisie demandaient des tableaux qui attestaient de leur position sociale, ce pourquoi le genre du portrait développa une autonomie de plus en plus grande.

Frans Hals et Rembrandt comptent parmi les maîtres les plus importants des Pays-Bas septentrionaux. Les portraits de Hals se distinguent souvent – jusque dans la touche – par une grande liberté ; les premiers tableaux de Rembrandt sont caractérisés par des contrastes de clair-obscur et par un rendu magistral des textures et des détails. En partie à cause des bouleversements dans la vie personnelle du peintre, ce mode de représentation – très demandé par les clients – fit ensuite place à un

Porträts

In den gesamten Niederlanden verstärkte sich ab etwa 1600 die Nachfrage nach Porträts. Vor allem Adel und Bürgertum verlangten nach Bildern, die den gesellschaftlichen Rang der eigenen Person bezeugten, weshalb die Bildgattung Porträt eine immer größere Eigenständigkeit entwickelte.

Zu den bedeutendsten Bildnismalern der Nördlichen Niederlande gehören Frans Hals, dessen Porträts sich – auch in der Pinselführung – häufig durch Ungezwungenheit auszeichnen, und Rembrandt, dessen frühe Bildnisse durch den Gegensatz von Hell und Dunkel sowie eine meisterhafte Ausarbeitung von Texturen und Details gekennzeichnet sind. Bedingt durch die Veränderung der persönlichen Lebensumstände des Malers wich diese bei Auftraggebern gefragte Darstellungsweise

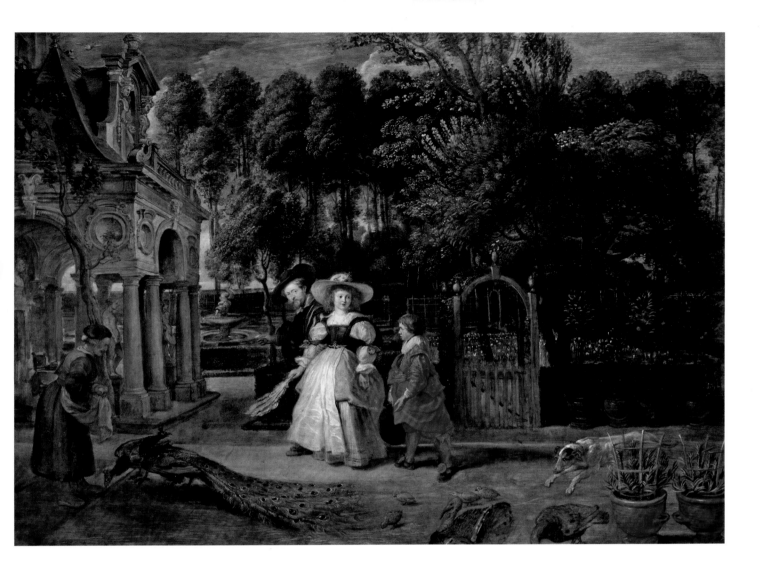

Retratos

En todos los Países Bajos se intensificó la demanda de retratos desde alrededor de 1600. Sobre todo nobles y plebeyos exigían imágenes que fueran testigos de su posición social, por lo que el género del retrato desarrolló una autonomía cada vez mayor.

Entre los retratistas más importantes de los Países Bajos del norte se encuentran Frans Hals, cuyos retratos – incluso en la pincelada – a menudo se caracterizan por la informalidad, y Rembrandt, cuyos primeros retratos se caracterizan por el contraste de la luz y la oscuridad, así como por una elaboración magistral de texturas y detalles. Debido al cambio en las circunstancias personales del pintor esta demanda de representaciones a modo de retratos psicológicos de los clientes tornó en una paleta más oscura – incluyendo los ya famosos autorretratos

Ritratti

A partire dal 1600 circa, in tutti i Paesi Bassi aumentò la domanda di ritratti, soprattutto da parte di nobili e borghesi che desideravano possedere quadri che testimoniassero la loro condizione sociale. In conseguenza di ciò, il genere del ritratto ottenne un'autonomia sempre maggiore.

Tra i più importanti ritrattisti dei Paesi Bassi settentrionali si annoverano Frans Hals, i cui ritratti sono spesso caratterizzati dalla spontaneità, anche nella pennellata, e Rembrandt, i cui primi ritratti sono contraddistinti dal contrasto tra luce e ombra e da una resa magistrale delle trame e dei dettagli. A seguito del mutamento delle circostanze personali del pittore, questo tipo di ritratti, molto richiesto dai committenti, lasciò il posto a rappresentazioni psicologiche con una tavolozza più scura, che in tale

Portretten

In de Nederlanden als geheel nam de vraag naar portretten vanaf circa 1600 sterk toe. Vooral leden van de adel en de gegoede burgerij wilden schilderijen waarop zij hun sociale status konden tonen, zodat het portret een steeds zelfstandiger genre werd.

Tot de grote portretschilders van de Noordelijke Nederlanden behoorden Frans Hals, wiens portretten zich (ook in de penseelvoering) kenmerkten door ongedwongenheid, en Rembrandt, wiens vroege portretten opvielen door contrasten van licht en donker, en door de meesterlijke uitwerking van texturen en details. Als gevolg van de persoonlijke leefomstandigheden van de schilder maakten deze bij opdrachtgevers populaire portretten plaats voor psychologische uitbeeldingen in een donker palet,

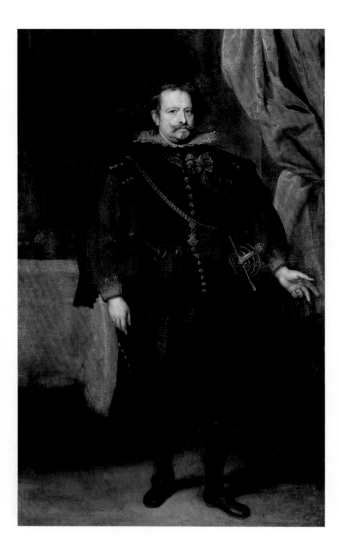

Anthonis van Dyck (1599–1641)

Diego Mexía Felípez de Guzmán, Marqués de Leganés

1634, Oil on canvas/Huile sur toile, 200 × 125 cm, Fundación Banco Santander, Madrid

the self-portraits which are so famous today, but which were barely appreciated at the time.

Peter Paul Rubens and Anthonis van Dyck were two of Flanders' outstanding portraitists. Drawing inspiration from rules of portraiture developed in the Italian Renaissance, Rubens created not only portraits that showed the sitters' prestige (including many rulers of the era), but also extremely intimate images such as those of his second wife Hélène Fourment. Van Dyck, who had already developed an international reputation, was named court painter to King Charles I of England in 1632. His refined and elegant portrait style was a major influence on the English portraiture of the 17th and 18th centuries.

The tronie, meanwhile, was a genre similar to the portrait, painted based on live models, but turned into stock characters or types.

traitement plus sombre, par exemple dans les célèbres autoportraits tardifs (alors peu appréciés).

Peter Paul Rubens et Anthony van Dyck sont des portraitistes flamands d'exception. Reprenant des solutions iconographiques imaginées par des artistes italiens de la Renaissance, Rubens créa des portraits extrêmement représentatifs (dont ceux de nombreux seigneurs) mais aussi des tableaux très intimes, comme ceux de sa seconde épouse, Hélène Fourment. Van Dyck, également actif sur le marché international, devint en 1632 peintre du roi Charles Iᵉ d'Angleterre. Son style élégant et raffiné exerça une grande influence sur l'art anglais du portrait aux XVIIᵉ et XVIIIᵉ siècles.

Le *tronie* (mot néerlandais) est une forme de tableau proche du portrait. Il s'agissait, en partant de modèles humains, de créer des « têtes de caractère » ou certains types déterminés, souvent caricaturaux.

psychologischen Bildnissen in einer dunkleren Palette – darunter die heute berühmten späten Selbstporträts, die damals aber kaum geschätzt wurden.

Als herausragende Porträtmaler Flanderns sind Peter Paul Rubens und Anthonis van Dyck zu nennen. Rubens schuf, auf in der italienischen Renaissance entwickelten Bildnisformeln aufbauend, sowohl äußerst repräsentative Porträts (darunter zahlreiche Herrscherporträts) als auch höchst intime Bilder wie die seiner zweiten Frau Hélène Fourment. Der ebenfalls international tätige van Dyck wurde 1632 Hofmaler des englischen Königs Charles I. Sein raffinierter und eleganter Porträtstil übte großen Einfluss auf die englische Bildniskunst des 17. und 18. Jahrhunderts aus.

Eine dem Porträt ähnliche Bildform ist das Tronie. Hierfür standen zwar wirkliche Menschen Modell, doch handelt es sich um Charakterköpfe oder bestimmte Menschentypen, die häufig überzeichnet abgebildet wurden.

Peter Paul Rubens (1577–1640)

Ferdinand, Cardinal Infante of Spain,
Governor General of the Southern Netherlands

Ferdinand, cardinal-infant d'Espagne, à la bataille de Nördlingen

Ferdinand, Kardinalinfant von Spanien,
Generalgouverneur der Südlichen Niederlande

Fernando, Cardenal-Infante de España,
gobernador general de los Países Bajos del sur

Ritratto di Ferdinando, infante-cardinale di Spagna,
governatore generale dei Paesi Bassi meridionali

Ferdinand, Kardinaal-infant van Spanje,
landvoogd der Zuidelijke Nederlanden

1634/35, Oil on canvas/Huile sur toile, 337,5 × 261 cm, Museo del Prado, Madrid

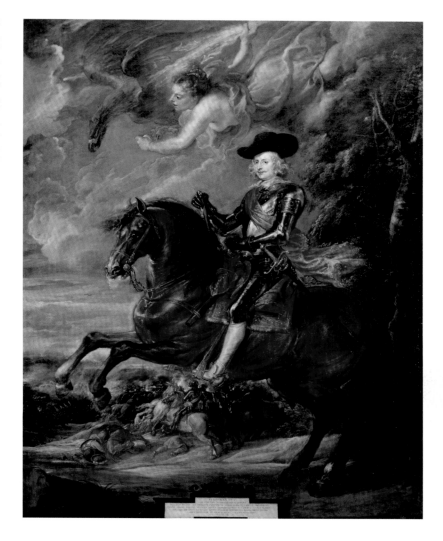

finales, los cuáles en ese momento apenas se apreciaban.

Se pueden mencionar como destacados retratistas de Flandes a Peter Paul Rubens y a Anthonis van Dyck. Rubens creaba, sobre la base desarrollada durante las fórmulas retratistas del Renacimiento italiano, tanto retratos altamente representativos (incluyendo numerosos retratos de gobernantes) como cuadros más íntimos como los de su segunda esposa Hélène Fourment. Van Dyck también desarrollaba encargos internacionales al convertirse en 1632 en pintor de la corte del rey Carlos I. Su estilo de retrato refinado y elegante ejerció gran influencia en el arte inglés del retrato de los siglos XVII y XVIII.

Una forma de tipo de pintura similar al retrato es el tronie ("rostro" en holandés). Por esto, si bien actúan personas reales como modelos, muestran características de fisonomía o tipos de personas especiales, que a menudo se representaban marcadamente.

momento furono fu poco apprezzata. Ne sono un esempio i famosi autoritratti della maturità.

Nelle Fiandre, tra i principali ritrattisti si possono citare Peter Paul Rubens e Anthonis van Dyck. A partire dal modello della ritrattistica italiana rinascimentale, Rubens creò sia ritratti altamente rappresentativi (tra cui numerosi ritratti di sovrani) sia quadri più intimi, come il ritratto della sua seconda moglie Hélène Fourment. Nel 1632 van Dyck, che al tempo era attivo a livello internazionale, fu nominato pittore di corte di Carlo I d'Inghilterra. Lo stile raffinato ed elegante dei suoi ritratti esercitò grande influenza sulla ritrattistica inglese del XVII e XVIII secolo.

Un genere simile al ritratto è il tronie, ovvero teste di carattere o tipologie umane particolari dipinte a partire da persone reali ma spesso raffigurate a forti tinte.

waaronder zijn nu beroemde late zelfportretten, die destijds echter nauwelijks werden gewaardeerd.

De belangrijkste portretschilders van Vlaanderen waren Peter Paul Rubens en Anthonis van Dyck. Rubens schiep portretcomposities die op de Italiaanse renaissance voortbouwden, maar ook representatieve portretten (waaronder veel vorstenportretten) en intieme uitbeeldingen van zijn tweede vrouw Hélène Fourment. De eveneens internationaal opererende Van Dyck werd in 1632 hofschilder van de Engelse koning Charles I. Zijn geraffineerde en elegante portretstijl zou een enorme invloed op de Engelse schilderkunst van de zeventiende en achttiende eeuw uitoefenen.

Een motief dat aan het portret verwant was, was het zogenaamde troniestuk, die naar reële modellen waren geschilderd maar als karikaturen of stereotypen waren bedoeld.

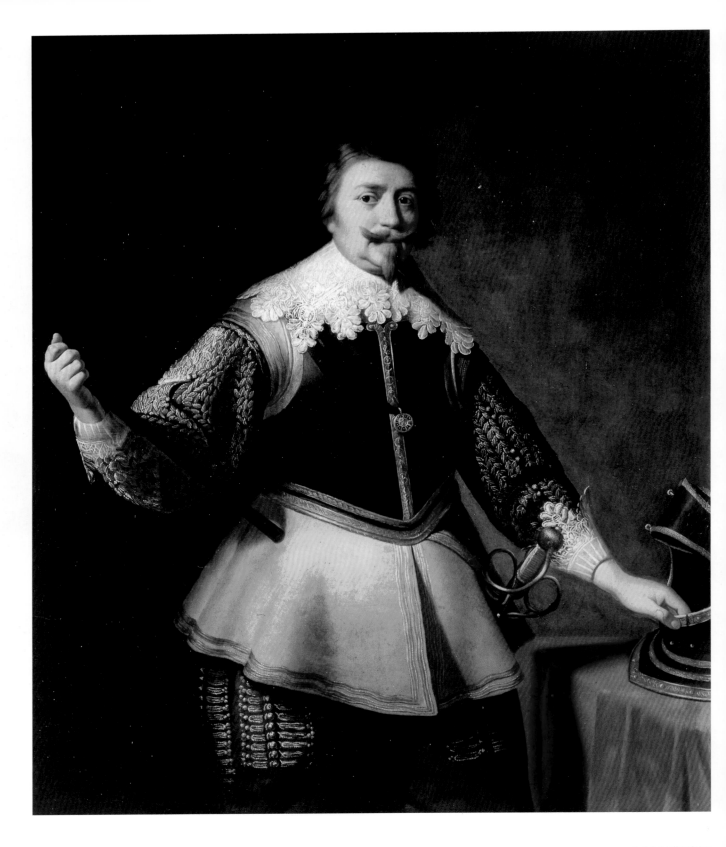

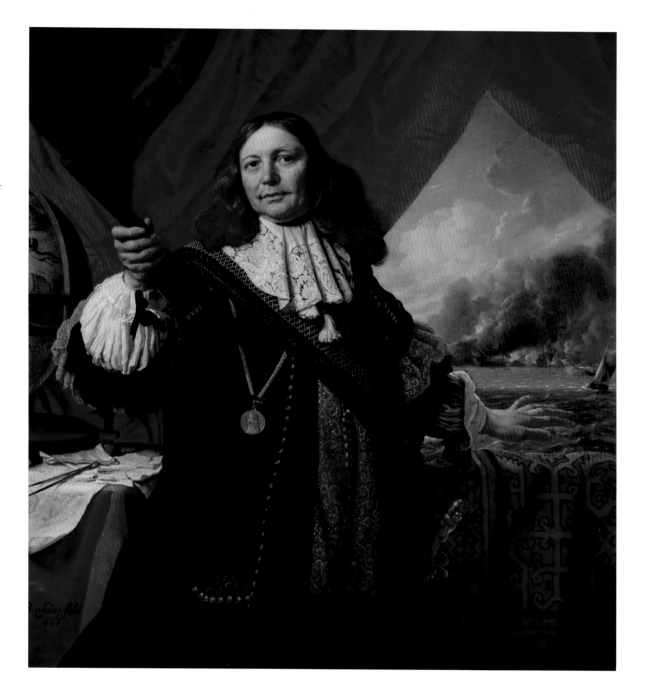

Attr. to/attr. à Michiel Jansz. van Mierevelt (1566–1641)

Frederick Henry, Prince of Orange, Stadtholder of the Dutch Republic

Frédéric-Henri de Nassau, prince d'Orange, stathouder des Provinces-Unies

Friedrich Heinrich von Oranien, Statthalter der Vereinigten Niederlande

Federico Enrique de Orange-Nassau, Estatúder de las Provincias Unidas

Federico Enrico d'Orange, Statolder delle Province Unite

Frederik Hendrik van Oranje, stadhouder der Verenigde Nederlanden

c. 1630, Oil on canvas/ Huile sur toile, 134 × 111 cm, Gallerie dell'Accademia, Venezia

Ludolf Backhuysen (1630–1708), Bartholomeus van der Helst (1613–70)

Vice Admiral Johan de Liefde

Le Vice-amiral Johan de Liefde

Vizeadmiral Johan de Liefde

Vicealmirante Johan de Liefde

Vice-Ammiraglio Johan de Liefde

Viceadmiraal Johan de Liefde

1668, Oil on canvas/Huile sur toile, 139 × 122 cm, Rijksmuseum, Amsterdam

Workshop/Atelier de Peter Paul Rubens (1577–1640)

Philip IV of Spain

Philippe IV, roi d'Espagne

Philipp IV. von Spanien

Felipe IV de España

Filippo IV di Spagna

Philipp IV van Spanje

Oil on canvas/Huile sur toile, 112 × 84 cm, Staatsgalerie, Neuburg an der Donau

Peter Paul Rubens was not only a painter, but also a diplomat on behalf of Isabella Clara Eugenia, who was committed to peace. In 1628, he was sent to Spain, where he worked for King Philip IV, a passionate collector of Flemish paintings. Rubens's journey to England in 1629 was similarly successful. Among other things it resulted in Rubens's ceiling paintings with the *Apotheosis of James I* for London's Banqueting House and in the signing of the Spanish-English peace treaty in 1630.

Rubens fut non seulement peintre, mais aussi diplomate au service d'Isabelle d'Autriche, soucieuse de la paix des provinces qu'elle administrait. Mandaté en 1628 en Espagne, il travailla aussi comme artiste pour Philippe IV, collectionneur passionné de peinture flamande. En 1629, la mission de Rubens en Angleterre fut doublement fructueuse : il peignit une partie des plafonds de la Maison des banquets de Londres avec l'*Apothéose de Jacques Ier*, et un traité de paix anglo-espagnol fut signé en 1630.

Peter Paul Rubens war nicht nur Maler, sondern für die um Frieden bemühte Isabella Clara Eugenia auch als Diplomat unterwegs. 1628 wurde er nach Spanien gesandt, wo er für König Philipp IV. – einen leidenschaftlichen Sammler flämischer Gemälde – zudem künstlerisch tätig war. Rubens' Englandreise 1629 war ähnlich erfolgreich: Aus ihr resultierten unter anderem die Deckengemälde mit der *Apotheose James' I.* im Londoner Banqueting House und 1630 die Unterzeichnung des spanisch-englischen Friedensvertrags.

Peter Paul Rubens no era solo un pintor, sino también un diplomático para Isabel Clara Eugenia, empeñada en la búsqueda de la paz. En 1628 fue enviado a España, donde trabajó para el rey Felipe IV – un apasionado coleccionista de pinturas flamencas – como artista en activo. El viaje de Rubens a Inglaterra en 1629 fue un éxito similar: entre otras obras completó los frescos del techo con *La apoteosis de Jaime I* en Banqueting House en Londres, y en 1630 la firma del tratado de paz español-inglés.

Peter Paul Rubens è stato non solo un pittore, ma anche un diplomatico al servizio di Isabella Clara Eugenia per l'ottenimento della pace. Nel 1628 fu inviato in Spagna, dove lavorò, anche come pittore, per il re Filippo IV, un appassionato collezionista di quadri fiamminghi. Il viaggio di Rubens in Inghilterra nel 1629 riscosse un successo simile: dopo tale viaggio, l'artista realizzò i dipinti sul soffitto della Banqueting House di Londra con la *Glorificazione di Giacomo I*, e nel 1630 fu firmato il trattato di pace anglo-spagnolo.

Peter Paul Rubens was niet alleen schilder, maar ook diplomaat voor landvoogdes Isabella van Spanje, die streefde naar vrede. In 1628 werd Rubens naar Spanje gezonden, waar hij voor koning Philips IV – een groot verzamelaar van Vlaamse kunst – ook als kunstenaar werkte. Ook Rubens' gezantschap naar Engeland in 1629 was succesvol: hij beschilderde er later het plafond van het Londense Banqueting House met de *apotheose van James I* en bereidde het Spaans-Engelse vredesverdrag van 1630 voor.

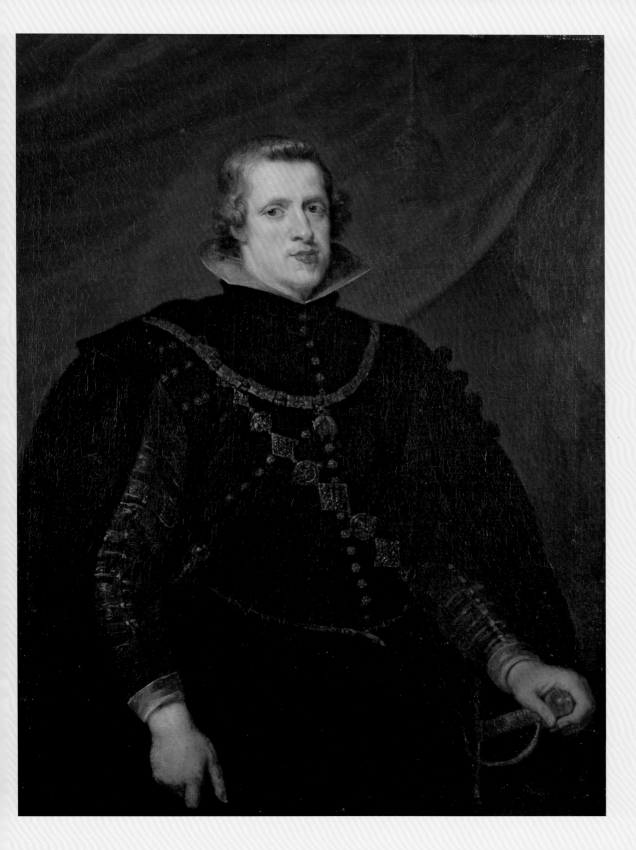

Rembrandt Harmensz. van Rijn (1606–69)

The Night Watch

La Ronde de nuit

Die Nachtwache

La ronda de noche

La ronda di notte

De Nachtwacht

1642, Oil on canvas/Huile sur toile, 379,5 × 453,5 cm, Rijksmuseum, Amsterdam

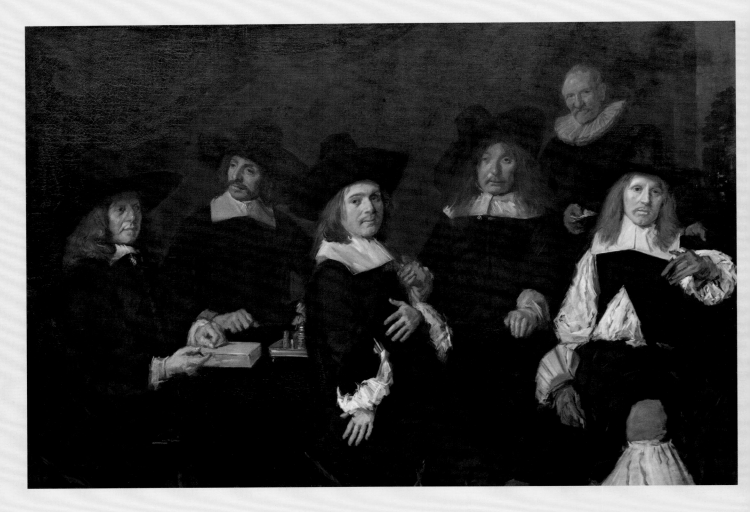

Frans Hals (c. 1580–1666)
The Regents of the Old Men's Alm House, Haarlem
Les Régents de l'hospice des vieillards
Die Regenten des Altmännerhauses in Haarlem
Los regentes del asilo de Haarlem
I reggenti della Oudemannenhuis di Haarlem
De regenten van het Oudemannenhuis te Haarlem
c. 1664, Oil on canvas/Huile sur toile, 172,3 × 256 cm, Frans Hals Museum, Haarlem

The Dutch Republic saw a number of group portraits during this time. While earlier examples often show rather cheerful militia groups, these two paintings are evidence of a different type of social engagement. The city of Haarlem had lost almost a third of its inhabitants to the plague in 1664. Many people were forced to rely on charitable institutions such as the Old Men's Alms House, whose regents sat for two group portraits by local painter Frans Hals.

Nous avons de nombreux portraits de groupe, surtout en provenance des Pays-Bas septentrionaux. Les premiers montrent souvent de joyeuses milices municipales, mais ces deux tableaux attestent un autre type d'engagement de la bourgeoisie. En 1664, une épidémie de peste tua presque un tiers de la population de Haarlem. Il fallut recueillir nombre de démunis dans des institutions de bienfaisance comme l'hospice dont Frans Hals a portraituré ici les régents et les régentes.

Vor allem aus den Nördlichen Niederlanden haben sich zahlreiche Gruppenporträts erhalten. Zeigen frühere Beispiele häufig fröhliche Schützengilden, sind diese beiden Gemälde Zeugnisse eines anders gearteten bürgerschaftlichen Engagements: Die Stadt Haarlem verlor 1664 durch eine Pestepidemie fast ein Drittel ihrer Einwohner. Viele Menschen mussten in gemeinnützigen Einrichtungen wie dem Altmännerhaus versorgt werden, dessen Regenten und Regentinnen Frans Hals porträtierte.

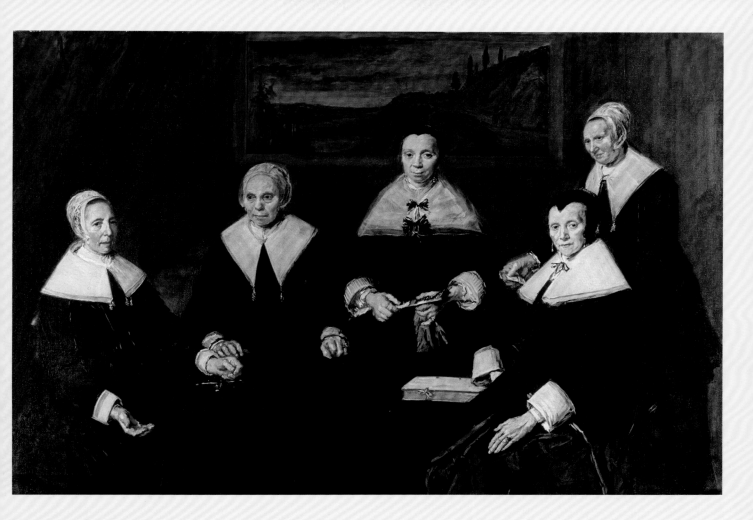

Frans Hals (c. 1580–1666)

The Regents of the Old Men's Alm House, Haarlem

Les Régentes de l'hospice des vieillards

Die Regentinnen des Altmännerhauses in Haarlem

Las regentes del asilo de Haarlem

Le reggenti della Oudemannenhuis di Haarlem

De regentessen van het Oudemannenhuis te Haarlem

c. 1664, Oil on canvas/Huile sur toile, 170,5 × 249,5 cm, Frans Hals Museum, Haarlem

Especialmente en los Países Bajos del norte se han conservado numerosos retratos de grupo. Si antes mostrábamos ejemplos de alegres personajes, estas dos pinturas son evidencia de un tipo diferente de compromiso ciudadano: la ciudad de Haarlem perdió en 1664 casi a un tercio de sus habitantes por una epidemia de peste. Muchas personas tuvieron que ocuparse de instituciones sin ánimo de lucro tales como el asilo, del cual retrata Frans Hals a los regentes.

Soprattutto nei Paesi Bassi settentrionali vennero prodotti numerosi ritratti di gruppo. Esempi precedenti avevano spesso come soggetto milizie allegre, mentre questi due dipinti sono una testimonianza di un diverso tipo di impegno civico: nel 1664 la città di Haarlem perse quasi un terzo dei suoi abitanti a causa di un'epidemia di peste, e molte persone dovettero essere assistite in istituti di carità, come la Oudemannenhuis, i cui reggenti sono qui ritratti da Frans Hals.

Vooral uit de Noordelijke Nederlanden zijn veel groepsportretten bewaard gebleven. Terwijl vroege werken in dit genre vaak vrolijke schuttersgilden toonden, getuigden latere schilderijen van een andere houding onder de burgerij. Door een pestepidemie verloor de stad Haarlem in 1664 bijna een derde van haar inwoners. Veel mensen moesten in inrichtingen als het Oudemannenhuis worden verzorgd, waarvan de regenten en regentessen door Frans Hals werden geportretteerd.

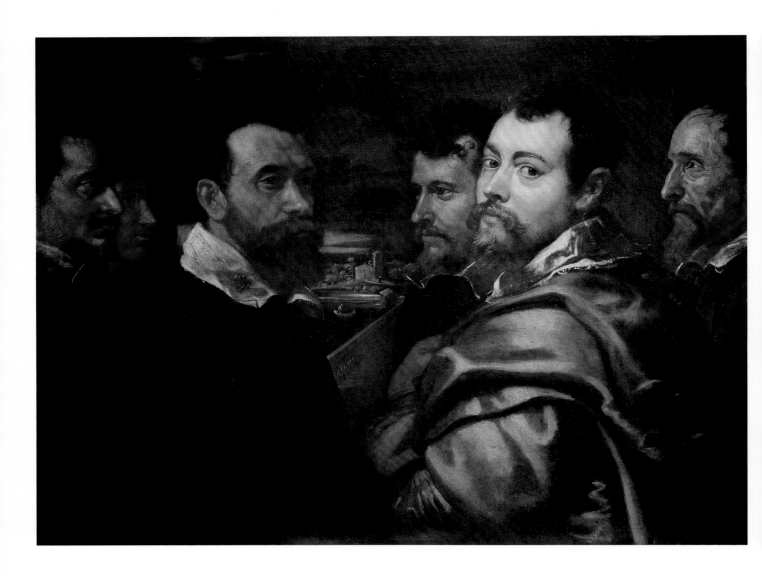

Peter Paul Rubens (1577–1640)

Self-Portrait Surrounded by Friends from Mantua

Autoportrait au milieu d'un cercle d'amis de Mantoue

Selbstbildnis im Kreis der Mantuaner Freunde

Autorretrato en un círculo de amigos de Mantua

Autoritratto con amici a Mantova

Zelfportret in gezelschap van vrienden uit Mantua

c. 1602–05, Oil on canvas/Huile sur toile, 77,5 × 101 cm,
Wallraf-Richartz-Museum & Fondation Corboud, Köln

Peter Paul Rubens (1577–1640)

Rubens and Isabella Brant in the Honeysuckle Bower

Sous la tonnelle de chèvrefeuille

Rubens und Isabella Brant in der Geißblattlaube

Autorretrato con su esposa Isabel Brant

Autoritratto con la moglie Isabella Brant

Rubens met zijn eerste echtgenote Isabella Brant

c. 1609/10, Oil on canvas, transferred to wood/Huile sur toile, reportée sur bois,
178 × 136,5 cm, Alte Pinakothek, München

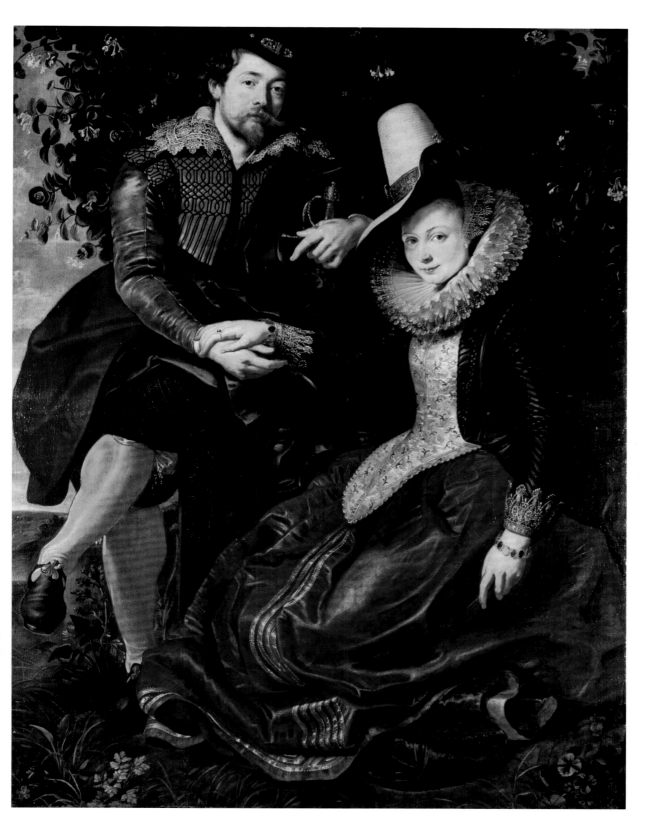

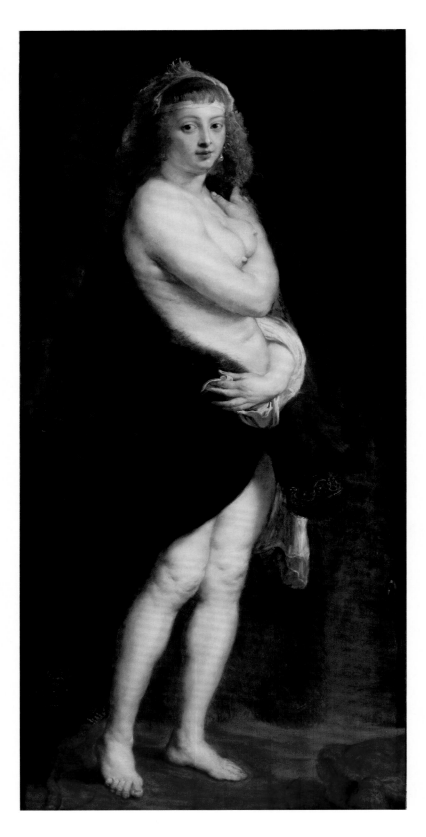

Peter Paul Rubens (1577–1640)

Hélène Fourment (The Fur)

Hélène Fourment *ou* Vénus en manteau de fourrure

Hélène Fourment (Das Pelzchen)

Hélène Fourment (La piel)

Ritratto di Hélène Fourment (La pelliccia)

Hélène Fourment (Het pelsken)

c. 1636–38, Oil on wood/Huile sur bois, 178,7 × 86,2 cm, Kunsthistorisches Museum, Wien

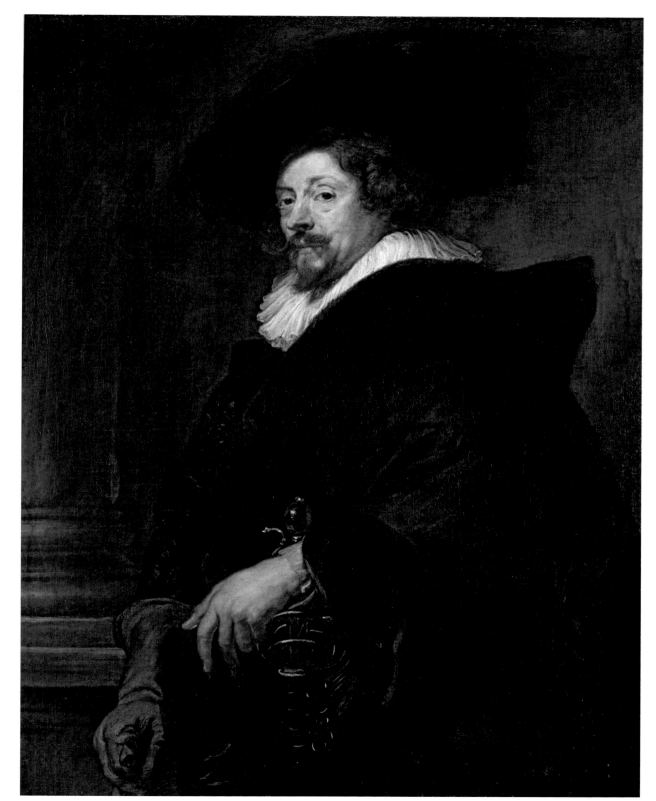

**Peter Paul Rubens
(1577–1640)**
Self-Portrait
Autoportrait
Selbstbildnis
Autorretrato
Autoritratto
Zelfportret
c. 1638, Oil on
canvas/Huile sur
toile, 110 × 85,5 cm,
Kunsthistorisches
Museum, Wien

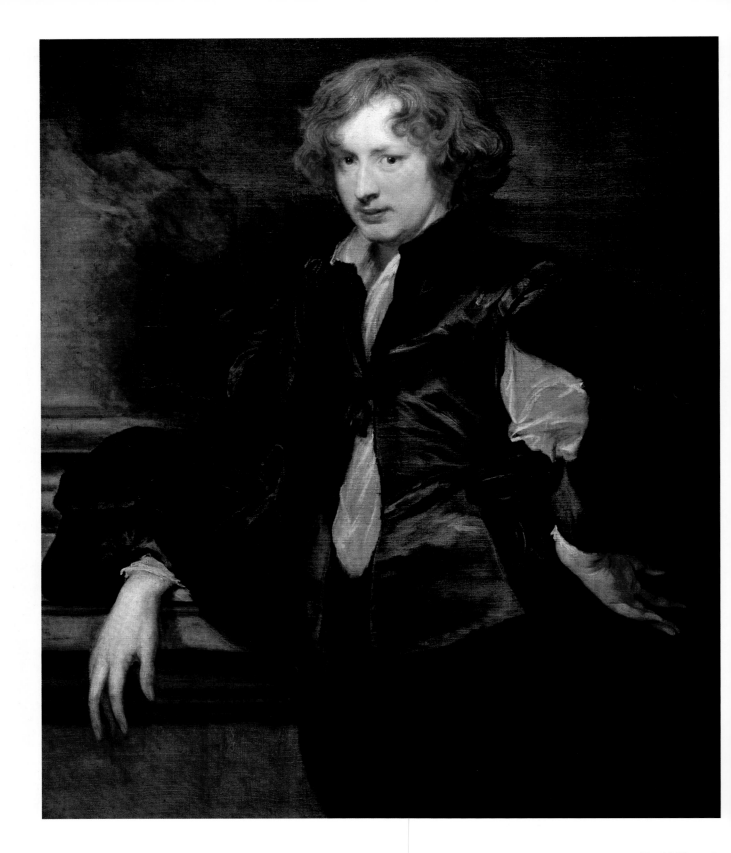

**Anthonis van Dyck
(1599–1641)**

Self-Portrait

Autoportrait

Selbstbildnis

Autorretrato

Autoritratto

Zelfportret

c. 1622/23, Oil on
canvas/Huile sur toile,
116,5 × 93,5 cm, State
Hermitage Museum,
St. Petersburg

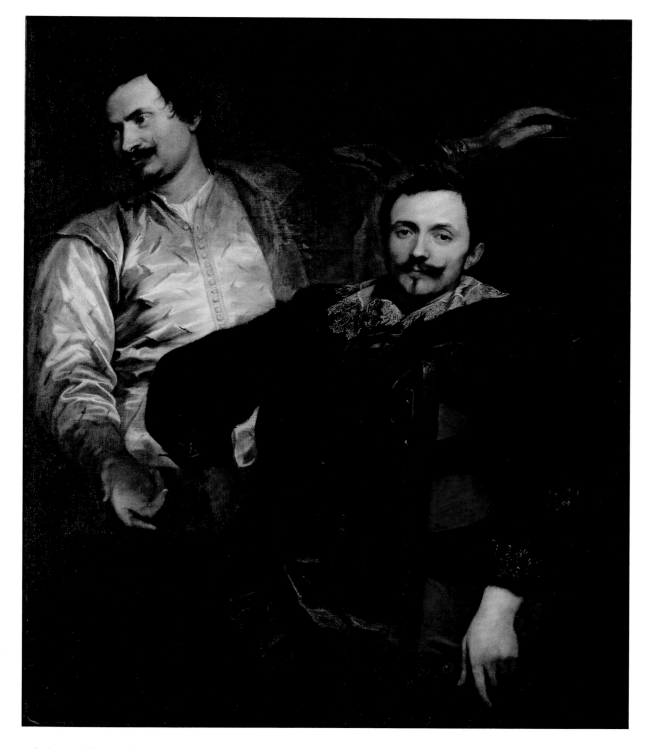

Anthonis van Dyck (1599–1641)

Lucas and Cornelis de Wael Lucas und Cornelis de Wael Ritratto dei pittori Lucas e Cornelius de Wael

Les Frères Lucas et Cornelis de Wael Lucas y Cornelis de Wael Lucas en Cornelis de Wael

c. 1627, Oil on canvas/Huile sur toile, 120 × 101 cm, Pinacoteca Capitolina, Roma

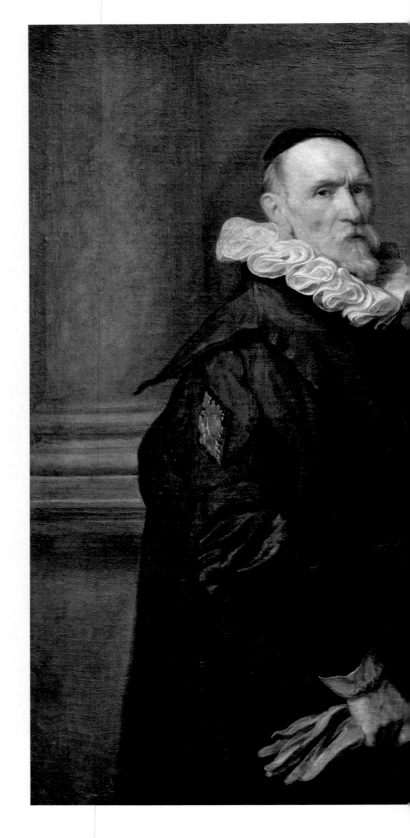

Flemish/Flamande

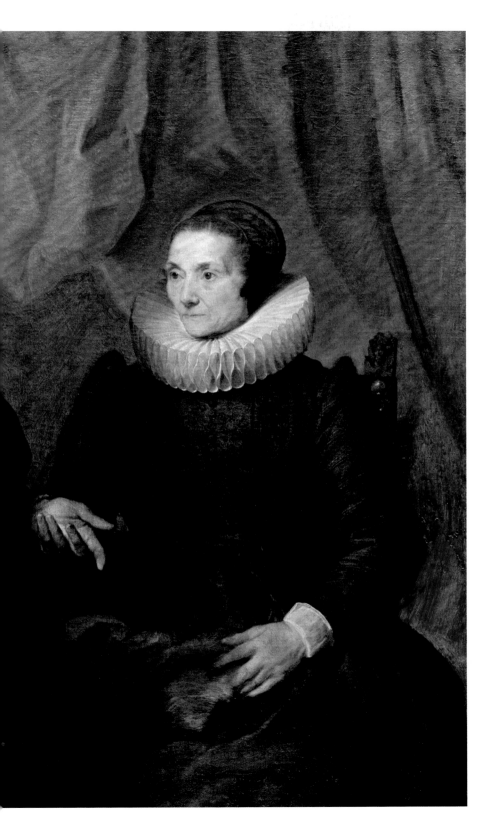

Anthonis van Dyck (1599–1641)

Jan de Wael and His Wife Gertrude de Jode

Le Peintre Jan de Wael et son épouse Gertrude de Jode

Jan de Wael und seine Frau Gertrude de Jode

Jan de Wael y su esposa Gertrude de Jode

Ritratto del pittore Jean de Wael e della moglie Gertrude de Jode

Jan de Wael en zijn vrouw Gertrude de Jode

c. 1629, Oil on canvas/Huile sur toile,
125,3 × 139,7 cm, Alte Pinakothek, München

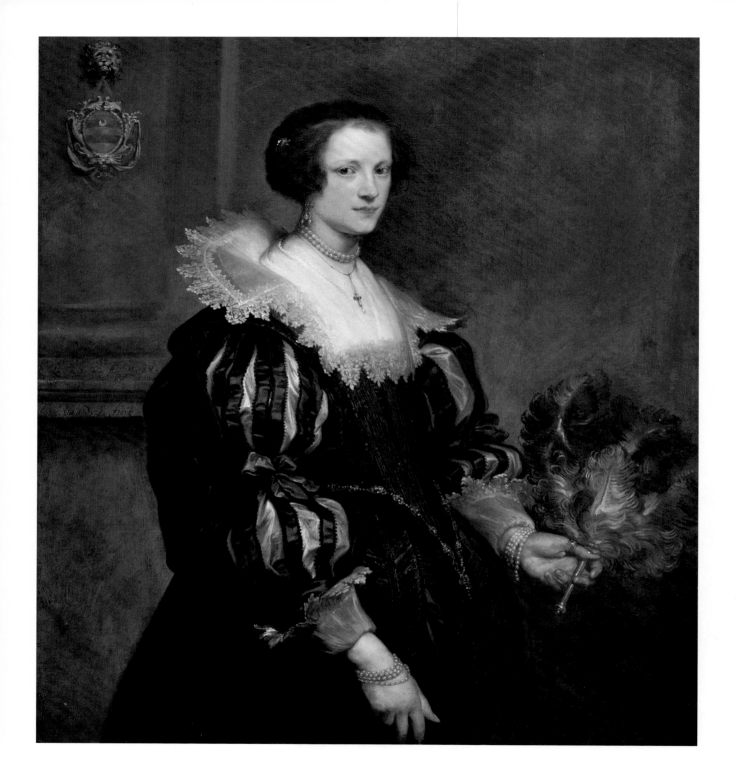

Anthonis van Dyck (1599–1641)

Anna Wake

1628, Oil on canvas/Huile sur toile, 112,5 × 99,4 cm, Mauritshuis, Den Haag

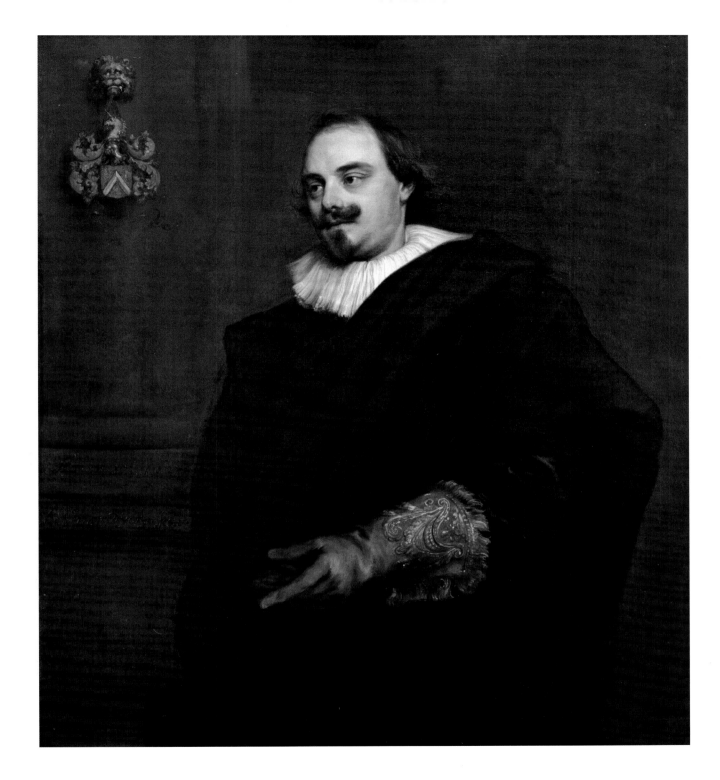

Anthonis van Dyck (1599–1641)

Peeter Stevens

1627, Oil on canvas/Huile sur toile, 112,5 × 99,3 cm, Mauritshuis, Den Haag

Anthonis van Dyck (1599–1641)

Charles I from Three Angles

Triple portrait de Charles Iᵉʳ

Charles I. in drei Ansichten

Carlos I en tres posiciones

Triplo ritratto di Carlo I

Charles I vanuit drie gezichtspunten

1635, Oil on canvas/Huile sur toile, 84,5 × 99,7 cm, Windsor Castle, Windsor

Anthonis van Dyck (1599–1641)

Karl Ludwig, the Prince Palatine, and His Brother Ruprecht

Portrait des princes palatins Charles-Louis Iᵉʳ et son frère Robert

Karl Ludwig von der Pfalz und sein Bruder Ruprecht

Carlos Luis del Palatinado y su hermano Ruperto

Carlo Ludovico e Rupert, principi palatini

Karl Ludwig von der Pfalz en zijn broer Ruprecht

1637, Oil on canvas/Huile sur toile, 132 × 152 cm, Musée du Louvre, Paris

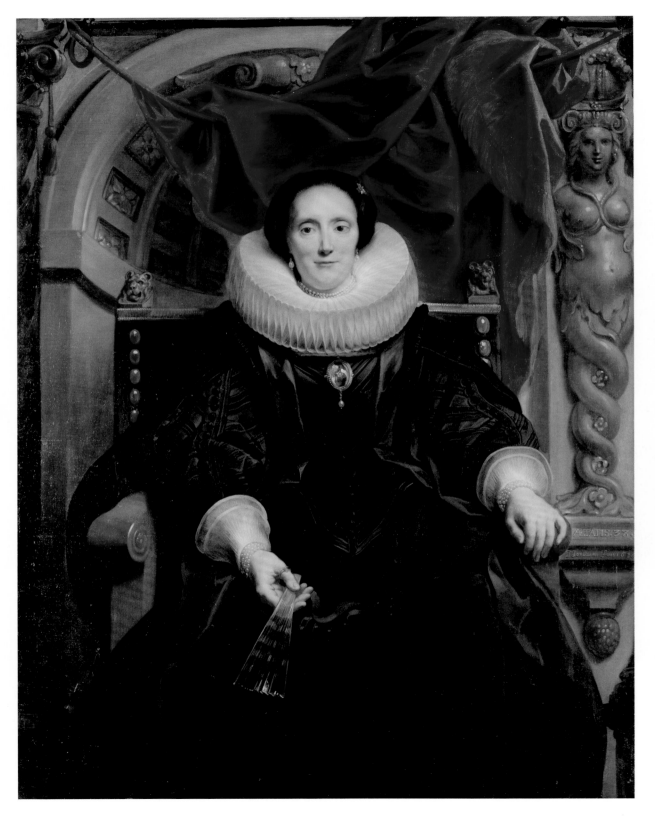

**Jacob Jordaens
(1593–1678)**

Catharina
Behaghel

1635, Oil on canvas/
Huile sur toile,
152 × 116 cm,
Rijksmuseum,
Amsterdam

Flemish/Flamande

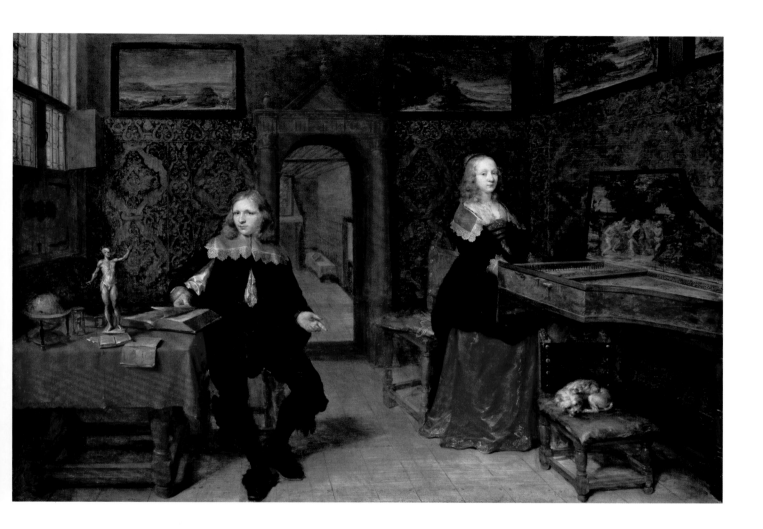

Gonzales Coques (1618–84)

The Young Scholar and His Wife

Le Jeune Savant et son épouse

Der junge Gelehrte und seine Frau

El joven estudiante y su esposa

Il giovane studioso e sua moglie

De jonge geleerde en zijn vrouw

1640, Oil on wood/Huile sur bois, 41 × 59,5 cm, Gemäldegalerie Alte Meister, Kassel

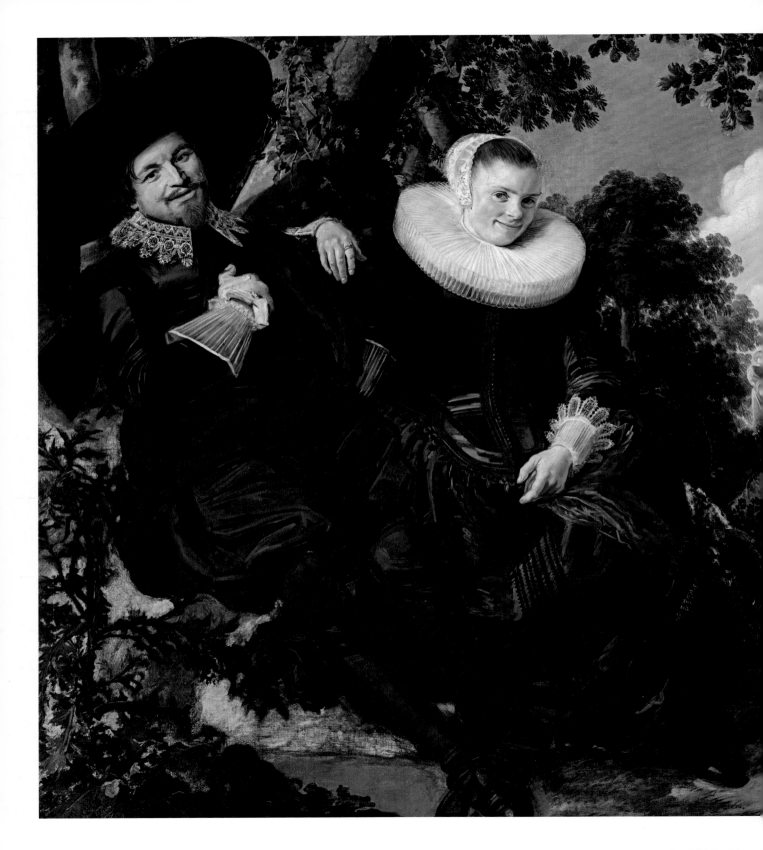

Frans Hals (c. 1580–1666)

Wedding Portrait of Isaac Massa and Beatrix van der Laen

Portrait de mariage d'Isaac Massa et Beatrix Van der Laen

Hochzeitsporträt Isaac Massa und Beatrix van der Laen

Retrato de boda de Isaac Massa y Beatriz van del Laen

Ritratto di nozze di Isaac Massa e Beatrix van der Laen

Huwelijksportret van Isaac Massa en Beatrix van der Laen

c. 1622, Oil on canvas/Huile sur toile, 140 × 166,5 cm, Rijksmuseum, Amsterdam

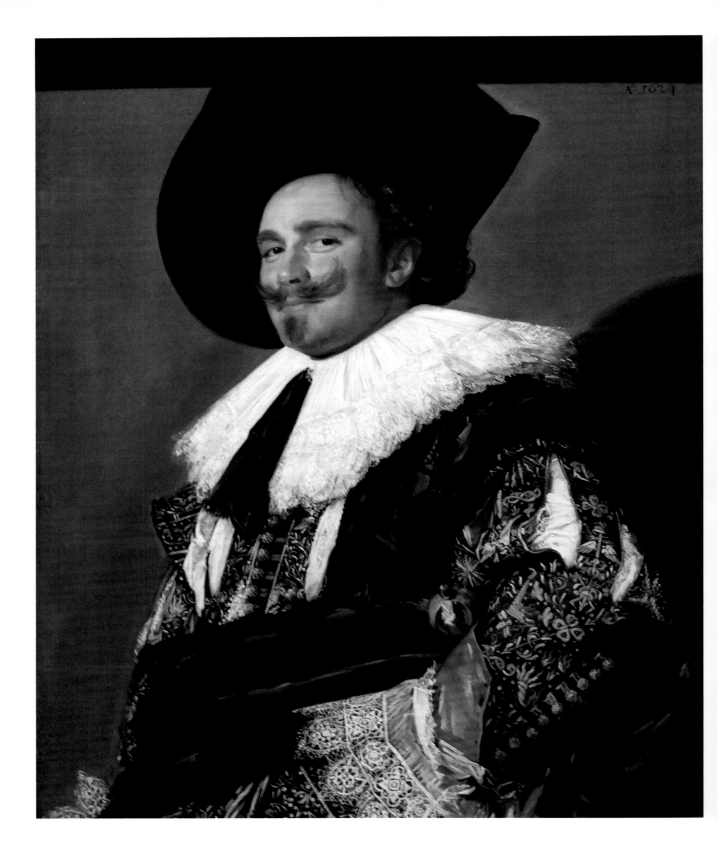

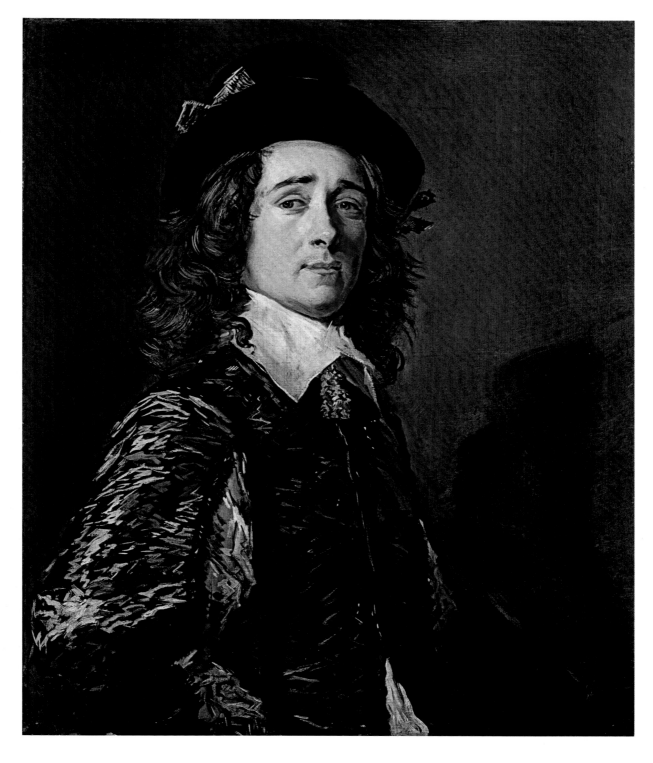

Frans Hals (c. 1580–1666)

Jasper Schade

c. 1645, Oil on canvas/Huile sur toile, 80 × 67,5 cm, Národní galerie, Praha

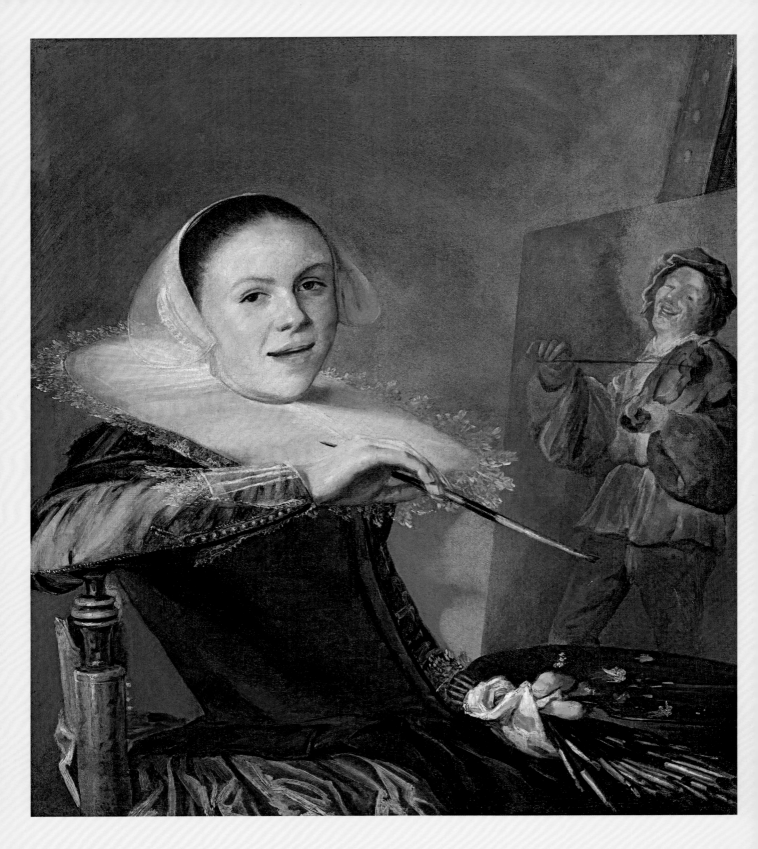

Among the women painters of the 17th century was Judith Leyster. She had had an artistic education, ran her own studio and had students, and was a member of the Guild of Saint Luke in Haarlem together with her fellow painters. In her *Self-portrait,* she self-confidently presents herself at the easel.

Judith Leyster fut une des peintres hollandaises actives au XVIIᵉ siècle. Après sa formation artistique, elle eut un atelier et des élèves et fut comme ses collègues hommes membre de la guilde de Saint-Luc à Haarlem. Dans son *Autoportrait,* elle s'est fièrement représentée devant un chevalet.

Zu den im 17. Jahrhundert aktiven Malerinnen gehörte Judith Leyster. Sie erhielt eine künstlerische Ausbildung, hatte ein eigenes Atelier und Schüler und war wie ihre Malerkollegen Mitglied der Lukasgilde in Haarlem. In ihrem *Selbstbildnis* stellte sie sich selbstbewusst an der Staffelei dar.

Judith Leyster pertenecía al grupo de pintoras en activo del siglo XVII. Recibió formación artística, tenía su propio estudio con estudiantes y, al igual que sus colegas pintores, era miembro de la Cofradía de San Lucas de Haarlem. En su *Autorretrato* se representa en el caballete de manera confiada.

Tra i pittori attivi nel XVII secolo si annovera Judith Leyster, che ricevette una formazione artistica, aprì un suo studio con apprendisti propri, e, come i suoi colleghi pittori, fu membro della Gilda di San Luca di Haarlem. Nel suo *Autoritratto* appare seduta al cavalletto, sicura di sé.

Tot de vrouwelijke schilders die in de zeventiende eeuw actief waren, behoorde ook Judith Leyster. Zij volgde een kunstopleiding, had haar eigen atelier en was lid van het schildersgilde van Sint-Lucas in Haarlem. In haar *Zelfportret* presenteert zij zich zelfbewust bij haar schildersezel.

Judith Leyster (1609–60)

Self-Portrait

Autoportrait

Selbstbildnis

Autorretrato

Autoritratto

Zelfportret

c. 1630, Oil on canvas/Huile sur toile, 74,6 × 65,1 cm, National Gallery of Art, Washington

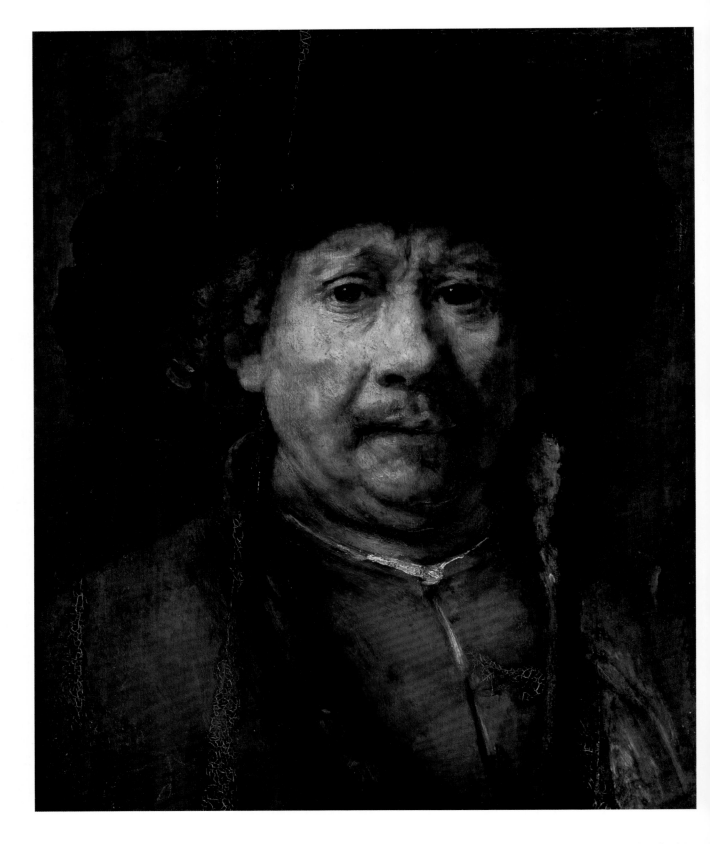

Rembrandt Harmensz. van Rijn (1606–69)

Small Self-Portrait

Petit autoportrait

Kleines Selbstbildnis

Pequeño autorretrato

Piccolo autoritratto

Klein zelfportret

c. 1657, Oil on wood/Huile sur bois, 48 × 40,6 cm, Kunsthistorisches Museum, Wien

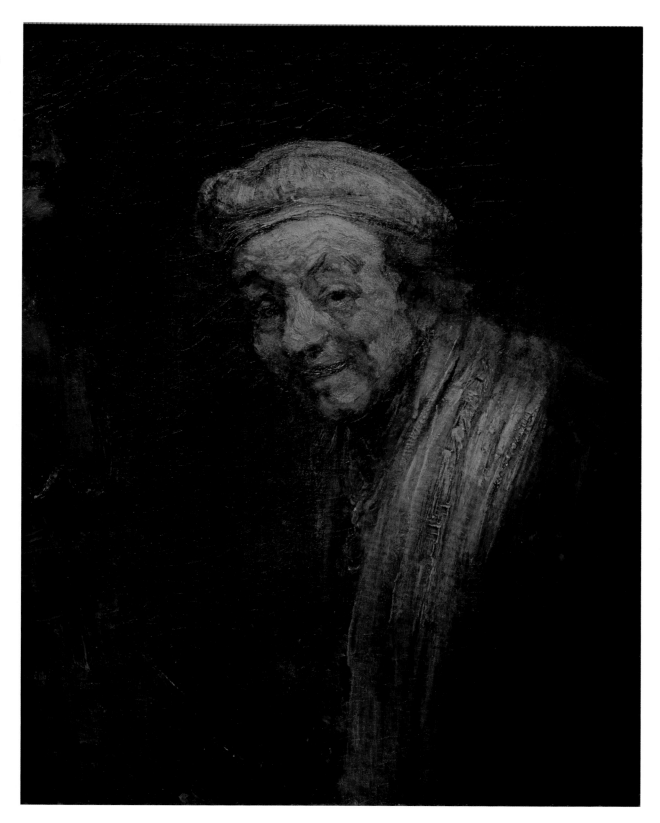

Rembrandt Harmensz. van Rijn (1606–69)

Self-Portrait

Autoportrait en Zeuxis

Selbstbildnis

Autorretrato

Autoritratto

Zelfportret

c. 1668, Oil on canvas/Huile sur toile, 82,5 × 65 cm, Wallraf-Richartz-Museum & Fondation Corboud, Köln

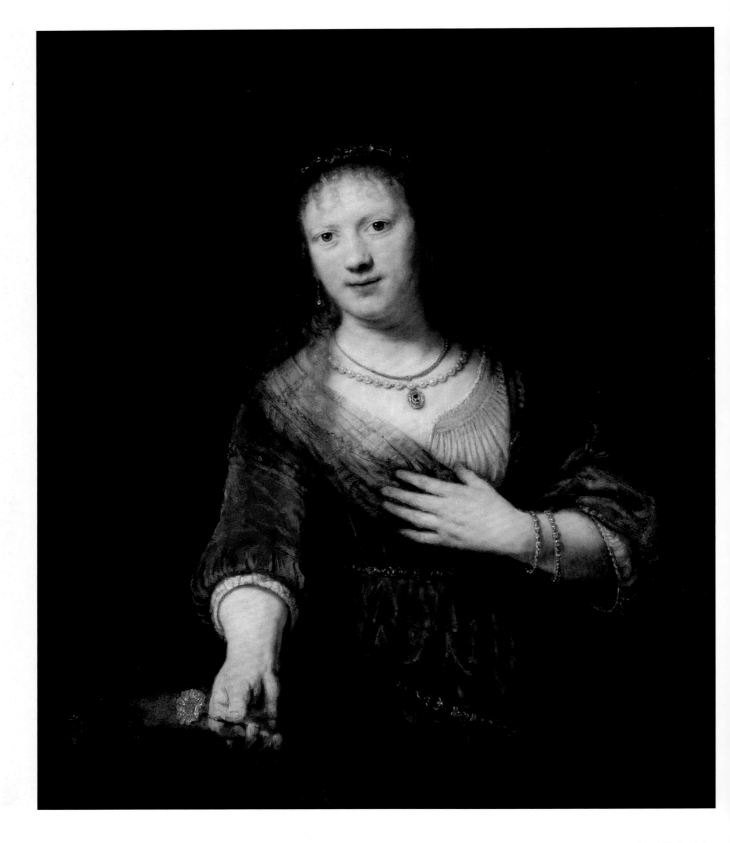

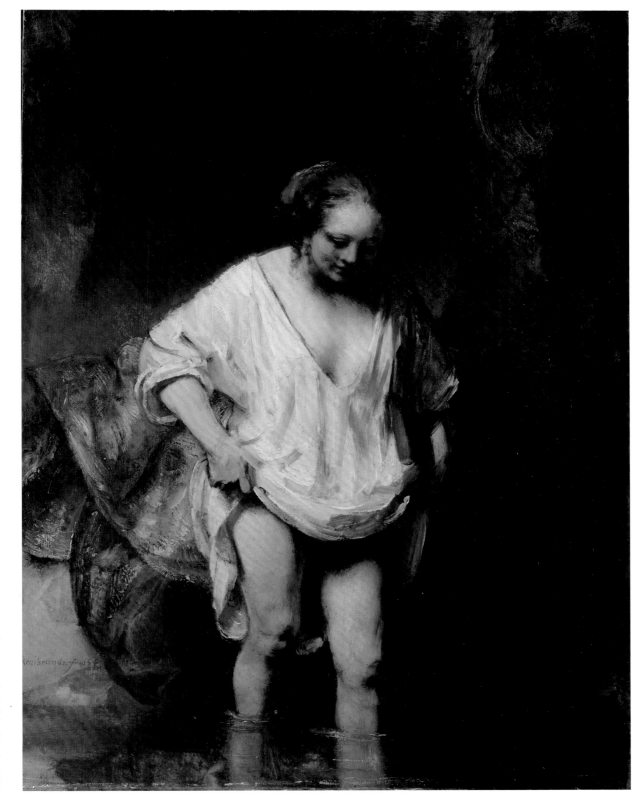

**Rembrandt
Harmensz. van Rijn
(1606–69)**

Saskia with a
Red Flower

Saskia avec une
fleur rouge

Saskia mit
roter Blume

Saskia con una
flor roja

Saskia con un
fiore rosso

Saskia met een
rode bloem

1641, Oil on wood/
Huile sur bois,
98,5 × 82,6 cm,
Gemäldegalerie Alte
Meister, Dresden

**Rembrandt
Harmensz. van Rijn
(1606–69)**

Girl Bathing
(Hendrickje Stoffels)

Femme se baignant
dans un ruisseau

Badendes Mädchen
(Hendrickje Stoffels)

Mujer bañándose

Giovane donna al
bagno in un ruscello
(Hendrickje Stoffels)

Badende vrouw
(Hendrickje Stoffels)

1654, Oil on canvas/
Huile sur bois,
61,8 × 47 cm, National
Gallery, London

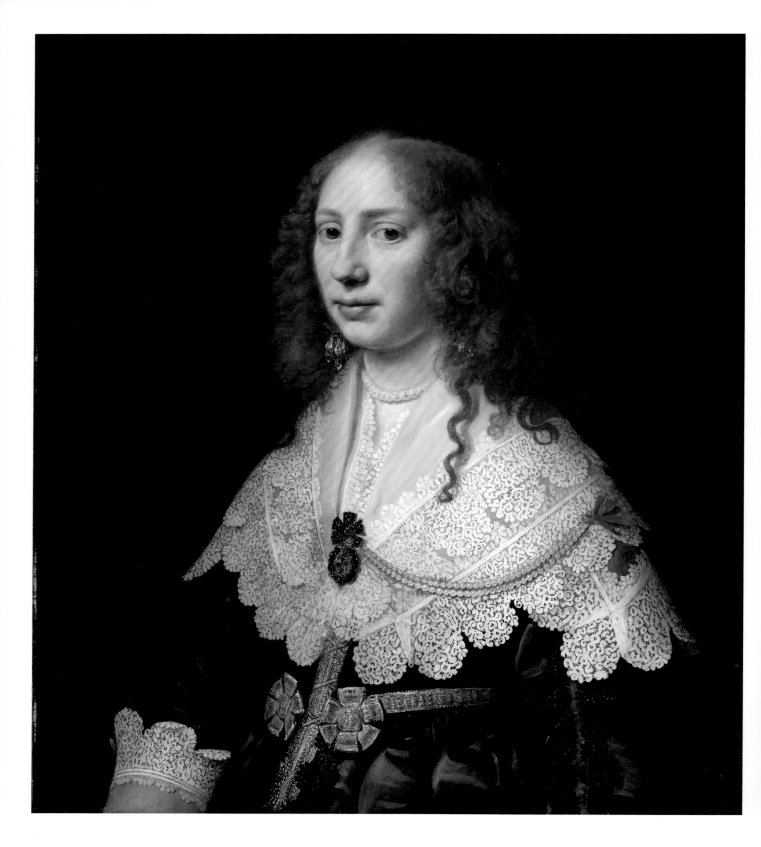

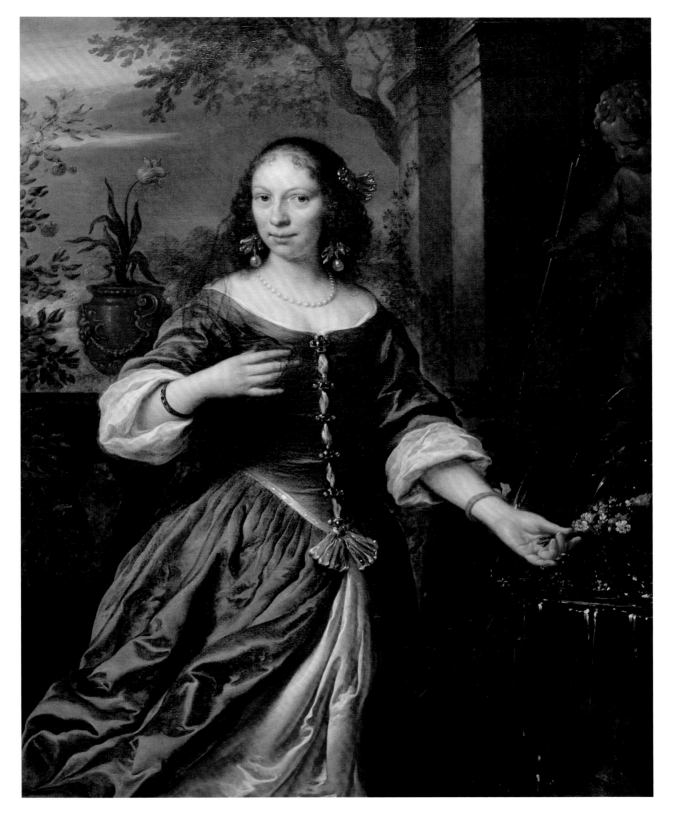

Michiel Jansz. van Mierevelt (1566–1641)

Aegje Hasselaer

1640, Oil on wood/Huile sur bois, 69,7 × 60 cm, Rijksmuseum, Amsterdam

Govert Flinck (1615–60)

Suzanna van Baerle

1655, Oil on canvas/Huile sur toile, 138 × 103,5 cm, Gemäldegalerie Alte Meister, Kassel

Rembrandt Harmensz. van Rijn (1606–69)
The Mennonite Preacher Anslo and His Wife
Le Prédicateur mennonite Anslo et son épouse
Der Mennonitenprediger Anslo und seine Frau
El predicador menonita Anslo y su esposa
Ritratto di Cornelis Claeszoon Anslo e di sua moglie Aaltje Schouten
Cornelis Claesz Anslo in gesprek met zijn vrouw Aaltje
1641, Oil on canvas/Huile sur toile, 176,5 × 209 cm, Gemäldegalerie, Berlin

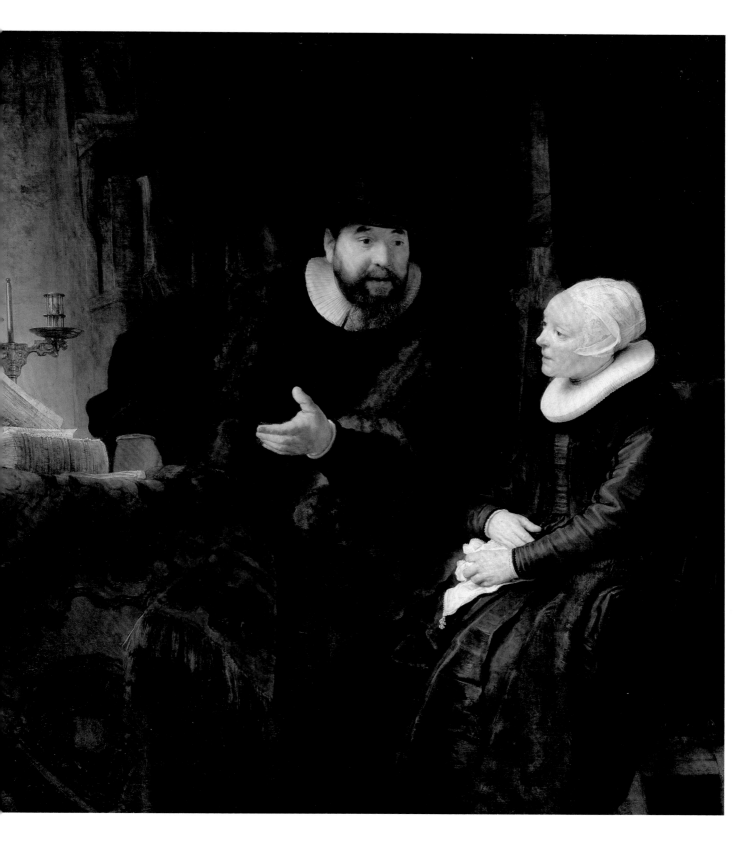

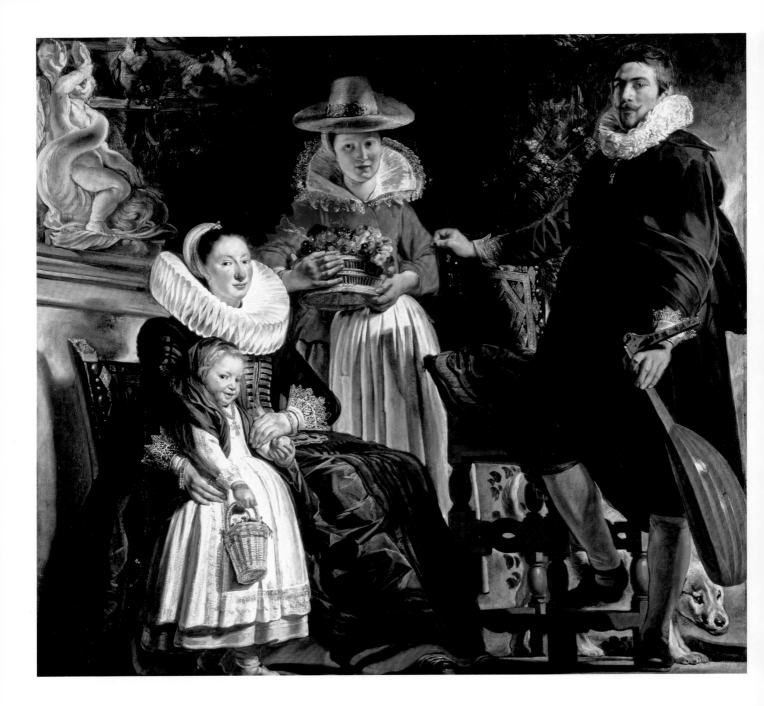

Jacob Jordaens (1593–1678)

The Painter's Family

La Famille du peintre dans le jardin

Die Familie des Malers

La familia del pintor

La famiglia del pittore

De gezin van de schilder

1621/22, Oil on canvas/Huile sur toile, 181 × 187 cm, Museo del Prado, Madrid

Anthonis van Dyck (1599–1641)

Portrait of a Family

Portrait de famille

Bildnis einer Familie

Retrato de una familia

Ritratto di famiglia

Portret van een gezin

1621, Oil on canvas/Huile sur toile, 113,5 × 93,5 cm, State Hermitage Museum, St. Petersburg

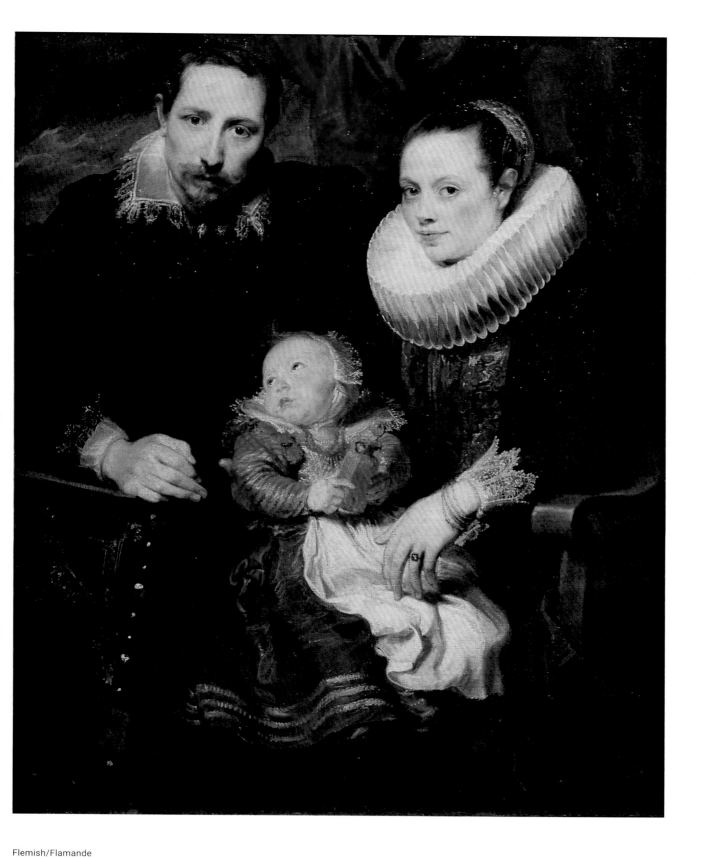

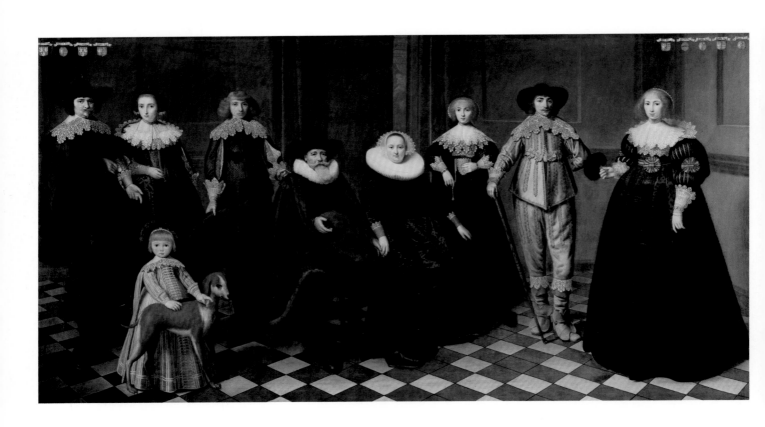

Dirck Dircksz. van Santvoort (1610–80)

The Family of Dirck Bas Jacobsz, Mayor of Amsterdam

Portrait de la famille de Dirck Bas Jacobsz, bourgmestre d'Amsterdam

Die Familie des Amsterdamer Bürgermeisters Dirck Bas Jacobsz

La familia del burgomaestre de Ámsterdam Dirck Bas Jacobsz

La famiglia del sindaco di Amsterdam Dirck Bas Jacobsz

De familie van de Amsterdamse burgemeester Dirck Bas Jacobsz

1634/35, Oil on canvas/Huile sur toile, 136 × 251 cm, Rijksmuseum, Amsterdam

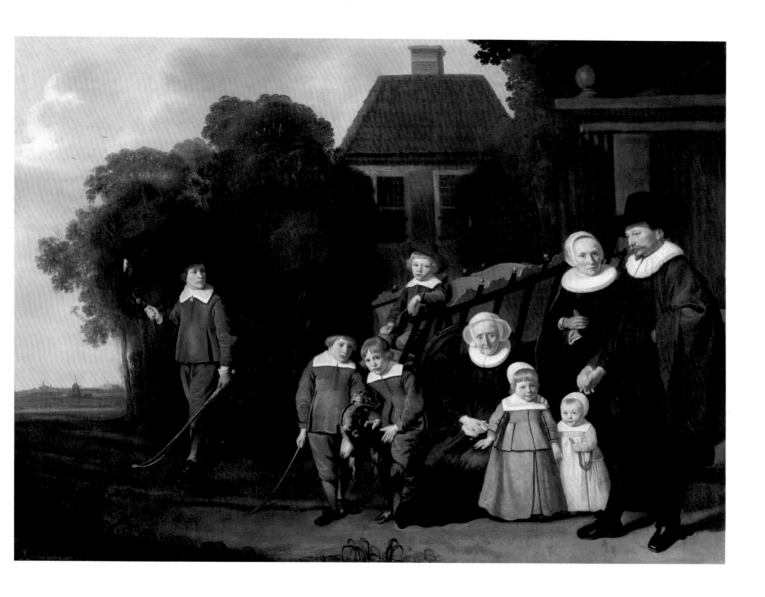

Jacob van Loo (1614–70)

The Meebeeck Cruywagen Family on their Estate near Amsterdam

La Famille Meebeeck Cruywagen devant leur maison de campagne, près d'Amsterdam

Die Familie Meebeeck Cruywagen auf ihrem Landsitz bei Amsterdam

La familia Meebeeck Cruywagen en su finca cerca de Ámsterdam

La famiglia Meebeeck Cruywagen nella sua tenuta vicino ad Amsterdam

De familie Meebeeck Cruywagen op haar landgoed bij Amsterdam

1640–45, Oil on canvas/Huile sur toile, 100 × 133,5 cm, Rijksmuseum, Amsterdam

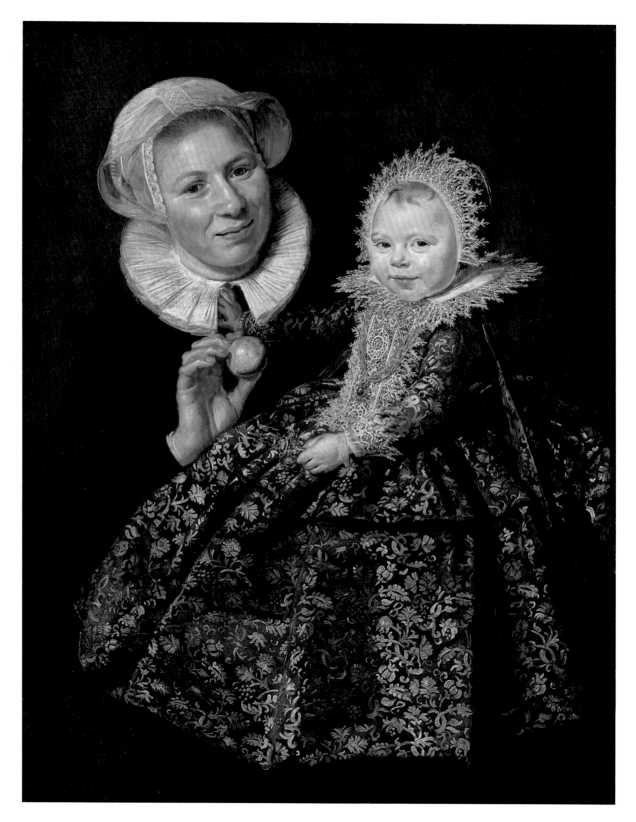

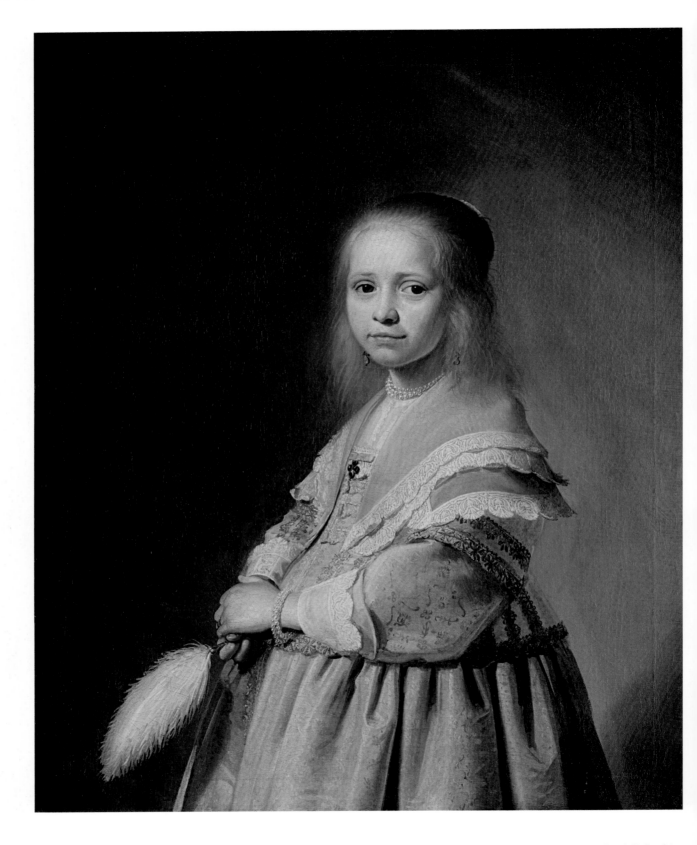

Johannes Cornelisz.
Versbronck
(1597–1662)

Girl in Blue

Portrait d'une
jeune fille en bleu

Mädchen in Blau

Muchacha en azul

Fanciulla in azzurro

Meisje in het blauw

1641, Oil on canvas/
Huile sur toile,
82 × 66,5 cm,
Rijksmuseum,
Amsterdam

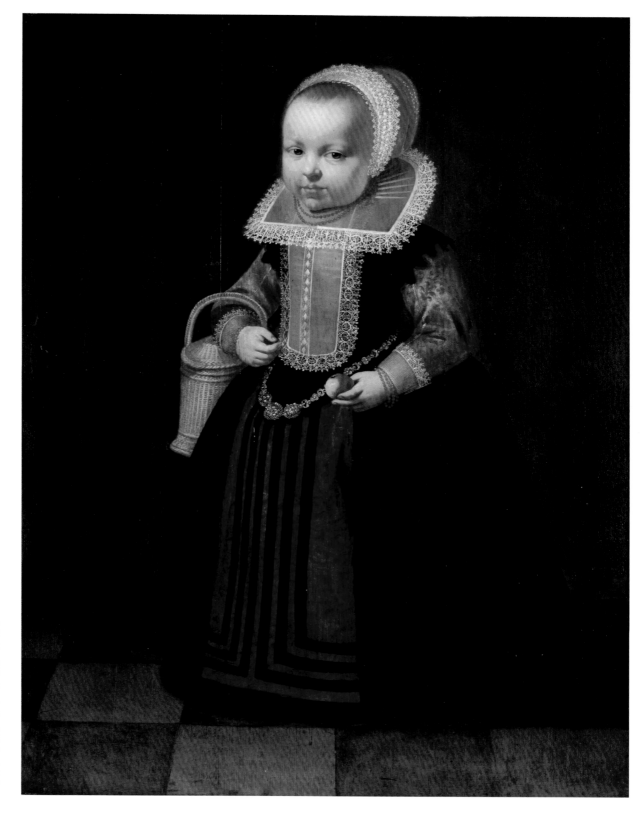

Cornelis de Vos
(c. 1584–1651)

Portrait of a Girl

Portrait d'une
petite fille

Mädchenbildnis

Retrato de niña

Ritratto di fanciulla

Portret van
staand meisje

1640, Oil on wood/
Huile sur bois,
106 × 82 cm, Museo
Nacional de Bellas
Artes, La Habana

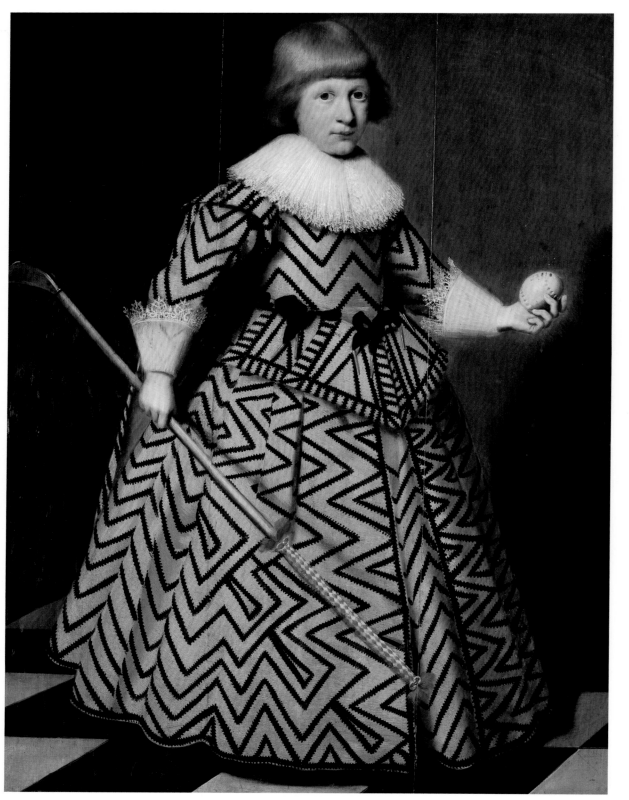

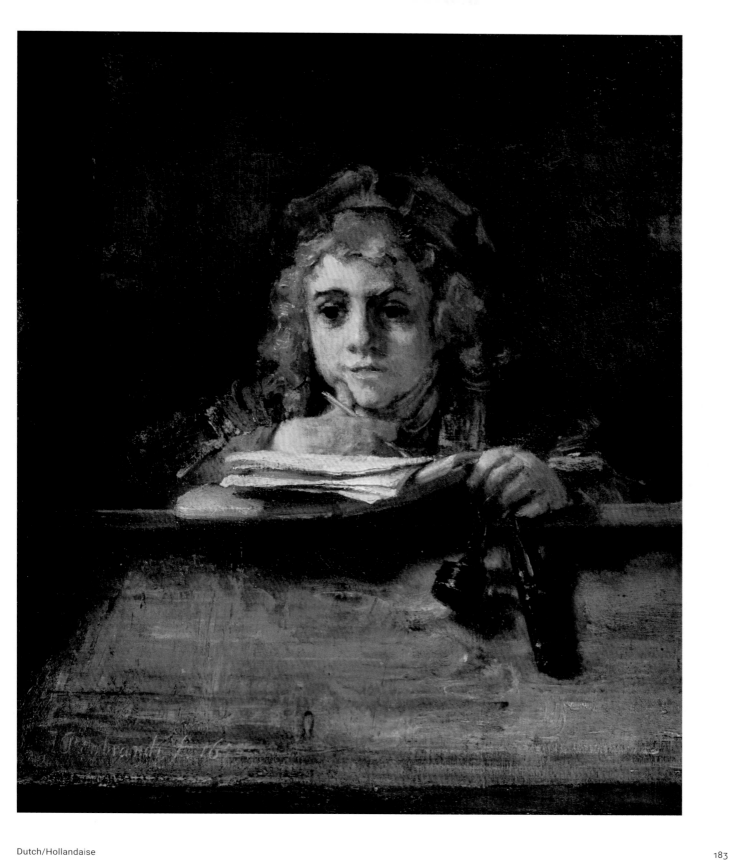

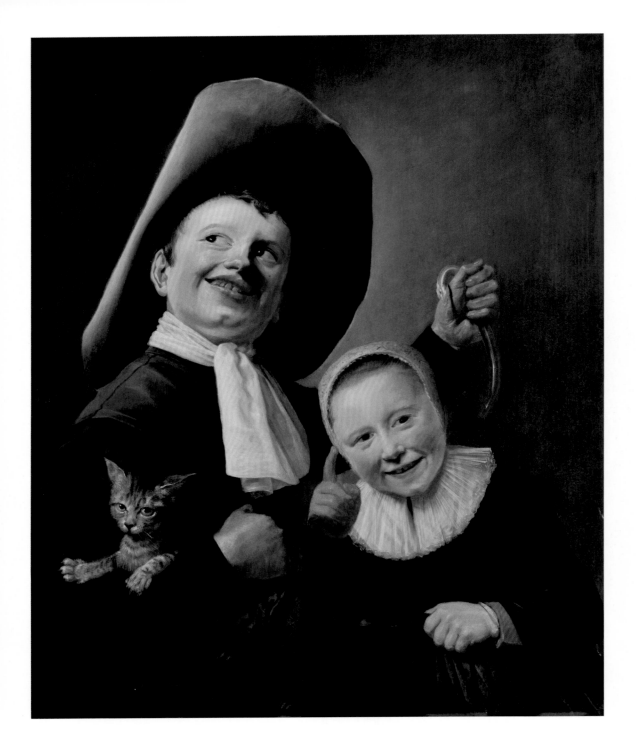

Judith Leyster (1609–60)

Boy and Girl with Cat and Eel

Un garçon et une fille avec un chat et une anguille

Junge und Mädchen mit Katze und Aal

Un niño y una niña con un gato y una anguila

Ragazzo e ragazza con un gatto e un'anguilla

Jongen en meisje met kat en hazelworm

c. 1635, Oil on wood/Huile sur bois, 59,4 × 48,8 cm, National Gallery, London

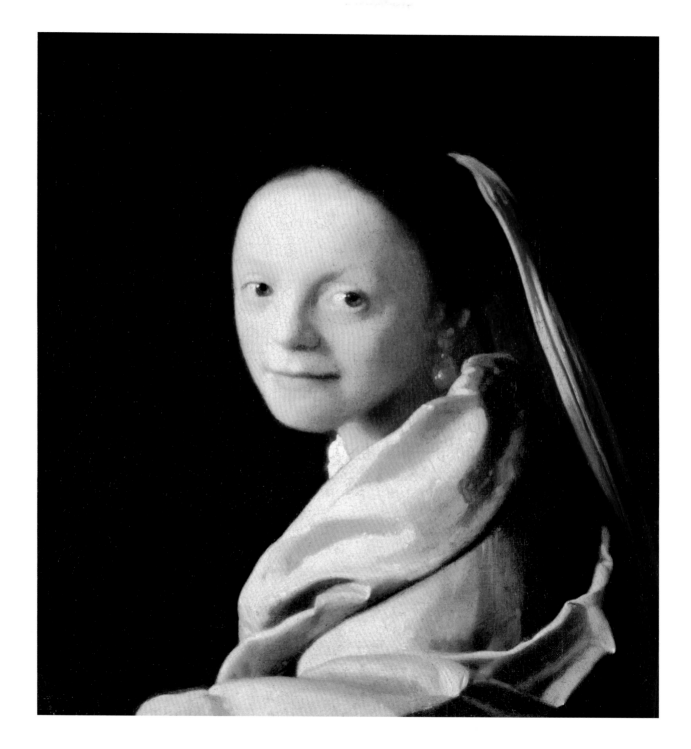

Jan Vermeer van Delft (1632–75)

Study of a young Girl Mädchenkopf Ragazza con velo

Étude de jeune femme Mujer joven Meisjeskopje

c. 1665–67, Oil on canvas/Huile sur toile, 44,5 × 40 cm, Metropolitan Museum of Art, New York

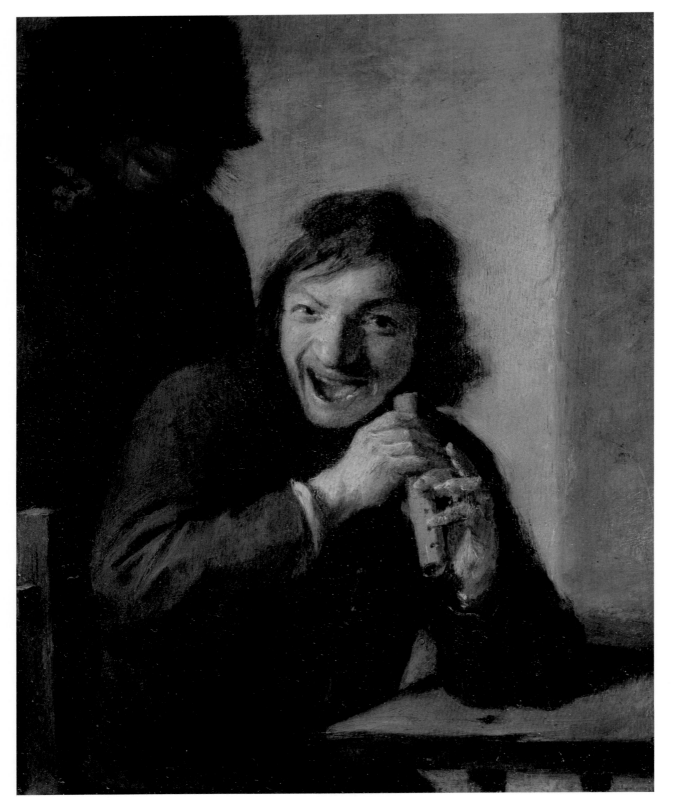

Adriaen Brouwer (c. 1605–38)

The Flute Player

Le Flûtiste

Der Flötenspieler

El flautista

Il flautista

De fluitspeler

n.d., Oil on copper/Huile sur plaque de cuivre, 16,5 × 13 cm, Musée Oldmasters Museum, Bruxelles

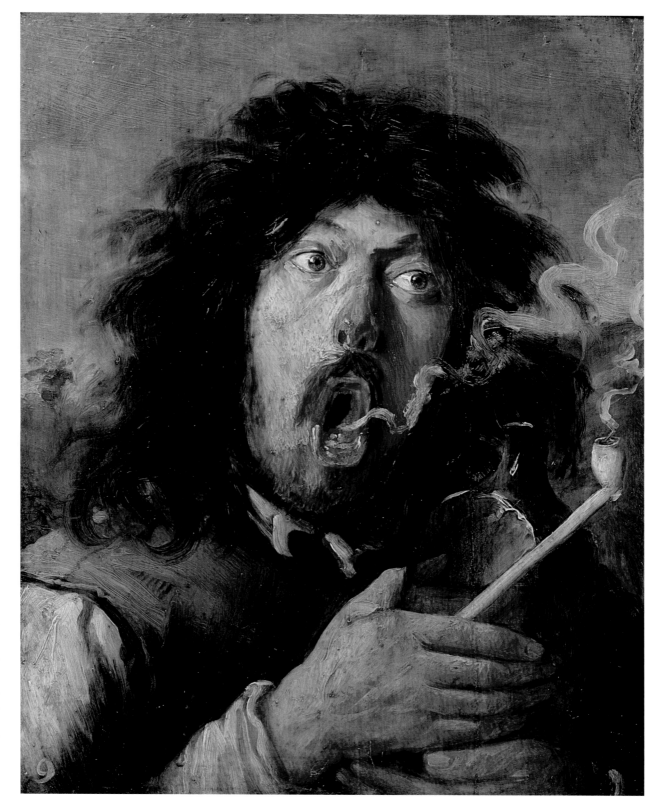

Joos van Craesbeeck
(c. 1606–54/62)

The Smoker

Le Fumeur
(portrait de
l'artiste ?)

Der Raucher

El fumador

Il fumatore

De pijproker

c. 1630–50,
Oil on wood/
Huile sur bois,
41 × 32 cm, Musée
du Louvre, Paris

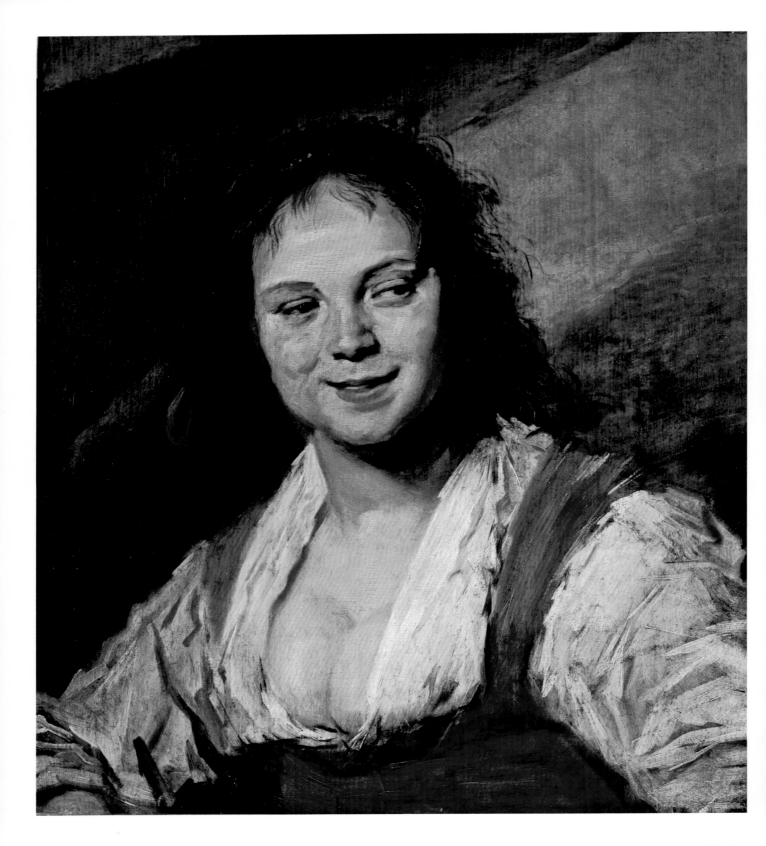

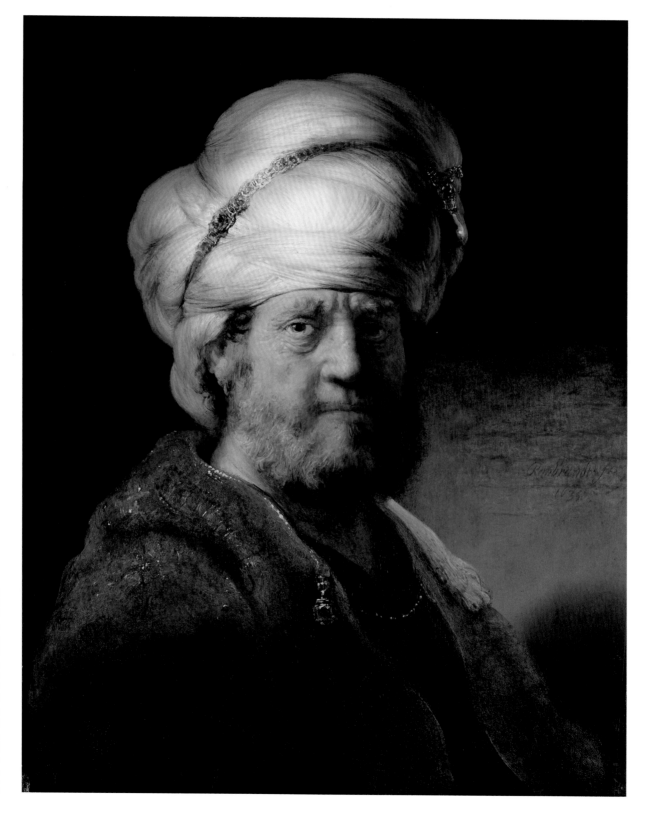

Frans Hals
(c. 1580–1666)

Gypsy

La Bohémienne

Zigeunerin

La gitana

Zingara

Zigeunerin

c. 1628–30, Oil on
wood/Huile sur bois,
58 × 52 cm, Musée
du Louvre, Paris

Rembrandt
Harmensz. van Rijn
(1606–69)

Man in Oriental Dress

Portrait d'un homme
en costume oriental

Mann in
orientalischem
Kostüm

Retrato de oriental

Ritratto di uomo
orientale

Man in oosterse
kleding

1635, Oil on wood/Huile
sur bois, 72 × 54,5 cm,
Rijksmuseum,
Amsterdam

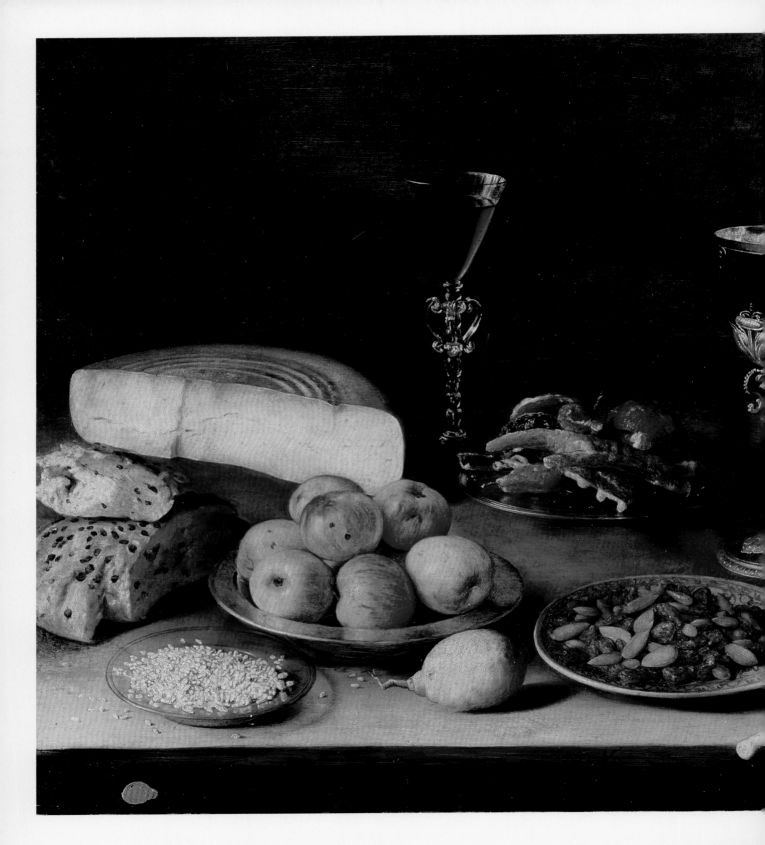

STILL LIFES
NATURES MORTES
STILLLEBEN
NATURALEZAS MUERTAS
NATURA MORTA
HET STILLEVEN

Flemish School/École flamande

Still Life with Goblets

Nature morte au calice

Stillleben mit Kelchen

Bodegón con copas

Natura morta con calici

Stilleven met kelken

c. 1600–20, Oil on wood/Huile sur bois, 63 × 92 cm, Gallerie dell'Accademia, Venezia

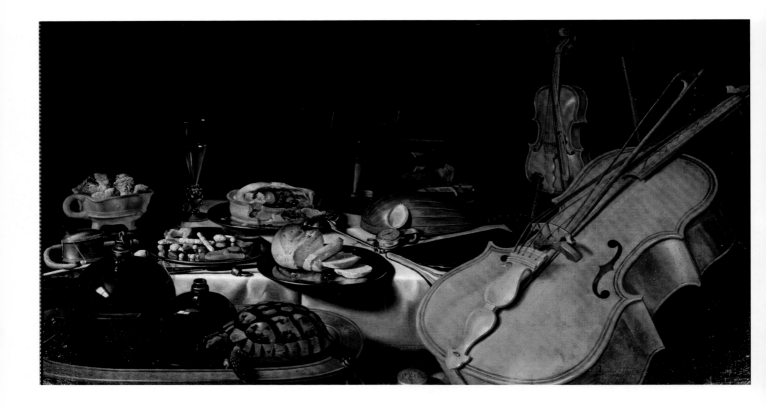

Pieter Claesz (c. 1597–1660)
Still Life with Music Instruments
Nature morte aux instruments de musique
Stillleben mit Musikinstrumenten
Bodegón con instrumentos musicales
Natura morta con strumenti musicali
Stilleven met muziekinstrumenten
1623, Oil on canvas/Huile sur toile, 69 × 122 cm, Musée du Louvre, Paris

Still Lifes

The first separate still lifes, i.e. arrangements of various inanimate objects but also of, among others, flowers and dead animals, emerged in the 16th century, but it was not until the 17th century that this genre became very popular, especially in the Low Countries. Many Flemish and Dutch artists specialized in still lifes with certain objects. Subjects included meals, fruits, flowers, decorative items, fish, smoking utensils, books, etc. Cities would even specialize in certain types of still lifes.

Still lifes testify to the pleasure artists and clients derived from the naturalistic of their world. But they also embrace an illusionistic reproduction of reality, reflected in glass, silver, the shimmer of a shell, or finely painted bird feathers. They also provide an opportunity for showing off the wealth acquired

Natures mortes

Les premières natures mortes autonomes – compositions d'objets, mais aussi de fleurs, d'animaux morts, etc. – sont nées au XVIᵉ siècle, mais le genre devint vraiment populaire au XVIIᵉ, surtout dans les Pays-Bas. De nombreux artistes flamands et hollandais se spécialisaient dans des sujets déterminés : il y avait ainsi des natures mortes « de table mise », « de fruits », « de fleurs » et « d'apparat », ainsi que des natures mortes « de poissons », « de tabagies » ou « de livres ». Certaines villes se spécialisaient même dans certaines sous-catégories déterminées.

Les natures mortes dénotent un plaisir du rendu naturaliste, voire illusionniste dans le reflet d'un verre, l'éclat d'un plat d'argent, l'irisation nacrée d'un coquillage ou dans la finesse de reproduction d'un plumage d'oiseau. Elles mettent en valeur la

Stillleben

Die ersten eigenständigen Stillleben – Kompositionen von Objekten, aber auch von Blumen, toten Tieren etc. – entstanden im 16. Jahrhundert, wirklich populär wurde diese Bildgattung jedoch im 17. Jahrhundert vor allem in den Niederlanden. Viele flämische und holländische Künstler spezialisierten sich auf Stillleben mit bestimmten Objekten. So gab es Mahlzeiten-, Früchte-, Blumen- und Prunkstillleben ebenso wie Stillleben mit Fischen, Rauchutensilien, Büchern usw. Auch in einzelnen Städten fand eine gewisse Spezialisierung auf bestimmte Stillleben-Formen statt.

Stillleben bezeugen einerseits die Freude an der naturalistischen oder sogar illusionistischen Wiedergabe, die sich in der Spiegelung in einem Glas, im Glanz eines Silbertellers, im Schimmer einer Muschel oder in fein gemalten Vogelfedern

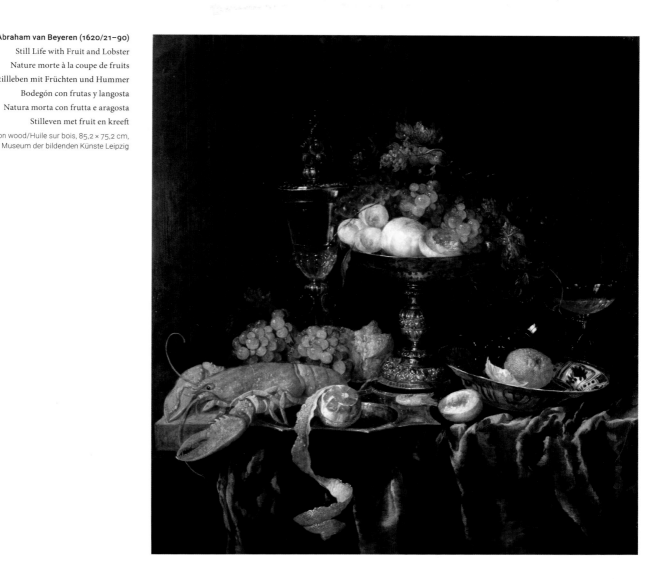

Naturalezas muertas

La primera naturaleza muerta como tal – composiciones de objetos, y también de flores, animales muertos, etc. – apareció en el siglo XVI, pero sin embargo se convirtió en un género muy popular en el siglo XVII, especialmente en los Países Bajos. Muchos artistas flamencos y holandeses se especializaron en naturalezas muertas de ciertos objetos. Así encontramos naturalezas muertas con comida, frutas, flores y algunas muy ostentosas, y también naturalezas muertas con pescado, utensilios para fumar, libros, etc. De igual manera, se encuentran en algunas ciudades una cierta especialización en determinadas formas de naturalezas muertas.

Las naturalezas muertas o bodegones testimonian, por un lado la alegría de la reproducción naturalista o incluso ilusoria, que se manifiesta en el reflejo en

Natura morta

Le prime nature morte indipendenti, ovvero composizioni di oggetti, fiori, animali morti, ecc., furono prodotte nel XVI secolo, tuttavia questo genere acquisì una grande popolarità solo nel XVII secolo, soprattutto nei Paesi Bassi. Molti artisti fiamminghi e olandesi si specializzarono nella realizzazione di nature morte raffiguranti oggetti specifici: pasti, frutta, fiori e oggetti pregiati, oltre a pesci, oggetti usati dai fumatori e libri, tra gli altri. La specializzazione in forme specifiche di natura morta ebbe luogo anche in determinate città.

Le nature morte da un lato testimoniano il piacere tratto dalla riproduzione naturalistica o anche illusionistica, che si manifesta nel riflesso in un bicchiere, nel bagliore di un piatto d'argento, nel luccichio di una conchiglia o in piume d'uccello

Het stilleven

De eerste zelfstandige stillevens – composities met losse voorwerpen, bloemen, wild… – ontstonden in de zestiende eeuw, maar echt populair werd dit genre in de zeventiende eeuw, vooral in de Nederlanden. Veel Vlaamse en Hollandse meesters richtten zich op een specifiek type stilleven, met één bepaalde groep voorwerpen: zo waren er stillevens met maaltijden of vruchten, bloemstillevens en pronkstillevens, en stillevens met onder andere vissen, rookgerei of boeken. Ook tussen de diverse steden tekende zich een zekere specialisatie naar onderwerp af.

Deze werken getuigden van het plezier in de natuurgetrouwe of zelfs illusionistische weergave, waarbij de kunstenaar zijn talent toonde in de weerspiegeling in een glas, de schittering van een schaal of de glans van een mossel. Met objecten als

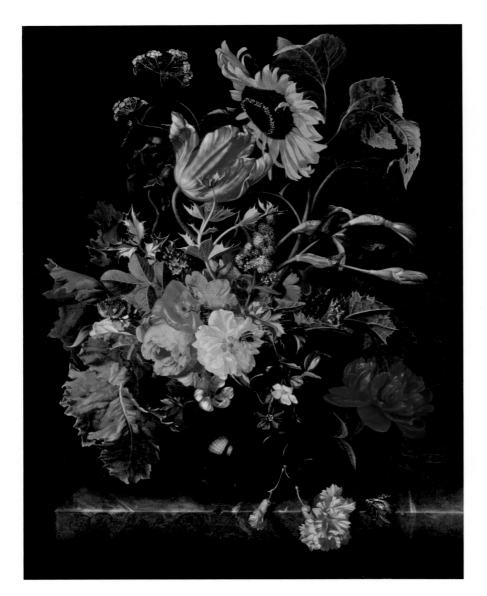

Maria van Oosterwyck (1630–93)

Bouquet in a Vase

Bouquet de fleurs dans un vase

Blumenstrauß in einer Vase

Flores en un jarrón

Mazzo di fiori in un vaso

Vaas met boeket bloemen

c. 1670–79, Oil on canvas/Huile sur toile,
73 × 55 cm, Denver Art Museum, Denver

Leiden School/École de Leyde

Vanitas: Still Life with Two Violins and Skull

Vanité aux deux violons

Vanitas-Stillleben mit zwei Violinen und Totenkopf

Vanitas con dos violines y calavera

Vanitas con due violini e un teschio

Vanitas-stilleven met twee violen en schedel

c. 1625, Oil on wood/Huile sur bois, 58,5 × 79 cm, Museum
Oskar Reinhart «Am Römerholz», Winterthur

through trade, with such objects as Oriental carpets, East Asian porcelain, and exotic fruit. Painters frequently added details such as faded flowers and dead insects as allusions to the ephemeral nature of the treasures shown. This came to be concentrated in the so-called vanitas still lifes, which directly point out the ephemeral nature of all things earthly (with death skulls or extinguished candles) together with other symbols (musical instruments, money, clocks) directly related to the transience of all earthly things, asking the viewer to reflect.

richesse des objets acquis par le commerce, tels que tapis d'Orient, porcelaines d'Extrême-Orient ou fruits exotiques. Toutefois, les peintres y ajoutent souvent certains détails – fleurs fanées, insectes morts – qui font allusion à la fugacité des trésors exposés. Ces éléments se retrouvent dans les vanités, natures mortes renvoyant à l'éphémère de toutes choses terrestres (crânes ou chandelles éteintes), combinées à d'autres objets symboliques (instruments de musique, argent, montres). Le tout doit susciter la réflexion du spectateur.

äußert, und stellen mit Objekten wie Orientteppichen, ostasiatischen Porzellanen und exotischen Früchten auch den durch Handel erworbenen Reichtum zur Schau. Doch häufig fügten die Maler Details wie verwelkte Blüten und tote Insekten ein, die auf die Flüchtigkeit der präsentierten Schätze anspielen. Diese Aussage konzentriert sich im Vanitas-Stillleben, das direkt auf die Vergänglichkeit alles Irdischen verweisende Dinge (wie Totenschädel oder verlöschte Kerzen) mit anderen dafür symbolhaften Gegenständen (Musikinstrumente, Geld, Uhren) kombiniert und den Betrachter zur Reflexion auffordert.

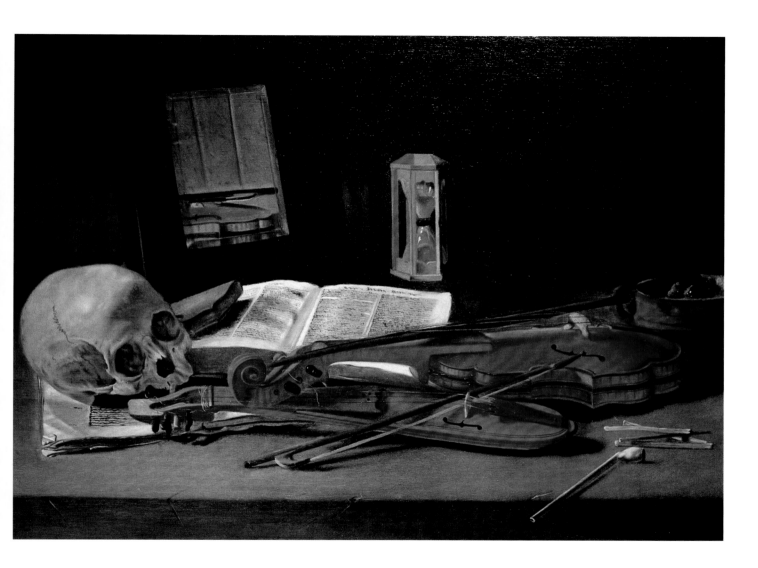

un espejo, en el resplandor de un plato de plata, en el brillo de una concha o en unas plumas finamente pintadas y colocadas con objetos tales como alfombras orientales, porcelanas de Asia Oriental y frutas exóticas, muestra de la riqueza adquirida a través del comercio. A menudo el pintor añadía detalles como unas flores marchitas e insectos muertos, en alusión a la volatilidad de los tesoros presentados. Esta declaración se concentra en las naturalezas muertas vanitas, que se refieren directamente a la transitoriedad de todas las cosas de la tierra (como calaveras o velas apagadas) combinados con otros objetos simbólicos (instrumentos musicales, dinero, relojes) que invitan al espectador a la reflexión.

squisitamente dipinte; dall'altro, ostentano la ricchezza, acquisita anche mediante il commercio, attraverso la rappresentazione di oggetti quali tappeti orientali, porcellane asiatiche e frutta esotica. Spesso, però, i pittori aggiungevano dettagli come fiori appassiti e insetti morti, alludendo alla fugacità dei tesori raffigurati. Quest'ultimo messaggio è rinvenibile soprattutto nelle nature morte chiamate *vanitas,* che combinano oggetti che alludono direttamente alla caducità delle cose terrene (come teschi o candele spente) con altri oggetti simbolici (strumenti musicali, soldi, orologi), e inducono l'osservatore alla riflessione.

oosterse tapijten, porselein uit het Verre Oosten of exotische vruchten werd de rijkdom getoond die door de wereldhandel was verworven. Vaak voegden de schilders details als verwelkte bloemen of dode insecten toe, die moesten waarschuwen voor de vluchtigheid van de getoonde welvaart. Deze boodschap vormde de kern van het vanitas-stilleven, waarin de beschouwer op de vergankelijkheid van het aardse werd gewezen – op directe wijze (met schedels en uitgeblazen kaarsen) of indirect (met symbolische voorwerpen als muziekinstrumenten, munten of uurwerken) – en tot beschouwelijkheid werd gemaand.

Pieter Boel (1622–74)
Still Life with Globe and Cockatoo
Nature morte au globe et au cacatoès
Stillleben mit Globus und Kakadu
Naturaleza muerta con globo terráqueo y cacatúa
Natura morta con mappamondo e cacatua
Stilleven met globe en kaketoe
c. 1658, Oil on canvas/Huile sur toile, 129 × 168 cm, Akademie der bildenden Künste, Wien

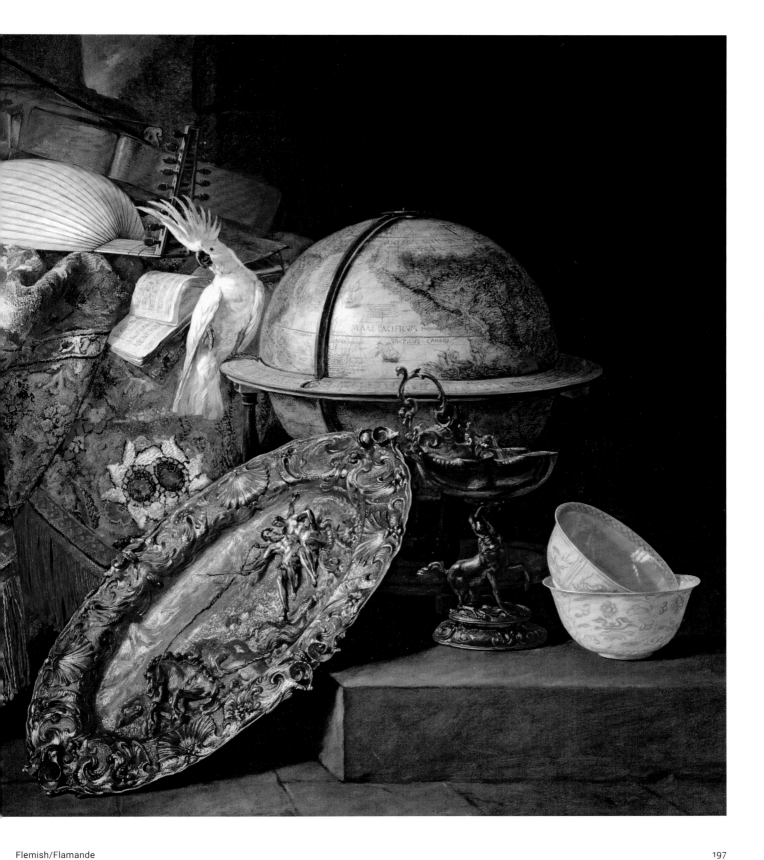

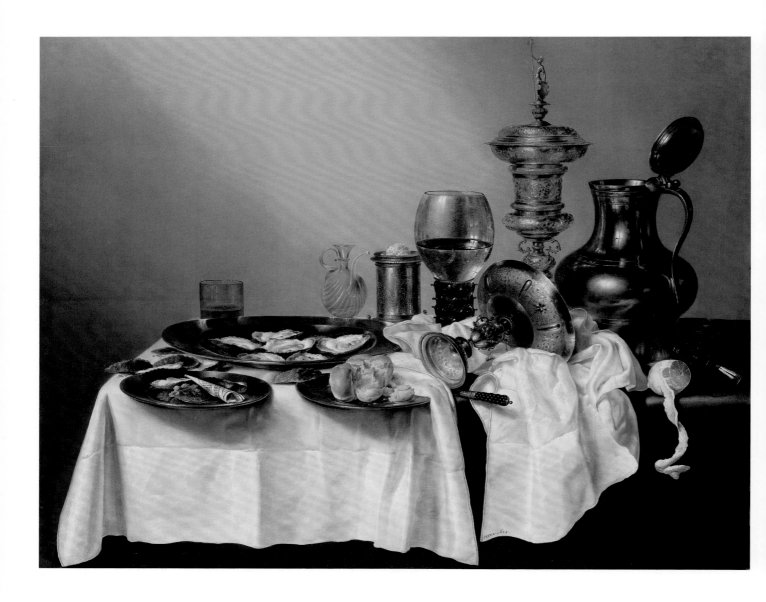

Willem Claesz. Heda (1594–1680)

Still Life with Gilded Cup

Nature morte à la coupe d'or

Stillleben mit vergoldetem Pokal

Bodegón con copa dorada

Natura morta con calice dorato

Stilleven met vergulde beker

1635, Oil on wood/Huile sur bois, 88 × 113 cm, Rijksmuseum, Amsterdam

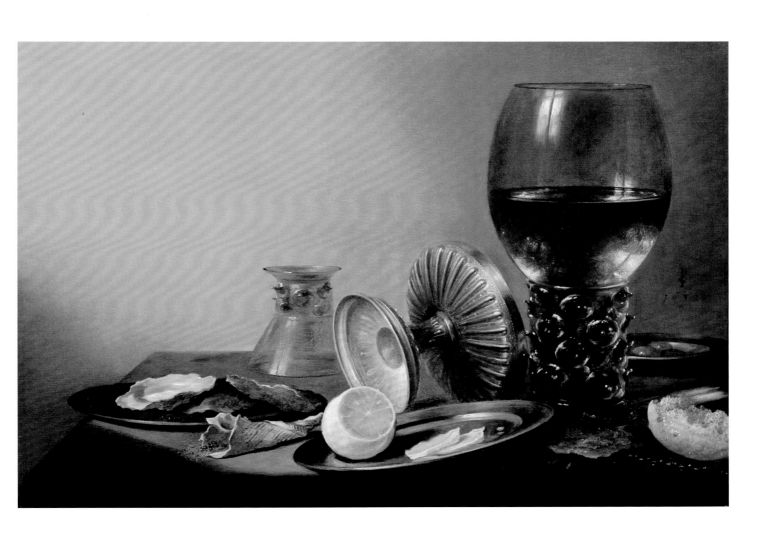

Pieter Claesz (c. 1597–1660)

Still Life with Roemer

Nature morte

Stillleben mit Römer

Bodegón con copa de vino

Natura morta con bicchiere da vino a forma di calice

Stilleven met roemer

c. 1630, Oil on wood/Huile sur bois, 43,3 × 63,2 cm, Private collection

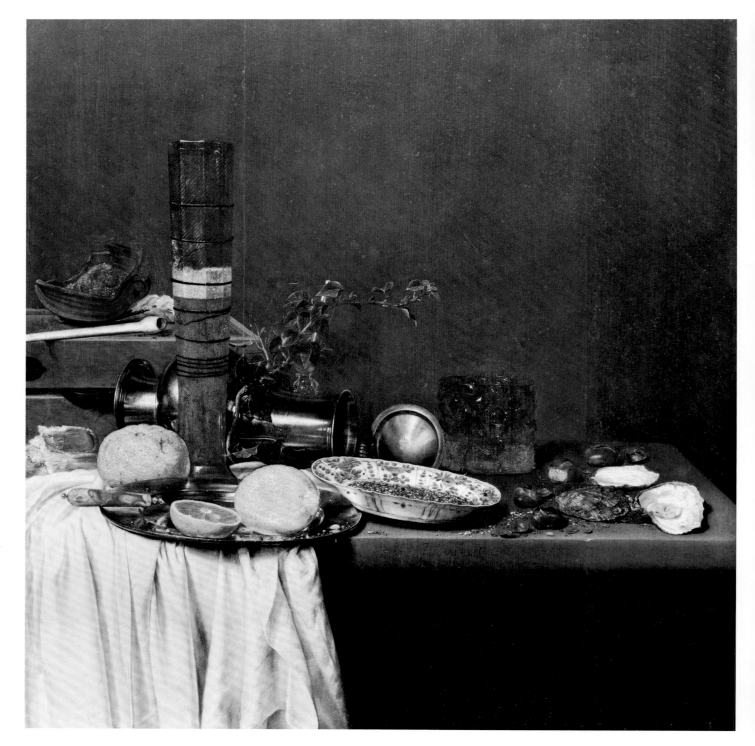

Jan Jansz. van de Velde III (1619/20–1663/64)

Still Life with Beer Glass Stillleben mit Bierglas Natura morta con bicchiere di birra

Nature morte au verre de bière Bodegón con vaso de cerveza Stilleven met bierglas

1647, Oil on wood/Huile sur bois, 64,5 × 59 cm, Rijksmuseum, Amsterdam

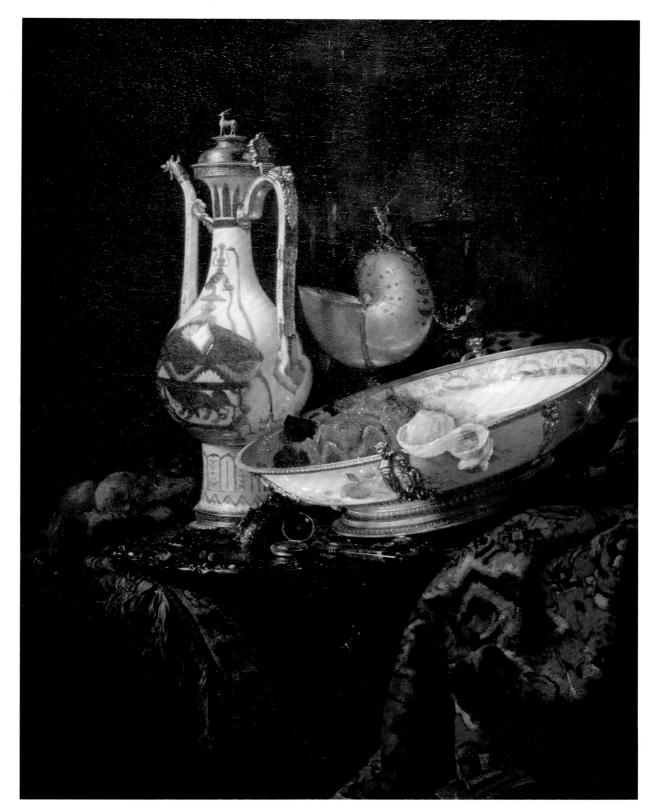

Willem Kalf
(1619–93)

Still Life with
Porcelain Flagon,
Dish, and
Nautilus Cup

Nature morte
à l'aiguière et
au nautile

Stillleben mit
Porzellankanne,
Schüssel und
Nautiluspokal

Naturaleza muerta
con jarra de
porcelana, fuente
y copa nautilus

Natura morta
con brocca di
porcellana, ciotola
e calice nautilus

Stilleven met
porseleinen
kan, schaal en
nautilusbeker

c. 1660, Oil on
canvas/Huile sur
toile, 111 × 84 cm,
Museo Thyssen-
Bornemisza, Madrid

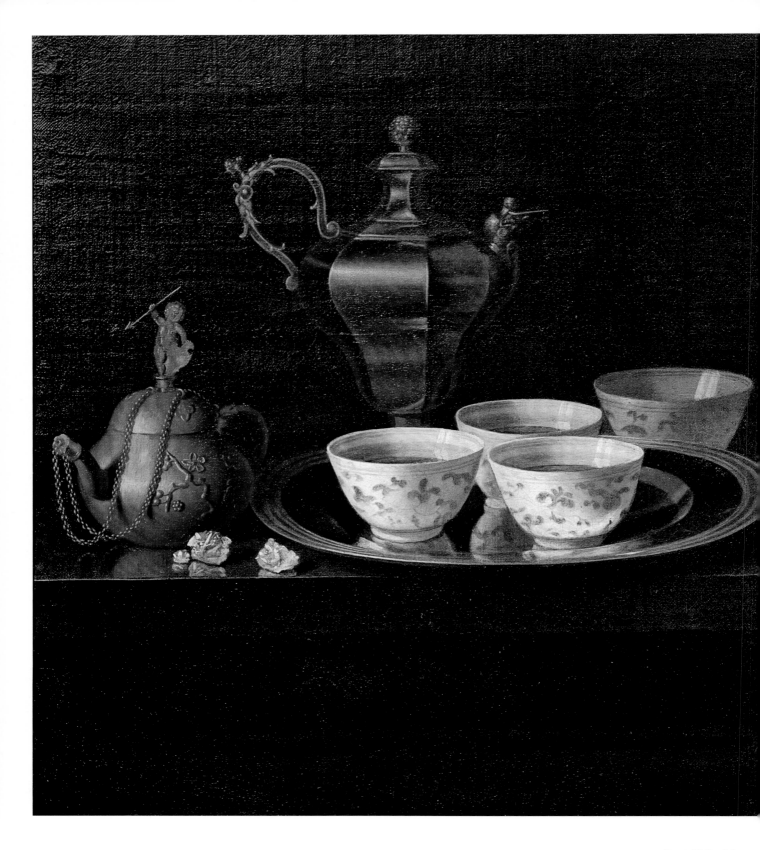

Pieter Gerritsz. van Roestraeten (1629/30–1700)

Still Life with Tea Set

Nature morte au service à thé

Stillleben mit Teegeschirr

Bodegón con juego de té

Natura morta con servizio da tè

Stilleven met theeservies

c. 1680, Oil on canvas/Huile sur toile, 43,5 × 60,5 cm, Museum Oskar Reinhart «Am Römerholz», Winterthur

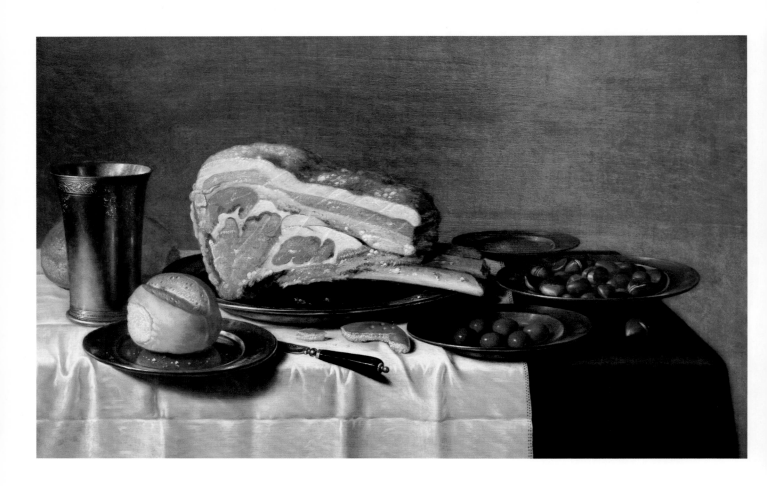

Floris Gerritsz. van Schooten (c. 1585–1656)

Breakfast with Ham, Olives, and Chestnuts

Nature morte avec jambon, olives et marrons

Frühstück (ontbijtje) mit Schinken, Oliven und Kastanien

Desayuno con jamón, aceitunas y castañas

Colazione (ontbijtje) con prosciutto, olive e castagne

Ontbijt met ham, olijven en kastanjes

c. 1650, Oil on wood/Huile sur bois, 52,5 × 82,5 cm, Private collection

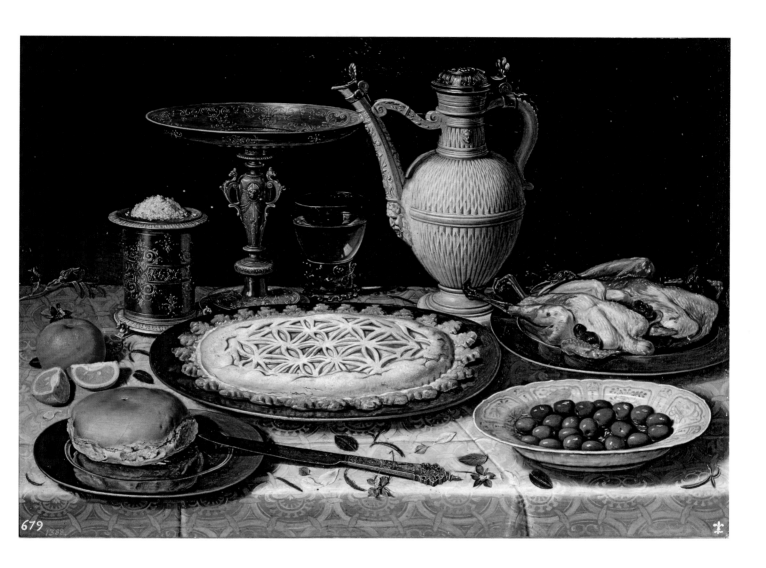

Clara Peeters (1588/90–post. 1621)

Still Life with Table Set for Dinner

Table avec coupe d'or, gâteau, olives et oiseaux grillés

Mahlzeitenstillleben

Naturaleza muerta con comida

Natura morta di un pasto

Stilleven met tazza, steengoedkan, zoutpot en lekkernijen

c. 1611, Oil on wood/Huile sur bois, 55 × 73 cm, Museo del Prado, Madrid

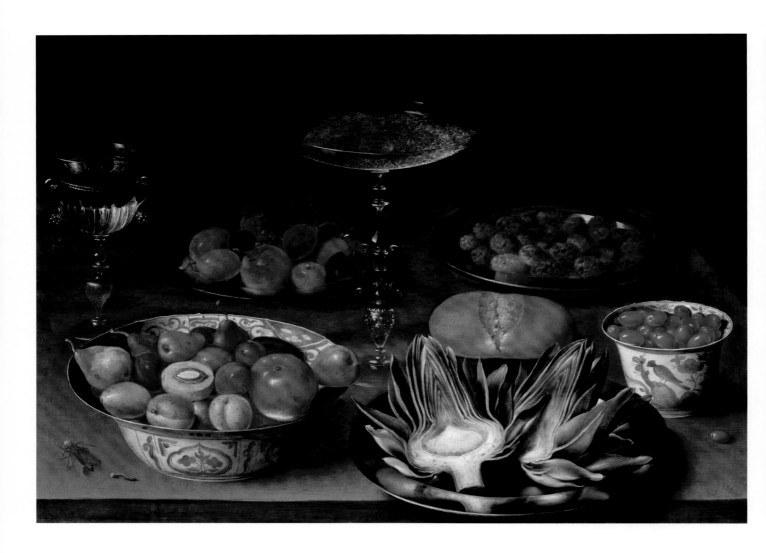

Osias Beert de Oude/the Elder/l'Ancien (c. 1580–1624)

Still Life with Artichokes, Fruit, and Glass Goblets

Nature morte avec artichauts, fruits et coupes

Stillleben mit Artischocken, Früchten und Glaspokalen

Naturaleza muerta con alcachofas, fruta y copas de cristal

Natura morta con carciofi, frutta e calici di vetro

Stilleven met artisjokken, fruit en glaswerk

c. 1600–24, Oil on wood/Huile sur bois, 51,5 × 72 cm, Musée de Grenoble, Grenoble

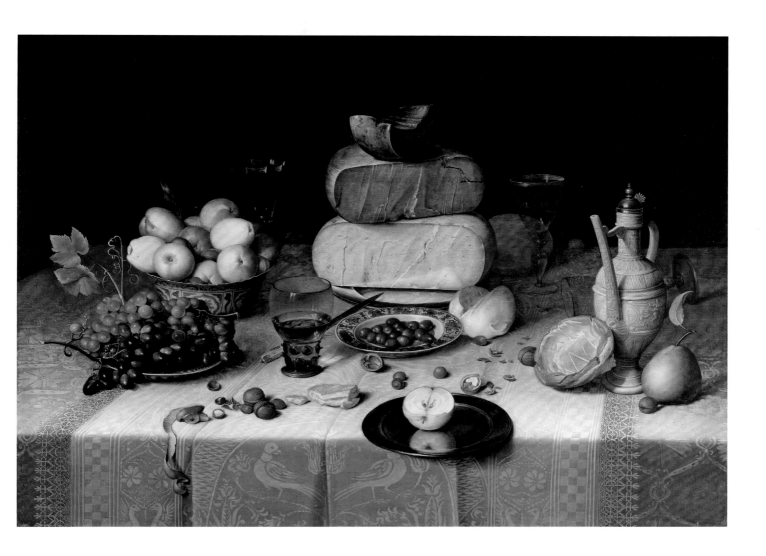

Floris Claesz. van Dijck (c. 1575–1651)

Still Life with Cheese

Nature morte au fromage

Stillleben mit Käse

Bodegón con queso

Natura morta con formaggio

Stilleven met kazen

c. 1615, Oil on wood/Huile sur bois, 82,2 × 111,2 cm, Rijksmuseum, Amsterdam

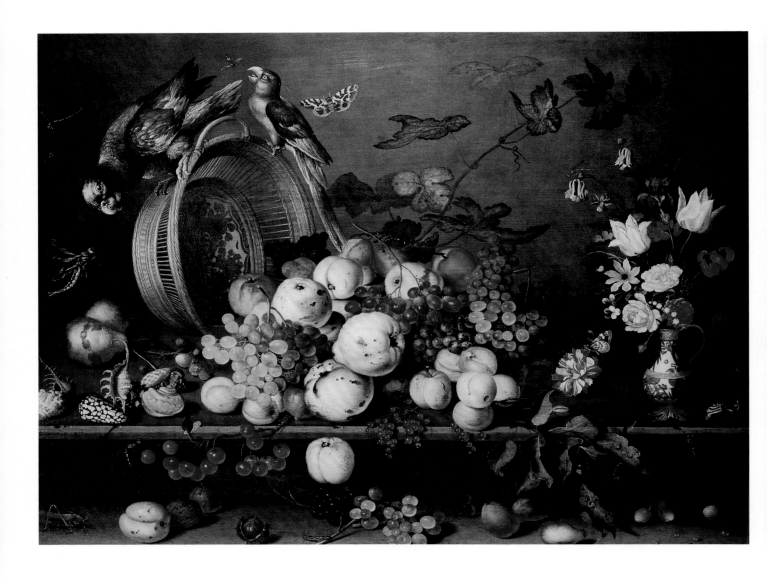

Balthasar van der Ast (c. 1593–1657)

Still Life with Fruit, Mussels, and Insects

Nature morte aux fruits

Stillleben mit Früchten, Muscheln und Insekten

Naturaleza muerta con frutas, conchas e insectos

Natura morta con frutta, crostacei e insetti

Stilleven met omgevallen mand, fruit en boeket bloemen

1620–30, Oil on wood/Huile sur bois, 75 × 104 cm, State Hermitage Museum, St. Petersburg

Jan Davidsz. de Heem (1606–83/84)

Eucharist Surrounded by Garlands of Fruit

Calice de messe entouré de guirlandes de fruits

Eucharistie, von Fruchtgirlanden umgeben

Eucaristía rodeada de guirnaldas de frutas

Eucaristia circondata da ghirlande di frutta

Miskelk omgeven door fruitguirlandes

1648, Oil on canvas/Huile sur toile, 138 × 125,5 cm, Kunsthistorisches Museum, Wien

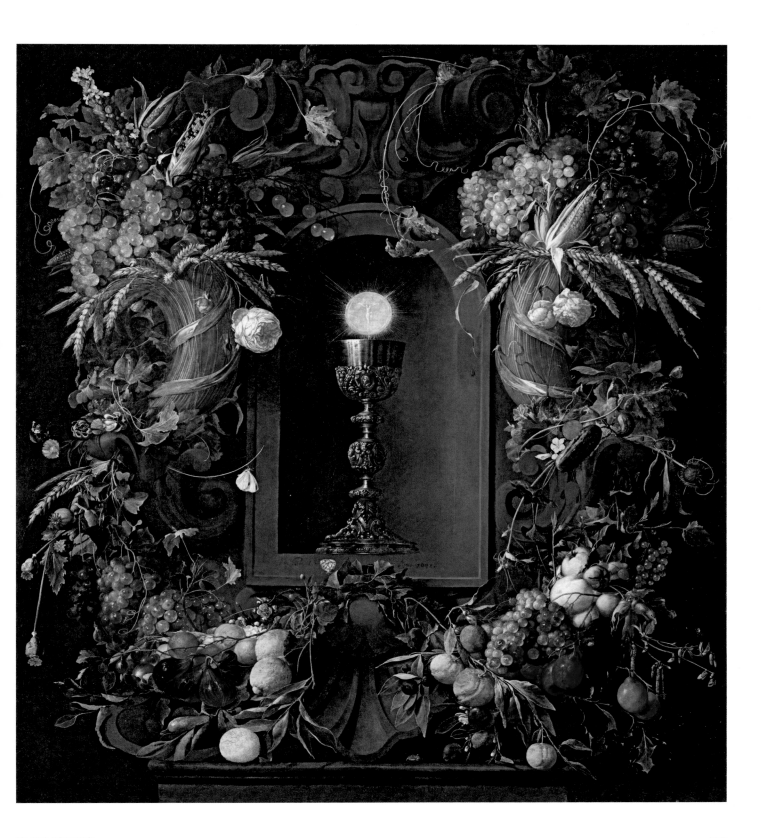

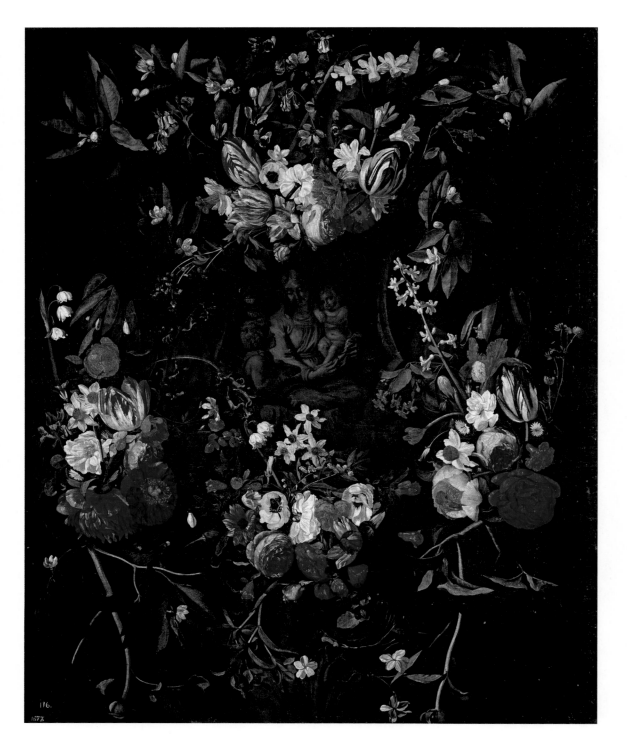

Rachel Ruysch (1664–1750)

Bouquet

Bouquet de fleurs

Blumenstrauß

Ramo de flores

Mazzo di fiori

Boeket bloemen

c. 1705, Oil on canvas/Huile sur toile, 142 × 111,9 cm, Muzeul Național de Artă al României, București

Erasmus Quellinus II (1607–78), Daniel Seghers (1590–1661)

Garland of Flowers and the Mother of God

Blumengirlande mit Muttergottes

Ghirlanda di fiori con Madonna

Couronne de fleurs entourant la Vierge, l'Enfant et le jeune saint Jean Baptiste

Guirnalda de flores con Madonna

Bloemenguirlande met afbeelding van Maria en kind

1625–50, Oil on canvas/Huile sur toile, 130 × 105 cm, Museo del Prado, Madrid

Flemish/Flamande

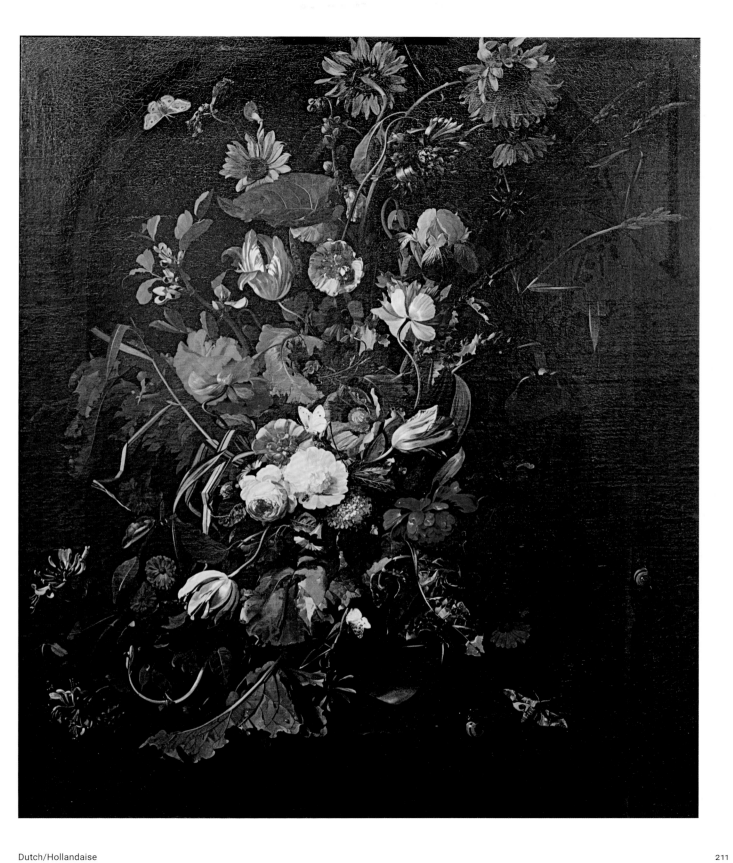

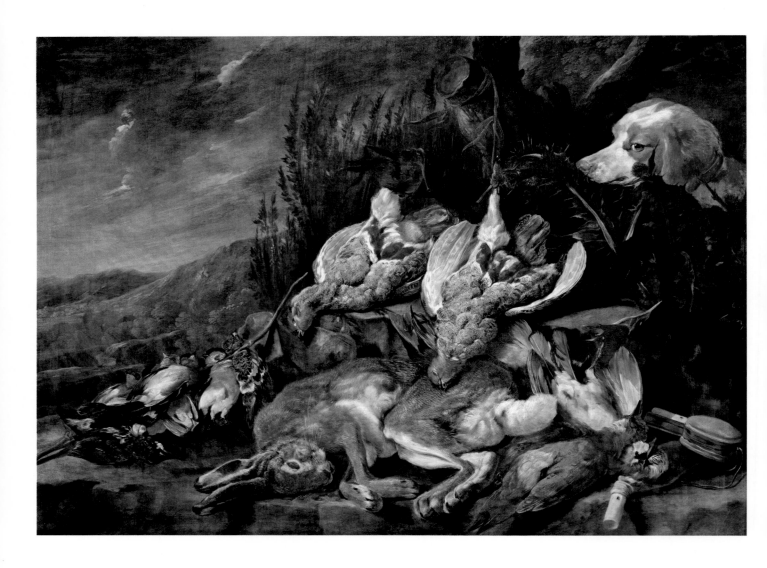

Jan Fyt (1611–61)

Still Life After the Hunt

Nature morte de chasse avec un chien

Jagdstillleben

Bodegón de caza

Natura morta con cacciagione

Jachtstilleven

c. 1650, Oil on canvas/Huile sur toile, Musée des Beaux-Arts, Dijon

Jan Weenix (1642–1719)

Still Life with Flayed Hare

Nature morte de chasse

Jagdstillleben mit erlegtem Hasen

Bodegón de caza con liebre muerta

Natura morta con cacciagione con lepre abbattuta

Jachtstilleven met dode haas

c. 1690, Oil on canvas/Huile sur toile, 85,5 × 68 cm, Hamburger Kunsthalle, Hamburg

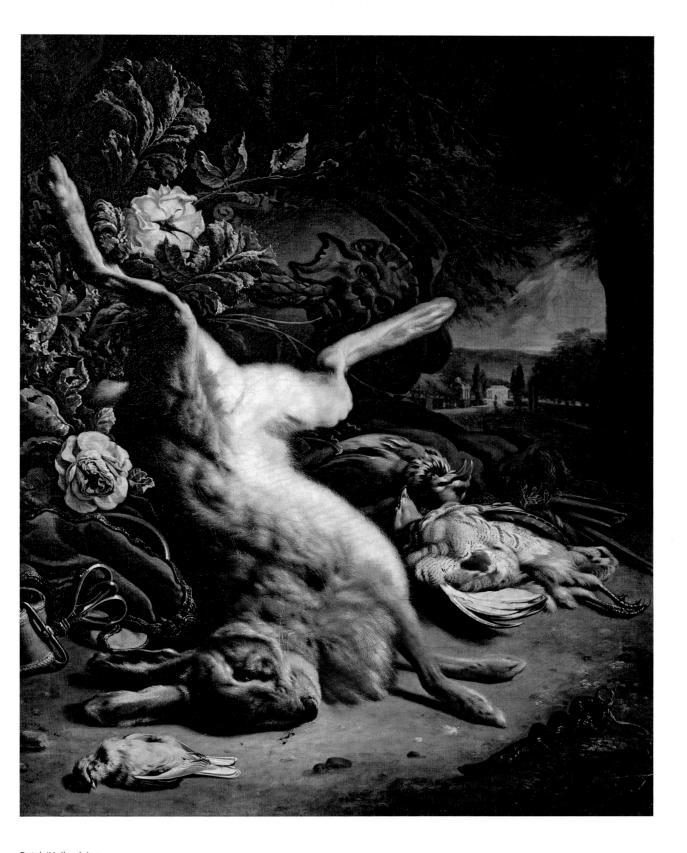

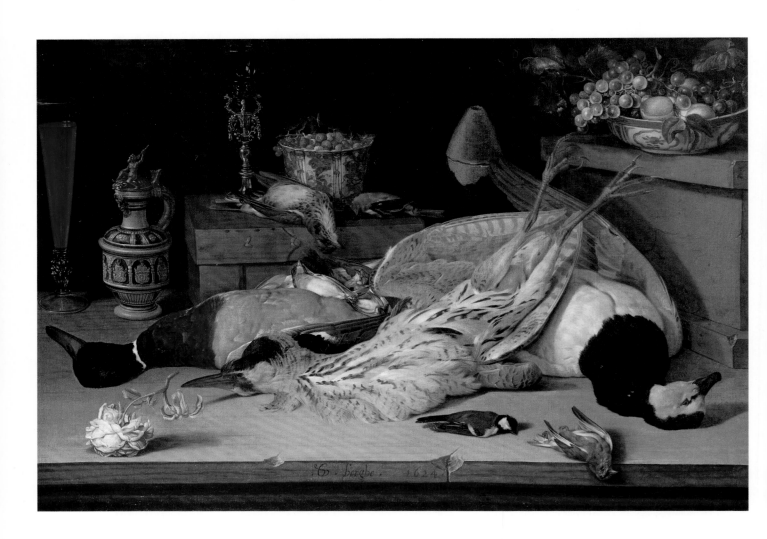

Christoffel van den Berghe (c. 1590–c. 1642)

Still Life with Dead Birds

Nature morte aux oiseaux

Stillleben mit toten Vögeln

Bodegón con pájaro muerto

Natura morta con cacciagione d'uccelli

Stilleven met dode vogels

1624, Oil on canvas/Huile sur toile, 74,6 × 105,4 cm, Getty Center, Los Angeles

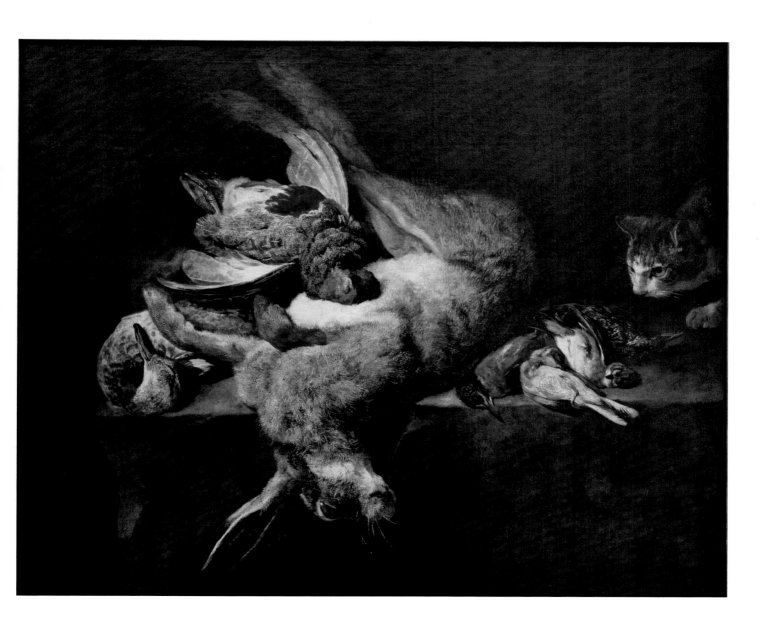

Pieter Boel (1622–74)

Still Life with Dead Hare

Nature morte aux lièvres

Stillleben mit totem Hasen

Bodegón con liebre muerta

Natura morta con lepre uccisa

Stilleven met dode haas

c. 1645–55, Oil on canvas/Huile sur toile, 64 × 80,5 cm, Gemäldegalerie, Berlin

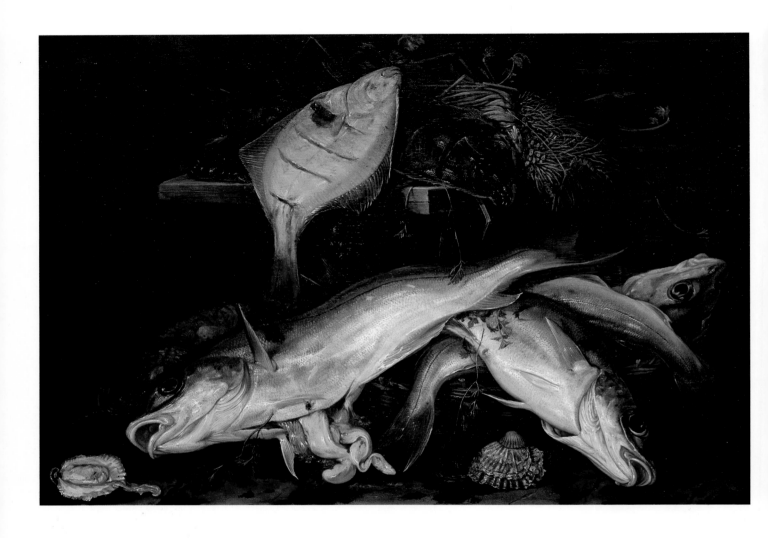

Jacob Gillig (c. 1636–1701)

Still Life with Fish, Oysters, and Kelp

Nature morte aux poissons et aux huîtres

Stillleben mit Meeresfischen, Austern und Seetang

Naturaleza muerta con peces marinos, ostras y algas

Natura morta con pesci di mare, ostriche e alghe

Stilleven met zeevissen, oesters en zeewier

1674, Oil on wood/Huile sur bois, 47,9 × 68 cm, Museum Oskar Reinhart «Am Römerholz», Winterthur

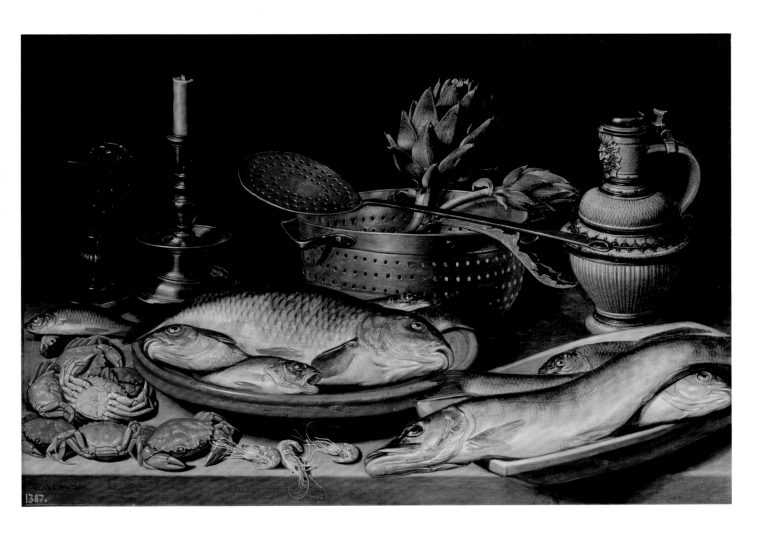

Clara Peeters (1588/90–post. 1621)

Still Life with Fish

Nature morte aux poissons

Stillleben mit Fischen

Bodegón con peces

Natura morta con pesci

Stilleven met vissen

1611, Oil on wood/Huile sur bois, 50 × 72 cm, Museo del Prado, Madrid

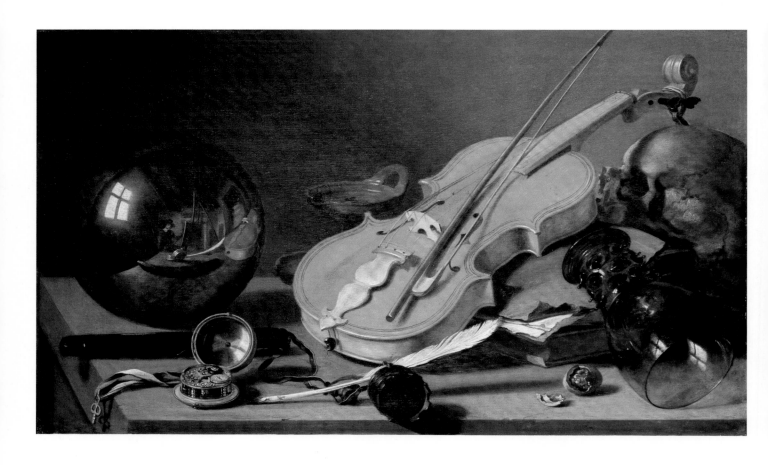

Pieter Claesz (c. 1597–1660)

Vanitas: Still Life with Self-Portrait

Vanité *ou* Nature morte au globe de verre avec autoportrait

Vanitas-Stillleben mit Selbstbildnis

Vanitas con autorretrato

Vanitas con autoritratto

Vanitas-stilleven met zelfportret

c. 1628, Oil on wood/Huile sur bois, 35,9 × 59 cm, Germanisches Nationalmuseum, Nürnberg

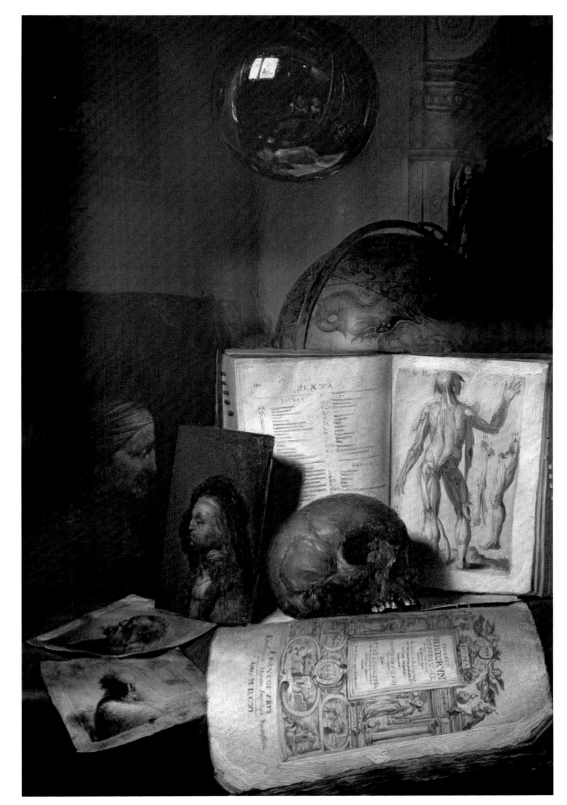

Simon Luttichuys (1610–61)

Still Life with Skull

Vanité

Stillleben mit Totenschädel

Naturaleza muerta con calavera

Natura morta con teschio

Stilleven met schedel

c. 1631, Oil on wood/Huile sur bois,
Muzeum Narodowe, , Gdańsk

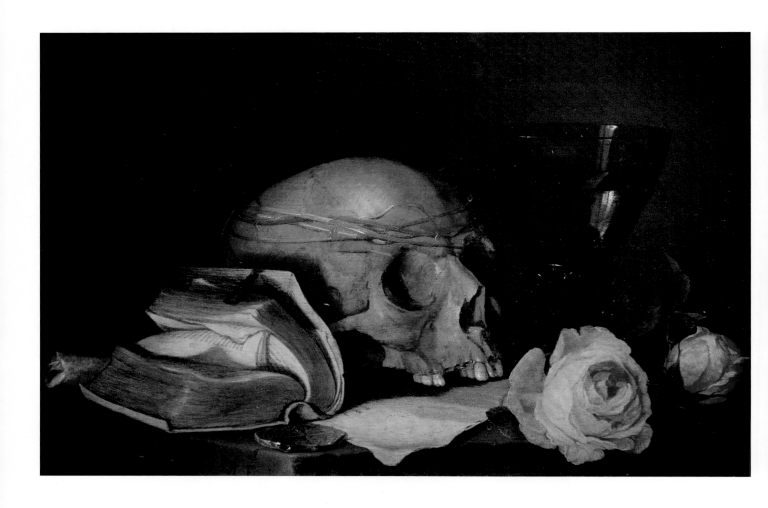

Jan Davidz. de Heem (1606–83/84)

Vanitas Still Life

Vanité *ou* Nature morte avec crâne, livres et roses

Vanitas-Stillleben

Vanitas

Vanitas

Vanitas-stilleven

c. 1630, Oil on wood/Huile sur bois, 23,2 × 34,6 cm, Nationalmuseum, Stockholm

<div align="right">

Adriaen van Nieulandt (1587–1658)

Vanitas: Still Life with Flowers and Skull

Vanité *ou* Nature morte avec fleurs et crâne

Vanitas-Stillleben mit Blumen und Totenkopf

Vanitas con flores y calavera

Vanitas con fiori e teschio

Vanitas-stilleven met bloemen en schedel

1636, Oil on wood/Huile sur bois, 40 × 37,2 cm, Frans Hals Museum, Haarlem

</div>

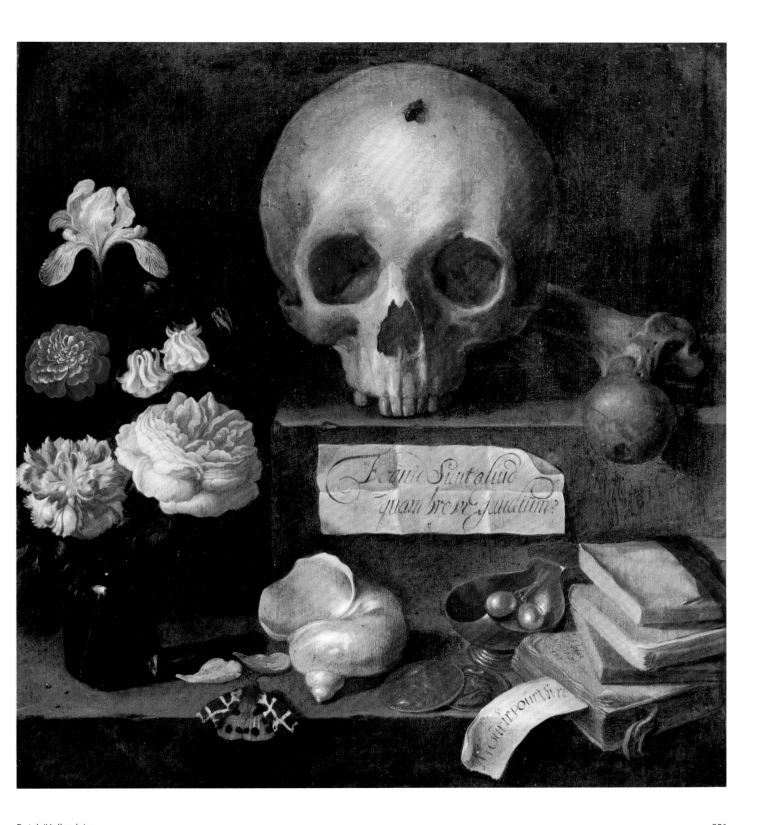

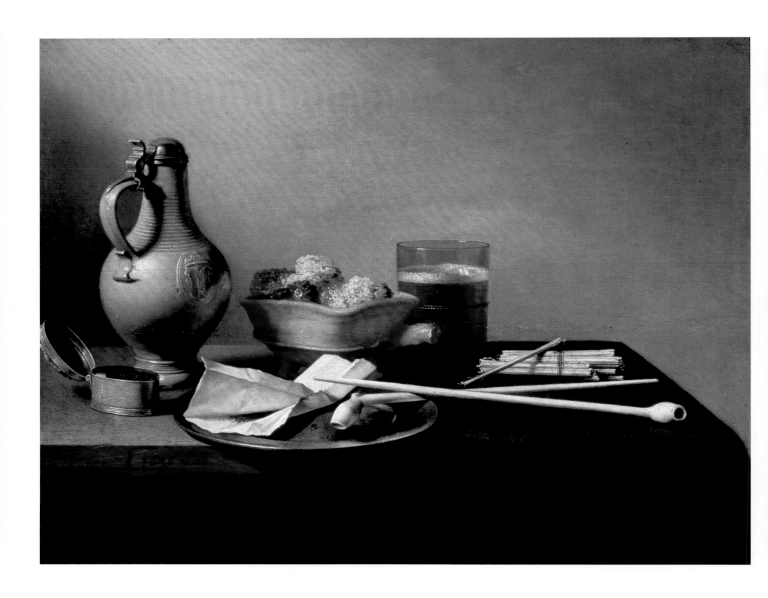

Pieter Claesz (c. 1597–1660)

Still Life with Clay Pipes

Nature morte aux pipes

Stillleben mit Tonpfeifen

Naturaleza muerta con pipa

Natura morta con pipe di argilla

Stilleven met pijpen van klei

1636, Oil on wood/Huile sur bois, 49 × 63,5 cm, State Hermitage Museum, St. Petersburg

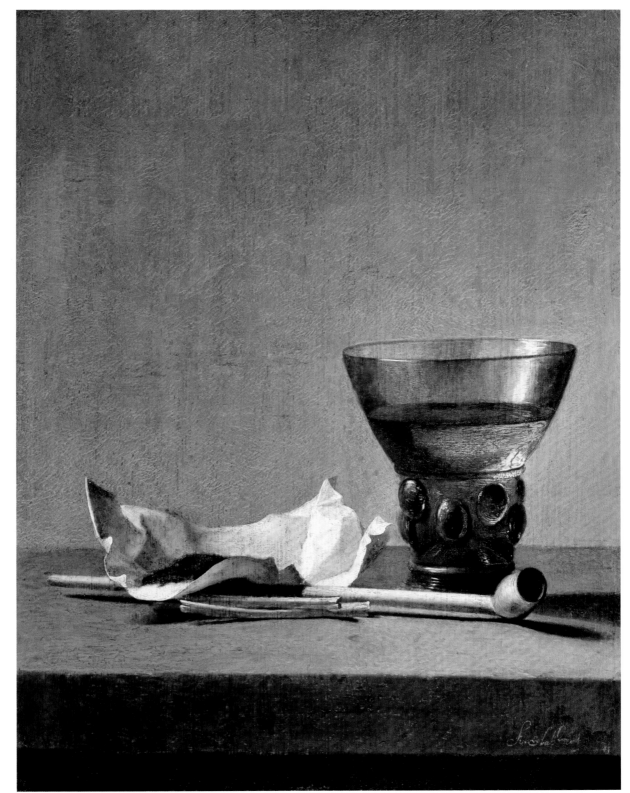

Karel Slabbaert
(c. 1619–54)

Still Life with
Smoker's Kit

Nature morte au tabac

Raucherstillleben

Naturaleza muerta
del fumador

Natura morta con
oggetti del fumatore

Stilleven met rookgerei

1641, Oil on wood/Huile
sur bois, 41 × 34 cm,
Private collection

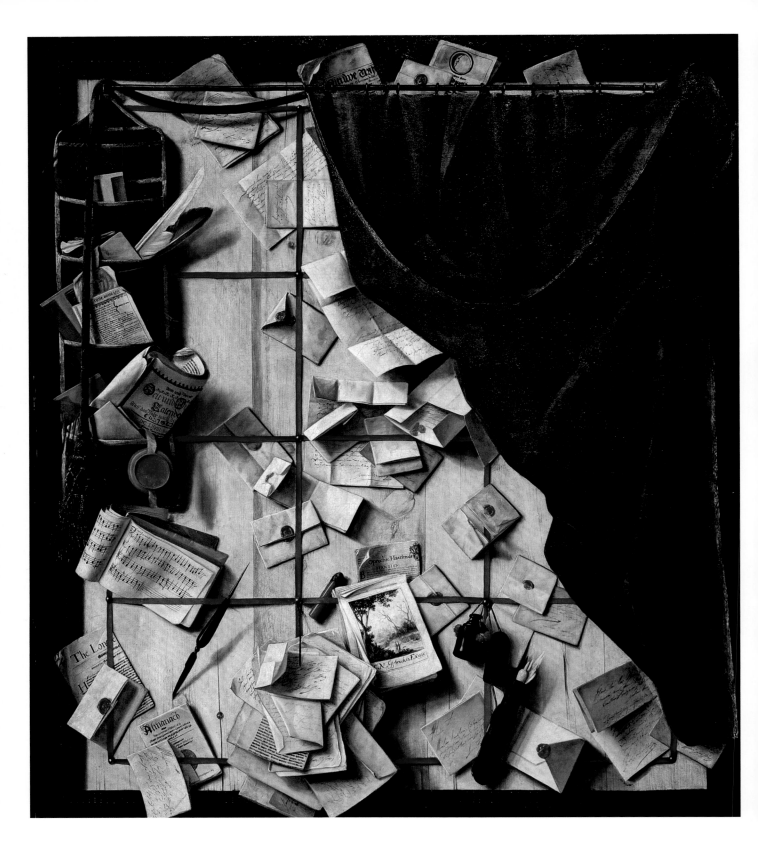

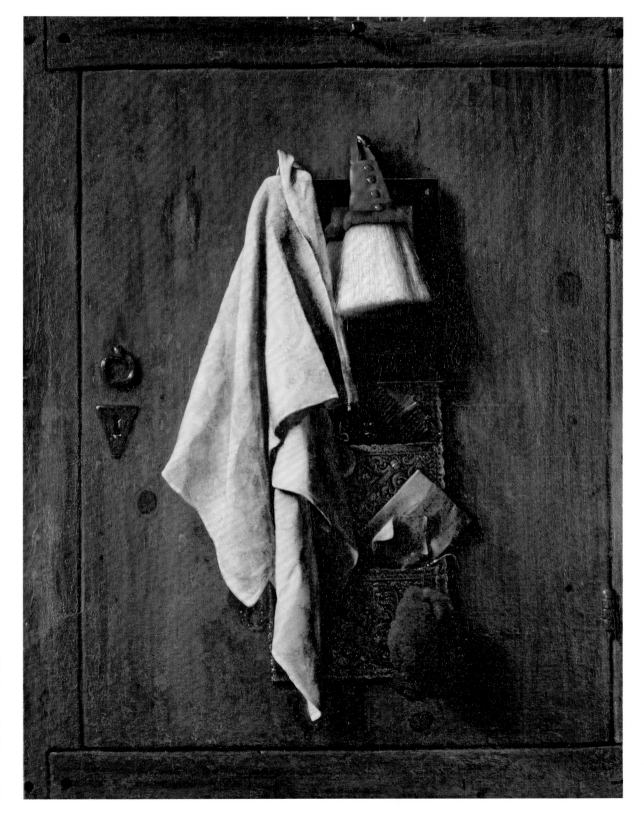

Flemish/Flamande

MYTHOLOGY, RELIGION, HISTORY
MYTHOLOGIE, RELIGION, HISTOIRE
MYTHOLOGIE, RELIGION, HISTORIE
MITOLOGÍA, RELIGIÓN, HISTORIA
MITOLOGIA, RELIGIONE, STORIA
MYTHOLOGIE, RELIGIE, GESCHIEDENIS

Gerard Seghers (1591–1651)

Virgin with Jesus and John the Baptist

Vierge à l'Enfant avec le jeune saint Jean Baptiste

Maria mit dem Kind und dem Johannesknaben

María con el Niño y San Juan Bautista niño

Madonna col Bambino e san Giovanni Battista

Maria met kind en Johannes de Doper als kind

c. 1630–35, Oil on canvas/Huile sur toile, 100,5 × 152 cm, Kunsthistorisches Museum, Wien

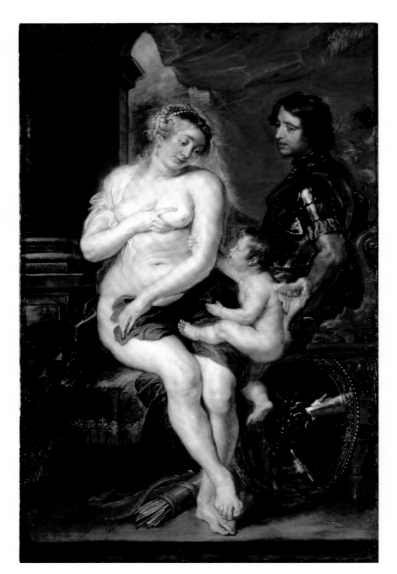

Peter Paul Rubens (1577–1640)

Venus, Mars, and Amor

Vénus, Mars et Cupidon

Venus, Mars und Amor

Venus, Marte y Amor

Venere, Marte e Cupido

Venus, Mars en Amor

c. 1635, Oil on canvas/Huile sur toile, 192,5 × 133 cm, Dulwich Picture Gallery, London

Mythology, Religion, History

In the Baroque period and through to the 19th century, history painting came to be regarded as the most important of genres. It included not only strictly historical events, but also scenes from mythology and the Christian religion, as well as other subjects claiming greater significance than the event represented. These works were often commissioned by the church and by the ruling classes.

The latter frequently demanded subjects from ancient mythology for they saw the gods of Olympus as personifications of abstract ideas that justified their own claims to power. Venus represented the power of love, Mars the power of war, and Hercules the virtuous ruler. Flemish painters such as Jacob

Mythologie, religion, histoire

À l'époque baroque – et jusqu'au XIXᵉ siècle – la peinture d'histoire était considérée comme le genre pictural le plus distingué. Parmi ses sujets figuraient non seulement les événements historiques mais aussi la mythologie et la religion, ainsi que d'autres sujets dont la représentation devait faire percevoir un message porteur de valeurs morales ou intellectuelles. Les commanditaires de ces tableaux étaient souvent l'Église et les princes.

Ces derniers demandaient des sujets tirés de la mythologie antique, car les dieux de l'Olympe personnifiaient des idées abstraites utilisables pour une mise en valeur personnelle : Vénus symbolisait l'amour, Mars, la guerre, Hercule, la puissance

Mythologie, Religion, Historie

Im Barock – und noch bis ins 19. Jahrhundert – galt die Historienmalerei als die vornehmste Gattung der Malerei. Zu ihren Themen gehören nicht nur historische Begebenheiten, sondern vor allem Mythologie und Religion sowie andere Sujets, die Anspruch auf eine das jeweilige Ereignis überschreitende Gültigkeit erheben. Auftraggeber von Historiengemälden waren häufig die Kirche und Herrscher.

Bei Letzteren waren Sujets aus der antiken Mythologie gefragt, denn die Götter des Olymp personifizierten abstrakte Ideen, die sich für die Selbstdarstellung von Herrschern nutzen ließen. So war Venus die Liebe, Mars der Krieg und Herkules

Rembrandt Harmensz. van Rijn (1606–69)

Jacob Wrestling the Angel
La Lutte de Jacob et de l'ange
Jakobs Kampf mit dem Engel
Jacob luchando contra el ángel
Giacobbe lotta con l'angelo
Jakob worstelend met de engel

c. 1659/60, Oil on canvas/Huile sur toile,
140,1 × 120 cm, Gemäldegalerie, Berlin

Mitología, religión, historia

En el barroco – e incluso hasta el siglo XIX – la pintura histórica se consideraba el género más distinguido dentro de la pintura. Sus temas incluyen no sólo los acontecimientos históricos, sino sobre todo, la mitología y la religión y otros temas que reclamaban su presencia debido a la más que suficiente validez del correspondiente acontecimiento. La iglesia y los gobernantes eran a menudo los principales contratantes de pintura histórica.

En este último, había demanda de temas de la antigua mitología, en la que los dioses del Olimpo personificaban ideas abstractas que podían utilizarse para la auto-representación de los gobernantes. Así, Venus era el amor, Marte la guerra y Hércules el

Mitologia, religione, storia

Nel Barocco, e fino al XIX secolo, la pittura storica continuò ad essere il genere più nobile. Questo tipo di pittura raffigurava non solo eventi storici, bensì soprattutto motivi di carattere mitologico e religioso, nonché altri soggetti che rivendicano la loro validità rispetto a un certo avvenimento. I committenti di dipinti storici erano spesso la Chiesa e i sovrani.

Questi ultimi commissionavano spesso quadri su temi della mitologia antica, in quanto gli dei dell'Olimpo personificavano idee astratte che potevano essere da loro utilizzati come mezzi di autoespressione. Ad esempi, Venere era la personificazione dell'amore, Marte quella della guerra ed Ercole quella del sovrano virtuoso. Pittori fiamminghi come Jacob Jordaens,

Mythologie, religie en geschiedenis

In de barok (en nog tot in de negentiende eeuw) werd het historiestuk als het belangrijkste genre in de schilderkunst beschouwd. Tot de thema's die daarin werden behandeld, behoorden niet alleen historische gebeurtenissen maar vooral ook de mythologie, de religie en andere onderwerpen waarmee een universele boodschap werd uitgedragen. Opdrachtgevers van historiestukken waren vooral vorsten en de kerk.

Bij vorsten was de klassieke mythologie zeer geliefd, want de goden van de Olympus belichaamden immers de abstracte ideeën waaraan deze heersers hun representatieve status ontleenden. Zo stond Venus voor de liefde, Mars voor de oorlog en Hercules voor de deugdzame vorst. Vlaamse schilders als Jacob

Peter Paul Rubens (1577–1640)

Venus at her Toilet

La Toilette de Vénus

Die Toilette der Venus

El tocador de Venus

Venere al bagno

Het toilet van Venus

1613/14, Oil on wood/Huile sur bois, 124 × 98 cm,
Liechtenstein, The Princely Collections, Wien

Jordaens, Peter Paul Rubens, and Anthonis van Dyck created mythological paintings, especially for foreign courts. A masterpiece skillfully intertwining historical events, the self-presentation of rulers, and mythology is Rubens' *Medici Cycle,* in honor of French queen Maria de' Medici.

There was also a renaissance in religious painting in Flanders from the beginning of the 17th century. In 1566, during the clashes between the Protestants and the Spanish rulers, the interiors of churches and monasteries across the Netherlands were damaged and stripped of their furnishings. This proved to be a fruitful stimulus for the subsequent religious painting of the Southern Netherlands, especially when political and economic stability set in after the Armistice of 1609. As the Counter-Reformation restored the Catholic dominance in Flanders, there was a huge

vertueuse du souverain. Des peintres flamands comme Jordaens, Rubens et Van Dyck réalisèrent ainsi de nombreux tableaux mythologiques, surtout pour les cours étrangères. Un des sommets de ces réalisations historiques exploitant les ressources de la mythologie à des fins de propagande politique est le *Cycle de Marie de Médicis* par Rubens, exaltant la gloire de l'épouse du roi Henri IV.

Dans les Flandres, au début du XVIIᵉ siècle, la peinture religieuse connut également un nouvel épanouissement. En 1566, pendant les hostilités entre protestants et pouvoir espagnol, l'ensemble des Pays-Bas connut une crise iconoclaste qui conduisit à la destruction et à l'endommagement d'églises, de monastères et des tableaux qui les ornaient. Cet épisode se révéla bénéfique pour la peinture religieuse des Pays-Bas méridionaux : au cours de la phase économique

der tugendhafte Herrscher. Vor allem für ausländische Höfe schufen flämische Maler wie Jacob Jordaens, Peter Paul Rubens und Anthonis van Dyck mythologische Gemälde. Einer der Höhepunkte dieser geschichtliche Ereignisse, herrscherliche Selbstdarstellung und Mythologie gekonnt verquickenden Kunstform ist Rubens' *Medici-Zyklus,* der die französische Königin Maria de' Medici verherrlicht.

Ebenfalls in Flandern gelangte Anfang des 17. Jahrhunderts die religiöse Malerei zu neuer Blüte. 1566 war es während der Auseinandersetzungen zwischen den Protestanten und den spanischen Machthabern in den gesamten Niederlanden zu einem Bildersturm gekommen, der Kirchen und Klöster mitsamt ihrer Gemälde zerstörte oder stark beschädigte. Für die religiöse Malerei der Südlichen Niederlande erwies sich dies als fruchtbar: In der

Peter Paul Rubens (1577–1640)

The Festival of Venus Verticordia	Das Venusfest (Fest der Venus Verticordia)	Il culto di Venere (Culto di Venere Verticordia)
La Fête de Vénus	La fiesta de venus	Feest ter ere van de Venus Verticordia

c. 1636/37, Oil on canvas/Huile sur toile, 217 × 350 cm, Kunsthistorisches Museum, Wien

gobernante virtuoso. Pintores flamencos como Jacob Jordaens, Peter Paul Rubens y Anthonis van Dyck crearon pinturas mitológicas especialmente para las cortes extranjeras. Uno de los puntos culminantes de esta forma de arte que combinaba con habilidad estos acontecimientos históricos, auto-representaciones de gobernantes y mitología es *El ciclo de la Vida*, de Rubens, que enaltece a la reina francesa María de Medici.

También en Flandes llegó la pintura religiosa de principios del siglo XVII a nuevas alturas. En 1566 se había producido un iconoclastia durante los enfrentamientos entre los protestantes y los gobernantes españoles en los Países Bajos, y las iglesias y los monasterios junto con sus pinturas fueron destruidos o gravemente dañados. Para la pintura religiosa de los Países Bajos del sur esto resultó

Rubens e Anthonis van Dyck dipinsero quadri mitologici soprattutto per corti straniere. Uno dei capolavori di questa forma artistica, magistralmente correlato alla mitologia e alla storia e usato come mezzo di autoautoespressione, è il *Ciclo di Maria de' Medici* di Rubens, che glorifica la regina francese.

Anche nelle Fiandre, la pittura religiosa conobbe all'inizio del XVII secolo una nuova fioritura. Nel 1566, durante gli scontri tra i protestanti e i governanti spagnoli in tutti i Paesi Bassi, ebbe luogo un'iconoclastia, nel corso della quale furono distrutti o gravemente danneggiati chiese e monasteri, insieme ai dipinti in essi conservati. Questo evento si rivelò fruttuoso per la pittura religiosa dei Paesi Bassi meridionali: nel periodo di stabilità politica ed economica che seguì l'armistizio del 1609, che coincise con la fase di rinnovo della fede cattolica per opera

Jordaens, Peter Paul Rubens en Anthonis van Dyck creëerden hun mythologische historiewerken vooral voor buitenlandse hoven. Een van de hoogtepunten van deze ideële kunstvorm, waarin geschiedenis, vorstelijke propaganda en mythologie op vernuftige wijze werden verweven, was Rubens' *Medici-cyclus,* waarin de Franse koningin Maria de' Medici werd verheerlijkt.

In Vlaanderen kwam begin zeventiende eeuw ook de religieuze schilderkunst tot nieuwe bloei. In 1566 vond te midden van de strijd tussen de protestanten en de Spaanse machthebbers overal in de Nederlanden een Beeldenstorm plaats, waarbij kerken en kloosters met al hun schilderijen werden verwoest of zwaar werden beschadigd. Voor de religieuze schilderkunst in de Zuidelijke Nederlanden bleek dit een nieuw begin: in een tijd van meer politieke en economische stabiliteit,

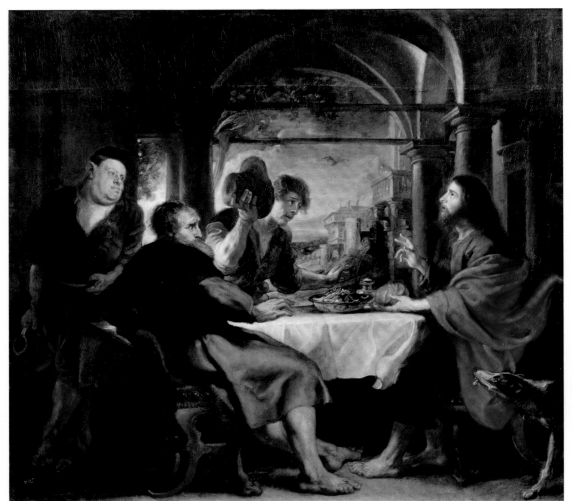

Peter Paul Rubens (1577–1640)

Christ in Emmaus

Le Christ à Emmaüs

Christus in Emmaus

Cristo en Emaús

Cena a Emmaus

Het avondmaal te Emmaüs

c. 1638, Oil on canvas/Huile sur toile,
144 × 157 cm, Museo del Prado, Madrid

Hendrick Terbrugghen (1588–1629)

Doubting Thomas

L'Incrédulité de saint Thomas

Der ungläubige Thomas

Tomás el incrédulo

Incredulità di San Tommaso

De ongelovige Thomas

c. 1622, Oil on canvas/Huile
sur toile, 108,8 × 136,5 cm,
Rijksmuseum, Amsterdam

demand for altar and devotional images. The province's rulers Isabella and Albrecht initiated a program to restore and rebuild its churches and outstanding artists such as Rubens and van Dyck, who had returned from Italy in 1608, were available to carry out this work.

The Protestants in the Dutch Republic, meanwhile, had rejected the use of imagery in their churches and most painters were more interested in secular subjects. Nevertheless, the Dutch commissioned many religious paintings, which, in accordance with the exact interpretation of the Scriptures by the Protestants, often emphasized the moral aspects of religion in the Old Testament and the life of Christ.

et politique plus stable qui suivit l'armistice de 1609, période où la foi catholique revient en force grâce à la Contre-Réforme, se manifesta un énorme besoin de retables et de tableaux de dévotion. Les régents Isabelle et Albert initièrent alors un programme de restauration et de construction d'églises : des artistes éminents comme Rubens (revenu d'Italie en 1608) et Van Dyck participèrent à la réalisation des tableaux devenus nécessaires.

Dans les Pays-Bas septentrionaux où les protestants refusaient les représentations religieuses dans les églises, la plupart des peintres s'intéressaient plutôt aux sujets profanes. De nombreux tableaux religieux y furent quand même réalisés, exaltant souvent – en correspondance avec des interprétations précises de l'Écriture – les leçons morales contenues dans des épisodes de l'Ancien Testament et dans la vie du Christ.

politisch und ökonomisch stabileren Phase nach dem Waffenstillstand von 1609, die zudem in die Zeit fiel, in der der katholische Glaube durch die Gegenreformation erneuert wurde, wurde einem riesigen Bedarf an Altar- und Andachtsbildern entsprochen. Die Statthalter Isabella und Albrecht initiierten ein Programm des Neu- und Wiederaufbaus von Kirchen, und für das Ausführen von Bildern standen herausragende Künstler wie der 1608 aus Italien zurückgekehrte Rubens und van Dyck zur Verfügung.

Die Protestanten in den Nördlichen Niederlanden lehnten religiöse Darstellungen in den Kirchen ab, und die meisten Maler interessierten sich eher für weltliche Sujets. Dennoch entstanden auch in Holland viele religiöse Gemälde, welche im Einklang mit der genauen Auslegung der Heiligen Schrift durch die Protestanten häufig die moralischen Aspekte betonen, die sie in Geschichten des Alten Testaments und im Leben Christi fanden.

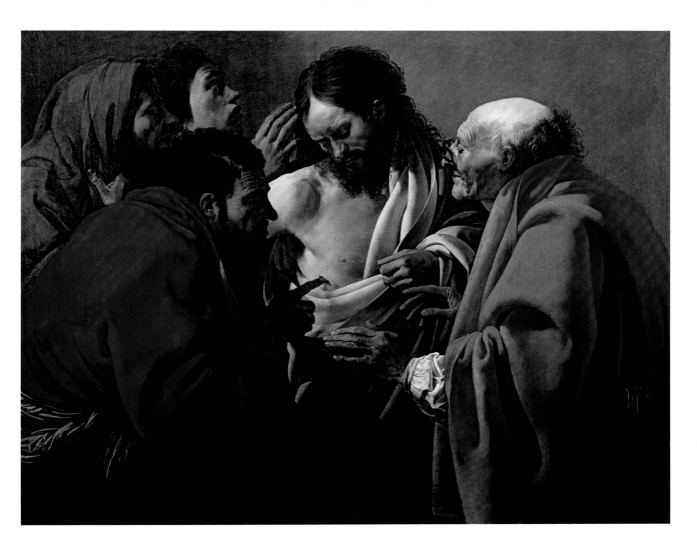

fructífero: en la fase política y económicamente estable después del armisticio de 1609, que también cayó en el momento en el que la fe católica fue renovada por la Contrarreforma, hubo una enorme demanda de imágenes devocionales y de altar. Los gobernantes Isabel y Alberto iniciaron un programa para reconstruir y hacer nuevas iglesias, y para las imágenes que se necesitaban estaban a disposición artistas destacados como Van Dyck o Rubens, que había regresado de Italia en 1608.

Los protestantes de los Países Bajos del norte rechazaron las representaciones religiosas en las iglesias, y la mayoría de los pintores estaban interesados en temas más mundanos. Sin embargo, se crearon en Holanda muchas pinturas religiosas que a menudo resaltaban los aspectos morales que se encontraban en las historias del Antiguo Testamento y en la vida de Cristo de acuerdo con la interpretación exacta de la Escritura por los protestantes.

della Controriforma, fu infatti soddisfatta un'enorme necessità di pale d'altare e dipinti devozionali. I governatori Isabella e Alberto avviarono un programma di ricostruzione e nuova edificazione di chiese, potendo contare per la produzione dei quadri su artisti eccezionali quali van Dyck e Rubens, tornato dall'Italia nel 1608.

Nei Paesi Bassi settentrionali, invece, i protestanti respinsero le rappresentazioni religiose nei luoghi di culto, pertanto la maggior parte dei pittori si dedicò piuttosto a soggetti profani. Ciononostante, anche in Olanda vennero prodotti numerosi dipinti religiosi, che spesso mettevano in risalto gli aspetti morali promossi dai protestanti in linea con un'interpretazione esatta delle Sacre Scritture, i quali potevano essere rinvenuti nelle storie dell'Antico Testamento e nella Vita di Gesù.

na de wapenstilstand van 1609 (bovendien een tijd waarin het katholieke geloof door de Contrareformatie nieuw zelfbewustzijn had gekregen), ontstond een grote naar altaar- en votiefstukken. De landvoogden Isabella en Albrecht begonnen een programma voor de bouw of renovatie van kerken en de uitvoering van schilderwerken door uitmuntende kunstenaars als Van Dyck en de in 1608 uit Italië teruggekeerde Rubens.

De protestanten in de Noordelijke Nederlanden wezen religieuze afbeeldingen in kerken af, en de meeste schilders interesseerden zich hier meer voor wereldlijke onderwerpen. Toch ontstonden ook in Holland veel religieuze werken, die in detail aansloten op de protestantse uitleg van de Bijbel en in het uitbeelden van scènes uit het Oude en Nieuwe Testament een duidelijk moralistische boodschap uitdroegen.

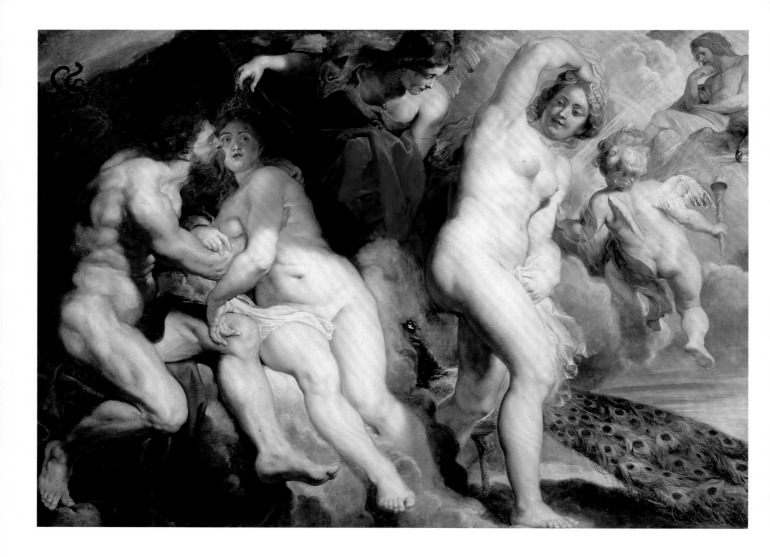

Peter Paul Rubens (1577–1640)

Ixion Deceived by Juno

Ixion, roi des Lapithes, trompé par Junon, qu'il voulait séduire

Ixion, von Juno getäuscht

Ixión engañado por Juno

Issione ingannato da Giunone

De verleiding van Ixion door Hera

c. 1615, Oil on canvas/Huile sur toile, 175 × 245 cm, Musée du Louvre, Paris

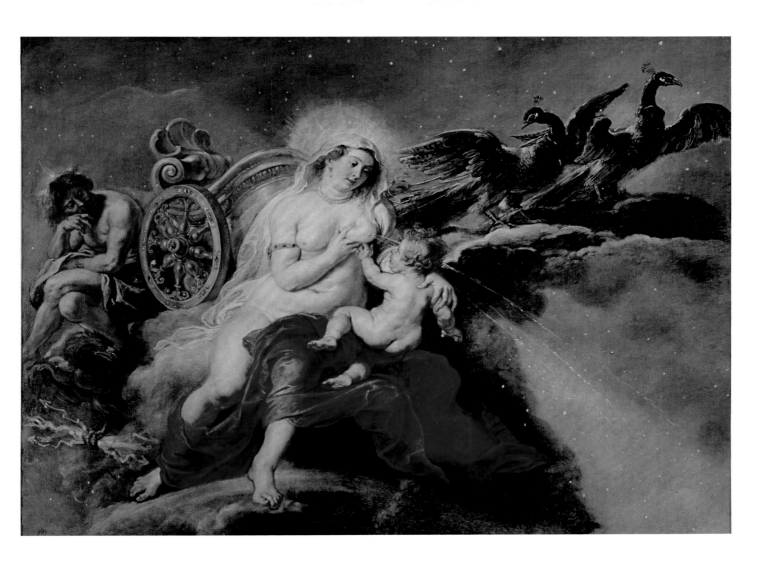

Peter Paul Rubens (1577–1640)

The Creation of the Milky Way

La Naissance de la Voie lactée

Die Entstehung der Milchstraße

La formación de la Vía Láctea

L'origine della Via Lattea

Het ontstaan van de Melkweg

1636–38, Oil on canvas/Huile sur toile, 181 × 244 cm, Museo del Prado, Madrid

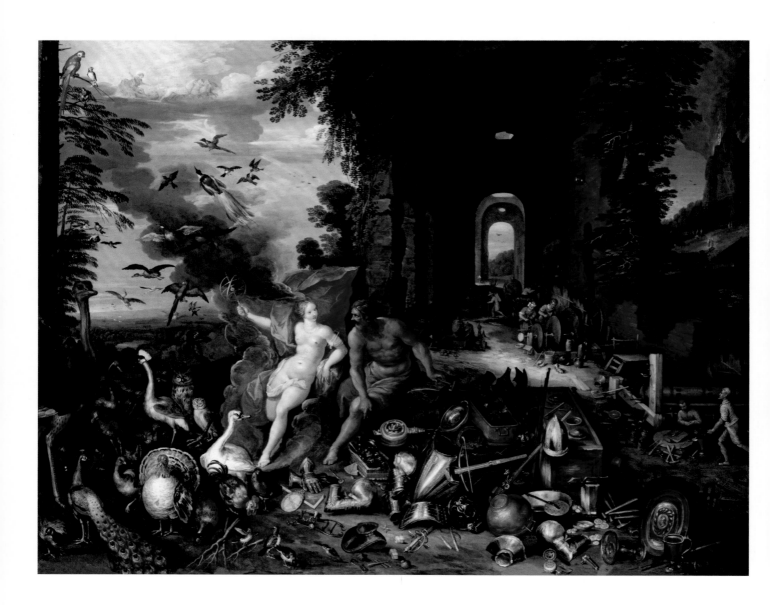

Jan Brueghel de Jonge/the Younger/le Jeune (1601–78), Frans Francken de Jonge/the Younger/le Jeune (1581–1642)

Allegory of Fire and Air with Venus in Vulcan's Workshop

Allégorie du feu et de l'air

Allegorie des Feuers und der Luft mit Venus in der Schmiede des Vulkan

Alegoría del fuego y el aire con Venus en la fragua de Vulcano

Allegoria del fuoco e dell'aria con Venere nella Fucina di Vulcano

Allegorie van het Vuur en de Lucht met Venus in de smidse van Vulcanus

c. 1640, Oil on copper/Huile sur plaque de cuivre, 50,8 × 63,5 cm, Private collection

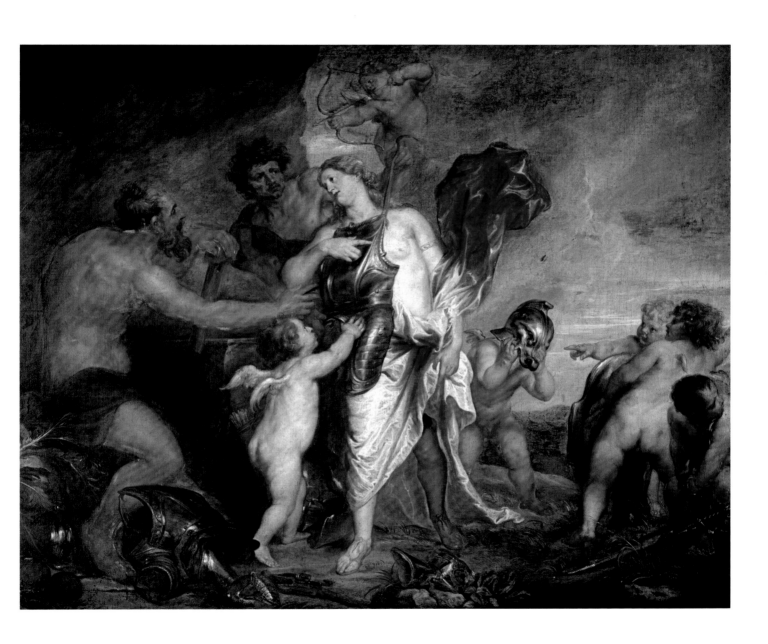

Anthonis van Dyck (1599–1641)

Thetis Accepting Achilles' Weapons from Hephaistos

Héphaïstos donnant à Thétis les armes d'Achille

Thetis empfängt von Hephaistos die Waffen für Achill

Tetis recibe de Hefesto las armas de Aquiles

Teti riceve da Efesto le armi per Achille

Thetis ontvangt van Hephaistos de wapens voor Achilles

c. 1630–32, Oil on canvas/Huile sur toile, 117 × 156 cm, Kunsthistorisches Museum, Wien

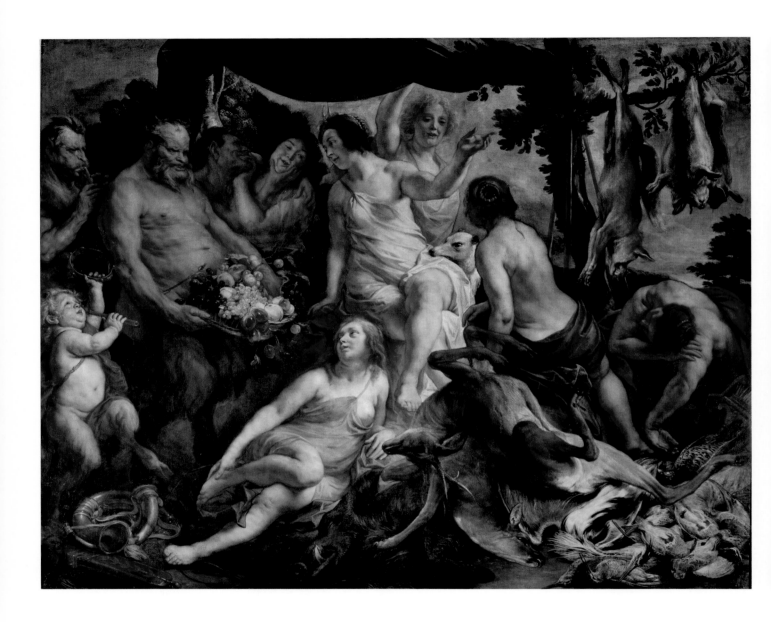

Jacob Jordaens (1593–1678)

Diana Resting after the Hunt

Le Repos de Diane après la chasse

Die Rast der Diana nach der Jagd

El descanso de Diana después de la caza

Il riposo di Diana dopo la caccia

De rustende Diana na de jacht

c. 1640–50, Oil on canvas/Huile sur toile, 203 × 254 cm, Musée du Louvre, Paris

Jan Vermeer van Delft (1632–75)

Diana and Her Companions

Diane et ses compagnes

Diana mit ihren Gefährtinnen

Diana y sus compañeras

Diana e le ninfe

Diana en haar metgezellinnen

c. 1653/54, Oil on canvas/Huile sur toile, 97,8 × 104,6 cm, Mauritshuis, Den Haag

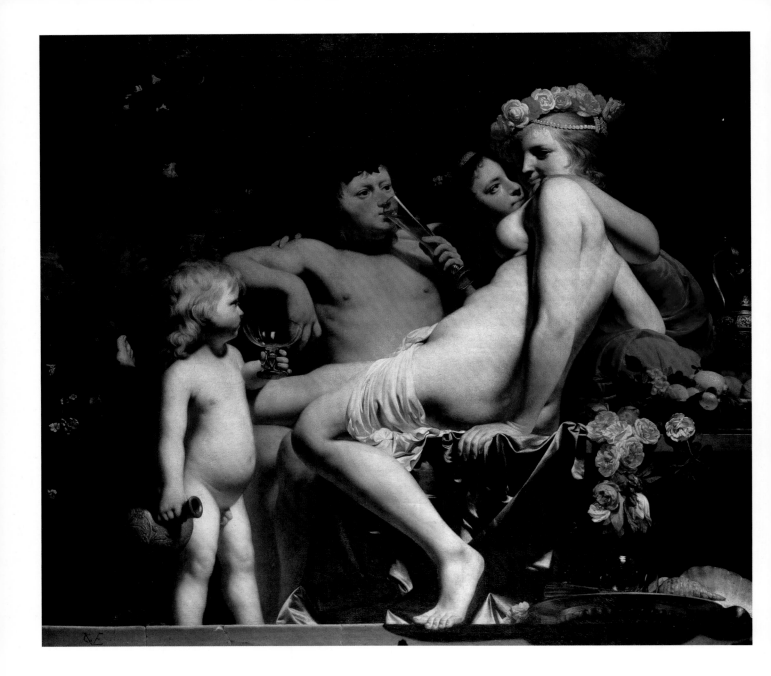

Caesar Boetius van Everdingen (1616/17–78)

Bacchus and Ariadne on Naxos

Bacchus et Ariane

Bacchus und Ariadne auf Naxos

Baco y Ariadna en Naxos

Bacco e Arianna a Nasso

Bacchus en Ariadne op Naxos

c. 1650–60, Oil on canvas/Huile sur toile, 147 × 161 cm, Gemäldegalerie Alte Meister, Dresden

Dutch/Hollandaise

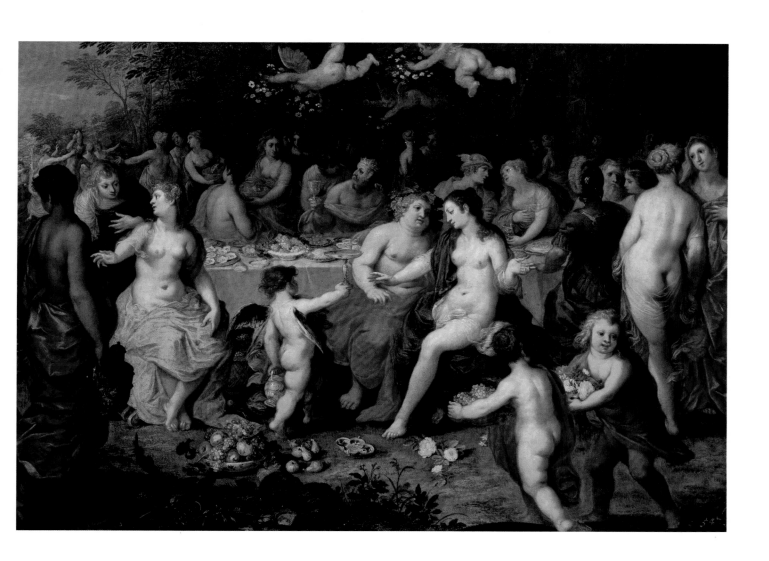

Hendrik van Balen (1575–1632)

The Wedding of Bacchus and Ariadne

Les Noces de Bacchus et Ariane

Die Vermählung von Bacchus und Ariadne

La boda de Baco y Ariadna

Le nozze di Bacco e Arianna

Het bruiloftsmaal van Bacchus en Ariadne

c. 1630, Oil on copper/Huile sur plaque de cuivre, 36,5 × 51,5 cm, Gemäldegalerie Alte Meister, Dresden

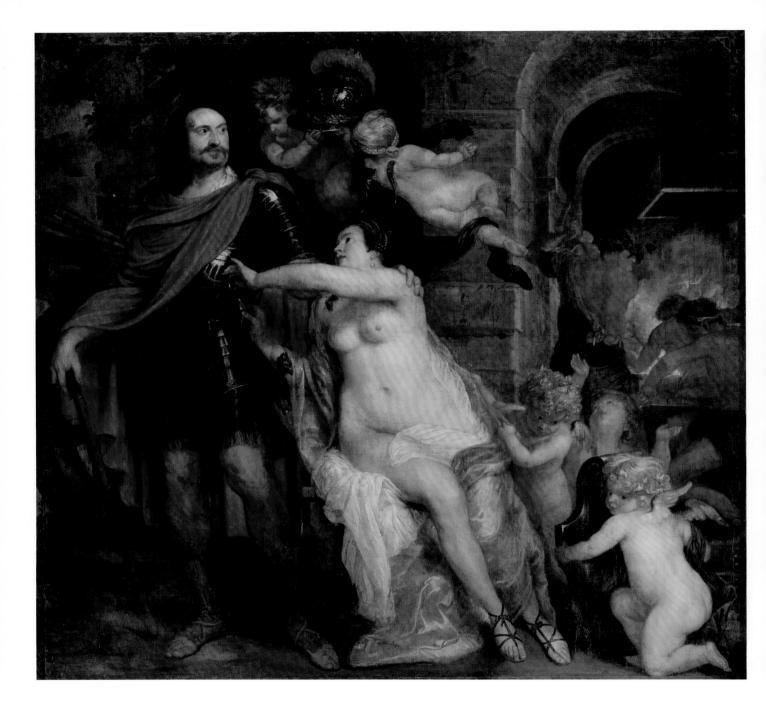

Thomas Willeboirts Bosschaert (1613–54)

Allegory: Mars Accepting the Weapons from Venus and Vulcan

Allégorie de Mars recevant ses armes des mains de Vénus et Vulcain

Allegorie: Mars erhält von Venus und Vulkan die Waffen

Alegoría: Marte recibe las armas de Venus y Vulcano

Allegoria: Marte riceve le armi da Venere e Vulcano

Allegorie op de vrede: Frederik Willem ontvangt als Mars de wapenen van Venus en Vulcanus

c. 1650, Oil on canvas/Huile sur toile, 225 × 238,5 cm, Rijksmuseum, Amsterdam

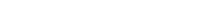

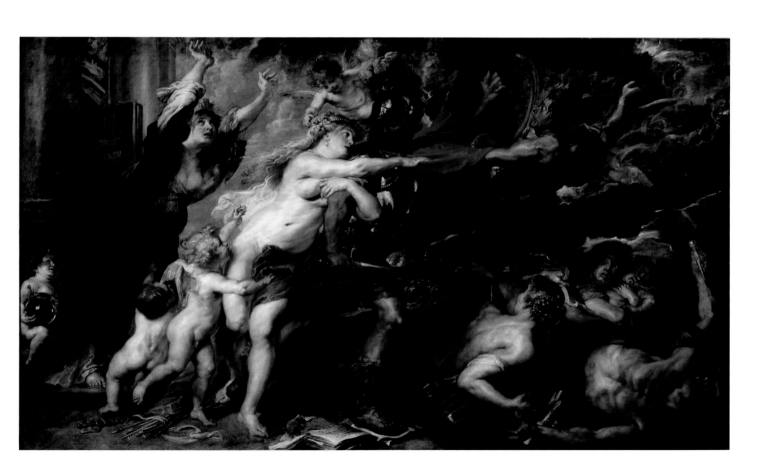

Peter Paul Rubens (1577–1640)

The Consequences of War

Les Horreurs de la guerre

Die Folgen des Krieges

Las consecuencias de la guerra

Le conseguenze della guerra

De gruwelen van de oorlog

c. 1637/38, Oil on canvas/Huile sur toile, 206 × 345 cm, Galleria Palatina, Palazzo Pitti, Firenze

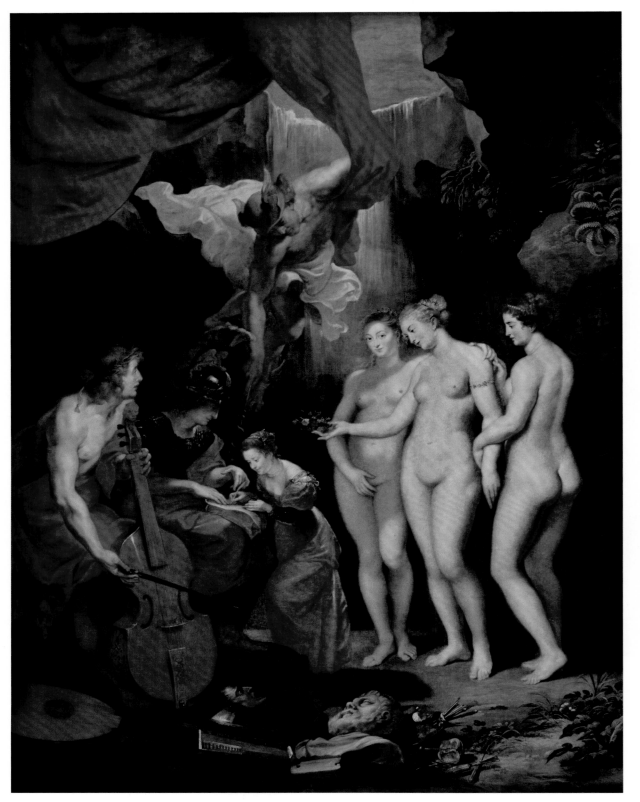

Peter Paul Rubens
(1577–1640)

Medici Cycle:
The Education of
Maria de' Medici

Cycle de la vie de
Marie de Médicis :
L'Instruction
de la reine

Medici-Zyklus:
Die Erziehung der
Maria de' Medici

El ciclo de la vida:
la educación de
María de Medici

Ciclo di Maria de'
Medici: L'educazione
della regina

Medici-cyclus: Het
onderricht van
Maria de' Medici

1622–25, Oil on
canvas/Huile sur toile,
394 × 295 cm, Musée
du Louvre, Paris

Peter Paul Rubens
(1577–1640)

The Three Graces

Les Trois Grâces

Die drei Grazien

Las tres gracias

Le tre Grazie

De Drie Gratiën

1630–35, Oil on
wood/Huile sur bois,
220,5 × 182 cm,
Museo del
Prado, Madrid

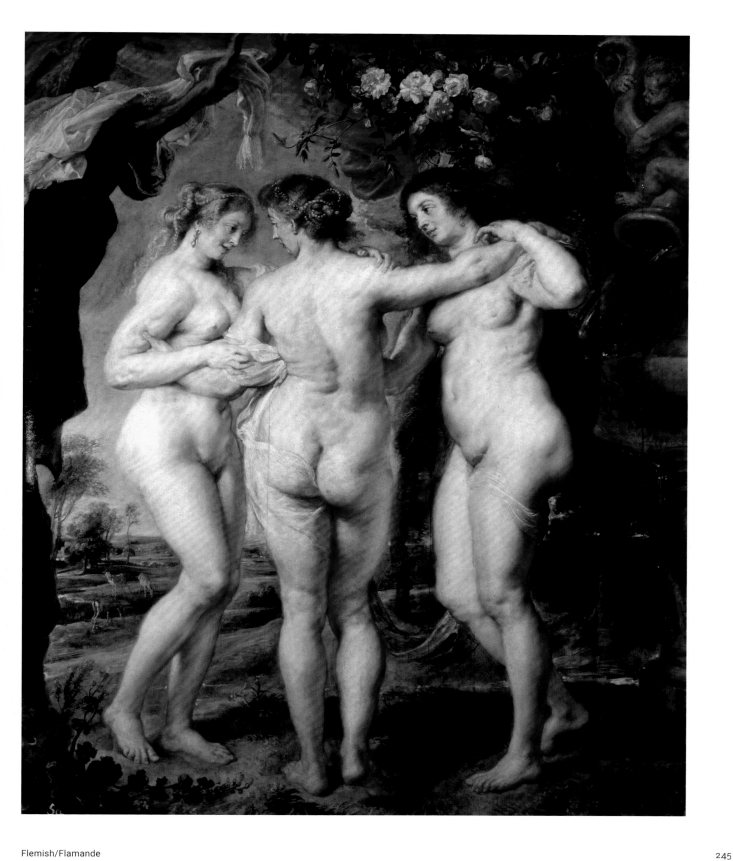

Flemish/Flamande

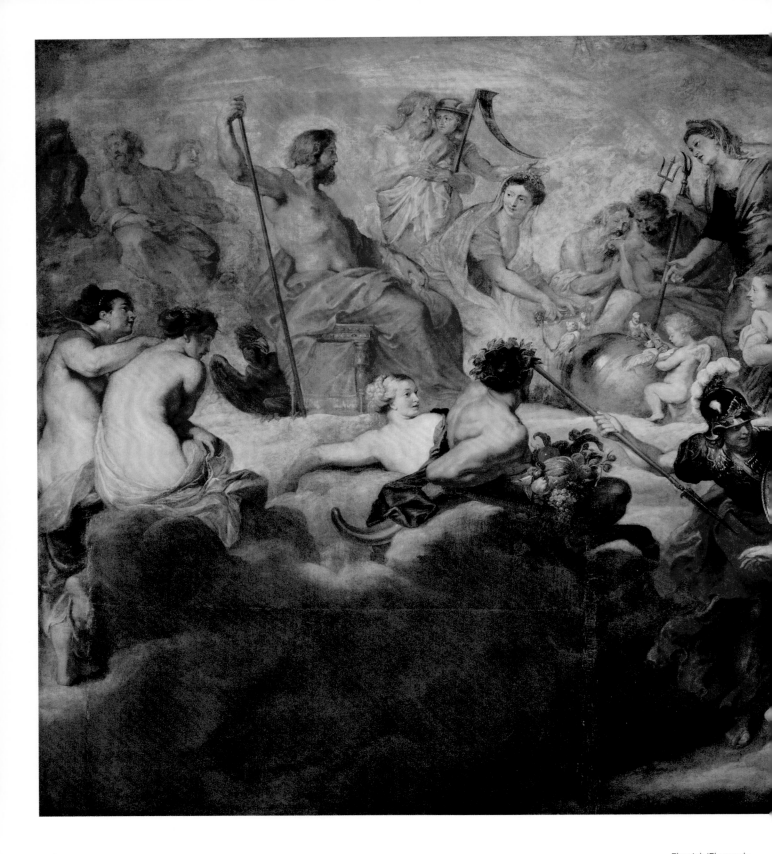

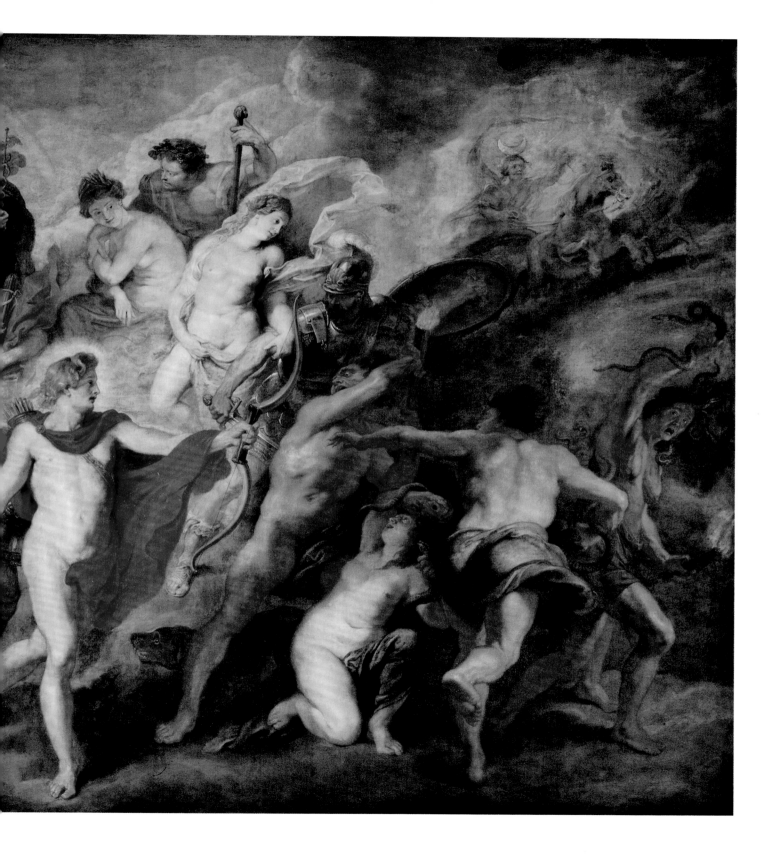

p. 246/247

Peter Paul Rubens (1577–1640)

Medici Cycle: The Council of the Gods

Cycle de la vie de Marie de Médicis : Le Conseil des dieux

Medici-Zyklus: Der Götterrat

El ciclo de la vida: El consejo de los dioses

Ciclo di Maria de' Medici: Il consiglio degli dei

Medici-cyclus: De goden op de Olympus

1622–25, Oil on canvas/Huile sur toile, 394 × 702 cm, Musée du Louvre, Paris

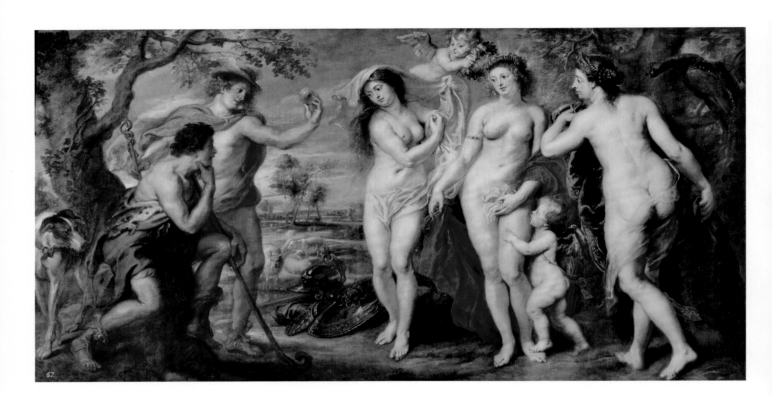

Peter Paul Rubens (1577–1640)

The Judgment of Paris

Le Jugement de Pâris

Das Urteil des Paris

El juicio de Paris

Il giudizio di Paride

Het Oordeel van Paris

c. 1638, Oil on canvas/Huile sur toile, 199 × 381 cm, Museo del Prado, Madrid

Jan Dirksz. Both (c. 1615–52), Cornelis van Poelenburgh (1594/95–1667)

Landscape with the Judgment of Paris

Paysage avec le jugement de Pâris

Landschaft mit dem Urteil des Paris

Paisaje con el juicio de Paris

Paesaggio con il giudizio di Paride

Landschap met het Oordeel van Paris

c. 1645–50, Oil on canvas/Huile sur toile, 97 × 129 cm, National Gallery, London

Dutch/Hollandaise

Roelant Savery (c. 1576–1639)

The Paradise, with the Fall from the Garden of Eden

Le Paradis, avec la Chute en arrière-plan

Das Paradies mit dem Sündenfall

El paraíso con el pecado original

Il paradiso con il peccato originale sullo sfondo

Het Paradijs met op de achtergrond de Zondeval

1628, Oil on copper/Huile sur plaque de cuivre, 41 × 57,3 cm, Kunsthistorisches Museum, Wien

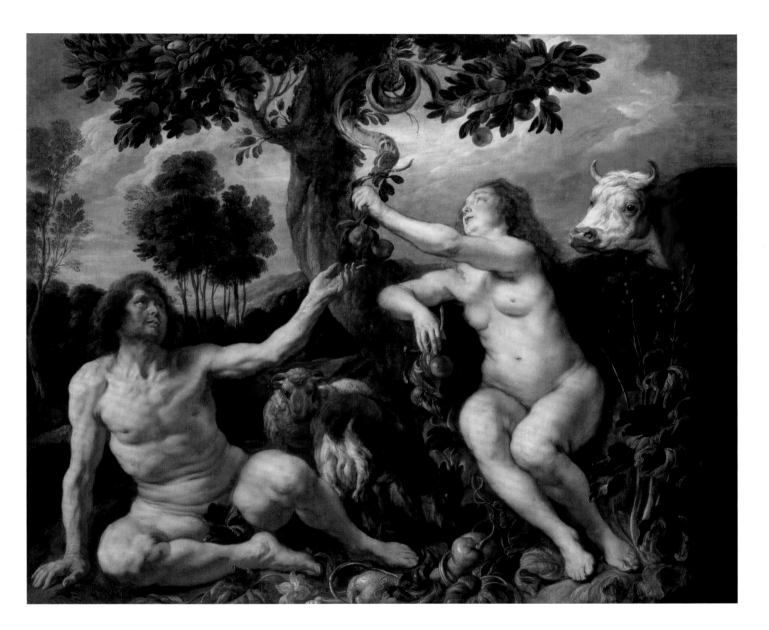

Jacob Jordaens (1593–1678)

The Fall

Adam et Ève *ou* La Chute

Der Sündenfall

El pecado original

Il peccato originale

De Zondeval

c. 1630, Oil on canvas/Huile sur toile, 184,5 × 221 cm, Szépművészeti Múzeum, Budapest

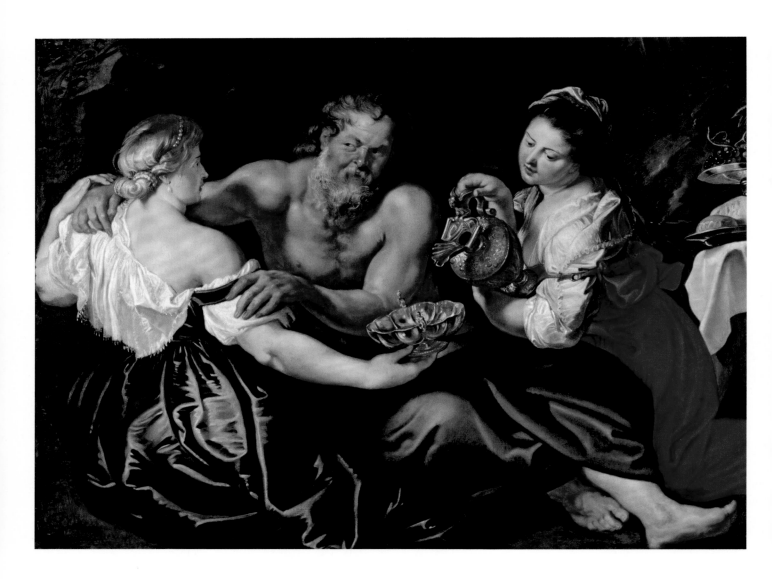

Peter Paul Rubens (1577–1640)

Lot and His Daughters

Loth et ses filles

Lot und seine Töchter

Lot y sus hijas

Lot e le sue figlie

Lot en zijn dochters

c. 1610/11, Oil on canvas/Huile sur toile, 108 × 146 cm, Staatliches Museum, Schwerin

Frans Francken de Jonge/the Younger/le Jeune (1581–1642)

Lot with His Daughters

Loth et ses filles

Lot mit seinen Töchtern

Lot con sus hijas

Lot con le sue figlie

Lot met zijn dochters

c. 1620, Oil on wood/Huile sur bois, 56 × 76 cm, Museo de Santa Cruz, Toledo

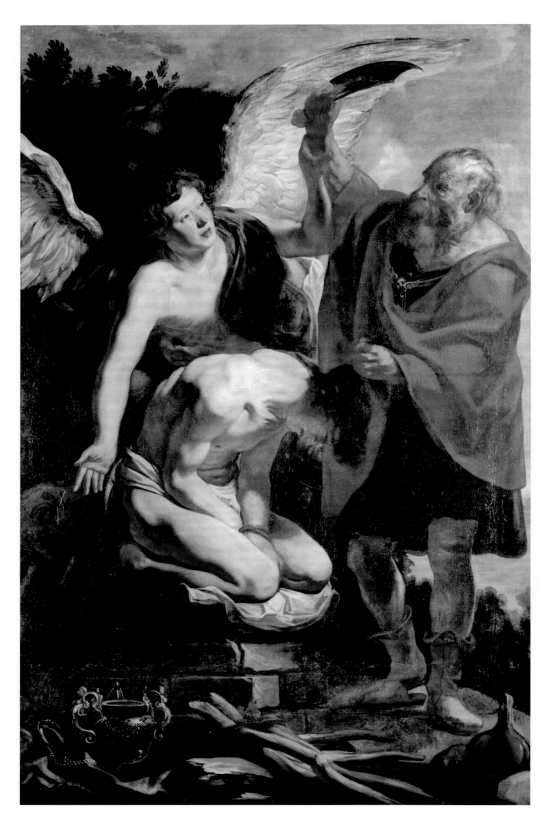

Jacob Jordaens (1593–1678)

The Sacrifice of Isaac

Le Sacrifice d'Isaac

Die Opferung Isaaks

El sacrificio de Isaac

Il sacrificio di Isacco

De engel weerhoudt Abraham om Isaak te offeren

1625/26, Oil on canvas/Huile sur toile,
242 × 155 cm, Pinacoteca di Brera, Milano

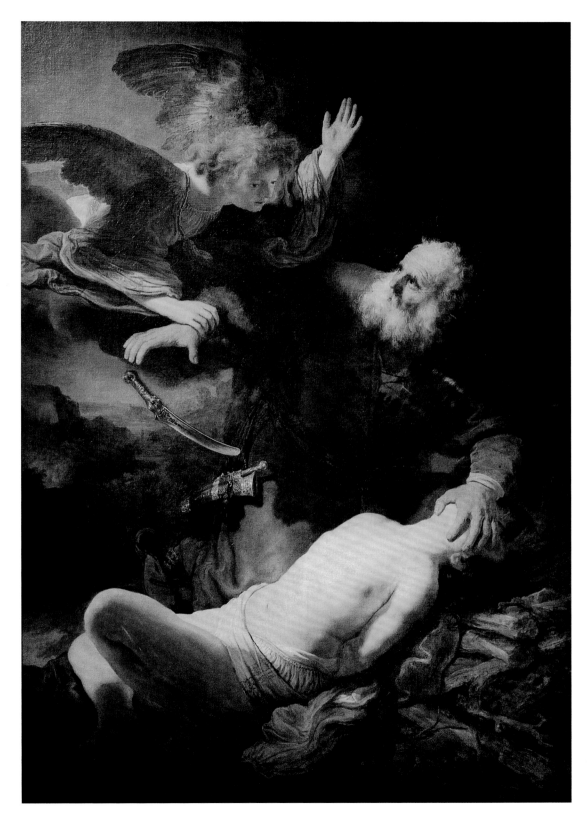

Rembrandt Harmensz. van Rijn
(1606–69)

The Sacrifice of Isaac

Le Sacrifice d'Isaac

Die Opferung Isaaks

El sacrificio de Isaac

Sacrificio di Isacco

Het offer van Abraham

1635, Oil on canvas/Huile sur toile,
193 × 132 cm, State Hermitage
Museum, St. Petersburg

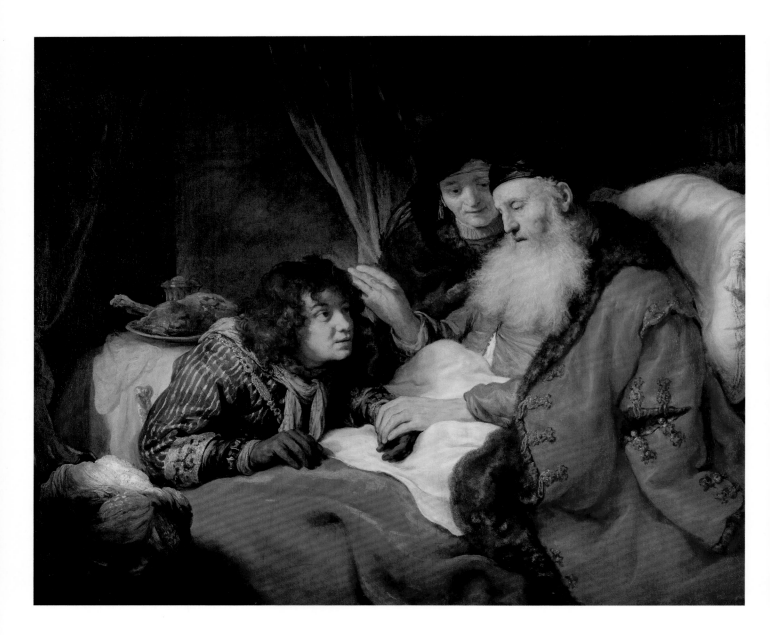

Govert Flinck (1615–60)

Isaac Blessing Jacob

Isaac bénissant Jacob

Isaak segnet Jakob

Isaac bendice a Jacob

Isacco benedice Giacobbe

Isaak zegent Jakob

c. 1638, Oil on canvas/Huile sur toile, 117 × 141 cm, Rijksmuseum, Amsterdam

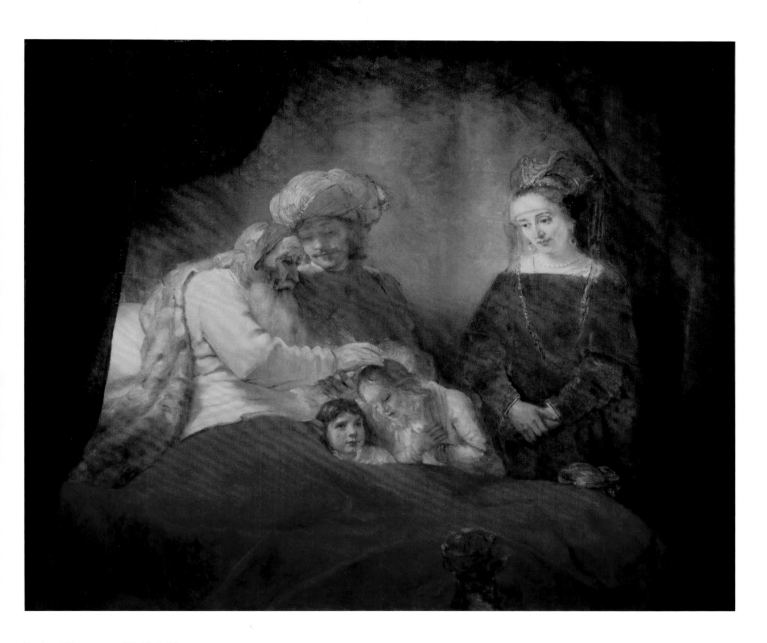

Rembrandt Harmensz. van Rijn (1606–69)

Jacob Blessing Ephraim and Manasseh

Jacob bénissant Ephraïm et Manassé

Jakob segnet Ephraim und Manasse

Jacob bendice a Efraín y Manasés

Jacob benedice Efraim e Manasse

Jakob zegent Efraïm en Manasse

1656, Oil on canvas/Huile sur toile, 173 × 209 cm, Gemäldegalerie Alte Meister, Kassel

Jan Steen (1626–79)
Esther before Ahasuerus, *Detail*
Esther devant Assuérus, *détail*
Esther vor Ahasver, *Detail*
Ester ante Asuero, *detalle*
Ester davanti ad Assuero, *particolare*
Esther voor Ahasveros, *detail*
1665–69, Oil on canvas/Huile sur toile, 106 × 83,5 cm, State Hermitage Museum, St. Petersburg

During the Babylonian captivity of the Israelites, Esther was able to persuade her husband, the Persian king Ahasuerus, not to destroy the Jewish people after palace intrigue had caused them to fall into disrepute. The book of Esther proved to be an exciting source of many motifs for works of art, as seen in numerous Baroque paintings. This was especially the case in the Dutch Republic, where Rembrandt also devoted several works to this subject.

Dans le temps de l'exil à Babylone, Esther – favorite juive du roi perse Assuérus – réussit à convaincre ce dernier de ne pas exterminer le peuple hébreu tombé en disgrâce à la suite des intrigues du vizir Aman. Dans l'Ancien Testament, le Livre d'Esther est une histoire passionnante offrant de nombreux sujets de tableau. De nombreuses toiles baroques attestent de sa popularité – en particulier dans les Pays-Bas septentrionaux (où Rembrandt a plusieurs fois traité ce thème).

Die Jüdin Esther konnte während der babylonischen Gefangenschaft der Israeliten ihren Gatten, den persischen König Ahasver, überzeugen, das durch eine Intrige in Misskredit geratene jüdische Volk nicht zu vernichten. Das Buch Esther des Alten Testaments ist eine spannende Erzählung, in der sich viele Bildmotive finden ließen. Zahlreiche barocke Gemälde belegen, wie beliebt es war – insbesondere in den Nördlichen Niederlanden, wo sich auch Rembrandt mehrfach diesem Thema widmete.

La judía Ester pudo persuadir a su marido, el rey persa Asuero, de no destruir al pueblo judío, desacreditado por una conspiración de los judíos durante la cautividad babilónica de los israelitas. El Libro de Ester del Antiguo Testamento es una historia apasionante en la que se podían encontrar muchos motivos. Numerosas pinturas barrocas muestran lo popular que era – sobre todo en los Países Bajos del norte, donde Rembrandt se dedicó varias veces a este tema.

Durante l'esilio babilonese dei Giudei, l'ebrea Ester riuscì a convincere suo marito, il re persiano Assuero, a non distruggere il popolo ebraico, che era caduto in discredito a causa di un complotto. Il Libro di Ester contenuto nell'Antico Testamento è una storia emozionante, da cui possono essere tratti numerosi motivi artistici. Molti dipinti barocchi testimoniano la popolarità, soprattutto nei Paesi Bassi settentrionali, di questa storia, la quale fu portata più volte su tela anche da Rembrandt.

Tijdens de Babylonische Ballingschap van de Israëlieten wist de Joodse Esther haar echtgenoot, de Perzische koning Ahasveros, ervan te overtuigen om het Joods volk (dat door een intrige in ongenade was gevallen) niet te vernietigen. Het Bijbelboek Esther uit het Oude Testament is een spannend verhaal waarin kunstenaars talloze beeldmotieven konden vinden. Veel barokschilderijen getuigen dan ook van de populariteit van dit verhaal – met name in de Noordelijke Nederlanden, waar ook Rembrandt zich meermalen aan dit thema wijdde.

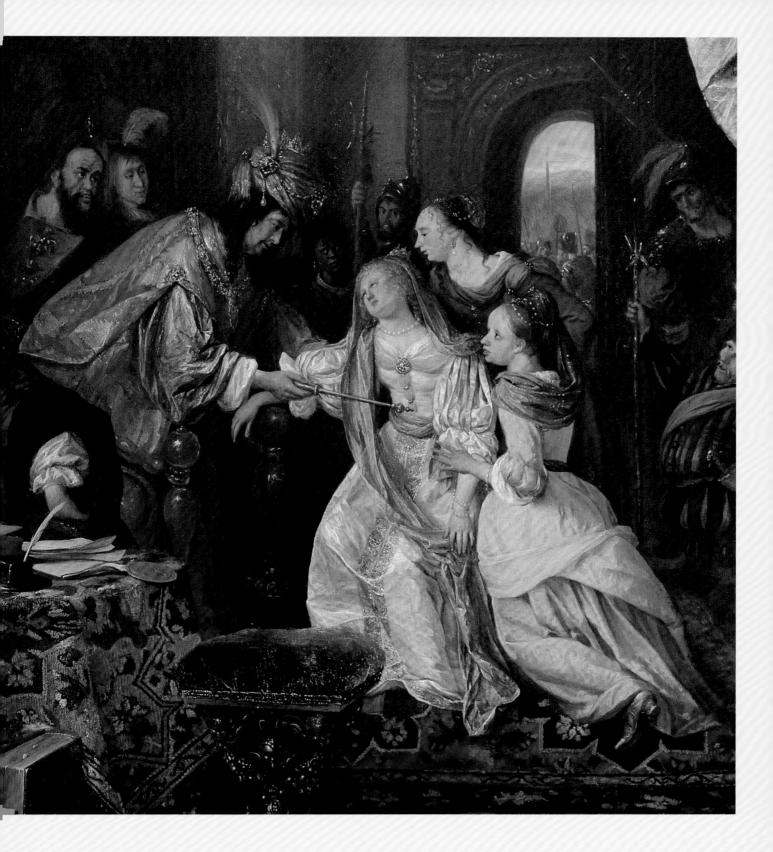

Aert de Gelder (1645–1727)

King Ahasuerus Honoring Mordecai

Le Roi Assuérus honorant Mardochée

König Ahasver ehrt Mardochai

El rey Asuero honra a Mardoqueo

Il re Assuero onora Mardocheo

Koning Ahasveros eert Mordechai

c. 1685, Oil on canvas/Huile sur toile, 79 × 94,5 cm, Statens Museum for Kunst, København

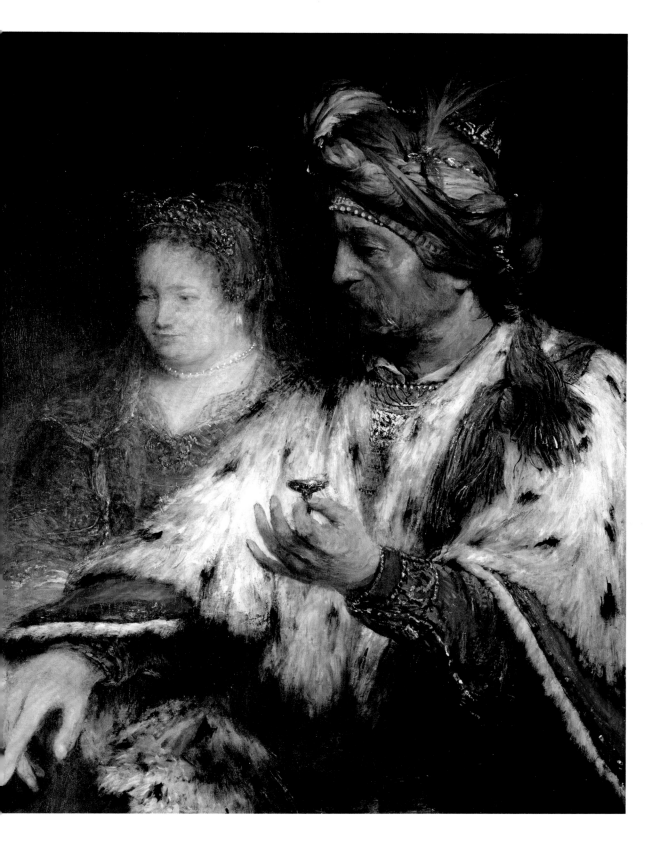

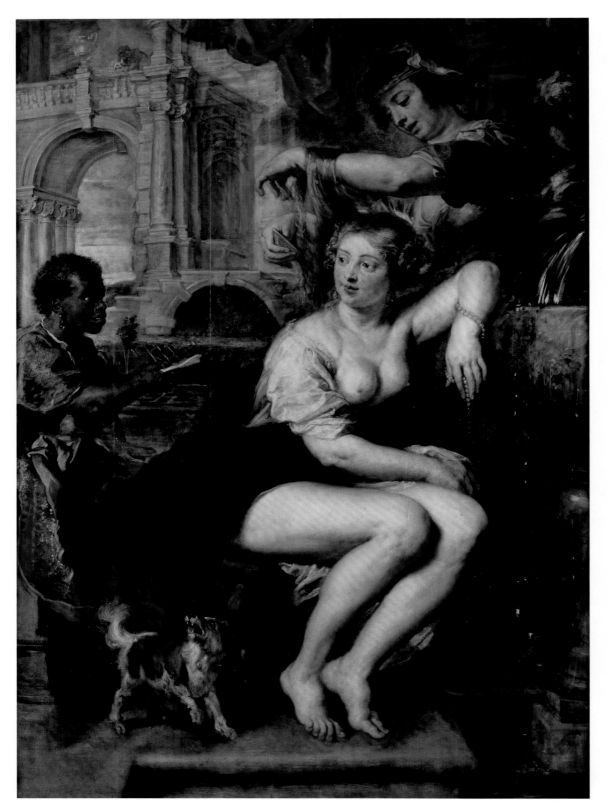

**Peter Paul Rubens
(1577–1640)**

Bathsheba Taking Her Bath

Bethsabée à la fontaine,
recevant la lettre de David

Bathseba am Springbrunnen

Betsabé en una fuente

Betsabea alla fontana

Bathsheba bij de put

c. 1635, Oil on wood/Huile
sur bois, 175 × 126 cm,
Gemäldegalerie Alte
Meister, Dresden

Willem Drost (1633–59)

Bathsheba Receiving
King David's Letter

Bethsabée recevant
la lettre de David

Bathseba empfängt den
Brief König Davids

Betsabé recibe la carta
del rey David

Betsabea con la lettera di David

Bathsheba ontvangt de
brief van koning David

1654, Oil on canvas/Huile
sur toile, 103 × 87 cm,
Musée du Louvre, Paris

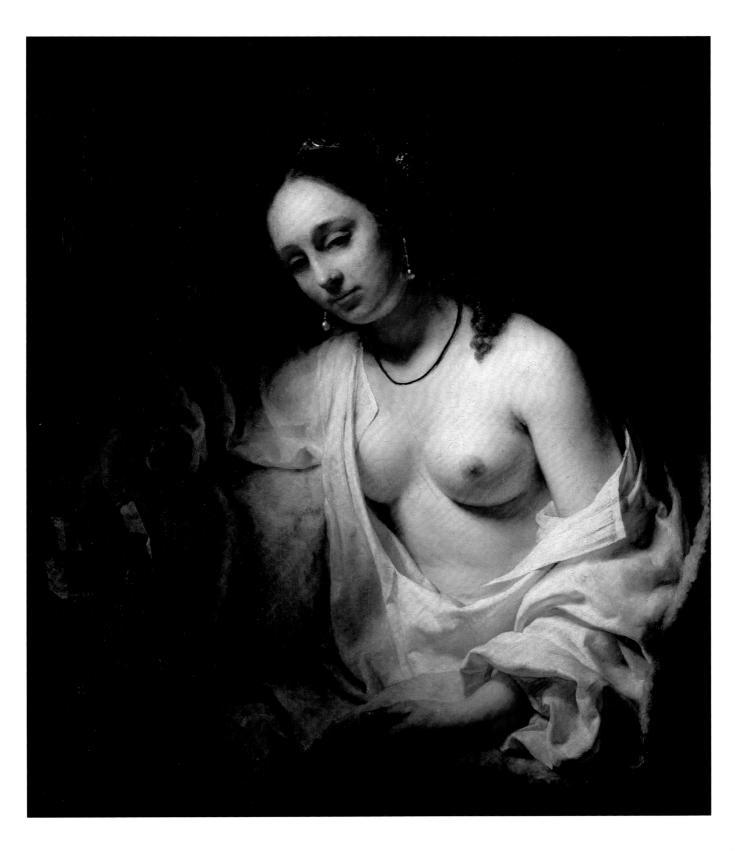

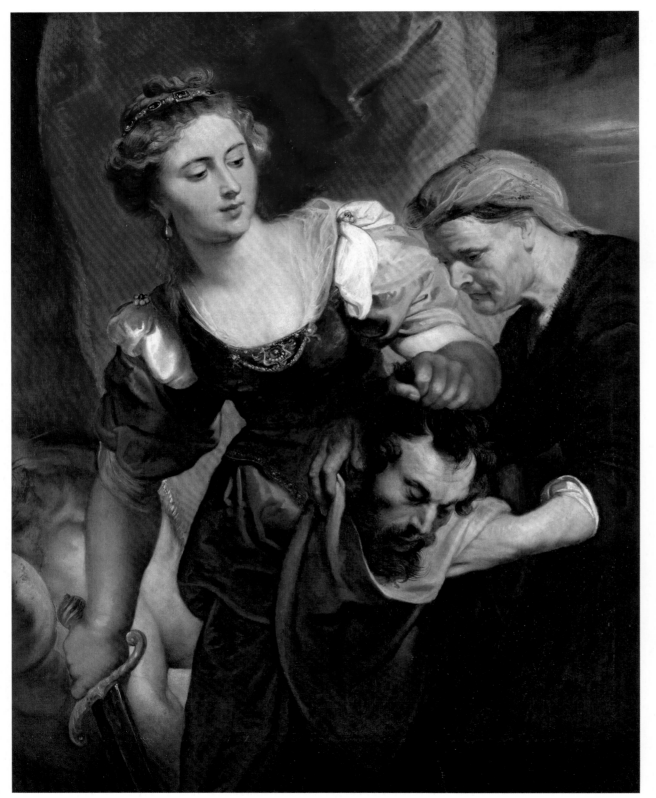

Peter Paul
Rubens
(1577–1640)

Judith with
the Head of
Holofernes

Judith
tenant la tête
d'Holopherne

Judith mit
dem Haupt des
Holofernes

Judit con la
cabeza de
Holofernes

Giuditta con
la testa di
Oloferne

Judith met
het hoofd van
Holofernes

1625, Oil on
canvas/Huile sur
toile, 113 × 89 cm,
Galleria degli
Uffizi, Firenze

Jan de Bray
(c. 1627–97)

Judith and
Holofernes

Judith et
Holopherne

Judith und
Holofernes

Judit y
Holofernes

Giuditta e
Oloferne

Judith en
Holofernes

1659, Oil on
wood/Huile
sur bois,
40 × 32,5 cm,
Rijksmuseum,
Amsterdam

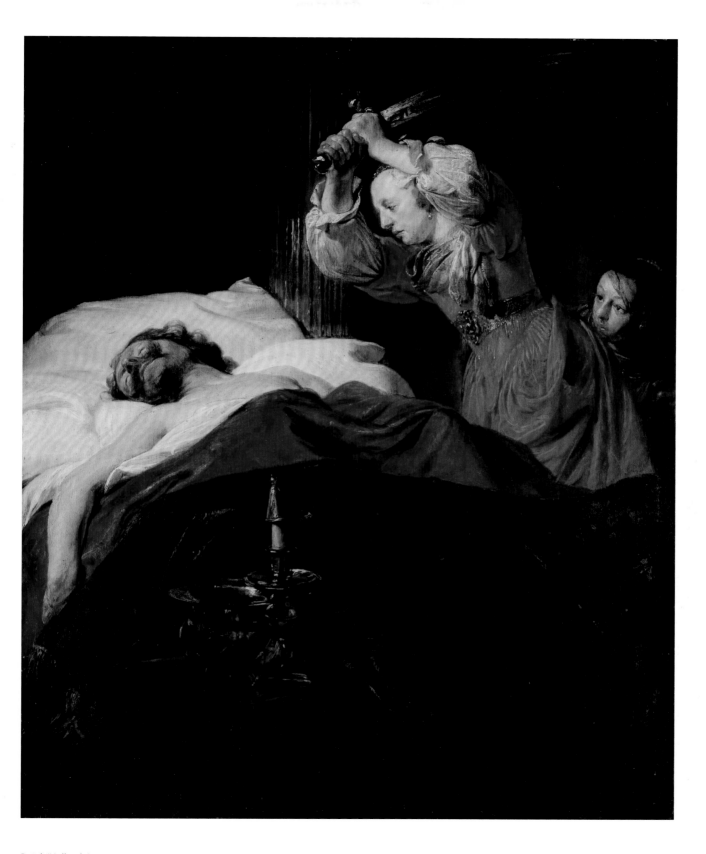

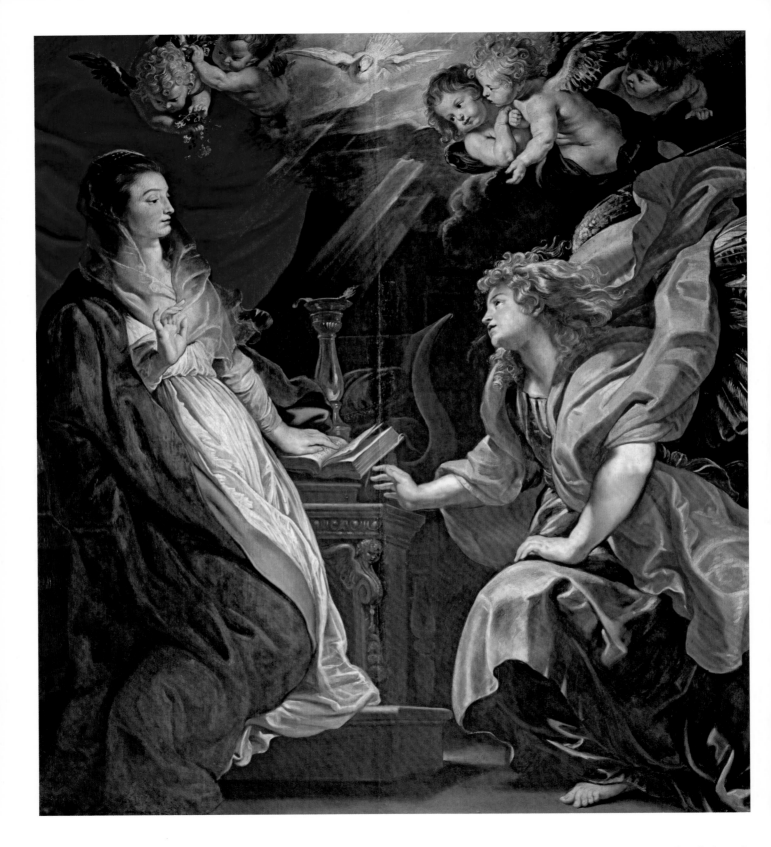

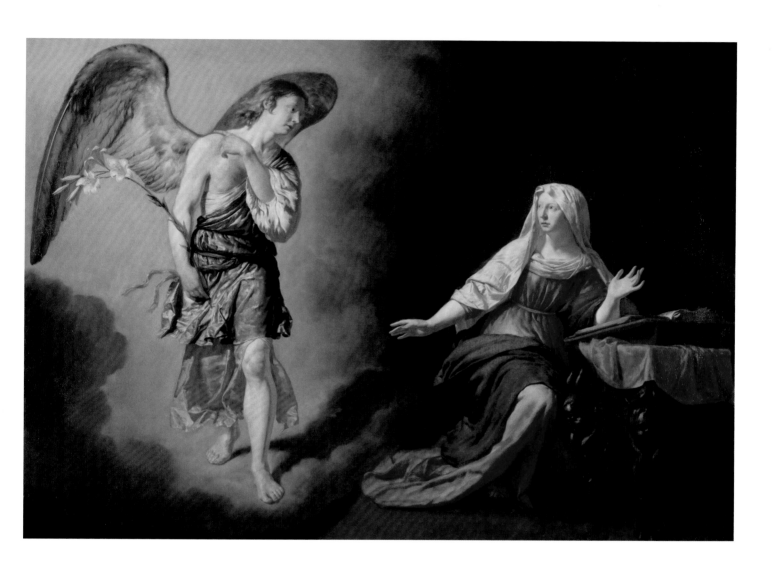

Peter Paul Rubens (1577–1640)

The Annunciation

L'Annonciation

Verkündigung Mariae

La Anunciación

Annunciazione

De Aankondiging

c. 1609, Oil on canvas/Huile sur toile, 225 × 202 cm, Kunsthistorisches Museum, Wien

Adriaen van de Velde (1636–72)

The Annunciation

L'Annonciation

Die Verkündigung an Maria

La Anunciación de María

L'Annunciazione a Maria

De Aankondiging

1667, Oil on canvas/Huile sur toile, 128 × 176 cm, Rijksmuseum, Amsterdam

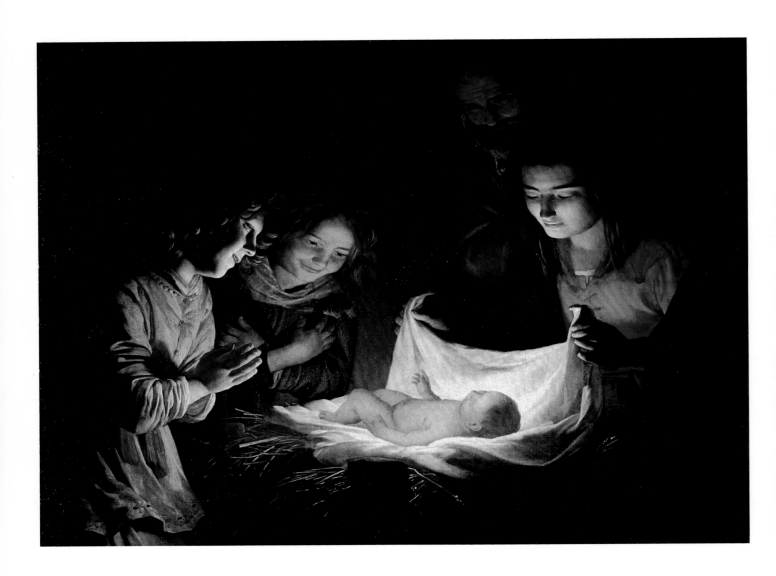

Gerrit van Honthorst (1590–1656)

The Adoration of the Baby Jesus

L'Adoration de l'Enfant Jésus

Die Anbetung des Kindes

La Adoración del Niño

Adorazione del Bambino

De Aanbidding van het Kind

c. 1620, Oil on canvas/Huile sur toile, 95,5 × 131 cm, Galleria degli Uffizi, Firenze

Jacob Jordaens (1593–1678)

The Adoration of the Shepherds

L'Adoration des bergers

Die Anbetung der Hirten

La Adoración de los pastores

Adorazione dei pastori

De Aanbidding door de Herders

c. 1650, Oil on canvas/Huile sur toile, 185 × 180 cm, Musée du Louvre, Paris

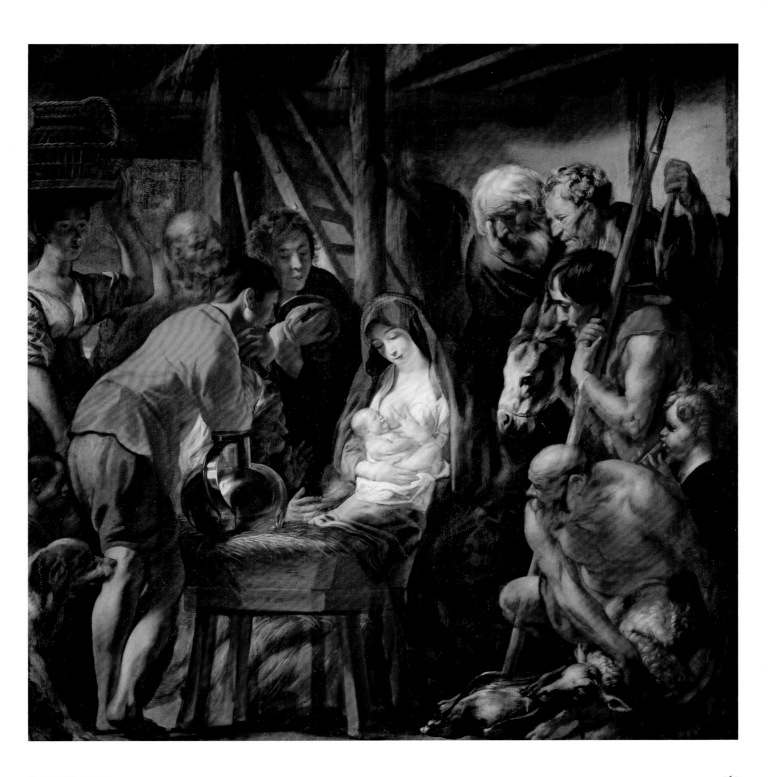

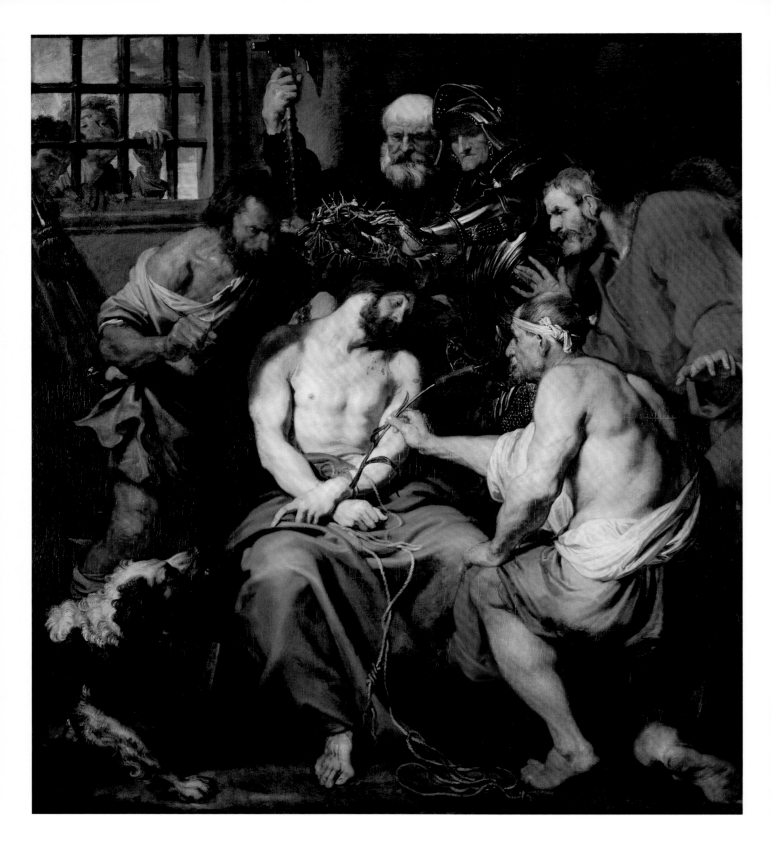

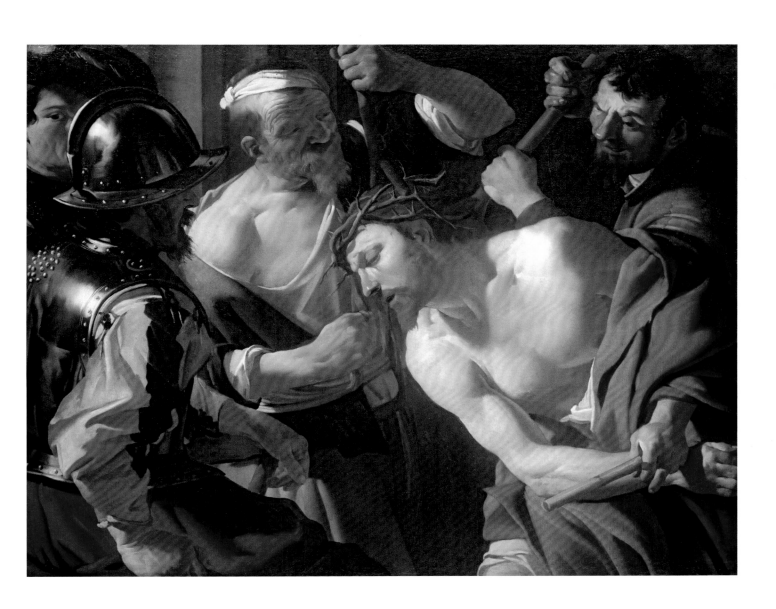

Anthonis van Dyck (1599–1641)

The Crown of Thorns

Le Couronnement d'épines

Die Dornenkrönung

La coronación de espinas

Incoronazione di spine

De Doornenkroning

1618–20, Oil on canvas/Huile sur toile, 225 × 197 cm, Museo del Prado, Madrid

Dirck van Baburen (c. 1594–1624)

The Crown of Thorns

Le Couronnement d'épines

Dornenkrönung Christi

Cristo con la corona de espinas

La corona di spine

De Doornenkroning van Christus

1622/23, Oil on canvas/Huile sur toile, 106 × 136 cm, Museum Catharijneconvent, Utrecht

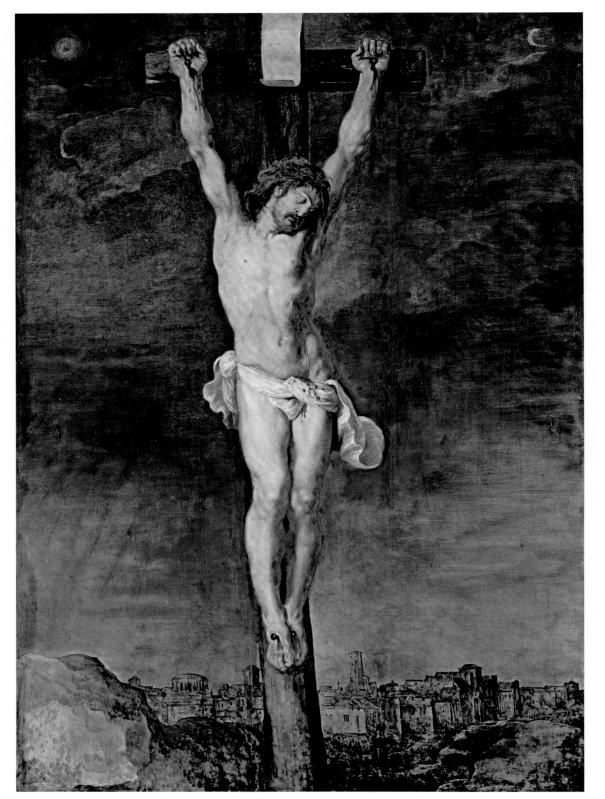

Peter Paul Rubens (1577–1640)

Christ Crucified

La Crucifixion

Christus am Kreuz

Cristo en la cruz

Cristo crocifisso

Christus aan het Kruis

c. 1610, Oil on wood/Huile sur bois, 105,5 × 74 cm, Statens Museum for Kunst, København

Anthonis van Dyck (1599–1641)

Christ Crucified with Mary, John, and Mary Magdalene

Le Christ en croix avec la Vierge, saint Jean et sainte Madeleine

Christus am Kreuz mit Maria, Johannes und Maria Magdalena

Cristo en la cruz con María, Juan y María Magdalena

Cristo in croce con Maria, Giovanni e Maria Maddalena

Christus aan het Kruis met Maria, Johannes en Maria Magdalena

c. 1622, Oil on canvas/ Huile sur toile, 330 × 282 cm, Musée du Louvre, Paris

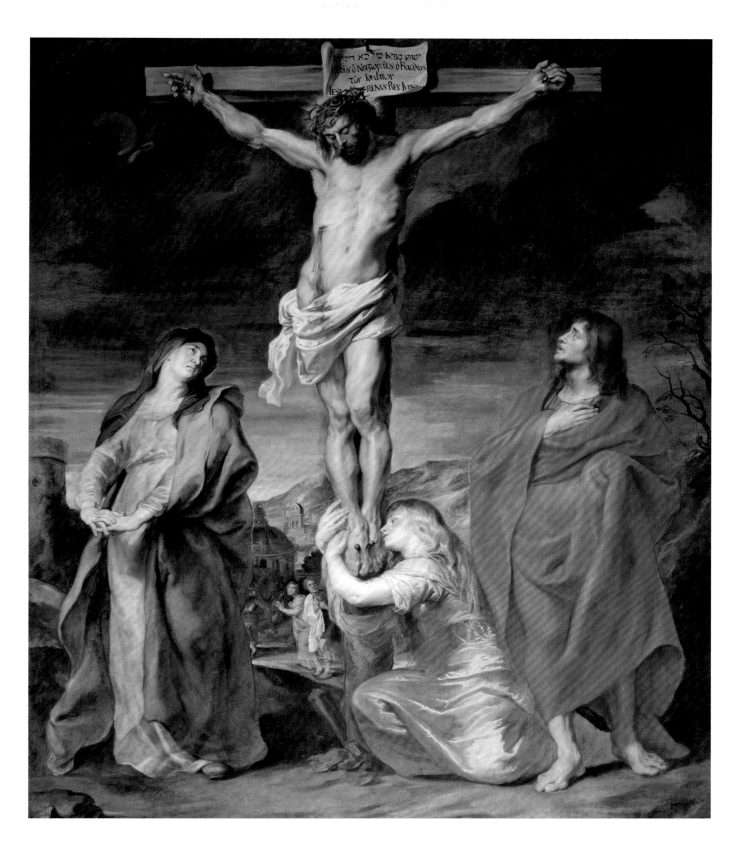

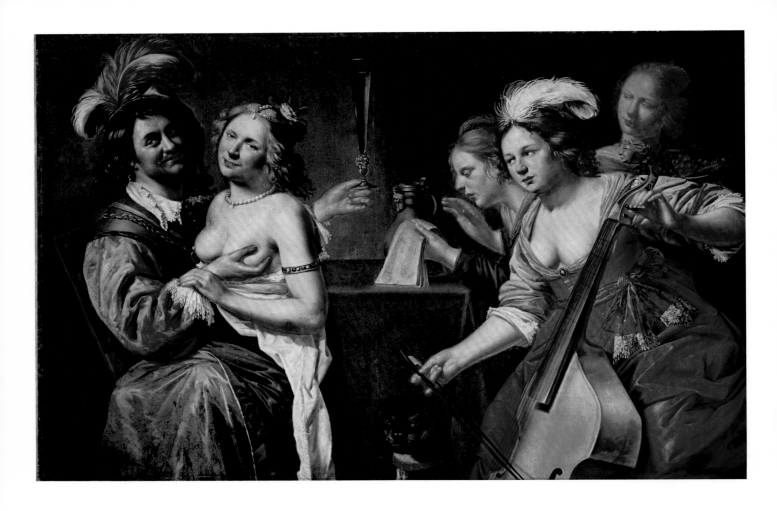

Johannes Baeck (c. 1600–1654/55)

Parable of the Prodigal Son

Le Fils prodigue

Gleichnis vom verlorenen Sohn

Parábola del hijo pródigo

La parabola del figliol prodigo

De gelijkenis van de verloren zoon

1637, Oil on canvas/Huile sur toile, 122,5 × 184,5 cm, Kunsthistorisches Museum, Wien

Rembrandt Harmensz. van Rijn (1606–69)

The Return of the Prodigal Son

Le Retour du fils prodigue

Die Heimkehr des verlorenen Sohnes

El retorno del hijo pródigo

Ritorno del figliol prodigo

De terugkeer van de verloren zoon

c. 1668, Oil on canvas/Huile sur toile, 262 × 205 cm, State Hermitage Museum, St. Petersburg

Dutch/Hollandaise

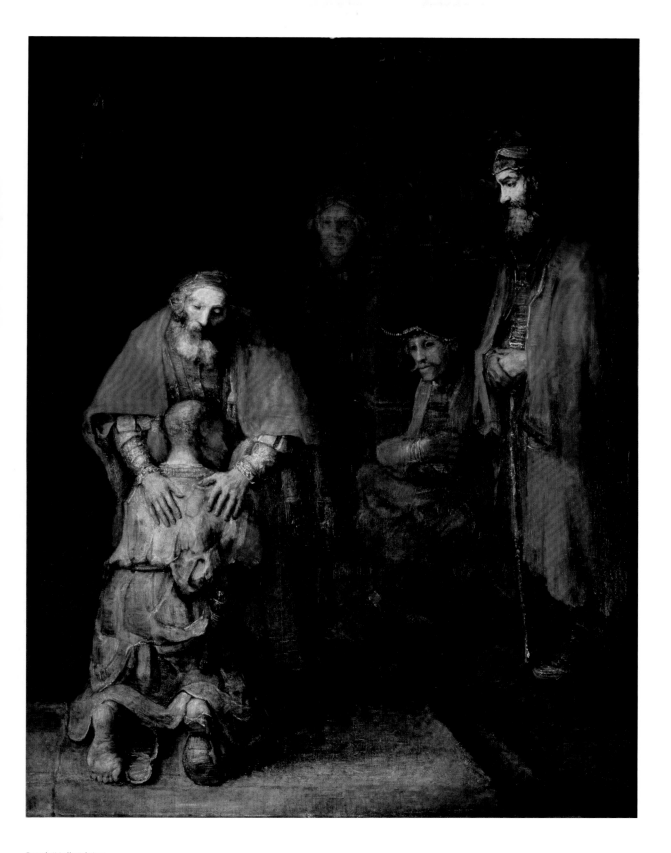

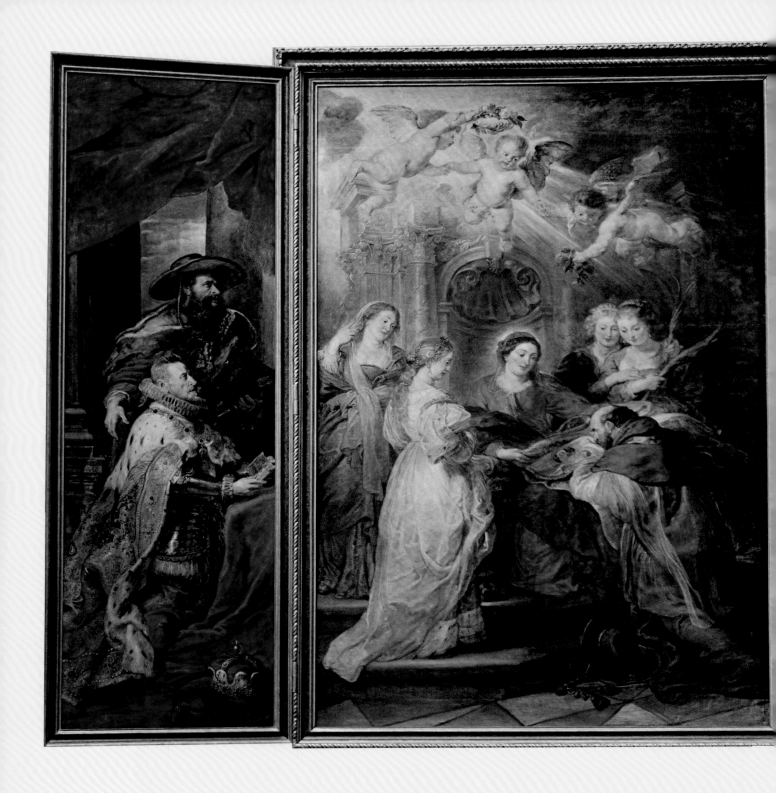

Peter Paul Rubens (1577–1640)

San Ildefonso Altar

Retable de saint Ildefonse

Ildefonso-Altar

Altar de San Ildefonso

Trittico di Sant'Ildefonso

Triptiek van San Ildefonso

c. 1630–32, Oil on wood/Huile sur bois, 352/352 × 236/109 cm, Kunsthistorisches Museum, Wien

On the middle of Rubens' *San Ildefonso Altar*, the Virgin Mary appears to Saint Ildefonso, a 7th century bishop of Toledo, giving him a liturgical garment. The side wings show the Flemish rulers Isabella Clara Eugenia (the client) and Archduke Albrecht of Habsburg (who, with the founding of the Order of San Ildefonso, wanted to spread the cult of the popular Spanish saint to Flanders) together with their patron saints. The sensitive portrayal of the vision of Saint Ildefonso is typical of the Counter-reformation, in which Catholic doctrine and works of art emphasized the emotional aspects of the Christian faith.

Sur le panneau central de ce triptyque, la Vierge apparaît à saint Ildefonse (évêque de Tolède au VIIᵉ siècle) pour lui remettre un habit liturgique. Les panneaux latéraux représentent les régents Isabelle (donatrice du retable) et Albert de Habsbourg (qui voulait populariser dans les Flandres le culte du saint vénéré en Espagne, en fondant un ordre à son nom), chacun d'eux étant accompagné de son saint patron. La représentation empathique de la vision du saint est typique de l'époque de la Contre-Réforme, dans laquelle la doctrine catholique et les œuvres d'art correspondantes accentuaient les aspects affectifs de la foi.

Auf dem Mittelbild von Rubens' *Ildefonso-Altar* erscheint Maria dem heiligen Ildefonso (im 7. Jhd. Bischof von Toledo) und übergibt ihm ein liturgisches Gewand. Die Seitenflügel zeigen die Statthalter Isabella Clara Eugenia (die Stifterin des Altars) und Albrecht von Habsburg (der mit der Gründung des Ildefonso-Ordens den in Spanien verehrten Heiligen in Flandern populär machen wollte) mitsamt ihren Schutzheiligen. Die einfühlsame Darstellung der Vision des heiligen Ildefonso ist typisch für die Zeit der Gegenreformation, in der die katholische Doktrin und Kunstwerke die emotionalen Aspekte des christlichen Glaubens betonten.

En la parte central del *Altar de San Ildefonso* de Rubens aparecen María que entrega a San Ildefonso (obispo de Toledo en el siglo VII) una prenda litúrgica. Las tablas laterales muestran a los gobernadores Isabel Clara Eugenia (donante del altar) y Alberto de Austria (que quería hacer popular en Flandes al venerado santo en España con la fundación de la Orden de San Ildefonso), junto con su patrón. El sensible retrato de la visión de San Ildefonso es típico de la época de la Contrarreforma, en el que la doctrina y las obras de arte católicas hacían hincapié en los aspectos emocionales de la fe cristiana.

Nel pannello centrale del *Trittico di Sant'Ildefonso* di Rubens è raffigurata l'apparizione a sant'Ildefonso (vescovo di Toledo nel VII secolo) della Vergine Maria, che gli porge una casula. Nei pannelli laterali sono rappresentati i governatori Isabella Clara Eugenia (la donatrice dell'altare) e Alberto VII d'Asburgo (che con la fondazione dell'Ordine di Sant'Ildefonso voleva rendere popolare nelle Fiandre questo santo venerato in Spagna) insieme al loro patrono. La rappresentazione emotiva della visione di sant'Ildefonso è tipica dell'epoca della Controriforma, in cui la dottrina cattolica e le opere d'arte sottolineavano gli aspetti emozionali della fede cristiana.

Op het middenpaneel van Rubens' *Ildefonso-triptiek* verschijnt Maria aan de heilige Ildefonso (een zevende-eeuwse bisschop van Toledo) en overhandigt hem een liturgisch gewaad. Op de beide zijvleugels zien we landvoogds Isabella van Spanje (de donateur van het triptiek) en wijlen Albrecht van Habsburg (die met de oprichting van de Ildefonso-broederschap deze in Spanje vereerde heilige ook in Vlaanderen populair had willen maken) en hun beschermheiligen. De gevoelvolle uitbeelding van de visie van de heilige Ildefonso is kenmerkend voor de tijd van de Contrareformatie, waarin de katholieke doctrine en kunst de emotionele aspecten van het christelijk geloof wilden benadrukken.

Index

Bibliography Bibliographie Bibliografie Bibliografía Bibliografia Bibliografie

Timothy Brook, *Vermeer's Hat: The Seventeenth Century and the Dawn of the Global World*, New York 2009 (D, F, I: *Vermeers Hut / Le Chapeau de Vermeer / Il cappello di Vermeer*)

Simon Schama, The Embarrassment of Riches: *An Interpretation of Dutch Culture in the Golden Age*, 1987 (D, F, NL, I: *Überfluss und schöner Schein / L'embarras de richesses / Overvloed en Onbehagen / La cultura olandese dell'epoca d'oro*)

Seymour Slive, *Dutch Painting, 1600–1800*, New Haven/London 1995

Hans Vlieghe, *Flemish Art and Architecture, 1585–1700*, New Haven/London 1999

Ernst van de Wetering, *Rembrandt: The Painter Thinking*, Amsterdam 2016

Adriaan van der Willigen and Fred G. Meijer, *A Dictionary of Dutch & Flemish Still Life Painters Working in Oils 1525–1725*, Leiden 2003

Van Dyck 1599–1641, exh. cat. Koninklijk Museum voor schone Kunsten, Antwerpen; Royal Academy of Arts, London 1999

Vermeer et le maîtres de la peinture de genre / Vermeer and the Masters of Genre Painting: Inspiration and Rivalry, exh. cat. Musée du Louvre, Paris; National Gallery of Ireland, Dublin; National Gallery of Art, Washington D.C. 2017

Martin Warnke, *Rubens: Leben und Werk*, Köln 2011

Museums / Musées

Gemäldegalerie Alte Meister, Kassel:
altemeister.museum-kassel.de/

Koninklijk Museum voor schone Kunsten, Antwerpen:
kmska.be

Kunsthistorisches Museum Wien:
khm.at

Mauritshuis, Den Haag:
mauritshuis.nl

Musée du Louvre, Paris:
louvre.fr

Museo del Prado, Madrid:
museodelprado.es

National Gallery, London:
nationalgallery.org.uk

Rijksmuseum, Amsterdam:
rijksmuseum.nl

State Hermitage Museum, St. Petersburg:
hermitagemuseum.org